VISIONS OF WAR

Art of the Imperial War Museums

Claire Brenard

Published by IWM, Lambeth Road, London SE1 6HZ
iwm.org.uk

© The Trustees of the Imperial War Museum, 2023
All rights reserved. No part of this publication may be reproduced, stored in a retrieval system or transmitted, in any form or by any means, electronic, mechanical, photocopying, recording or otherwise without the prior permission of the copyright holder and publisher.

ISBN 978-1-912423-64-4

A catalogue record for this book is available from the British Library.
Printed and bound by Printer Trento
Colour reproduction by DL Imaging
Editing by Mark Hawkins-Dady
Index by Nicola King

Quotation from 'The Men who Paint Hell' by Wyndham Lewis
in the *Daily Express* © Daily Express

Quotation from 'Contemporary War; Contemporary Art'
by Sue Malvern in *War and Art* © PSLclear
Reproduced with permission of the Licensor

Every effort has been made to contact all copyright holders. The publishers will be glad to make good in future editions any error or omissions brought to their attention.

Front cover: Art.IWM ART LD 1353 (page 97)
Back cover: Art.IWM ART LD 1353 (detail)

Contents

6 Foreword

8 Introduction

12 *We are Making a New World*
 Art of the First World War

72 *The Unreality of it all*
 Art of the Second World War

136 *Pale Armistice*
 Art of the Cold War Era

180 *Theatre of Fantasy*
 Art from the Cold War to
 the Digital Age

242 Afterword

244 Notes

248 Image List

249 Acknowledgements and
 About the Author

250 Index

A new subject matter has been found for Art. That subject matter is not War, which is as old as the chase or love, but modern war.

Wyndham Lewis, 'The men who paint hell – modern war as a theme for the artist', *Daily Express* (10 February 1919)

The new digital visualities of contemporary conflict seem beyond human comprehension. The boundaries between war and peace, home front and war front have collapsed and war is endless… Conflict, violence and their human consequences seem likely to preoccupy contemporary artists and curators for the foreseeable future.

Sue Malvern, 'Contemporary War; Contemporary Art', in Joanna Bourke (ed.), *War and Art: A Visual History of Modern Conflict* (2017)

A new subject matter has been found for Art. That subject matter is not War, which is as old as the chase or love, but modern war.

Wyndham Lewis, 'The men who paint hell – modern war as a theme for the artist', *Daily Express* (10 February 1919)

The new digital visualities of contemporary conflict seem beyond human comprehension. The boundaries between war and peace, home front and war front have collapsed and war is endless... Conflict, violence and their human consequences seem likely to preoccupy contemporary artists and curators for the foreseeable future.

Sue Malvern, 'Contemporary War; Contemporary Art', in Joanna Bourke (ed.), *War and Art: A Visual History of Modern Conflict* (2017)

Foreword

Imperial War Museums hold one of the most significant collections of British art anywhere in the world. It includes around 16,000 works of fine art, comprising paintings, sculpture, drawings, artist prints, photography, films and installations. Added to this are the extensive holdings of postcards, ephemera, popular prints and posters. Expand the definition to include the War Artists Archive – the minutes, correspondence and memos that provide an invaluable source for understanding the government-instigated war artist schemes of both world wars – and the collection swells to around 94,000 items. It is a collection with a purpose: to preserve and make available the responses of artists to the transformational cultural and social impacts of conflict across more than 100 years.

The artists who produced this work, and who are highlighted in this book, do not belong to a coherent movement. They are linked by a longer endeavour: to make an artistic record of war; or rather, using whatever media they work in, to reflect their responses to war and conflict as parts of human existence. Their works often performed specific roles in the times they were made; but they also continue to contribute to the long history of visual representation in war. To grasp the dimensions in full is therefore to appreciate that IWM's art collection goes well beyond the documentary. Artists as eyewitnesses, commentators, participants and activists breathe life into discussion of war and conflict, their work offering new ways into ideas and subjects that can, at times, be challenging.

To bring coherence to the many-tentacled art collection is a large task. The works described in this book were, variously, commissioned, purchased, collected and donated during different phases of history and represent different modes of activity. Included here are artists both known and unknown, the well-represented and the culturally marginalised. Some are artists who were critical to the development of wider European art in the twentieth century and beyond. Some were, or became in their own time, household names; but many lesser-known voices, too, have contributed to the shape and significance of the IWM art collection, even if they have been accorded lesser attention in cultural or historical narratives.

Other individuals have also been highly influential. The IWM art collection has, since its inception in the First World War, been championed, marshalled and activated by human interaction – by cultural figures, government officials, museum curators and audiences. Recognised in this book, as well, are some

omissions from a national 'official' collection which has, for much of its life, developed within a strongly British-centric collecting framework. For example, restored to public attention are some of the émigré artists who fled Nazi Europe and who were, despite protestations, not considered appropriate for official war art commissions during the Second World War.

IWM's more recent engagement with international artistic perspectives and non-Western points of view – particularly those that bring with them direct experience of conflict events – has been thoughtful but remains relatively understated. This is where this book, alongside a commitment to exhibition, research and display, plays another role: to acknowledge the gaps and under-representation that persist within the broader sweep of stories about war art – and to ensure that they are excavated for future development.

In the twenty-first century, IWM's approach to commissioning new work continues to change and grow. Its Art Commissions Committee's sphere of reference has developed to respond to decreasingly definable and less categorisable aspects of contemporary conflict; it now includes a brief to commission more reflective, conceptual, probing work by independent artists no longer necessarily embedded in conflict zones. Indeed, artist engagement-work across the museum increasingly poses questions about the moral, legal and ethical questions of conflict. The committee has, since 2021, overseen the IWM 14–18 NOW Legacy Fund, a national partnership programme involving more than 20 artist commissions on the broad theme of the heritage of conflict from the First World War to the present day. This work, which will see commissions launch across the UK and outside IWM's walls, has offered a new model for artist commissioning and partnership working, and a new way in to IWM's own story. With the launch of the Blavatnik Art, Film and Photography Galleries (2023) at IWM London, audiences can see IWM's art collection displayed afresh. These galleries enable works of art to be presented in a sustained dialogue with the IWM photography and film collections, for the first time.

More strongly than ever, the art collection continues to perform its important function in a museum dedicated to collecting objects and stories that give an insight into people's experience of war. And our continued interest in studying and looking at the collection is testament to its richness and art-historical significance, and to its continued relevance today.

Rebecca Newell
Head of Art, IWM

Introduction

As the artist Wyndham Lewis observed in 1919, there is nothing new about art depicting war. The urge to harness humanity's creative energies in the portrayal of its most destructive ones has existed since ancient times, and artists have found myriad ways to represent, mythologise and memorialise the business of war. One of the earliest known examples of war art is an intricate little mosaic (c. 2,500 BCE) from Mesopotamia, kept now in the British Museum. Making up one side of a box referred to as *The Standard of Ur*, it shows armies with horses and wagons, trampling their enemies underfoot; above them, a larger, dominant figure surveys those he has vanquished. For millennia art about war continued to glorify victory on the battlefield – the artists' patrons made sure of that.

In the twelfth century BCE, the Egyptian Pharoah Ramesses III commissioned battle paintings commemorating great triumphs, to adorn the walls of his temple at Medinet Habu. In subsequent centuries, warrior culture was celebrated by the Ancient Greeks, whose temples featured realist stone carvings of their gods at war, and by the Romans, who commemorated battlefield victories in mosaic and in triumphal arches and columns.

Through its role in glorification and commemoration, war art has made a contribution to the prevailing narratives of history that cannot be downplayed. Who can say whether 1066 would be so well remembered without the Bayeux Tapestry (1070–1080)? Also important – in terms of artworks' cultural influence and longevity – is where such art is seen, and by whom. From around 1438, the Florentine artist Paolo Uccello painted three scenes of the *Battle of San Romano* for a wealthy gentleman who had witnessed that skirmish between Florentine and Sienese forces. One of these large paintings was eventually acquired by the National Gallery in London, where it became a touchstone for British artists interested in painting war imagery. Uccello's pioneering experiments with linear perspective, his attention to detail and his lavish design all combined to impose a kind of order on the chaos of battle – and the painting went on to influence generations of British artists.

While art that proudly commemorates war has existed for many centuries, art protesting its brutal excesses has been a comparatively recent development, precipitated by the invention of the printing press. The first European anti-war images were made by the French artist Jacques Callot in his horrifying series of etchings *The Miseries and Misfortunes of War* (1633), relating to the devastating Thirty Years War (1618–1648). The extraordinary effect of these images went

on to inspire the Spanish artist Francisco Goya, who created the gruesome and haunting series of etchings *Disasters of War* (1810–1820) in response to the Napoleonic invasion of his country. Although a successful court artist, Goya was motivated by events to create unflinching eyewitness art, which showed the depths of humanity's brutality and callousness. For these and other artists, printmaking was an affordable medium suitable for personal, experimental and polemical work.

Despite the existence of such harrowing imagery, triumphant battle painting continued to be a leading expression of royal and state power in the eighteenth and nineteenth centuries. In Britain, Victorian art reflected society's aspirations – and included paintings telling stories of the nation's history, as a means to affirm the country's self-image. But the early twentieth century brought great change to the nation: the death of Queen Victoria, the birth of modernism, and in 1914 the shock of the First World War, which, as Wyndham Lewis observed, brought a 'new subject' for artists: 'modern war'. That era is where this book's story of the art of the Imperial War Museums (IWM) begins.

As soon as the museum was founded, art was collected alongside all kinds of other material. Today, the art collection continues to hold an important and unique role within a museum dedicated to collecting objects and stories that give insights into people's experience of war. While such artefacts *can* exert a powerful and emotive presence, unlike artworks they are not created with this intention; instead, they are objects of evidence. Artistic responses are shaped and conceived by their makers, who bring them into existence with a great deal of thought and preparation. The artworks at IWM are very human responses to extreme circumstances, offering us a sense of what war *feels* like – from the sheer exhaustion of battle, to the fear of threat from the sky, to the after-effects of psychological trauma.

Taken together, IWM's collection contains artworks that follow the long-standing traditions of commemoration and dissent, alongside those that reflect developments and practices from the twentieth century onwards. The concept of the designated 'war artist', sent specially to the battlefront to witness and 'record' events first-hand, was born during the First World War. It was a role that became well established and strongly associated with the IWM; but it is also a convention that became outdated during the Cold War period. The term 'war artist', linked so much to the two world wars with their home fronts and multiple theatres of conflict, implies certain assumptions: that there must be a kind of battlefield; that one needs to travel some distance to reach it, therefore remaining somewhat detached from the situation; that the artist is likely (although not exclusively) to be male; and not least, that it is possible to record *objectively* in art what the artist sees. All this makes for a restrictive approach to war art, when it is in fact a hugely expansive, ever-changing field.

A century and more of change since 1914 – in society, art, geopolitics and war – has provided ever more fertile subject matter for artists and their evolving methods and practices. One area of profound change has been the role of women. In the two world wars, the relatively few women war artists were

usually expected to portray the activities of other women who stepped into traditionally masculine roles on the home front. Much later, as previously strict gender-based roles began to be blurred, artists were able to examine women's active participation in conflict-related violence and abuse.

It is clear from surveying the artists represented in IWM's collection that very few of them make war their primary subject; most approach it as one theme among many. Among contemporary artists in particular, there are those who explore the wider themes of history and memory, those who engage with current affairs and politics, and those who expose the role of the news media in portraying political events. All these preoccupations are likely to encompass war and conflict. Artists approach their work with varying degrees of distance: while some have an intellectual interest in the subject of conflict, others have been *directly* affected by conflict or its aftermath. Artists ask difficult questions or encapsulate contradictory ideas; they sometimes employ dark humour, or subtly create a bleak atmosphere. Many tackle the enduring subject of the human condition. There are, in short, endless possibilities for artistic exploration when it comes to the messy, chaotic, disturbing and extreme matter of war.

As the title of this book suggests, all the artworks discussed can be conceived as different 'visions of war' in the widest sense. It is a description that emphasises the role of the artist's perception and imagination in creating their work. In a more literal sense, 'visions of war' also alludes to the reality that IWM's artworks are almost entirely visual, the one exception being *From a Distance* (2009) by Susan Philipsz – a site-specific sound installation commissioned for a hangar at IWM Duxford.

In terms of organisation, *Visions of War* takes a chronological approach, setting out the broad historical context of each era and conflict, to help unlock understanding of the artists discussed and the artworks presented. Chapter One leads us from London's art scene at the turn of the twentieth century into the First World War and the early artistic responses to the conflict, before the British government established its first-ever official war artists scheme, in 1916. It reveals the IWM's initial forays into commissioning art, as well as the stories behind some of the most well-known works in the collection – and of the war – such as those created by Paul Nash, C R W Nevinson and John Singer Sargent. Chapter Two, on the art of the Second World War, illuminates the artworks collected and commissioned by the British government's official scheme, alongside work by artists who responded in a personal capacity to the terrifying prospect of war and its unfolding realities, in Britain and elsewhere. The little-known story of attempts by authorities to gather art from across the British Empire is told, too.

Chapter Three covers the period following the end of the Second World War to the early 1990s, an era dominated by the shadow of the Cold War. This long period marked a time of gradual transition, change and revival at the IWM, as a new art-commissioning body was created in 1972 – the Artistic Records Committee (ARC) – and the museum began to collect the work of contemporary artists once more. The 1980s saw the arrival of Angela Weight, the first woman to hold the title of IWM's Keeper of Art: over the next two decades, her influence

brought a radical shift in IWM's art collecting and witnessed the evolution of the ARC into the Art Commissions Committee. The final chapter encompasses the period following the end of the Cold War, when a new world order emerged after the fall of the Berlin Wall but conflicts continued – and new ones began, from the Balkans to the Middle East to Afghanistan. Artists found diverse means to respond to both current and past conflicts, making powerful and sensitive works, using thoughtful, conceptual methods.

Along the way, there are recurring themes, as successive generations of artists tackle the most painfully resonant subjects, often from personal perspectives. These include artworks about the Holocaust – both raw and immediate, as well as later, reflective pieces. Artistic responses to the long-running Troubles in Northern Ireland also fall into this category. Throughout, a picture emerges of a collection that represents a predominantly British experience of conflict – with some notable exceptions – echoing the interests and concerns of those who helped to shape it over the past century.

The evolving story of the museum itself runs through the background. Founded to remember and honour those who served in the First World War, as well as what they did in that war, the museum's original timeline was meant to conclude there; but, of course, this proved to be only the beginning. Since those early years, the IWM has meant different things to different generations. For much of the twentieth century, its fate as a repository for much of Britain's official art, together with its position as a national museum of social and military history, has had an effect of keeping 'war art' as a distinct and separate category from the mainstream of British art. While in recent years this perception has begun to change, the war museum remains a unique context for exhibiting art: contemporary artists continue to be drawn to the venue, given the potential for new audiences to encounter their work. The proximity of the paraphernalia and memorabilia of war makes for a very different visitor experience compared with the more formal and reverent environment of a conventional art gallery. Art, after all, is about humanity turning the lens back on itself – and what repository of material relating to human extremes of behaviour could be more extensive, or unflinching, than that of the IWM?

Of course, *Visions of War* cannot be all-encompassing. It is not a catalogue, and there have been many tough decisions as to which artworks to include. It is, therefore, a book of highlights, intended as a representative selection from IWM's collection, conveying something of the variety of artistic approaches against the background of their real-world events. While many of the artworks in these pages can be found on display in one of IWM's family of museums, this book is not simply an enlightening souvenir for the visitor; it is hoped that *Visions of War* will also stand alone as a stimulating guide to the art of the Imperial War Museums, of appeal to anyone, anywhere, with an interest in the fascinating intersection between modern art and modern war.

Claire Brenard
Curator, IWM

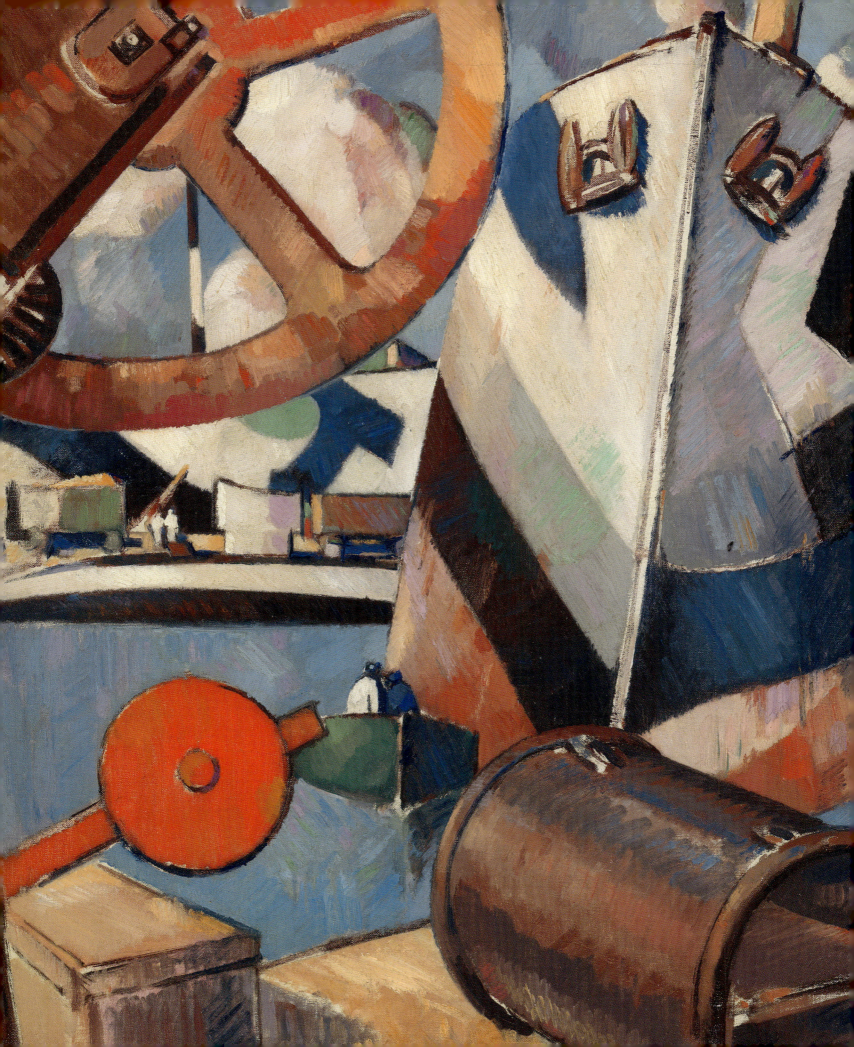

We Are Making a New World
Art of the First World War

At the turn of the twentieth century, Britain – one of the European 'Great Powers', along with France, Tsarist Russia, the Austro-Hungarian Empire and Imperial Germany – was the wealthiest nation on earth and the seat of a vast, maritime global empire. But this self-confident, powerful country was facing change and unrest at home and challenges abroad.

British society remained vastly unequal, its riches concentrated in the hands of a small minority, while trade unions fought for better pay and conditions with increasing militancy. Women, as well as many men, did not have the right to vote in elections, and the campaign for women's suffrage intensified, with attacks on property and hunger strikes in prison. In Ireland – all of it still part of the United Kingdom – there were bitter divisions over the prospect of devolved power, 'Home Rule', creating fears of civil violence and sowing the seeds for protracted conflict. On the continent, Germany had deepened ties with its Austro-Hungarian neighbours and was harbouring ambitions of imperial expansion, while Britain agreed new informal alliances with its old rivals Russia and France.

Despite the closer engagement between Britain and France, in cultural terms there remained a chasm between the two nations. Paris was still very much the centre of Western art. Yet the thriving and cosmopolitan culture of London attracted artists of all stripes, who were drawn to its opportunities and atmosphere of freedom. These artists included John Singer Sargent, born in Florence to American parents, and the Irishmen William Orpen and John Lavery, who all settled in London in the late nineteenth century. They enjoyed enormous success with their portrait commissions of the wealthy, with Sargent noted for capturing the easy opulence of the Edwardian era and Orpen enjoying flamboyant celebrity status. Lavery's work was collected internationally and was especially popular in Paris and Berlin. Orpen, the youngest of the three, was yet the most traditional in his approach, while Sargent and Lavery's fluid, painterly styles signalled the start of change in British painting, influenced by French impressionism and by the work of the American expatriate James McNeill Whistler. Late-Victorian painting was typified by a realist yet idealistic style; there was also a preoccupation with imitating naturalistic effects, such as light, as seen in the work of George Clausen, whose idyllic countryside scenes, featuring children or farm workers, went on to inhabit public galleries all over Britain. 'War art' at this time was essentially a form of 'history painting': epic scenes of historical events of

John Duncan Fergusson, *Dockyard, Portsmouth, 1918* (1918)
Oil on canvas, 770 x 688 mm

Transformed by the vibrancy of the First World War's dazzle schemes, British dockyards held fresh appeal for modern painters such as Fergusson, whose approach to colour was influenced by cubism and fauvism.

national or mythical importance. History painting had been a popular and respected genre during the Victorian era, when a number of artists were commissioned to make paintings between 1841 and 1863 for the new Palace of Westminster. A rare instance of state-funded art, the palace scheme included important scenes of British history, such as the burial of Charles I, but also scenes from Arthurian legend. For the House of Lords, the Irish artist Daniel Maclise was commissioned to paint huge murals of the battles of Waterloo and Trafalgar. Working decades after those Napoleonic conflicts, Maclise consulted survivors and obtained original equipment and uniforms to dress his models, reflecting established techniques in the creation of battle painting. He also utilised a generous helping of artistic imagination in the propagation of societal values that his era esteemed: cooperation, valour, duty. Military artists Lady Elizabeth Butler, James Prinsep Beadle and William Barnes Wollen would continue to paint scenes from the Napoleonic Wars into the early twentieth century.

It would not be these painters, however, but a new generation of artists – alongside the likes of Sargent and Orpen – who would be remembered for their imagery of the coming war. One of the leading lights of this generation was the sculptor Jacob Epstein, who, born in New York to Polish-Jewish parents, came to London via Paris in 1905. At that time, there were abundant sculptural commissions in Britain, especially in the form of memorial statues of Queen Victoria or symbolic figures within the design of grand new buildings. The Victorian style of sculpture (combining the idealistic, realistic and classical) was still favoured, as in the work of George Frampton. But Epstein developed a radically different 'modern' approach, reviving the practice of direct carving, as opposed to modelling in clay before casting in bronze. He was influenced by sculpture from around the ancient world, on display at the British Museum. It did not take him long to make his mark, offending the sensibilities of Edwardian society in 1908 with his nude sculptures symbolising the 'Ages of Man' for the façade of the British Medical Association building, on London's Strand. His work would continue to shock and offend, culminating in the disturbingly aggressive and mechanical *Rock Drill* (1913–1915).

The influential artist Walter Sickert also came to London from France in 1905. Far from idealistic, his enigmatic paintings portrayed shadowy interiors of contemporary urban life. He formed an exhibiting society, the Fitzroy Street Group, which evolved in 1911 into the Camden Town Group, bringing together a loose collective of artists who tackled modern city life in a range of different styles. This was a time when many different artist groups, clubs and societies were forming, vying for attention and keen to promote bold new approaches. The influential critic and painter Roger Fry sensed the mood and arranged ground-breaking exhibitions on the so-called 'post-impressionists' in 1910 and 1912, introducing the work of Cézanne, Matisse and the cubists Picasso and Braque to a sceptical British press and public. This traditionally conservative audience felt unsettled by the radical paintings, which they saw as symptoms of the current unrest and a threat to the established social order. But Fry's circle – the intellectuals and artists of the forward-looking Bloomsbury Group (including painters Duncan Grant and Vanessa Bell) – welcomed an approach to art that did not attempt merely to imitate reality, as had been a preoccupation of both

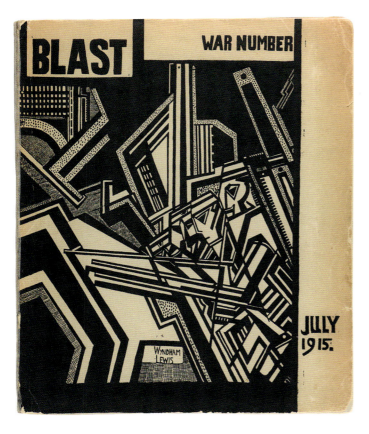

Front cover of *BLAST: War Number 2* (1915)
Woodcut on paper, 297 x 243 mm

This was the second and final publication of the short-lived vorticist magazine *BLAST*. Edited by Wyndham Lewis, it boasted contributors including Henri Gaudier-Brzeska, C R W Nevinson, William Roberts, Edward Wadsworth, Jessica Dismorr and Helen Saunders.

Victorian and impressionist art. Instead, this modern art was envisaged by its makers as a part of reality; now, a successful painting should have a life-force of its own. In 1913, Fry went on to establish the Omega Workshops, aided by Grant and Bell, to bring the modernist aesthetic, embracing bold colour and design, to the applied arts, including fabrics, furniture and ceramics.

Three years earlier, in 1910, the Italian poet and provocateur Filippo Tommaso Marinetti had arrived in England to publicise the shock and awe of Futurism, his uncompromising aesthetic that celebrated the sheer power, speed and dynamism of the machine age. More than that, the first Futurist manifesto (1909) had declared: 'we will glorify war – the world's only hygiene – militarism, patriotism, the destructive gesture of freedom-bringers'.[1] He hoped that in Britain, the first industrialised nation, he would find fertile ground for his obsessions. But he discovered that British artists could not take him seriously – with the exception of the painter C R W Nevinson, at least for a while. However, the presence of so many ego-driven characters within a rapidly diversifying art scene inevitably began to cause frictions.

In spring 1914, the artist and writer Wyndham Lewis (1882–1957) fell out with Fry and left the Omega Workshops to establish the Rebel Art Centre, where he was joined by Nevinson and others. Lewis railed against many aspects of contemporary art and society, but crucially the Centre became the crucible of vorticism – an avant-garde movement that drew on cubism and was characterised by bold geometric lines and patterns. The movement had parallels with Futurism but aimed to reflect, rather than celebrate, the harshness of the industrial age, by imitating the principles and organisation of machinery. Lewis despised Marinetti's romanticisation of the machine, as did many of his avant-garde compatriots. When Nevinson and Marinetti, without consulting Lewis or the other Rebel artists, published a manifesto in their name on 'Vital English Art' (June 1914), calling for 'an English art that is strong, virile and anti-sentimental', Lewis and his fellow artists (plus the poet Ezra Pound) responded: they produced a counter-manifesto, in their magazine *BLAST*.[2] Although the coming war would ultimately curtail the nascent movement, splintering its members, vorticism would soon prove to be an apt language for describing the conflict's realities.

In 1914, the world these artists knew – that all Europeans knew – ruptured. The assassination on 28 June of Archduke Franz Ferdinand, heir to the Austro-Hungarian throne, triggered a chain of events that activated the international alliances and led, within weeks, to conflict between Europe's Great Powers. Germany declared war on Russia and then France, before Britain entered the war on 4 August 1914, ostensibly outraged by Germany's incursion into neutral Belgium – but in truth, and more strategically, to prevent Germany from shifting the balance of power in Europe in its favour.

Across the belligerent nations, the general public met the news with a combination of trepidation and excitement – and crowds gathered to learn of developments from official proclamations or the latest editions of newspapers, sometimes erupting into displays of patriotic enthusiasm. The widespread view was that war would be brief. The British government immediately introduced sweeping legislation known as 'DORA' (Defence of the Realm Act), which allowed the government to control almost all aspects of civilian life, including communication. This was the first major war in the emerging age of mass media, and governments began to use the techniques of the advertising industry – notably the poster.

Britain – unlike its European counterparts – did not have conscription in 1914. When Lord Kitchener, the Consul-General of Egypt, was quickly co-opted as Secretary of State for War, he foresaw that a long conflict likely lay ahead. A celebrated imperial hero, Kitchener held great sway, and now he called for hundreds of thousands of new recruits. The Parliamentary Recruiting Committee (PRC) was convened to campaign, using social pressure to encourage men to enlist. The art of the poster might have been in its infancy, and around half of the PRC's output purely typographical rather than pictorial; but the committee did produce some memorable poster campaigns reinforced by striking if unsubtle imagery, one well-known example being *Daddy, what did YOU do in the Great War?* (1915). The single most enduring propaganda image to emerge from Britain's war was Alfred Leete's *Britons. Join Your Country's Army!* (1914), featuring the moustachioed Kitchener pointing his finger at the viewer. It was produced originally as a black and white cover image for the magazine *London Opinion* (5 September 1914) and in fact was never adopted in this guise by the PRC for its campaigns. The PRC published a far less punchy poster, featuring a more conventional portrait of Kitchener, the following year. Nevertheless, such was the potency of Leete's concept, it would go on to be recycled, replicated and subverted in a myriad of forms by designers thereafter, giving it a cult-like status. To subsequent generations, Kitchener was *the* face of the war.

Many young men rushed to enlist, sensing that the experience of war would broaden their horizons; others were driven by financial need, having lost their jobs during the recent economic downturn. But most of those who enlisted were compelled by a sense of duty, appalled by grisly reports of German atrocities in Belgium. Among them were many young artists, including the 25-year-old Paul Nash (1889–1946). Since dropping out of the Slade School of Art, Nash had been developing his practice as an understated yet poetic landscape painter, also working for the Omega Workshops; now, he put his nascent career on hold to join the Artists' Rifles – the battalion of his artistic heroes Dante Gabriel Rosetti and John Everett Millais. Another to answer the call was Nevinson (1889–1946), the same age as Nash. Although his persistent ill health debarred him from the British Army, he instead volunteered as an ambulance driver, 'pursued by the urge to do something, to be "in" the War'.[3] Yet another artist to sign up was Henri Gaudier-Brzeska (1891–1915), who had settled in London with his partner, the writer Sophie Brzeska, in 1911. The young Frenchman had risen quickly as an influential member of the Rebel Art Centre, later contributing to Wyndham Lewis's provocative *BLAST*, before he left everything and everyone behind to join the French Army in September 1914.

Walter Sickert, *Tipperary* (1914)
Oil on canvas, 508 x 406 mm

A large mirror – a frame within a frame – reveals a young woman seated at the piano. This unusual compositional device lends a jarring impression to the painting. It also allows the pianist and the listening soldier to be visually close but emotionally distant from one another.

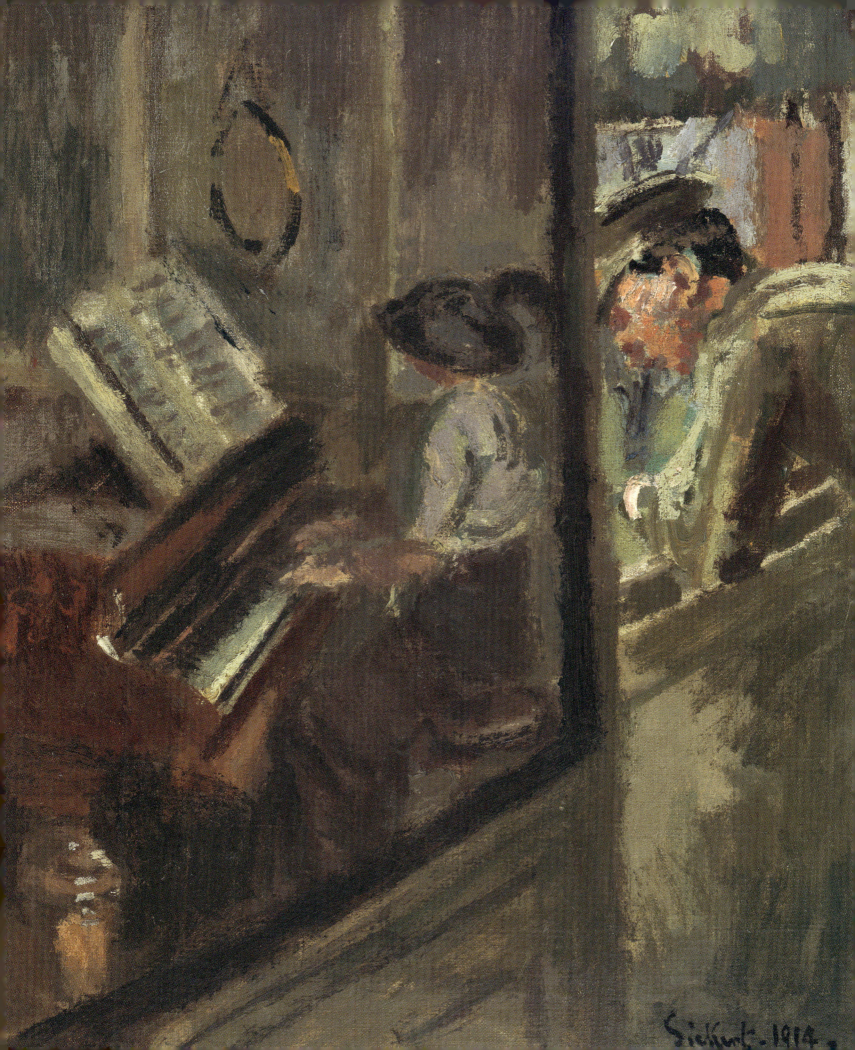

While these younger artists were instinctively drawn to the action, in 1914 few of the older and more established artists addressed the new realities in their art. Walter Sickert (1860–1942) – ever the outlier – painted a series of works entitled *Tipperary*, obliquely referencing the atmosphere of the British home front. As in the case of many other people, Sickert's horror at the news from Belgium compelled him to support the war; but, at the age of 54, he was too old to enlist. More than that, his German birthplace – Munich – brought him under temporary suspicion from the authorities, until he could prove his naturalisation status. His war-themed works were perhaps a pragmatic attempt to prove his patriotism, and he went on to make paintings on the war in Belgium, in support of the Belgian Relief Fund. Sickert's *Tipperary* (1914) paintings all show a young woman seated at a piano. They play on the popular resonance of the 1912 song 'It's a Long, Long Way to Tipperary', which was fast becoming a wartime staple, after the lyrics were printed in the *Daily Mail* in August 1914 along with the story of how the Connaught Rangers sang it to boost their morale. Sickert would often invoke popular culture in his art, and he particularly loved the music hall. By implying that the young woman was playing 'Tipperary', he was able to evoke the cheerful optimism characteristic of these early weeks of war, as regiments set off for France – albeit in his typically ambiguous way.

Mass-produced war imagery was not confined to posters; it was found everywhere in Britain: in illustrated magazines, in cartoons, in point-of-sale advertising, and on stage, in the music halls, and in the output of the young film industry. Taken together, such imagery fostered patriotic citizenship – on the one hand through emphasising the 'barbarism' of the German enemy, and on the other, through cheery humour. Bruce Bairnsfather (1888–1959), firmly of the latter trend, achieved a quick and roaring success with his work for *The Bystander* magazine. He poked gentle fun at the plight of the ordinary British soldier, the 'Tommy', through the character of 'Old Bill', a somewhat grumpy soldier of the British Expeditionary Force (BEF). Bairnsfather had experience of what he depicted, having served as a machine-gun officer in the fighting around Ypres until invalided out from the Front in 1915. As time went on, his Old Bill helped to raise morale among an increasingly desperate population, especially among British soldiers. Bairnsfather would go on to create a hugely successful play, *The Better 'Ole*, in 1917, following the popularity of hit sketch shows including *Where did that one go?* from the revue *See-Saw!*.

Without access to the battlefields, traditional military painters – accustomed to working from news reports and models in uniform – attempted to visualise scenes from the conflict, as they had done for the Anglo-Boer War (or South African War) and Crimean War before. Some artists, like John Hassall (1868–1948), even sought inspiration from the popular stories and myths about the fighting that were circulating. In the 1880s, before Hassall became an artist and a prolific illustrator, he had twice failed in his attempts to become an army officer. His battle scenes were based on others' accounts and stories, and they included, in 1915, *Bannockburn* – about the battle of 1314. Hassall also painted *St George Over the Battlefield*, one of the many portrayals of the so-called 'Angels of Mons', who reputedly appeared in the sky to cast their protective aura around the BEF as it retreated, following its first, and fierce, encounter with German forces at the Battle of Mons (23 August 1914).

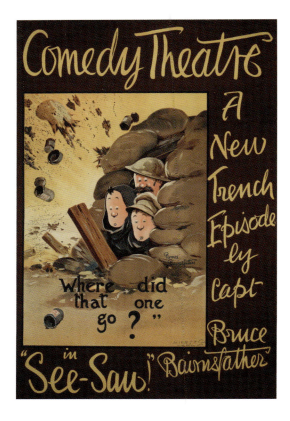

Bruce Bairnsfather, '*Where did that one go?*' (1917)
Lithograph on paper, 761 x 510 mm

This sketch was the second theatrical outing for Bairnsfather's much-loved comic creation Old Bill. It opened at the Comedy Theatre, London, in March 1917.

John Hassall, *St George Over the Battlefield* (1915)
Oil on canvas, 762 x 1,302 mm

The legend of the 'Angels of Mons' originated from a short story called *The Bowmen* by the fantasy author Arthur Machen, published in September 1914. Machen described Saint George summoning ghostly bowmen from Agincourt to help the retreating troops. In the public imagination the apparitions soon became angels, and even the returning troops seemed to corroborate the story, turning fiction into patriotic legend.

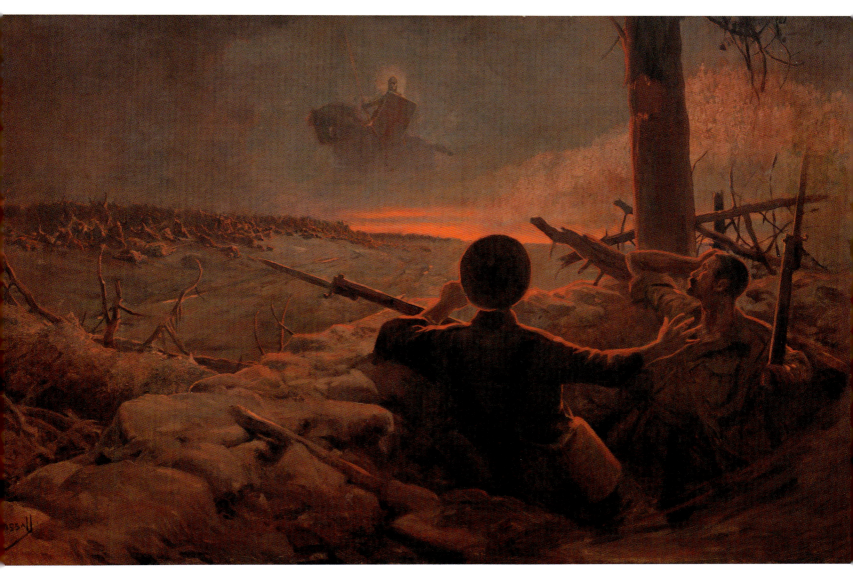

Meanwhile, those 'soldier artists' who had joined up were experiencing the reality of the Western Front, which, early in 1915, came to assume its character of networks of opposing trenches, separated by the contended 'no man's land'. On 5 June 1915, the 23-year-old Henri Gaudier-Brzeska's brief spell as a soldier was brought to an abrupt end when he was killed during an attack on Neuville-Saint-Vaast. The young artist was a pioneer of carved sculpture, inspired by ancient techniques from around the world; he had even managed to create some small wood carvings in the trenches. He also made drawings, usually executed at speed, including *Le Martyr de St Sébastien* (1914), likely made before his departure to France. *Le Martyr* eerily prefigures the artist's death, showing a victim whose features – oval eyes and high cheekbones – resembled Gaudier-Brzeska's own self-portraits. 'I am quite prepared,' he said, 'to lose my life. We here have nothing but death and desolation.'[4]

By 1916, the costs of the war were hitting home. The long and brutal Battle of the Somme was at the forefront of the British public's imagination. It had dragged on for five months at huge human and material expense, bringing little territorial gain for the Allies, though also wreaking a terrible toll on the German Army. This was also the first time that Britain had fielded a large army of citizen volunteers, and people from every walk of life had known someone who was there. When *The Battle of the Somme*, the first feature-length documentary ever made, was shown in British cinemas, an estimated 20 million people went to watch it, hoping to catch a glimpse of a loved one.[5]

Britain's war had no end in sight: 1916 also saw the deadly campaign against Ottoman forces in Gallipoli end in humiliation, along with the surrender of besieged British and Indian forces at Kut, in Mesopotamia (Iraq), heavy losses at sea in the Battle of Jutland, the Easter Rising in Dublin, and the beginning of conscription. The bleak situation combined with family tragedy to inspire a work by George Clausen (1852–1944), whose *Youth Mourning* (1916) was displayed in the Royal Academy that year. Moved by the death of his daughter's fiancé in 1915, Clausen offered, in his painting, a response to the war from one generation to another. His use of allegory – in the female nude, which represented the tragic innocence of youth – firmly set the painting in the style of the Edwardian past. But a newer generation of artists, seeing the war first-hand, was about to revolutionise the art of the First World War.

George Clausen, *Youth Mourning* (1916)
Oil on canvas, 914 x 914 mm

The enormity of the war's devasting impact on the young was a challenge for older artists to portray. Clausen's melodramatic imagery contrasts the stark nudity of the young woman with a barren landscape as a way of representing abstract concepts of universal grief and loss.

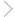

Henri Gaudier-Brzeska, *Le Martyr de St Sébastien* (1914)
Ink on paper, 255 x 386 mm

Over the centuries, many artists have turned to the subject of Saint Sebastian – the Christian martyr who survived execution by arrows only to be beaten to death. It is likely that Gaudier-Brzeska was also inspired by the controversial musical play *Le Martyre de Saint Sébastien* (1911), written by the Italian dramatist Gabriele D'Annunzio and scored by Claude Debussy.

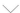

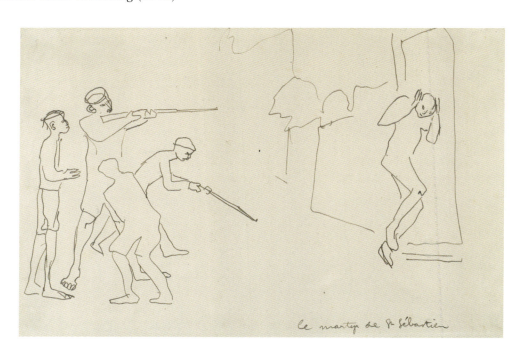

WE ARE MAKING A NEW WORLD: ART OF THE FIRST WORLD WAR

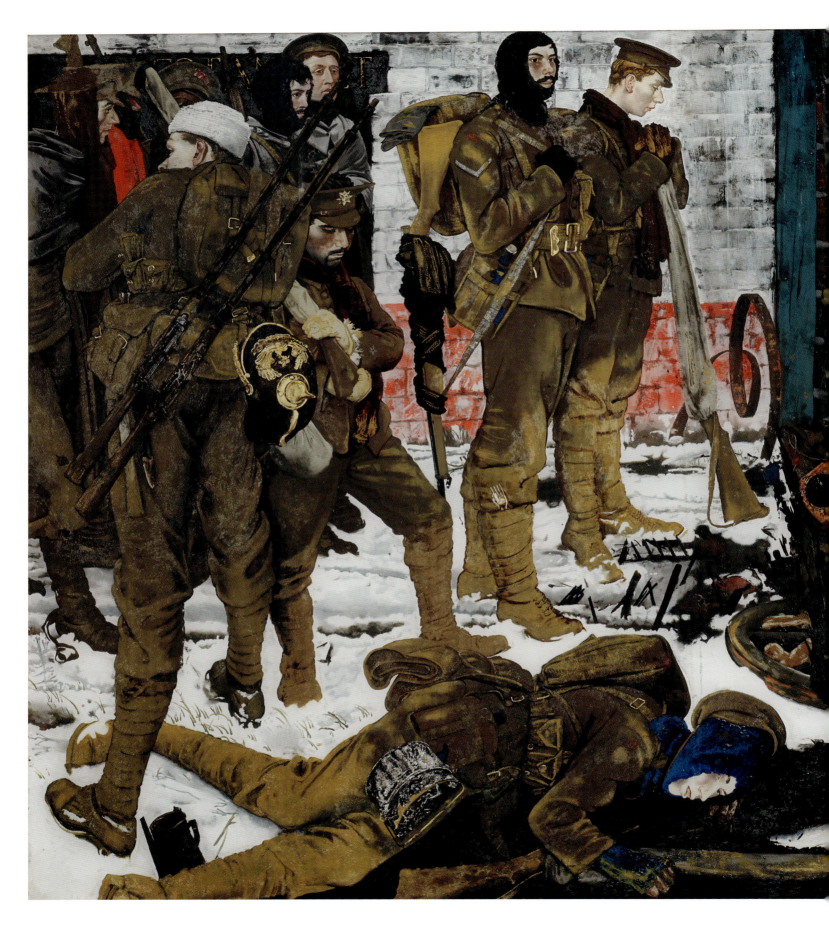

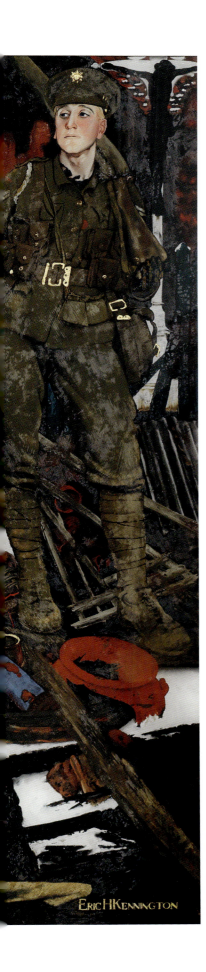

The first of the 'soldier-artists' to exhibit their work was Eric Kennington, in May 1916. The London-born Kennington (1888–1960) was a promising artist who had trained at Lambeth School of Art and had exhibited at the Royal Academy in 1908. But just two days after Britain declared war, he enlisted with the 13th (Kensington) Battalion of the London Regiment, which was sent to Estaires in northern France. Here, Kennington survived a treacherous winter in waterlogged trenches, then suffered a wound to his foot in January 1915, spending months in recovery, before being invalided out of service. During that period, he sketched his comrades and started work on an ambitious tribute to his battalion.

The Kensingtons at Laventie (1915) was one of the first paintings to be based on direct experience of the war. When it was exhibited in 1916, critics hailed it as a new kind of history painting. While the technique may have been ancient, there was something modern about the figures, whose exhaustion and disarray, after four days and nights in the trenches, was obvious. It was also a remarkable technical achievement, being painted on the reverse of a sheet of glass, which meant that layers of paint were applied by the artist in reverse order. With its flashes of gold paint and the luminosity emanating from the glass's glossy surface, Kennington's work elevated and honoured the soldiers without denying their hardships.

The attention that *The Kensingtons at Laventie* garnered marked a turning point in British war art and advanced Kennington's subsequent career as a war artist. It reinforced the idea that only those who had served and directly experienced the war could show the public what the conflict was really like.

C R W Nevinson's solo show at London's Leicester Galleries, in September 1916, was the next exhibition to have impact. War had profoundly affected him. His experiences as a medical orderly had been transformative – tending casualties who had been left for weeks on end, in a railway shed outside Dunkirk, their wounds festering. In his words, 'When a month had passed I felt that I had been born in the nightmare. I had seen sights so revolting that man seldom conceives them in his mind… .' Nevinson could only perform his medical role for a few months before he suffered a mental breakdown and was sent home. As he put it, 'Back I went to London, to see life still unshaken, with bands playing, drums banding, the New Armies marching, and the papers telling us nothing at all. A man is sadder for seeing war; but I grew better, and painted.'[6]

Eric Kennington, *The Kensingtons at Laventie* (1915)
Oil on glass, 1,397 x 1,524 mm

Kennington's gift for male portraiture is evident here in his ambitious tribute to his platoon, who are shown resting after a long stretch of duty in the Lys Valley, northern France, during the first winter of the war.

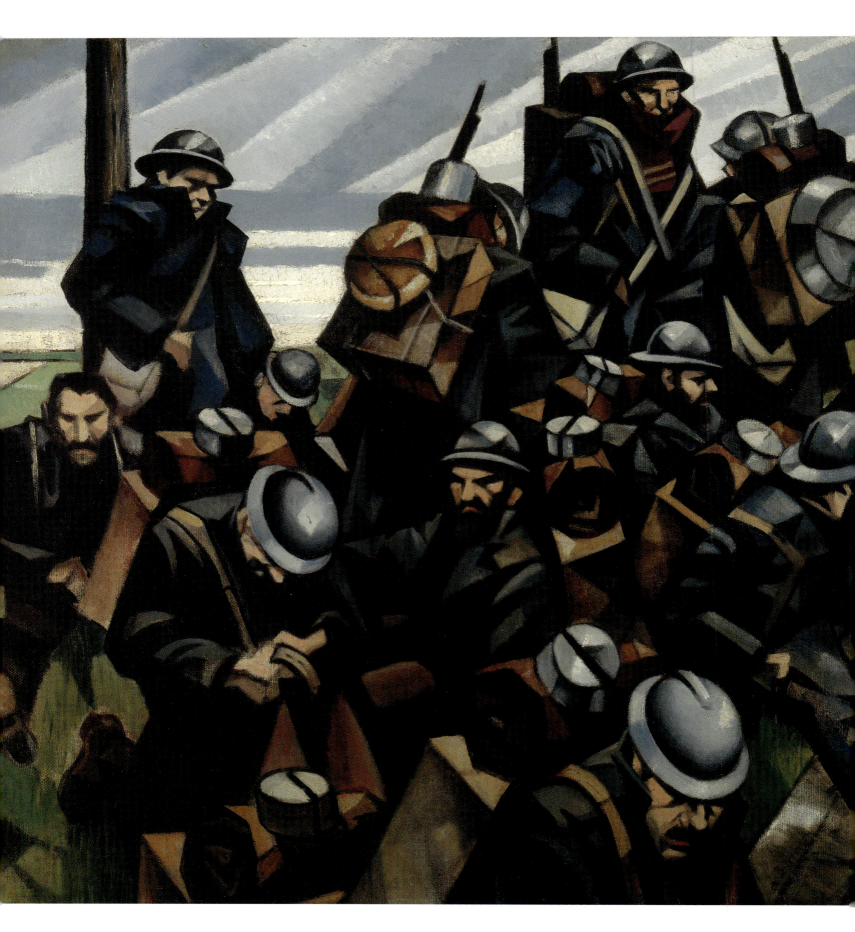

In fact, following his return from France, Nevinson was remarkably productive. Despite the shock of his experiences, he was able to draw on them to create a new series of bold, modern, yet accessible paintings. *French Troops Resting* (1916) shows how he adapted the ideas of Futurism to the bleak reality he witnessed, creating a visual language that was entirely his own.

Nevinson's 1916 show caused a sensation, and it led to calls for artists to be sent to the Front on official commissions – calls that were not lost on the influential Liberal MP Charles Masterman. Since 1914, Masterman had been responsible for the British government's propaganda aimed at neutral and Allied countries. His secretive War Propaganda Bureau went by the informal name of 'Wellington House', after its London location, and in 1916 it was brought fully under the Foreign Office. It had already covertly gathered an impressive roster of leading writers for its books, pamphlets and periodicals, and it employed Dutch artist Louis Raemaekers to produce explicit anti-German cartoons, which proved to be extremely popular. Masterman could see the value of pictorial propaganda: images were needed to supplement news and comment editorials in the illustrated papers, to help maintain public interest. In the early years of the war, the British press had published photographs taken by soldiers at the Front, but in 1915 the War Office banned unauthorised photography, in a bid to regain control of the narrative. Masterman now began to engage official photographers to document the Front, and all such images had to be submitted to the official censor prior to publication.

Masterman also selected Britain's very first 'official' war artist, the 40-year-old Scottish draughtsman and watercolourist Muirhead Bone (1876–1953), who had been lobbying for such an opportunity. The tone of both Bone's work and that of the official photographers was far removed from Nevinson's emotional output.

Following his appointment to the role, in May 1916, Bone was sent to France and Belgium to make quietly objective drawings for publication in *The Western Front*. These were intended to be mere 'factual' illustrations, to accompany the publication's ostensibly 'independent' news and comment about the war, describing the 'frightful' activities of the Germans. It was a subtle but highly effective approach to propaganda that would mark the start of Britain's tradition of official war art.

⟨

C R W Nevinson, *French Troops Resting* (1916)
Oil on canvas, 711 x 914 mm

In this painting, Nevinson's troops are rendered with blocky angles and without individuality; they are part of a larger machine but have none of the dynamism and speed celebrated in Futurist doctrine. Here, instead, is an exhausted, apathetic unit of men.

Bone's workload was immense. He spent a year trekking backwards and forwards across the Western Front, and on the home front he toured Britain's munitions factories, naval bases and dockyards. The result was around 500 drawings.

The start of 1917 was a particularly grim and weary time in Britain. Among the public, there were no longer any illusions about the scale of the carnage, because few were untouched by the war. The end of 1916 had seen a change at the top with David Lloyd George succeeding Herbert Asquith as prime minister. Lloyd George was highly aware of the public's general disillusionment and set about revamping government, creating a small war cabinet and new ministries, and appointing new and energetic individuals who would carry out his agenda of boosting morale and ultimately winning the war. It was Lloyd George's understanding of the importance of publicity, or propaganda, that ultimately led not only to the establishment of an official war art programme, but also to the founding of a new museum: the Imperial War Museum. Both developments represented a dialogue between the British state and its public; and both reflected official recognition of the efforts of the country's citizens in wartime.

In February 1917, the government created a new Department of Information (DOI) too. Lloyd George chose the novelist John Buchan to head it up. For the first time, the government was beginning to understand how to speak to a mass audience, through newspapers, magazines and film, for the purposes of both uniting the nation and boosting the morale of the British public.[7] These were politically necessary goals, to maintain support for a seemingly intractable war. The DOI encompassed news and propaganda, absorbing Wellington House into its Literature and Art section. This section, freed from Treasury interference – which had effectively ended further art commissions after Bone's and that of the portraitist Francis Dodd – could now create its own war artists commissioning programme. Led by the curator and writer Alfred Yockney, it marked the start of an entirely new role for artists in the context of war, particularly for those young enough to have served.

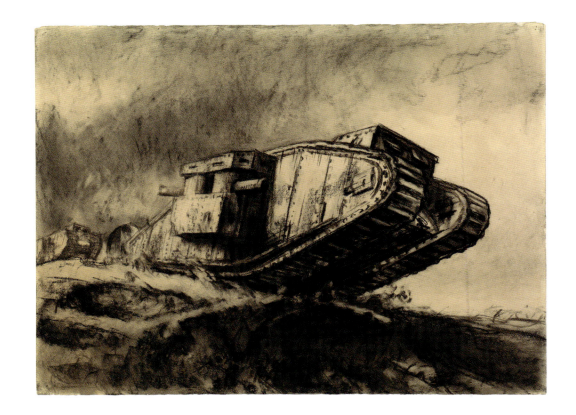

For war publicity to be effective, understanding the target audience was imperative. While Wellington House's propaganda cartoons and posters were successful with mass audiences, the DOI knew that this kind of imagery was too obvious and too vulgar to appeal to 'cultured' and (crucially) influential home audiences. These

were the sorts of circles that attended art exhibitions and whose discontent at the long war, accompanied by increasingly pacifist tendencies, was rising following the publication of soldier-poet Siegfried Sassoon's statement of protest in June 1917 – against a war he felt was 'deliberately prolonged by those who have the power to end it'.[8]

The artists chosen for the task included Nevinson and Kennington, who, along with Paul Nash and William Orpen, travelled to France to carry out their commissions. Another artist, the Scottish draughtsman James McBey, whose series of etchings of a French munitions factory and Somme battlefields had impressed the commissioners, was now sent as an official war artist to the Middle East, to record the British and Imperial advance against the Ottoman Empire, through Palestine. Meanwhile, John Lavery was tasked with depicting the effects of the war at home, in particular munitions production, the Royal Navy and air defences. It was envisaged that together, this clutch of official war artists would create images representing the 'true' experience of war – images that would be promoted in illustrated publications and exhibitions.

Following his officer training, Paul Nash had been posted with the Hampshire Regiment to the Ypres Salient in February 1917. There, he managed to have a rather uneventful time until he dislocated his rib one night after falling into a trench. Nash was sent home to recover, which proved to be an extraordinarily lucky and probably life-saving move. Most of the officers in his unit died only three days later, during an attack on a German-held spoil heap known as 'Hill 60'.

Nash wasted no time in working up his sketches made at the Front. His theme was the battered landscape's capacity for renewal, as he observed the blooms of spring break out among the rusty wire and sandbags of the battlefield. In July 1917, Nash's exhibition of war drawings opened at London's Goupil Gallery to a positive critical reception – and it was the influential support he garnered that proved enough to convince the DOI to employ him.
On his return to Ypres in November 1917, now as an official war artist, Nash found that much had changed. The rain-sodden Allied offensive of the Third Battle of Ypres was petering out, having consumed hundreds of thousands more lives. This, combined with previous years of brutal fighting, had left what Nash described as:

> ... the most frightful nightmare of a country more conceived by Dante or Poe than by nature, unspeakable, utterly indescribable... and the shells never cease. They alone plunge overhead, tearing away the rotting tree stumps, breaking the plank roads, striking down horses and mules, annihilating, maiming, maddening, they plunge into the grave which is this land; one huge grave, and cast up on it the poor dead. It is unspeakable, godless, hopeless.[9]

The paintings that he created in response modernised the landscape tradition, presenting the violation of nature as a metaphor for the nation's war trauma. They were reproduced in *Country Life* and in a special issue of *British Artists at the Front*, as well as in a highly anticipated London exhibition at the

Muirhead Bone, *Tanks* (c.1916)
Charcoal on paper, 572 x 760 mm

One of Bone's most dynamic drawings, this shows a strange new sight on the battlefield: the Mark 1 tank. It was introduced by the British during the Somme campaign, after which many artists found inspiration in its angular form.

Leicester Galleries in May 1918. *We Are Making a New World* (1918), with its bitterly ironic title, may seem unlikely as war propaganda – and it remains widely regarded as a powerful anti-war painting. But its emergence was timely, considering the continued public disillusionment with the war in 1918. The DOI could demonstrate that it understood public sentiment, and the 'truth' of Nash's romantic vision did indeed appeal to the opinion-forming elite they were targeting.

Paul Nash, *We Are Making a New World* (1918)
Oil on canvas, 711 x 914 mm

Nash's haunted and churning landscape remains a potent and enduring anti-war statement. As a piece of official war art, it is also a marker of the paradoxical, liberal impulses of the British governing classes of the time.

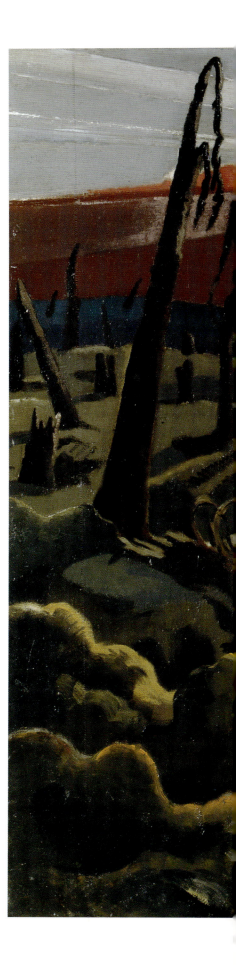

Front cover of *British Artists at the Front: Part Three, Paul Nash* (1918)
Lithograph on paper, 310 x 240 mm

Published by *Country Life* magazine – to suggest that its origin was non-governmental – this volume on Nash accompanied his Leicester Galleries exhibition. It followed earlier volumes on Nevinson and Lavery.

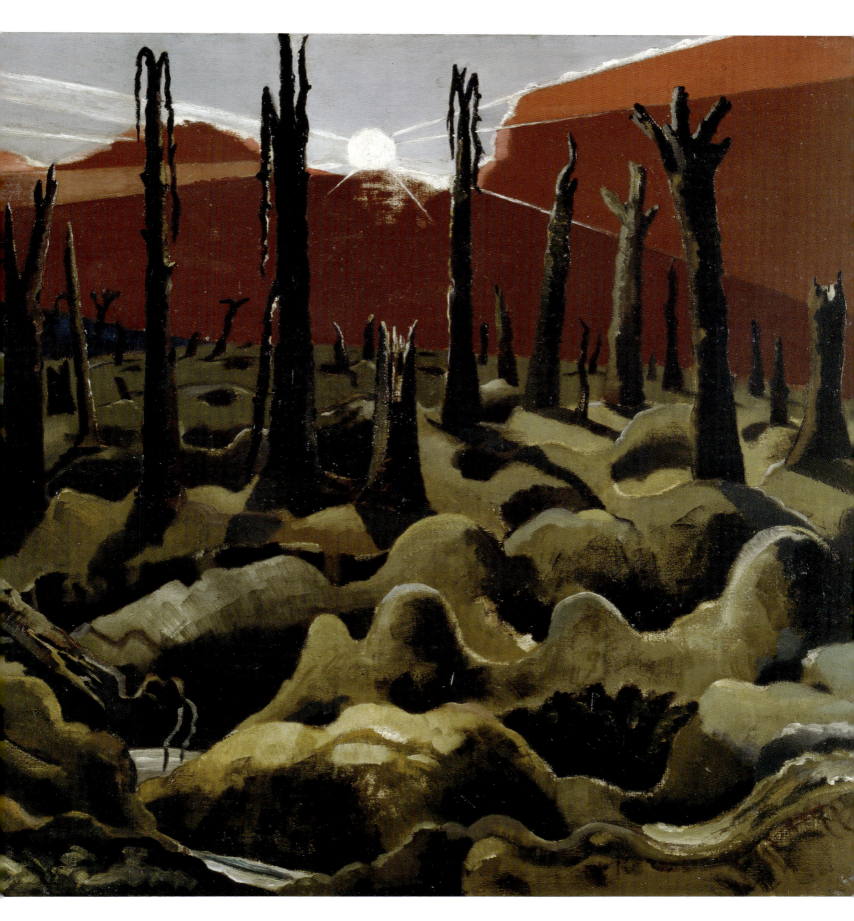

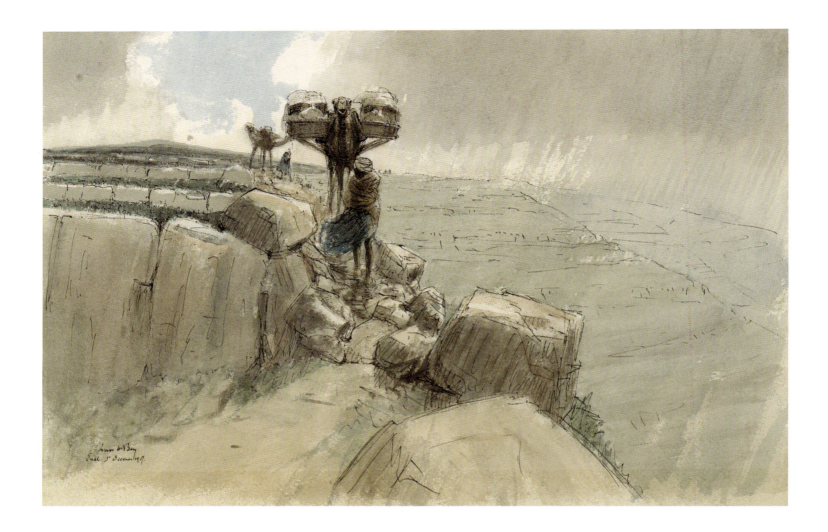

James McBey (1883–1959) was the first official artist to travel beyond the Western Front, his brief being 'to make drawings of appropriate war scenes in Egypt and Palestine for the purposes both of propaganda at the present time and of historical record in the future'.[10] He travelled throughout those parts of the Ottoman Empire seized from Ottoman control, including present-day Syria and Lebanon; he also visited refugee camps containing Armenian people forced from their homelands further east (in what has been called the 'Armenian Genocide') and painted a portrait of the burgeoning celebrity hero T E Lawrence; and he was present at the capture of Jerusalem by the Allies in December 1917. Entirely self-taught, the hard-working McBey strove to adapt to the difficult physical environments he encountered in the Middle East, where he observed that 'After walking more than say a mile in soft sand it is a physical impossibility to produce a good drawing, a performance which even under favourable conditions demands considerable nervous strain.'[11] After struggling with watercolours, which dried immediately in the heat, he learned to adapt his materials to the harsh climate. McBey was prolific as a war artist: he produced 300 drawings, watercolours and oils in 21 months, his sensitive and vivid work constituting an important artistic document of the last chapter of the Ottoman Empire.

James McBey, *Cacolets* (1917)
Ink and watercolour on paper, 311 x 508 mm

Here, men are leading camels loaded with covered stretchers (the cacolets) along a perilous path. McBey skilfully captures the ordeal, and its weather conditions, in December 1917, when British and Imperial forces were making their way through the Judean Hills en route to Jerusalem.

William Orpen, *Blown Up* (1917)
Pencil and watercolour on paper, 584 x 431 mm

Orpen's figure is distinctively stylised, but it is based on the artist's eyewitness recollection of a soldier who had survived a nearby shell blast, his clothing ripped away by the impact.

William Orpen (1878–1931) felt increasingly restless as he watched a younger generation of artists get attention for their exciting war artist commissions. Orpen had long been a fixture – and in demand – in London high society, so he was able to pull some strings to gain his own commission. The DOI's most famous artist first arrived in France in 1917 and, unlike the others who stayed about three weeks, Orpen stayed there for the next few years.[12] The assignment proved to be a creative breakthrough, in which he took on many subjects: highly individual studies of servicemen, ruined towns, portraits of generals and a few self-portraits. He painted otherworldly scenes of the deserted battlefields, too, with crosses in a landscape baked white in the intense heat of the French summer.

Orpen was also drawn to the subject of war's effect on human behaviour, using allegory in his images of encounters between civilians and soldiers, such as *Adam and Eve at Péronne*. These and others, including *Blown Up* (1917), of a shell-shocked semi-clad Tommy in a classical pose, were felt by some critics to be too mannered to evoke any raw feelings about war. But by this time, Orpen was no longer interested in realism. Instead, he brought a kind of fevered theatricality to his work, a state of mind attributed to the length of his stay, to his endless touring of battlefields and ravaged towns, and to his observations of the awful toll that the war took on soldiers and locals alike. In due course, Orpen's war series would be acknowledged as the most important and profound works in his *oeuvre*, while also providing him with a kind of artistic renaissance, following a relatively stagnating career defined by portraits of the wealthy.

The commencement of the DOI's war artists scheme was not the only innovation in 1917 that helped legitimise the concept and goals of war art. In the same year, the Imperial War Museum (IWM) was founded. There had been growing calls for such an institution, and the Liberal MP Sir Alfred Mond proposed the idea to the war cabinet.[13] He could see that a national collection of objects, representing the contribution of all who served, would go some way in officially recognising people's sacrifices and reassuring the public that their efforts were not in vain. And the collection would include art.

The museum was founded on 5 March 1917, with Mond as its chairman, and with a modest budget of £3,000 for purchases and the running costs involved in gathering material that could be stored until the end of the war.[14] Through its various sub-committees (Admiralty; Munitions; War Office; Medical; RAF; Dominions; Library; and Women's Work), in collaboration with the relevant armed services, the museum began collecting all sorts of

material, including letters, uniforms, discarded weaponry and photographs.[15] In truth, the early IWM had a huge and somewhat open-ended remit; but its collecting of all kinds did at least have a clear defining purpose – that it should be a form of historical record. In the IWM's perspective, this meant that the artist would have served in the war and witnessed the scene depicted in their work, and ideally would have sketched it on the spot. This artistic remit meant that the museum collected works by both well-known war artists, such as Nevinson, and lesser-known artists.

In 1918, the IWM purchased *Ruhleben Prison Camp: Christmas Dinner*, painted in 1917 by the Anglo-Dutch artist Nico Jungman (1872–1935). He had been a successful artist in London before the war, but in 1916, during a visit to the neutral Netherlands, he was captured and sent to the Ruhleben internment camp near Berlin, a former racecourse where more than 4,000 mainly British people were imprisoned. There, Jungman made paintings of life in the camp, including prisoners queueing for bread, bathing and passing the time by organising plays and sporting activities.

Jungman's paintings were bought from the artist following his exhibition in London and are a rare example of the IWM collecting on the theme of artworks by wartime captives. This area of the collection would, however, be developed in the years to come. Such works demonstrated how people could turn to creativity as a means of survival in adversity, as an assertion of individuality when freedom was denied, and to provide a record of the conditions under which they lived.

The effect of the war on everyday life in Britain was also well represented among the IWM's early acquisitions. These included the monumental painting *The Underworld* (1918) by Walter Bayes, which showed people sheltering from air raids in the London Underground station at Elephant & Castle. The First World War manifested the new and terrifying threat of aerial bombing on civilian areas, a threat that came first from airships, and which continued, from June 1917, in the shape of Gotha bombers and huge Zeppelin Staaken R series aircraft, which dropped bombs on London and elsewhere.

Bayes (1869–1956) was an established artist working in London, and no doubt he was trying to gain the attention of the war art commissioners when he painted this epic scene, so large that it consisted of two canvasses stitched together. Bayes's experience as a designer of stage sets is evident in the composition, with its foreground of shelter dwellers and elegant curved tunnels, revealing further groups of people in the background. On the Underground station walls are posters for Nevinson's war art exhibition – a favour returned by Nevinson in his painting *The Food Queue* (1918), which shows a poster for Bayes's exhibition behind the line of shoppers.

Nico Jungman, *Ruhleben Prison Camp: Christmas Dinner* (1917)
Tempera on paper, 762 x 635 mm

Jungman used tempera paint – an ancient technique, involving a water-soluble medium (such as egg yolk) to bind with the coloured pigment – giving his Ruhleben paintings a timeless quality.

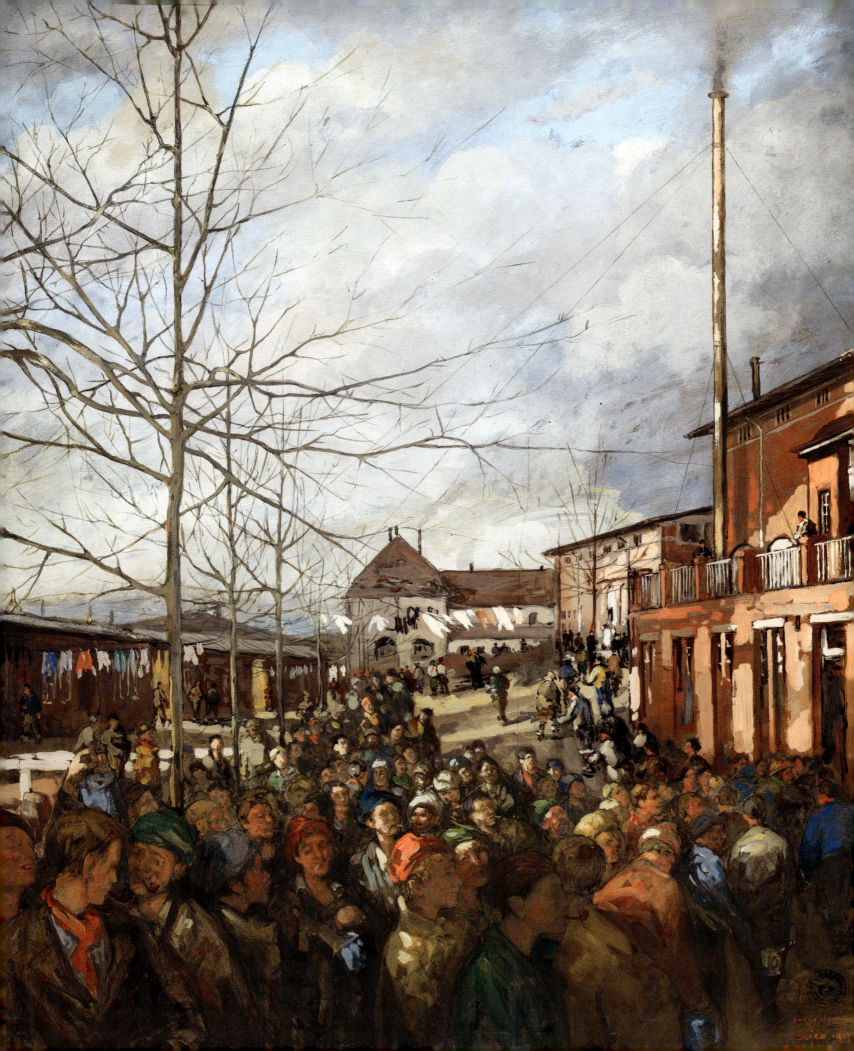

Walter Bayes, *The Underworld: Taking Cover in a Tube Station During a London Air Raid* (1918)
Oil on canvas, 2,540 x 5,486 mm

Bayes's epic canvas, from the imagined perspective of a passing train window, shows a slice of city life. Central to the composition, a well-dressed woman sits aloof, presumably waiting for a train rather than bedding down for the night with the others.

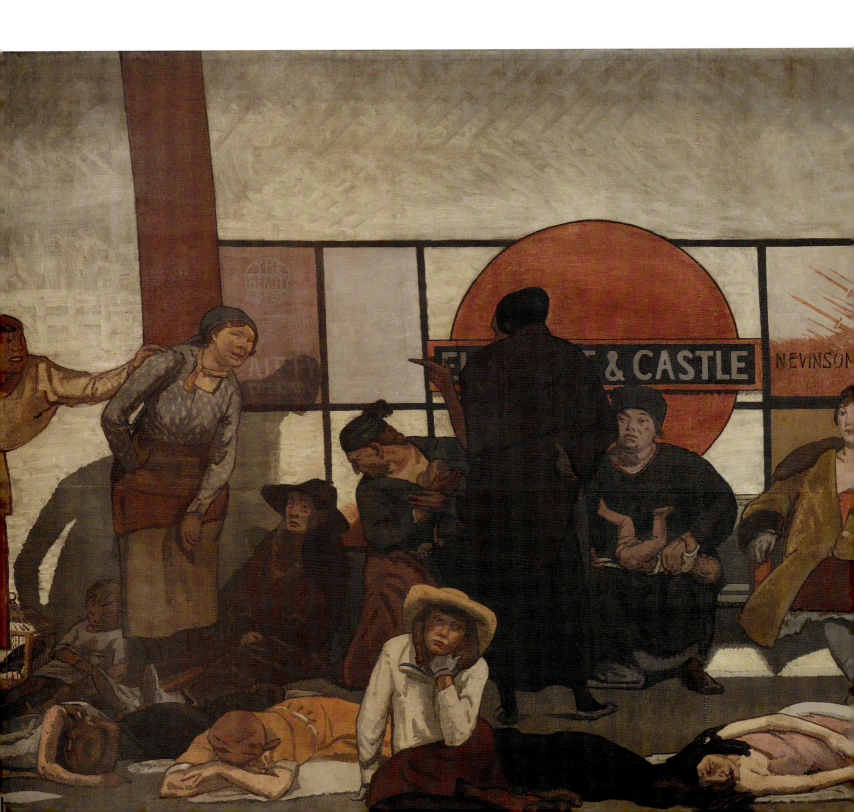

A very different aspect of the home front was illuminated by the artist Charles Burleigh (1868–1956). Based in Hove, he found an opportunity to paint wounded men of the Indian Army who, following their service on the Western Front, were sent to recover in the specially converted temporary hospital in Brighton's Royal Pavilion. The British authorities, in line with orientalist thinking of the time, felt that the exotic interior of the Pavilion, inspired by architecture from around the world, would make the soldiers feel more at home. The publicity about their convalescence within the Pavilion's unique and opulent surrounding would also encourage loyalty, in India, to the British Empire. When the Indian infantry was withdrawn from the Western Front in later 1915, British amputees came to be treated at the hospital instead. By then, the Indian patients were long gone. Burleigh's *Interior of the Pavilion, Brighton: Indian Army Wounded* (c.1915) was one of the IWM's first acquisitions.

Despite the fact that the IWM asserted in 1918 that 'works of art acquired for the Museum have been restricted to those artists actually present at the event depicted', it was not strictly true. Proof of that lay in fantastical works such as Jules de Bruycker's three etchings on the theme of Death, donated by Alfred Mond. De Bruycker (1870–1945) was a Belgian artist who had fled to Britain at the start of the war, when the German invasion of Belgium had spawned all the stories of massacred civilians and destroyed towns and villages that, in turn, underpinned much of the British propaganda effort. *La Mort Sonnant le Glas au dessus des Flandres (Sounding the Death Knell Above Flanders)* (1916) portrays Death as an omnipresent figure, cavorting on top of a tower, having ripped the bell from within. He surveys a barren landscape, while a hanged figure dangles beneath. Clearly, the museum decided it could bend its rules in order to acquire such arresting works, which spoke of a deeper emotional truth, from an artist who had seen and felt the threat of an invading army. This kind of acquisition would not be unique in the IWM's collecting of war art.

In addition to its active collecting programme, the IWM organised its own commissioning of artists to create eyewitness work. The museum's first commission was arranged by its War Trophies Section, set up in collaboration with the War Office to collect exhibits from the battlefields in France. They chose the young Adrian Hill (1895–1977), who had seen service on the Western Front as a private with the Honourable Artillery Company. Hill was invalided out in August 1917, bringing with him his sketches made at the Front. The drawings then caught the attention of the IWM's first curator, Charles ffoulkes. By December 1917, newly commissioned by the IWM, Hill was back in France, now with the rank of second lieutenant: this gave him access to a car and driver, and a permit for the whole of the Allied Front, including non-British sectors.

Hill set about comprehensively cataloguing what he saw, although in an understated and restrained way. The drawings – like those of his elder contemporary Muirhead Bone – were low on drama, documenting the ruined churches and villages, the gun- and tank-

Charles Burleigh, *Interior of the Pavilion, Brighton: Indian Army Wounded* (c.1915)
Oil on canvas, 558 x 457 mm

Burleigh's painting of the Pavilion's opulent music room offers the incongruous and somewhat forlorn-looking sight of patients recovering there among rows of hospital beds.

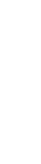

Jules de Bruycker, *La Mort Sonnant le Glas au dessus des Flandres* (1916)
Etching on paper, 897 x 729 mm

De Bruycker was not alone in his use of the skeletal figure of Death to express something of the war's extremes. However, the gigantic proportions and demented movements combine to highly disturbing effect in the Belgian artist's imagery.

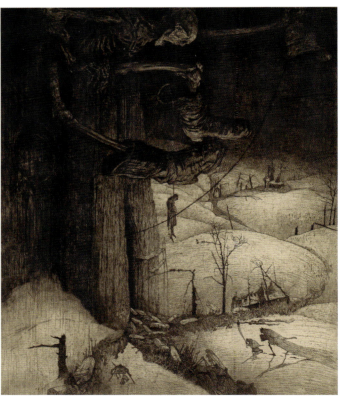

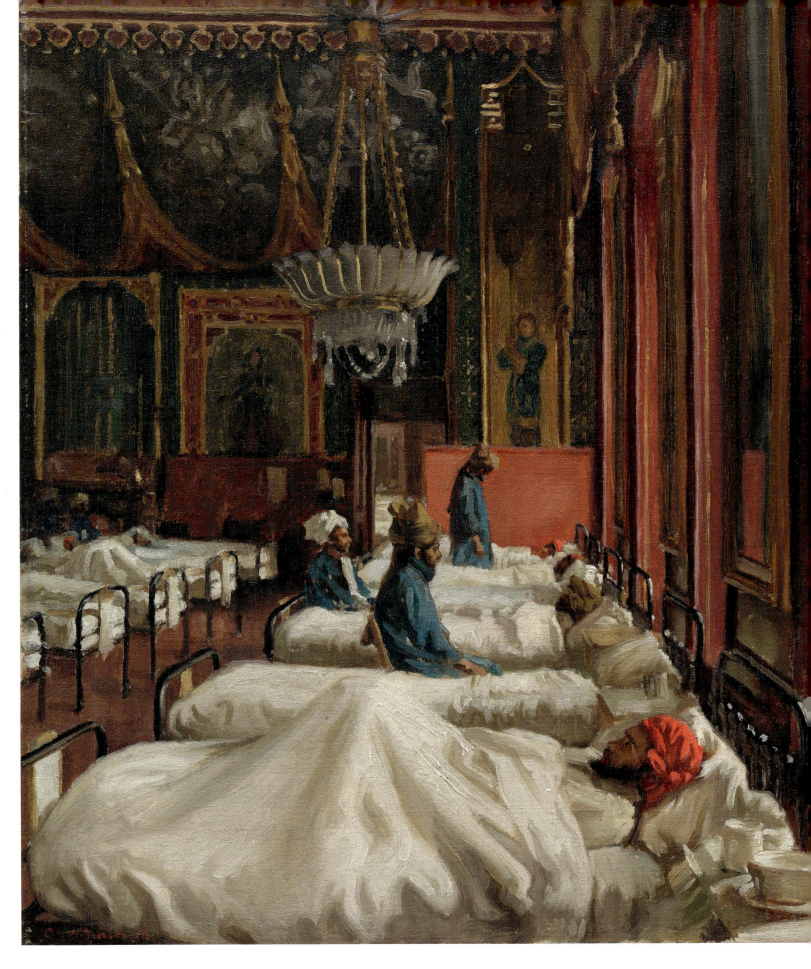

WE ARE MAKING A NEW WORLD: ART OF THE FIRST WORLD WAR 37

workshops, the stretcher parties quietly going about their way, the captured enemy guns ('war trophies') and the abandoned battlefields. Indeed, ffoulkes went as far as to request 'more uninteresting technical drawings', for he wanted both a sober record of the conflict and sketches that could serve as reference drawings for the museum's construction of display models and dioramas.[16] *The Railway Bridge, Hamel* (1918) is a typical example Hill made for this purpose, one among the 187 drawings he created in under a year for the collection. Like Bone, he was a draughtsman first and foremost. Indeed, he found the therapeutic value of drawing helped him cope with tuberculosis later in life. Decades after the war, Hill was instrumental in establishing the modern practice of art therapy.

The War Trophies Committee did not send any further artists to the Front after Adrian Hill – though not for want of trying. They had their sights on the sculptor Jacob Epstein (1880–1959), whose *The Tin Hat* (1916) had gained a lot of attention. Here, Epstein had modelled the head of an everyman British soldier, the Tommy, a weary and relatable human being caught up in the war. Epstein knew his audience: the authorities who were eager to represent effort of the people not as individuals, but as types.

Following the introduction of conscription, Epstein was also desperate to gain an official commission and thereby avoid being called up. Martin Conway, the IWM's director-general, had seen *The Tin Hat* – and he now chose Epstein for a commission to 'make a series of typical heads of private soldiers serving in the various contingents that make up the British Army'. Of Epstein, he acknowledged that 'though much of his work is of a character that I personally

Adrian Hill, *The Railway Bridge, Hamel* (1918)
Watercolour and ink on paper, 330 x 476 mm

This scene is characteristic of Hill's objective yet haunting style; such drawings were invaluable to the early IWM's model-makers in their visualisation of the battlefields. The railway near Hamel, in northern France, was destroyed in the fighting.

38 VISIONS OF WAR: ART OF THE IMPERIAL WAR MUSEUMS

Jacob Epstein, *The Tin Hat* (1916)
Bronze, 335 x 280 mm

This work marked a stylistic change for Epstein, away from stone carving: he even incorporated a real helmet into the sculpture. It chimed with the public mood of sympathy for the soldiers' stoicism when it was first displayed at the Leicester Galleries, London, in 1917.

do not like, his ability is unquestioned and his suitability for the type of work above indicated would be universally admitted'.[17] The War Office was not convinced that Epstein needed to visit France in order to do this, but Conway argued the case: 'we want type heads of the many groups of men employed in the war – in front and behind – Jews, Turks, infidels, heretics, and all the rest'.[18] By the later stages of the war, the Western Front – populated not just by Europeans, but by participants from across the British and French empires, and from the proliferating nations on the Allied side (including China and the United States) – was a uniquely cosmopolitan place.

Yet, Epstein's commission never materialised. It is not clear exactly why. The nature of the commission was not the reason, for representing people in such racialised terms was supposedly progressive at the time – an early twentieth-century version of 'diversity'. However, Epstein's work remained controversial, making him many enemies within the art establishment, in particular the sculptor George Frampton, who wrote a letter of objection to the IWM.

Frampton was firmly of the Victorian school of realist sculpture and would not have approved of Epstein's modernism; it is also possible that Frampton viewed Epstein as an objectionable outsider, as antisemitism was widespread in society of that time. Also well-known for his anti-German feelings, Frampton argued passionately for all artists he considered 'enemy aliens' to be expelled from artistic societies such as the Art Workers' Guild. His precise complaint can only be guessed at, because ffoulkes removed the letter from the files – but it seemed to have left a mark.[19] 'There is no intention to send out any more sculptors at present… there was a desire expressed that the aggressive modern school should also be represented but the proposal has been dropped,' Conway wrote in January 1918 – and that was that.[20]

In March 1918, there was another shake-up in government propaganda – and consequently in the conditions for commissioning war art – as the Department of Information evolved into a mighty Ministry of Information (MOI). The press tycoon Lord Beaverbrook (Max Aitken) was appointed the first Minister of Information, in recognition of his success in leading the war-propaganda campaign in his native Canada, and because Lloyd George felt it was important to keep someone as powerful as Beaverbrook – owner of the *Daily Express* – on side.[21] Beaverbrook was an early advocate of war art, having instigated the Canadian War Memorials Fund (CWMF; 1916), which commissioned artists to make large-scale paintings memorialising significant events in Canada's war contribution. In his new ministerial role, he immediately set to work on a new project along the same lines: the British War Memorials Committee (BWMC).

The BWMC was much more ambitious than anything that had come before in Britain. It comprised the country's cultural elite: art critics, the keeper of prints and drawings at the British Museum, and trustees of the National Gallery of British Art (which, in 1932, became the Tate Gallery). They saw it as a radical project, an expression of the spectrum of current British art, which would include established artists alongside the young avant-garde (many of whom were also working for the Canadian scheme).[22]

Muirhead Bone was involved in the BWMC, too. He had been forced to take a break in August 1917, because of physical and mental exhaustion, but he did not have the character to be put off, and over the course of the war – and beyond – he became associated with all things war art related. In 1918, he was chosen to sit as a member of the BWMC. An affable character, with a strong sense of duty, he was an apt choice for the role, which was to represent, informally, the views of the existing war artists.[23] Although his own war drawings were rather prosaic, Bone's tastes were not, and he enthusiastically supported the younger modern artists, including Nevinson, whose appointment as an official war artist he had advocated.[24]

To create some unity in the BWMC scheme, given its wildly differing artists, the committee decided that the paintings should be based on a uniform size and scale – 6 x 10 feet, which were the dimensions of Paolo Uccello's celebrated *Battle of San Romano* (c.1438–1440) in the National Gallery. In addition, a smaller size was allowed – 6 x 7 feet — as well as a larger size, a 'double-Uccello' of 6 x 20 feet, though in the end only one painting was completed at this size: John Singer Sargent's *Gassed* (1919; *see pp. 65–66*).[25]

Some MOI artists were contracted to submit any other work they made in the course of their commissions, so smaller works were also acquired. These included John Nash's *'Over the Top'. 1st Artists' Rifles at Marcoing, 30th December 1917* (1918). Like his brother Paul, John Nash (1893–1977) had served in the Artists' Rifles – and he owed his MOI commission to Paul's badgering of the authorities; and although he benefitted from Paul's guidance, he had no formal training. His painting is a rare picture of a specific action, in this case when the Artists' Rifles, having only just withdrawn, were recalled to the frontline to help repel a German attack. The disastrous result was burned into the artist's memory, for he narrowly survived it himself: 68 of the 80 men involved were killed or wounded.[26] It is no wonder that the work exerts such a stark and powerful impact.

Muirhead Bone recommended Stanley Spencer (1891–1959) for the scheme. This was fortuitous for Spencer, who was little suited to soldiering. He was described as a 'Confounded Nuisance' by his sergeant during his two-and-a-half-year posting to the Macedonian Front, where multinational Allied forces were holding a line in northern Greece, following the fall of Serbia.[27] Spencer's painting for the BWMC, *Travoys Arriving with Wounded at a Dressing-Station at Smol, Macedonia, September 1916* (1919), was inspired by his memories of a 'never ending stream' of wounded men arriving on mule-drawn stretchers, during an attack by the 22nd Division on a position known as Machine Gun Hill, east of the Vardar River.

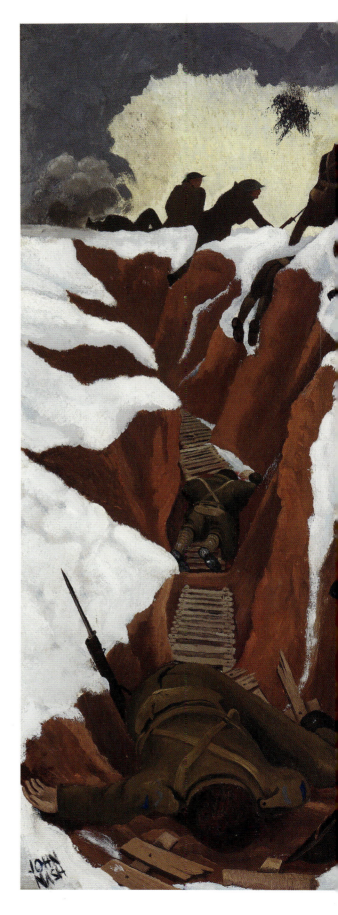

〉

John Nash, *'Over the Top'. 1st Artists' Rifles at Marcoing, 30th December 1917* (1918)
Oil on canvas, 708 x 1,080 mm

In this work, painted from memory, Nash's fellow soldiers are hunched resignedly as they are compelled into battle amid the winter's snow. Pervading the scene is a sickening sense of the deadly fate that awaits them.

An older generation of artists was represented in the scheme by the likes of Henry Tonks (1862–1937) and John Singer Sargent. Tonks had taught drawing to an exceptionally talented cohort at the Slade School of Art including Spencer, Paul Nash and Anna Airy. As a teacher, he was both revered and feared, once advising the young Nevinson to abandon any thoughts of a career in art.[28] Having trained as a surgeon before becoming an artist, Tonks then served during the war as a doctor in the Royal Army Medical Corps (RAMC), in which capacity he worked with one of the pioneers of plastic surgery, Sir Harold Gillies, drawing studies of facial injuries before and after operations. This wartime medical experience made him well-placed to address the subject he tackled in his *An Advanced Dressing Station in France, 1918* (1918).

Stanley Spencer, *Travoys Arriving with Wounded at a Dressing-Station at Smol, Macedonia, September 1916* (1919)
Oil on canvas, 1,828 x 2,184 mm

Spencer's treatment elevates an otherwise desperate and gruesome event into a scene of sp ritual redemption, exemplified by the calm efforts of the surgical team working in the brightly lit makeshift hospital, situated in a village church.

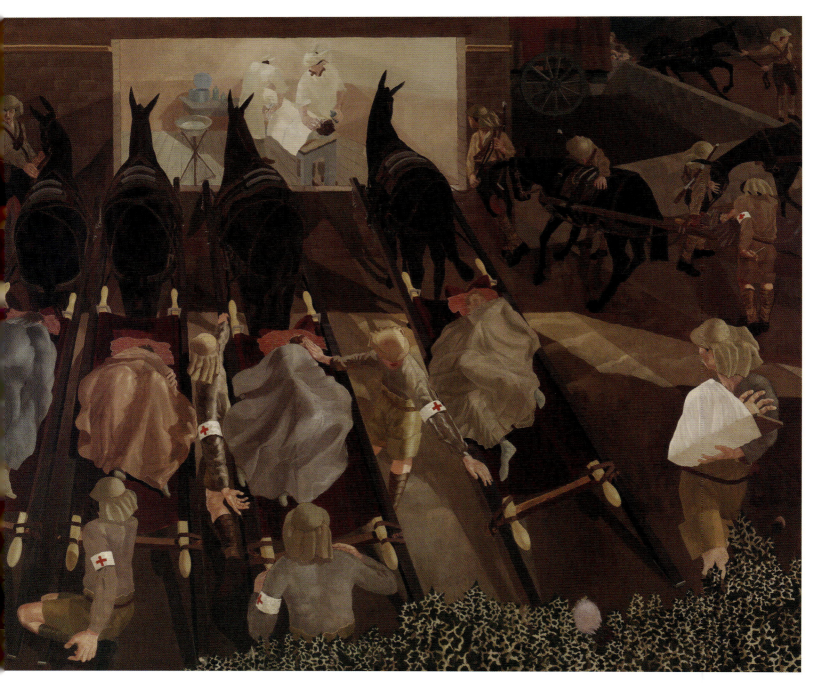

Henry Tonks,
An Advanced Dressing Station in France, 1918 (1918)
Oil on canvas, 1,828 x 2,184 mm

Set during a German offensive in 1918, the painting depicts the work of the RAMC as they treat the wounded away from the frontline. This complex group portrait gives a sense of the range of injuries suffered as well as the kind of field dressings and treatments used.

David Bomberg (1890–1957) had also studied under Tonks at the Slade School and was a radical artist associated with the vorticists and the Rebel Art Centre. He was not commissioned by the BWMC – and the reasons for his omission are still contested. He did, however, have a fraught experience with the Canadian War Memorials Fund, who commissioned him to paint a Canadian Tunnelling Company in action at St Eloi, south of Ypres. Bomberg had been serving as a sapper with the Royal Engineers, but following the deaths of close friends in 1917, his mental health unravelled to the extent that he took the decision to shoot himself in the foot.[29] After a period in recovery, without pay, Bomberg was returned to the Front, before the CWMF art commission brought him back to London. While the CWMF saved him from the perils of the Front, its wholesale

WE ARE MAKING A NEW WORLD: ART OF THE FIRST WORLD WAR 43

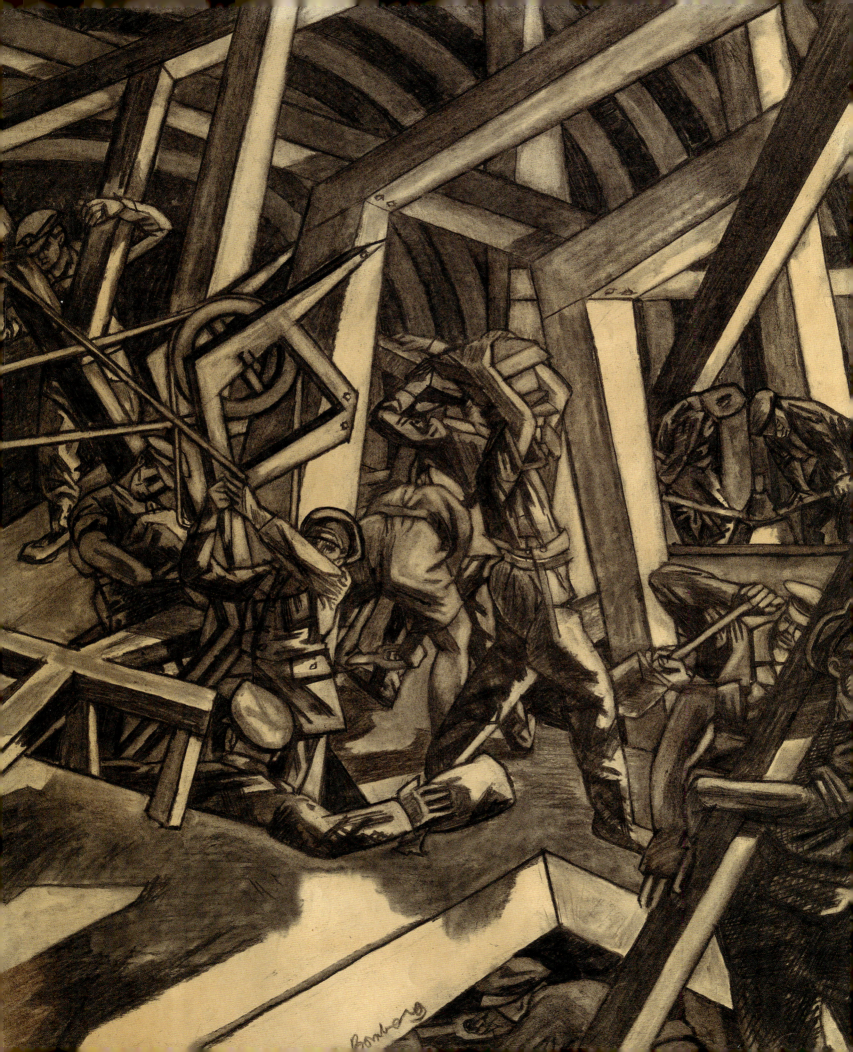

David Bomberg, *Sappers at Work: Canadian Tunnelling Company, R14, St Eloi* (1918–1919)
Charcoal on paper, 690 x 559 mm

Bomberg's drawing offers an insight into the highly hazardous job of tunnelling underneath enemy lines, to lay mines. Here, men strain within their subterranean world, hemmed in among the dominant supporting beams.

rejection of Bomberg's first version of the painting sent the already vulnerable painter into a state of dejection.[30] However, it was agreed that he would make a second attempt, this time avoiding any 'cubist abortions' – and this painting was eventually accepted. For the IWM, Muirhead Bone acquired a preparatory sketch, in 1919, for the second canvas entitled *Sappers at Work: Canadian Tunnelling Company, R14, St Eloi* (1918–1919).

The BWMC's sculptural scheme took longer to get off the ground, with only two sculptural reliefs – by Charles Sargeant Jagger (1885–1934) and Gilbert Ledward (1888–1960) – completed. Both sculptors had been awarded a prestigious scholarship, the Prix de Rome; and both had served in the war, with Jagger passing up his scholarship to enlist in the Artists' Rifles, in 1914. He suffered horrendous experiences at Gallipoli in 1915, where the rocky landscape made it almost impossible to find cover from the enemy – a reality that caused those participants who also knew the Western Front to long for the shelter of its trenches. Returning to England following injury, Jagger was determined to commemorate his experiences in sculpture.[31] The BWMC commission saved him from returning to the Front. In addition, he began working on a series of war memorials.

Jagger's work pays homage to the ordinary soldier, in realistic portrayals that build on the Victorian style of public sculpture while bringing something new to the genre: a rugged kind of heroism. These qualities are exemplified in *Wipers* – a maquette for the memorial at Hoylake and West Kirby in the Wirral (1919–1920) and his first representation of a stoic Tommy in sculpture. Maquettes provide a useful way to understand the artistic process, and in the case of public sculpture, the humble scale can bring different qualities to the fore. In *Wipers*, whose affectionate title was the mispronunciation of 'Ypres' adopted among British troops, Jagger demonstrated his clear regard for his fellow soldiers in the defiant stance of the figure.

While the IWM, DOI and BWMC all created institutional and official frameworks for commissioning, acquiring and displaying war art, the practice of informal art at the Front continued. Very often, these artworks were observational drawings done on active service, and they were made not with an audience in mind but simply as ways for their artists to continue their practice – or to distract themselves – during quieter moments.

C S Jagger, '*Wipers*' – *Maquette for the Hoylake War Memorial, West Kirby* (1919–1921)
Plaster and bronze powder finish, 470 x 420 mm

In Jagger's memorial sculpture, the Tommy might be battle-weary, but his faith in Britain's cause remains undiminished – as signified by the spiked German helmet (*Pickelhaube*) at his feet.

WE ARE MAKING A NEW WORLD: ART OF THE FIRST WORLD WAR

George Spencer Hoffman (1875–1950), an architect, made hundreds of drawings, often in sketchbooks, during his service as a captain with the Royal Army Medical Corps in northern France. Very often, sketchbook drawings are unfinished, but Hoffman's are a fine exception, showing his eye for detail: many are actually more than sketches, being carefully composed, with a finished quality. His sketchbooks reveal his journey through the experience of war, beginning with cartoons of his comrades, later abandoned in favour of delicately realised renderings of chilly-looking landscapes and towns, damaged and deserted apart from the soldiers. After the war, Hoffman continued to work in art and design, finding particular success with his detailed pictorial maps of English towns and cities.

The artist Percy Delf Smith (1882–1948) served as a gunner in the Royal Marine Artillery and was posted to the Somme in late 1916. He began sketching, but, unsatisfied with this medium, arranged for his parents to send him copper plates, which were smuggled in between the pages of a magazine. He used these to make drypoint images *in situ*, likely using a gramophone needle to scratch into the surface. This required a degree of optimism, for it meant that he would have to wait until his return home to print the resulting images.[32]

When, in 1917, the IWM commenced its own art-commissioning and collecting programmes, the result was a concentration on five areas: the Royal Navy, the Royal Air Force, medical activity, munitions and women's work. Although it was progressive of the museum to recognise women's unprecedented contribution to the national war effort, early plans for the museum's galleries told a somewhat different story, allocating just 5,000 square feet of space for the Women's Work section compared with 70,000 square feet for the section on the Royal Navy.[33] Both the IWM and the DOI prioritised the depiction of the war at sea, reflecting both the important role of the Royal Navy in the country's national image and a long and rich tradition of maritime painting. Moreover, IWM's Admiralty artists, like Norman Wilkinson, had all served in the navy.

Wilkinson (1878–1971) was an established marine artist. While serving in the Royal Naval Volunteer Reserve, he sketched the Dardanelles-Gallipoli operations. The IWM later asked Wilkinson to work these drawings up into paintings for its collection. But Wilkinson's most enduring and consequential visual contribution during the First World War was a highly practical application: his invention, in 1917, of the 'dazzle' camouflage pattern for ships. The idea was a response to the devastating campaign by Germany's U-boats, which, at its height, was sinking an average of 13 merchant ships a day and threatening Britain's ability to sustain itself. Camouflage in warfare was in its relative infancy, but Wilkinson quickly realised that it was impossible to paint a ship so that it could be hidden. Instead, he invented patterns that could be painted on, with the optical effect of breaking up a vessel's form, and so obscuring its course and speed. Wilkinson convinced the Admiralty of his idea and went on to lead a team of artists who designed models and plans, such as those of *HMS Dublin* (1917), which would be sent on to various ports around Britain so that the designs could be painted onto the ships.

G S Hoffman, selection of drawings from *First World War Sketchbook, Volume 1* (1916)
Pencil and crayon on paper, 354 x 228 (size of sketchbook)
Hoffman made numerous quick sketches of various sights at the Front. Clockwise from top: a tank; a dump exploding; a communication trench; vehicles, troops and horses on Brenfey Farm Road.

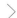

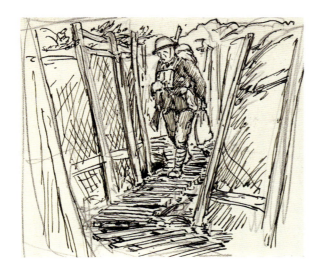

WE ARE MAKING A NEW WORLD: ART OF THE FIRST WORLD WAR

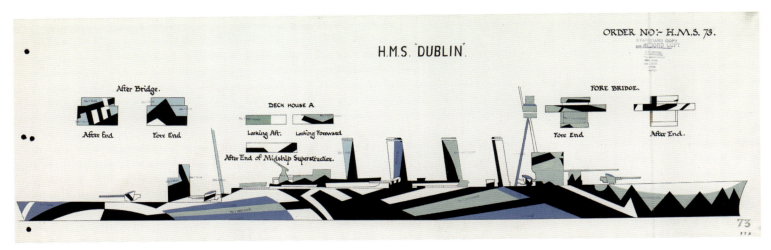

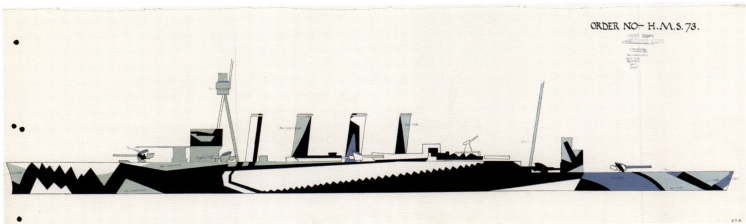

Among Wilkinson's team of dazzle artists was Edward Wadsworth (1889–1949), an avant-garde artist who had been a vorticist along with Wyndham Lewis. He served as an intelligence officer in the eastern Mediterranean for the Royal Naval Volunteer Reserve before being invalided home in July 1917. Wadsworth supervised the painting of the designs onto ships in dry dock, which in turn inspired him to create a series of woodblock prints and a painting for the Canadian War Memorials Committee. The Scottish colourist John Duncan Fergusson (1874–1961) – described as 'a very virile and scientific painter' and as 'a real pioneer of painting, who makes no concessions' – was also inspired by dazzle.[34] With a probationary assignment from the BWMC, he produced *Dockyard, Portsmouth, 1918 (see p.11)*, in which he applied the dazzle concept to the entire surface of the painting, playing with depth and form, and using bold colours. Perhaps it was too much for the BWMC, who turned it down, although the IWM was finally able to purchase it in 1975.

Back at the IWM's Admiralty committee, the commissioners had secured alongside Wilkinson the services of John Lavery (1856–1945), who was an artist in demand. His reputation as a fluent and gifted painter of society portraits, landscapes and interiors meant that he had been given free rein, as an official DOI war artist, to go where he pleased – though his injuries from a car accident in 1917 kept him on the home front for the remainder of the war.

Ministry of Shipping, *HMS Order No. 73 – HMS Dublin* (starboard above; port below) (1917)
Gouache and ink on paper, 230 x 739 mm (each)

These detailed designs for the light-cruiser HMS *Dublin* are typical of the plans drawn up by the dazzle artists, many of whom were women, including Wilkinson's wife, Evelyn.[35]

Edward Wadsworth,
Drydocked for Scaling and Painting (1918)
Woodcut on tissue paper, 330 x 264 mm

Wadsworth's work supervising the painting of the dazzle ships was a gift for his vorticist sensibilities. Here, the drydock setting, painted sections of the ship and the tiny figures beneath are synchronised in a stark, two-tone composition.

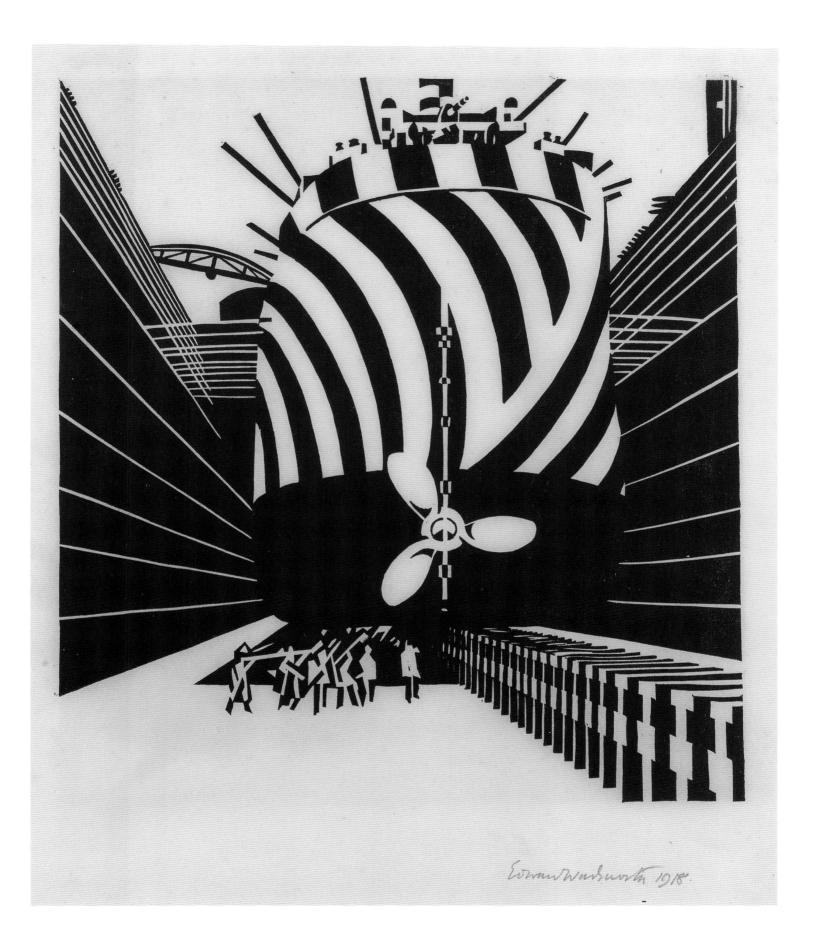

WE ARE MAKING A NEW WORLD: ART OF THE FIRST WORLD WAR

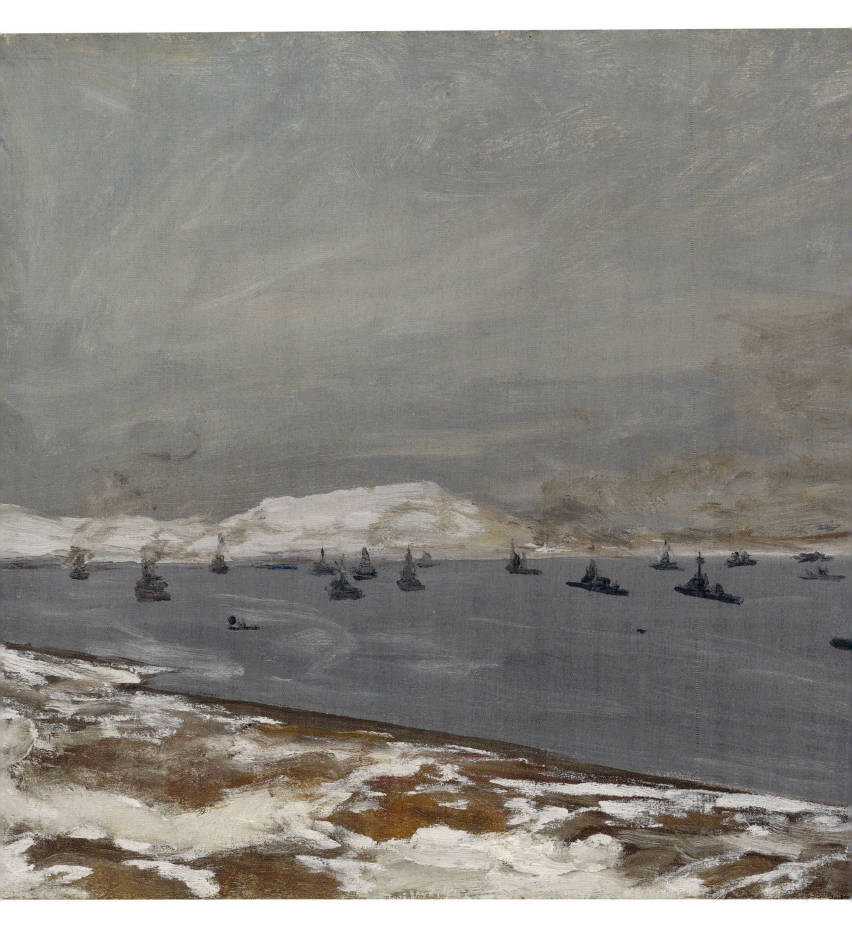

Nevertheless, he criss-crossed the country, painting scenes of docks, airships and factories. Post-war, he was commissioned by the IWM's Women's Work committee to travel to the Western Front to paint nurses as well as other aspects of women's war work (in bakeries, canteens and the new crèches). Lavery's IWM Admiralty commission in late 1917 saw him touring naval bases around Britain, before finally recording (together with Muirhead Bone) the surrender of the German Fleet at Rosyth. Of all his war work, Lavery's Scapa Flow paintings – of the Navy's northernmost base in Orkney, the home of the Grand Fleet – stand out not only for the artist's endurance at the age of 61, but for the sensitivity and elemental quality of the paintings.

In order to undertake these works, Lavery set off shortly after Christmas 1917 on the long, arduous journey from London by troop train, travelling via Thurso on Scotland's north coast. It was the most treacherous time of year to attempt such an expedition, let alone to paint outdoors, but capturing such hardships was arguably an aim of the commission. Lavery's crossing from Thurso was scheduled for 4am. It was a scene he described vividly:

> In the darkness and blinding snow I could only make out shadowy figures, muffled up, scrambling backward and forward, clinging to ropes and carrying things... The pier was a sheet of black glittering ice, and the wind swept everything before it.[36]

Working at speed, Lavery made five paintings in just four freezing days, before returning to London with a heavy cold.[37]

If Britain's sea power was centuries old, its air power was – like that of all nations fighting in the war – a novelty. Powered flight was just over a decade old by the start of the war, but military ambitions had provided a catalyst for the development of aircraft for reconnaissance, and then for aerial fighting and bombing. In 1914, Britain fielded the Royal Flying Corps (as a branch of the British Army) as well as the Royal Naval Air Service – and spawned the country's first generation of military pilots, whose bravery and exploits, tied up with romantic notions attached to the allure of conquering the skies, gripped the public's imagination. In recognition of the rapidly increasing importance of air power, the Royal Air Force (RAF) was founded as an independent armed service, in April 1918, and it was after this that the IWM set up its Air Force section.

〈

John Lavery, *Scapa Flow, 1917* (1917)
Oil on canvas, 645 x 762 mm

In its very brushwork, this painting records the freezing conditions in which it was painted. It is one of four of Lavery's Scapa Flow paintings at IWM: vivid and chilly depictions of the extreme landscape, with the dark ships of the fleet skilfully sketched in.

A group of 'aero-artists', nominally led by the young Richard Carline (1896–1980), was chosen to depict 'the War in the Air with the most important of its incidents'.[38] Carline's art studies in Paris had been interrupted by the war, and he was only 21 years old when he transferred from the Middlesex Regiment to the Royal Flying Corps in 1917, where he worked on developing aircraft camouflage. He immediately recruited his older brother, Sydney, as an artist – anxious to save him from the dangers involved in being a military pilot. The Carline brothers' commission took them from Europe to the Middle East; and their works provide a fascinating insight into these landscapes of war from the air. Together, the brothers produced a huge number of ground-breaking studies, drawn in the cockpit of an aeroplane. But the two men's fixation on the dizzying splendour of the landscape became a source of friction with the IWM's Air Force committee, which would have preferred them to prioritise the mechanical details of the aircraft. It was left to other aero-artists to pursue 'aviation art' as such, of a

Sydney Carline, *British Scouts Leaving Their Aerodrome on Patrol, over the Asiago Plateau, Italy 1918* (1918)
Oil on canvas, 762 × 914 mm

Marking the first years of aerial warfare, Sydney Carline's most well-known paintings emphasise the elegance of the aircraft, floating above magnificent landscapes – but lack a palpable sense of the very real dangers involved.

52 VISIONS OF WAR: ART OF THE IMPERIAL WAR MUSEUMS

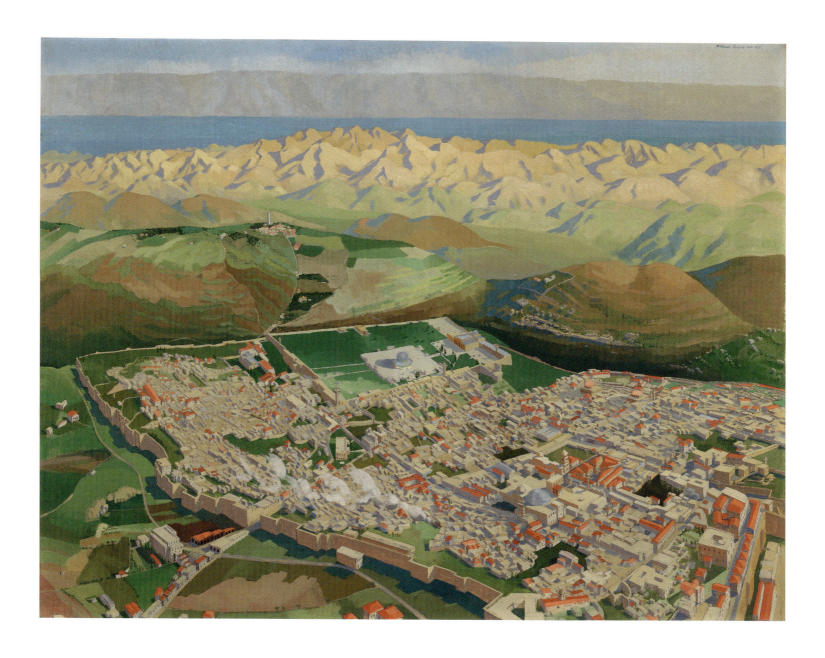

Richard Carline, *Jerusalem and the Dead Sea From an Aeroplane* (1919)
Oil on canvas, 1,070 x 1,320 mm

Many of Richard Carline's aerial paintings show the blocky forms of cities within spectacular landscapes. Aside from aerial photography, his work provides some of the very first imagery from the 'eye in the sky' in the context of wartime.

kind typified by a faithful rendering of aircraft mid-flight, in a celebration of pure spectacle and honourable derring-do. In contrast, the Carlines' focus was on the breathtaking landscape below. Sydney Carline conveyed the grace of the new flying machines soaring past mountains and towns in paintings such as *British Scouts Leaving Their Aerodrome on Patrol, over the Asiago Plateau, Italy 1918*. Richard Carline's *Jerusalem and the Dead Sea From an Aeroplane* (1919) shows an almost abstracted landscape laid out beneath. Although awe-inspiring, the painting conveys something of the emotional detachment implicit in the aerial view, which renders vulnerable populations below invisible. This distancing effect would become a developing theme for later artists, seeking to explore the ramifications of aerial-warfare developments in the twentieth and twenty-first centuries.

WE ARE MAKING A NEW WORLD: ART OF THE FIRST WORLD WAR

The IWM's Women's Work committee was chaired by Lady Priscilla Norman, a prominent suffragist who had helped to run a voluntary hospital in France in 1914. Covering all aspects of women's service during the war years, it appointed its first woman war artist, Victoria Monkhouse, in May 1918, marking the start of a trickle of commissions for women at the museum.

Monkhouse (1883–1970) had come to the attention of Agnes Conway, the secretary of the Women's Work committee (and daughter of the director-general), with a series of pre-war caricatures showing academic life at the University of Cambridge, which both women had attended. Conway now asked her to draw women in some of their new and myriad wartime roles: as window-cleaners, bus conductors, postwomen, ticket collectors, carriage cleaners and telegraph workers. 'Each drawing ought to be typical of the profession,' Conway instructed in October 1917, 'and not a mere fashion plate of the uniform with an ordinary dolly face.' The commission took time, as the women subjects were mostly too busy to sit for the artist, who portrayed them as dutiful and genteel despite their working in traditionally male roles. Monkhouse seems to have satisfied her brief, for the committee wrote admiringly of the final drawings, praising them for their 'individuality and character'.[39]

Anna Airy (1882–1964), who trained at the Slade School, was one of the leading realist painters of her day. She had already signed up to paint *Munitions Girls Leaving Work* for the BWMC when the IWM approached her for four more paintings on the same subject, taking advantage of her access to these secure industrial sites. However, her contract with the museum was

Victoria Monkhouse, *A Bus Conductress; A Woman Ticket-collector* (both 1919)
Pencil and watercolour on paper, 393 x 279 mm (each)

Monkhouse notably does not name the women she portrays, and it seems reasonable to assume they are indicative of 'types', as was the fashionable approach of the time.

Anna Airy, *A Shell Forge at a National Projectile Factory, Hackney Marshes, London, 1918* (1918)
Oil on canvas, 1,828 x 2,133 mm

Airy's series of factory paintings demonstrate her mastery of paint; here, the red-hot shells are luminous within the darkened interior – although the workers and the structural elements are equally diligently realised.

unusually strict, signed by Alfred Mond himself. It even included a clause on the course of action should she die mid-commission, since the munitions factories were notoriously dangerous places: in the event of her demise, the museum would have the right to purchase her unfinished paintings.[40] However, her IWM commission proved the happier one, and the museum received the paintings at a steady rate during 1919. The series, including *A Shell Forge at a National Projectile Factory, Hackney Marshes, London, 1918*, exemplifies Airy's precision and technical skill. From left to right, the painting shows the process of punching a hole into the red-hot billet to make it into a hollow shell case; a boy uses a rod to push the shell case away to cool, while the men load the cooled shell cases onto a cart. Airy described this as a continuous process that went on day and night.[41]

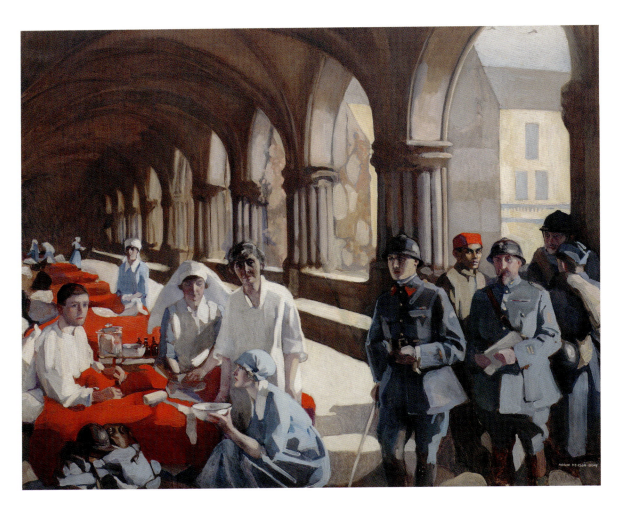

As for *Munitions Girls Leaving Work*, the BWMC eventually rejected it, and we can only imagine what it would have looked like, because Airy subsequently destroyed the painting. What remained was her accompanying note for the submission, mentioning that 'The London Girls, however long and hard their work, are always laughing.'[42] Given Airy's carefully observed factory interiors, with their faceless figures, such a merry scene by her is hard to envisage; perhaps the failure of her memorial commission suggests that she was much better suited to painting in the manner of record than to producing out-and-out propaganda.

In addition to recording women's wartime occupations on the home front, the Women's Work committee wanted to promote the contribution to medical care that many women were making behind the frontline. The subject was a personal one for Lady Norman, who had run a small hospital with her husband at Wimereux, in northern France. Norah Neilson-Gray was chosen to paint Dr Frances Ivens, the Chief Medical Officer and surgeon at the Scottish Women's Hospital at Royaumont. Neilson-Gray (1882–1931) had studied at the Glasgow School of Art and had built a promising career as a portrait painter, before she volunteered as a nursing orderly during the war. She worked at the same hospital as Dr Ivens and had already made a painting of a ward there, but Lady Norman wanted another version – with the doctor central in the composition.[43]

Norah Neilson-Gray, *The Scottish Women's Hospital: In the Cloister of the Abbaye at Royaumont. Dr. Frances Ivens Inspecting a French Patient* (1920)
Oil on canvas, 1,143 x 1,397 mm

Neilson-Gray's painting is a scene of serenity, carefully composed and beautifully lit, in which the figure of Dr Ivens reveals only the slightest emotion as she looks steadily, if wearily, out at the viewer.

Flora Lion, *Women's Canteen at Phoenix Works, Bradford* (1918)
Oil on canvas, 1,066 x 1,828 mm

Lion's scene is notable for its depiction of sisterhood, showing the women of the Phoenix Dynamo Company as confident and sociable in their new roles. The company produced sea planes and flying boats, shells and machine tools.

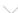

On 11 November 1918, after more than four years of war, the Armistice brought hostilities to an end and an Allied victory. Among the many ramifications, within a matter of weeks the MOI was shut down, in December 1918, having served its wartime purpose. Moreover, the IWM won its turf war with the BWMC, when the latter's ambitious plans for a Hall of Remembrance had to be abandoned and its artworks were transferred to the museum instead. Come 1919, the administration of the BWMC scheme was also assigned to the IWM, along with Alfred Yockney to steward its conclusion. However, with Treasury funds withdrawn, the cash-strapped museum had to curtail the project, sometimes choosing not to purchase later-completed paintings. For example, they turned down two paintings by Flora Lion, who in 1919 was the only woman still engaged on the BWMC scheme. Lion (1878–1958), an established society portraitist, was given access to factories in Leeds and Bradford to research her paintings, resulting in a pair of canvasses: *Building Flying Boats* and *Women's Canteen at Phoenix Works, Bradford* (1918). They depicted contrasting elements of factory life. In *Building Flying Boats*, men quietly toil away with great concentration, while in *Women's Canteen*, the female workers are on their break, exhausted, yet exuding an air of confidence and camaraderie. Following the IWM's rejection of the paintings, Lion toured them around the country, perhaps hoping to expand her reputation beyond portraiture.[44] In the event, she resumed her high-society portrait painting – and in 1927 donated her two factory paintings to the IWM.

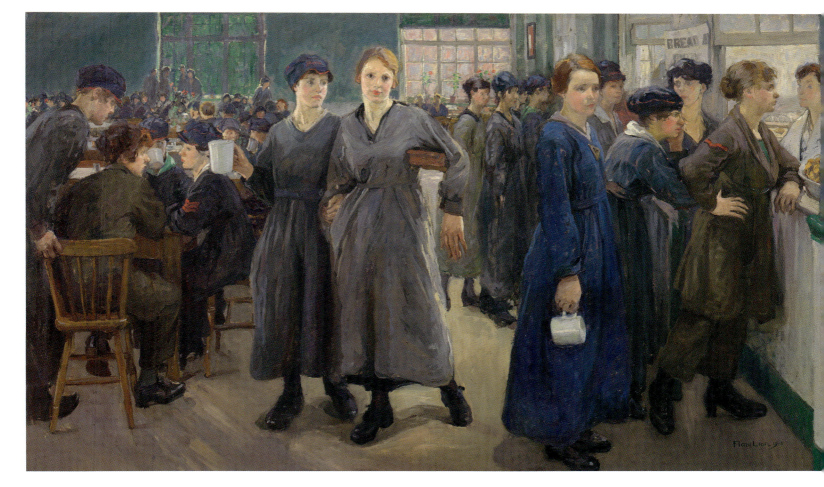

WE ARE MAKING A NEW WORLD: ART OF THE FIRST WORLD WAR

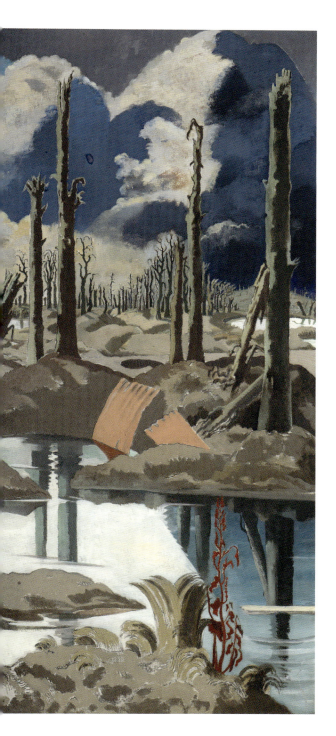

Paul Nash's own contribution to the BWMC scheme, *The Menin Road*, was completed in 1919, and it represented his first major work. It was an epic modern brutalised landscape, showing the Western Front but with no 'road' in sight. Despite the strangeness of the scene, there are natural rhythms across the canvas in the repetition of the trees, the corrugated iron and the pools of water. Smoke from explosives is treated the same as the shafts of sunlight and the clouds; the natural and the man-made combine to produce an impression of war as spectacle. It is an image of the sublime: awe-inspiring and terrifying in equal measure.

The work of the IWM's committees continued after the end of the war. Indeed, the 'medical artists' only began their work in late 1918, meaning that their perspective was affected by a sense of reflecting on the recent past. In the early days of the war, it was decided that the scale of the emergency response, and the innovations in the field of medicine, warranted special attention, and so a committee was formed to collect material of scientific and historical interest. In 1918, this initiative evolved into plans for an Army Medical Museum, and, as with the IWM, the planners wanted artworks to supplement the other objects. A team of artists was finally assembled to work for both museums following the signing of the Armistice.

Working from a studio in Fulham, these artists, led by Gilbert Rogers, produced a large number of paintings, sculptures, models and dioramas. Many of them were large-scale history paintings, on subjects such as the activities of advanced dressing stations, parties of stretcher-bearers, or the arrival of the wounded at railway stations.[45] As the IWM explained, 'all the models and works of art have been produced by artists who have seen actual service in France and obtained the data for their work firsthand' – phraseology that belies the fact that the artists worked mostly from models and equipment in the studio rather than *in situ* at the Front.[46]

Paul Nash, *The Menin Road* (1919)
Oil on canvas, 1,828 x 3,175 mm

Nash's suggested inscription for the painting reads: 'The picture shows a tract of country near Gheluvelt village in the sinister district of "Tower Hamlets", perhaps the most dreaded and disastrous locality of any area in any of the theatres of War.'[47]

WE ARE MAKING A NEW WORLD: ART OF THE FIRST WORLD WAR

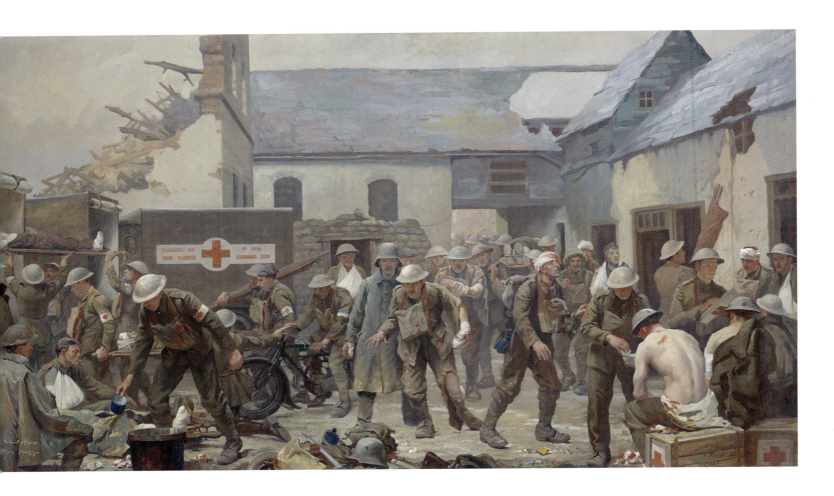

Rogers (1881–1956) was a successful portrait painter from Liverpool. During the war he served with the Royal Army Medical Corps, mainly at its headquarters and training school in Blackpool, before he was chosen in 1918 to lead the artistic scheme for the war's medical history. He did not visit the Western Front until after he was commissioned as an artist. Rogers's collaboration with Haydn Reynolds Mackey (1883–1979), *An Advanced Dressing Station, France* (1918–1919), is fairly typical of the large-scale canvasses produced. Mackey, a graduate of the Slade School, had also served in the RAMC, in France, where he won the Military Medal for recovering injured troops under fire.

During the war, censorship rules had meant that official photographers and filmmakers were forbidden from taking images of any Allied dead or grievously wounded, although they could show the tending of the wounded, to reassure the public that the soldiers were receiving excellent medical care. In March 1918, it was clear that this rule applied to artists too, when Nevinson had wanted to include his painting *Paths of Glory* in his official war artist exhibition. In response to the commission, Nevinson had completely changed his style of painting in favour of a kind of clumsy realism, with the result that *Paths of Glory* depicted the decomposing bodies of two British soldiers, lying in the mud. The War Office responded by forbidding its display. Nevinson reacted by covering his painting in brown paper and displaying it with the word 'Censored' emblazoned across, in a defiant spirit of showmanship which guaranteed his show's success.

Gilbert Rogers and Haydn Reynolds Mackey, *An Advanced Dressing Station, France: Cars Supplied by the BRCS and Order of St John Assisting the Evacuation of the Wounded* (1918–1919)
Oil on canvas, 2,025 x 3,640 mm

The impressive dimensions of this painting, along with its detail and ensemble cast of portraits, reflects a direct lineage from Victorian history painting. The work commemorates the scale and dedication of the wartime medical effort.

(Below Left) Austin O Spare, *Dressing the Wounded During a Gas Attack* (1919)

Pastel on paper, 1,012 x 759 mm

The artist's fascination with spiritualism and the occult – fashionable pastimes of the era – comes through in his eerie works as a medical artist, as in this example.

(Below Right) Percy Delf Smith, *Death Waits*, from the series *The Dance of Death* (1919)

Drypoint etching on paper, 264 x 328 mm

The series uses the old allegory of Death, a figure whose motivations are indiscriminate, and who comes for anyone, whatever their status in life. However, in Smith's perspective, Death is uniquely occupied with the carnage of the battlefield.

The medical artists had no such restrictions. War's end, bringing the end of censorship, meant that they were suddenly liberated to portray unapologetically grim and melodramatic subjects, as, for example, Rogers did in scenes of dead servicemen left to rot in the mud – imagery that remains strongly associated with the First World War. Another artist, Austin Spare (1886–1956), had a bystander's eye for curious horror: his drawings, such as *Dressing the Wounded During a Gas Attack* (1919), were praised by *The Times* for their 'grisly truthfulness' when unveiled – despite the fact that the artist had served in Blackpool for the duration of his war service, well away from the frontline.[48]

It was immediately after the war that Percy Delf Smith turned from his observational sketches to make a series of etchings entitled *The Dance of Death*. In seven different scenes, he portrayed Death as a kind of supervisory figure on the battlefield, sometimes in contemplation, sometimes denying final relief to hapless soldiers, sometimes even awed by the sights, sometimes merely waiting (as in *Death Waits*), head in his hands. Smith was not the only artist of the time to use the medieval allegory of Death – a cloaked, skeletal figure – to represent the universal brutality of the Great War.

At the IWM, art collecting in relation to the First World War continued in earnest until around 1920. Partly this was to allow time for commissions, including those for the BWMC, to wrap up; partly this was because of some important donations by well-known artists, including John Lavery and William Orpen, who gave to the museum their entire collections of artworks made during the course of the war. In addition, Muirhead Bone, being an enthusiastic patron of younger artists, wanted to see more of their work represented at the museum and formed a fund for new works of art – typically modern ones – that the IWM might otherwise have passed over.[49]

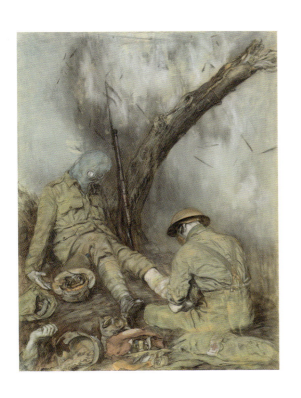

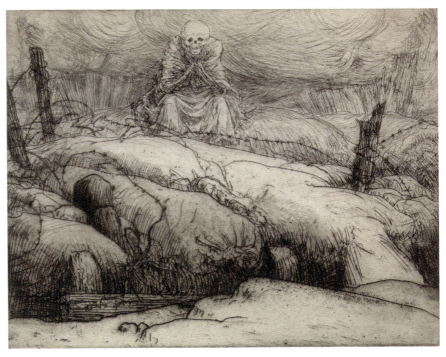

Bone chose all the art purchased by this fund. He had come across the work of Dorothy Coke (1897–1979) when she had submitted some sketches to the BWMC in 1918. She was, at that time, in her final year at the Slade School and, at age 21, the youngest artist the BWMC had considered; but a commission never materialised. Instead, Bone asked her to paint two watercolours for the IWM. The results were *Wounded Men on Duppas Hill, Croydon* (1919) and *War Allotments in a London Suburb* (1919). The conventional thinking tended to be that the few women artists should paint scenes depicting women, but Coke's two works were unusual exceptions, showing both sexes intermingling. Her technique with watercolour was refreshingly modern; in *Wounded Men on Duppas Hill*, she portrays one of the realities of post-war life in Britain, where large numbers of war veterans returned to civil society manifesting physical and/or psychological trauma or disabilities. Bone's commission would have been an important endorsement for Coke early in her career, and she went on to exhibit widely after the war, later teaching at the Brighton School of Art.

The Bone Fund also acquired additional works by Wyndham Lewis, William Roberts, John Singer Sargent and Henry Tonks for the IWM, along with

Dorothy Coke, *Wounded Men on Duppas Hill, Croydon* (1919)
Watercolour on paper, 452 x 609 mm

Coke's work shows an unusual contrast between the sexes, with the women – standing in the centre of the composition – fashionable and at ease with themselves, while the men are shadow-like in the blue uniforms of the wounded.

Alfred Neville Lewis, *Artillery Drivers in the Snow, Italian Front* (c.1918)
Oil on canvas, 914 x 711 mm

Although set during severe winter conditions, the painting's framing of the men, washing themselves against the pure white backdrop of the snow, imbues the work with a sense of vigour and purpose.

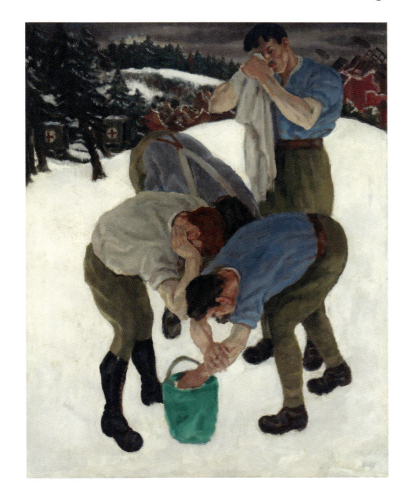

Bomberg's sketch for *Sappers at Work* and a work by Alfred Neville Lewis, *Artillery Drivers in the Snow, Italian Front* (c.1918). In 1912, Lewis (1895–1972), a promising young painter, had travelled from his home in Cape Town, South Africa, to study in Newlyn, Cornwall, before moving to London to attend the Slade School of Art in 1914–1916, under Tonks. Following the introduction of conscription in 1916, Lewis served in France, Belgium and Italy, and his painting recalls his service during the harsh winter of the Italian Front.

Following the Armistice, there was the necessity of determining the nature of the international peace settlement that would follow – the thorny matter tackled by the victorious powers at the Paris Peace Conference, which opened in January 1919. Orpen was still in France at this time, and he was given a final commission: to paint the assembled politicians and delegates gathering to sign the Treaty of Versailles, which laid down terms to the defeated Germany. By the time that the artist completed *The Signing of Peace in the Hall of Mirrors, Versailles, 28th June 1919*, he was thoroughly disillusioned with the political leaders in their formal frock coats, writing:

> It was all over. The 'frocks' had won the war. The 'frocks' had signed the Peace! The Army was forgotten. Some dead and forgotten, others maimed and forgotten, others alive and well – but equally forgotten... The whole thing was finished. Why worry to honour the representatives of the dead, or the maimed, or the blind, or the living that remained. Why? In Heaven's name, why not?[50]

In December 1919, the IWM unveiled a special exhibition entitled *The Nation's War Paintings* at the Royal Academy, which would last until February 1920. Organised by Yockney and Bone, the majority of the 925 pictures and sculptures were from the BWMC scheme and the Bone Fund. The two men strongly believed that these works elevated the overall quality of the IWM's art collection – and indeed the BWMC's monumental paintings went on to become some of the most recognised and admired among the museum's collection of art. They also hoped that the exhibition's impressive range and selection would lend weight to the campaign to create a dedicated picture gallery for war art. Yet, the exhibition drew a decidedly mixed response.

Paintings by John Nash, William Roberts and Wyndham Lewis created an uproar in the popular press. The *Manchester Evening News*'s headline ran 'Heroes Made to Look Like Clowns', while other articles expressed anger and disdain at the perceived subversive (even *German*) intentions behind the depiction of soldiers.[51] Alfred Mond, as First Commissioner of Works, faced a question in Parliament from Conservative MP Sir Clement Kinloch-Cooke about public money being spent on 'freak pictures'; another Conservative MP, Lieutenant-Colonel Archer-Shee, asked: 'Is he aware that a vast number

of people regard a great many of these pictures as atrocious libels on our troops… ?' Mond responded by distancing himself from the artworks in question, telling the House of Commons that the pictures were acquired by the Ministry of Information rather than the Imperial War Museum, and adding:

> I should like to say that a great difference of opinion exists on the merits of these pictures, and I have observed myself with some astonishment that most of the art critics consider them very fine works of art.[52]

Two artists in particular were the cause of upset and astonishment: the onetime vorticists Roberts and Lewis. William Roberts (1895–1980) had served as a gunner in the Royal Field Artillery. Although his pre-war work was entirely abstract, the schism of war had brought about a change of direction – as it did for many of the BWMC artists – and Roberts's output evolved, becoming more figurative and personal. In a series of watercolours purchased by the BWMC, Roberts revisited his experiences as a gunner. Scenes such as *Rosières Valley – Signallers Looping a Wire* (1918) show the men carrying out their tasks in the midst of an unimaginable world.

William Roberts, *Rosières Valley – Signallers Looping a Wire* (1918)
Ink and watercolour on paper, 217 x 320 mm

Roberts's figures are rendered in a blocky and unindividualised way, devoid of character; yet the scene is evidently drawn from memory, offering a fevered snapshot of the artist's war service.

Wyndham Lewis, *A Battery Shelled* (1919)
Oil on canvas, 1,828 x 3,175 mm

Here, three disinterested officers survey the chaos of the battlefield; their stillness provides a contrast to the frantic action of gunners. Heavily stylised, angular figures, these scurrying men are caught up in a struggle for survival.

Wyndham Lewis had served as a bombardier at the Third Battle of Ypres before he was commissioned by both the British and Canadian memorial schemes. His experiences induced a sense of nihilism about the war: he described Ypres and Vimy (site of an intense battle won largely by Canadian troops) as 'deliberately invented scenes, daily improved on and worked at by up-to-date machines, to stage war.'[53] A sense of this cynicism pervades his painting for the BWMC, *A Battery Shelled* (1919).

The backlash to these works confirmed the IWM's own view that 'modern art' was inappropriate for memorialising war – despite being created by veterans of the Western Front. The work of Lewis, Roberts and others was only admired by art critics, and it fell outside IWM's strict remit to gather 'records'. The overriding aim of the IWM at this time was to propagate the message that the unsurpassed horror and scale of the Great War should never be seen again, and that the war had been fought for a noble cause: to secure a better future.

WE ARE MAKING A NEW WORLD: ART OF THE FIRST WORLD WAR

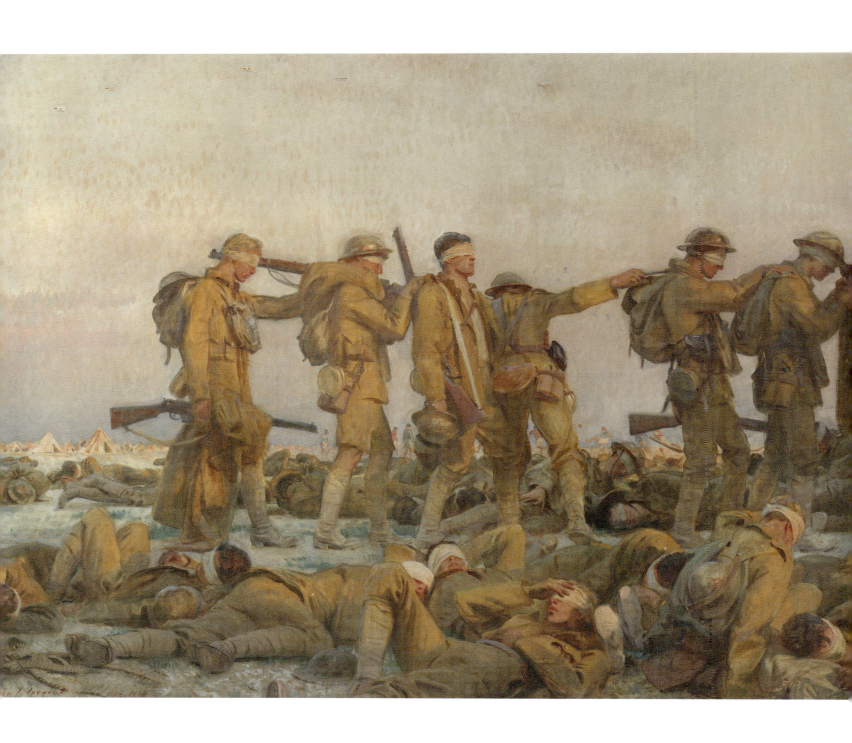

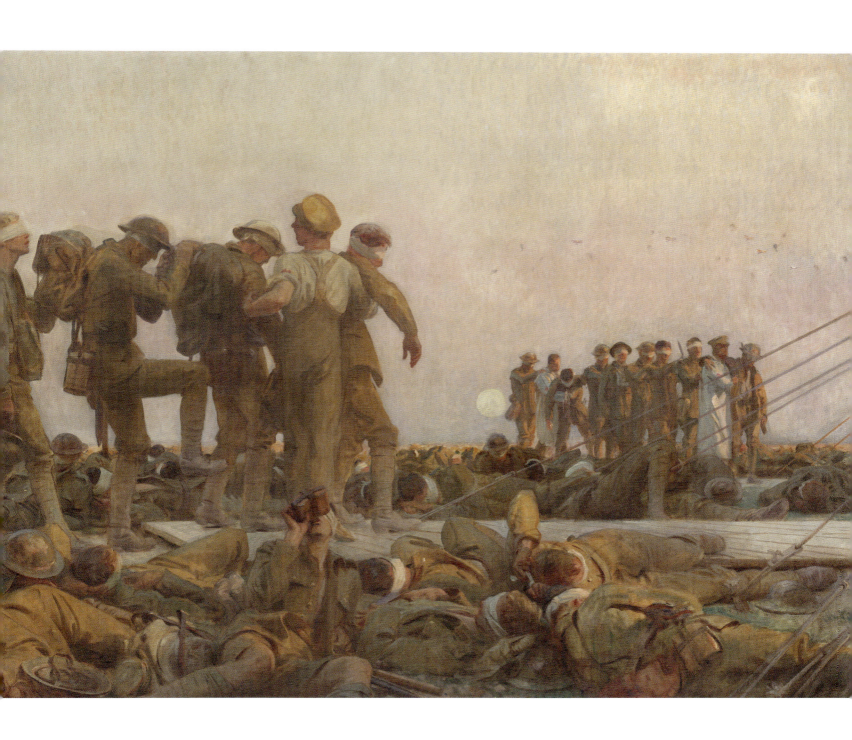

WE ARE MAKING A NEW WORLD: ART OF THE FIRST WORLD WAR

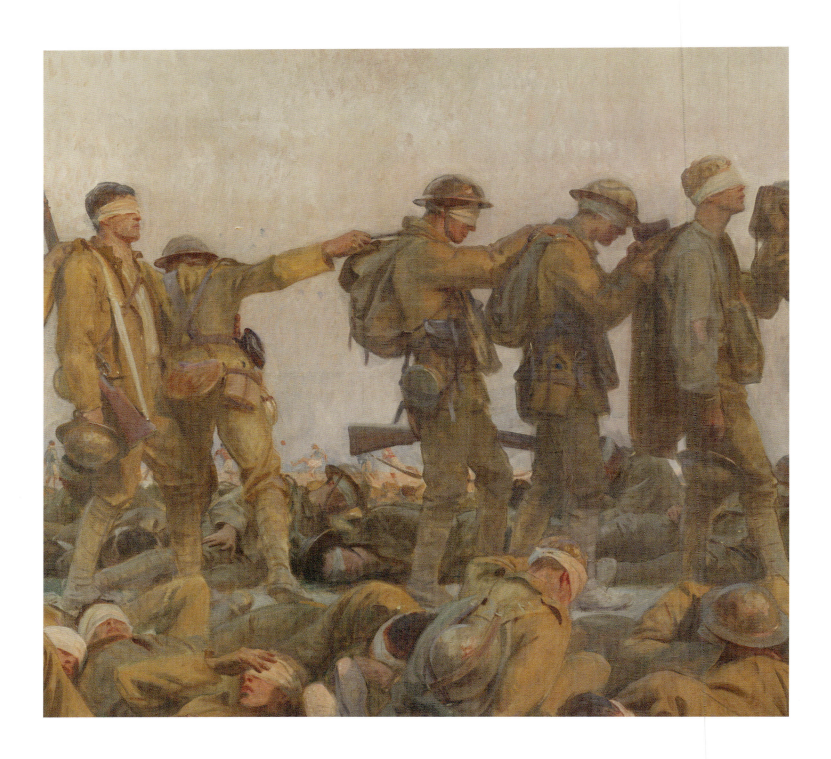

John Singer Sargent, *Gassed* (detail) (1919)
Oil on canvas, 2,310 x 6,111 mm

The subject of the painful effects of mustard gas was an unsettling departure for this celebrated society portrait-painter. But the elegance of Sargent's brushwork, coupled with the reassuring anticipation of a return to normality, lift his epic canvas.

Paintings by the older generation of artists proved to be much more in line with the early museum's thinking. The only super-sized canvas from the BWMC scheme, John Singer Sargent's ordered and elegiac *Gassed* (1919), was given pride of place in the IWM's first art galleries, at London's Crystal Palace, in 1920 – and through successive decades it would become the IWM's most popular work of art. Sargent (1856–1925) was originally commissioned by the BWMC to produce a painting on the theme of Anglo-American cooperation in the war. He had travelled to France with Henry Tonks but struggled to find inspiration until they visited a dressing station at le Bac-du-Sud on the Arras–Doullens Road. As Tonks wrote:

> Gassed cases kept coming in, lead along in parties of about six just as Sargent has depicted them, by an orderly. They sat or lay down on the grass, there must have been several hundred, evidently suffering a great deal, chiefly I fancy from their eyes which were covered up by a piece of lint... Sargent was very struck by the scene and immediately made a lot of notes.[54]

Mustard-gas poisoning took hours to take hold and was indiscriminate, causing blistering and painful blindness, though the loss of sight was mostly temporary. Sargent's painting fully evokes the suffering of the men; but their orderly procession towards the medical tent also emphasises a theme of survival and the hope of a better future. In the background, others play football, symbolising, in this glimpse of ordinary life, a return to normality following the privations of the frontline.

The First World War created such a widespread sense of loss, injury and dislocation that across the world, people needed means to mourn and memorialise the war in a way that no previous conflict had demanded. One result was the proliferation of war memorials. In Britain these ranged from the modest yet moving memorials that sprouted up in villages and towns everywhere to London's Cenotaph, designed by Edwin Lutyens, whose permanent incarnation in Portland stone was unveiled in 1920, on what has been ever since 'Remembrance Day': 11 November. The sculptor Charles Sargeant Jagger created some of the best-known of Britain's war memorials, including the Great Western Railway War Memorial (unveiled 1922) at Paddington station and the Royal Artillery Memorial (unveiled 1925) at Hyde Park. And on old battle fronts, across the globe, the Imperial War Graves Commission began creating and tending cemeteries for the war dead and memorials to the 'missing' – those whose bodies could never be found or identified, of which there were hundreds of thousands: artillery and the shattered battlefields had made sure of that.

On 11 November 1920 too, an 'Unknown Warrior' – termed 'warrior' to accommodate all the armed forces – was ceremonially interred in Westminster Abbey, becoming an important symbol and focus for national mourning in the years to follow. People lined the streets and followed the funeral procession, finally able to take part in a ceremony that, through its symbolic universality, embraced the loss of their own loved ones.

Still in his disillusioned post-war frame of mind, William Orpen painted his boldest statement yet on this theme. *To the Unknown British Soldier in France* (1921–1928) was supposed to be the third of his paintings based on the Paris Peace Conference. It caused a sensation when it was displayed at the Royal Academy in 1923 – and was voted 'Picture of the Year' by the public.[55] Yet it was attacked in the press. In that version of the work, two winged cherubs hovered in a grand arched hallway at Versailles, supporting a garland, while two emaciated semi-nude soldiers, holding rifles and wearing the typical Tommy's 'Brodie' helmet, guarded the tomb. (They were based on the figure in Orpen's drawing *Blown Up: see p.31*) The painting was rejected by the IWM, which was expecting a group portrait, as set out in the commission; but Orpen had painted over the 20 Allied generals and politicians he had originally included in the work.

Years later, in February 1928 – and following the recent death of his friend Field Marshal Haig (who had commanded British forces on the Western Front) – Orpen wrote to the IWM:

> ... do you remember the picture of 'the Unknown Soldier' which the war museum refused – would you put it before your people – that if I took out all the figures (cupids, soldiers, etc) and presented it to the IWM as a memorial to Haig, would it be accepted? I feel this picture ought to be there, and as the Field Marshal was one of the best friends I ever had – I would like to do my tiny bit to his memory.[56]

Although in later decades Haig's conduct of the war would be the subject of sometimes intense controversy and then further reassessment, in the immediate aftermath of war he was widely regarded as a hero, the man who had delivered Britain's share of victory. The unlikely friendship with Orpen had followed Haig's portrait-sitting for the artist in 1917. Orpen later recounted how the field marshal had told him to stop wasting his time and paint the men instead – which he duly did.

Martin Conway, the IWM's director-general, replied to Orpen's letter at once to say that the museum would be delighted with the painting even as it stood, and it was up to the artist whether he altered it. Perhaps the distance of the years had altered Conway's perspective. But by this point, Orpen had changed his mind about his ghostly characters and resolved to remove them, and in 1928 the museum accepted as a gift his revised version of the painting, free of cherubs and soldiers, and focusing instead on the flag-draped coffin in its architectural space.

The revisions created a quieter, reflective piece, the space of the echoing hallway allowing for sombre meditation on the collective loss of the nation. With so many of the war dead unidentifiable or irretrievable, many relatives were left in limbo, having no definitive news of their fate, no body to mourn and no resting place to grieve beside. By inserting the Unknown Warrior into the corridors of Versailles, Orpen gave primacy to the true heroes of the war: those who had served.

>

William Orpen, *To the Unknown British Soldier in France* (1921–1928)
Oil on canvas, 1,542 x 1,289 mm

Regardless of its controversial history, Orpen's painting remains an elegiac statement on the war's aftermath, reflecting the outlook of a nation in mourning.

The unreality of it all
Art of the Second World War

The cataclysmic impact of the First World War, with its millions of dead and missing, reverberated across societies and cultures worldwide. The global order existing before 1914 had broken down, and the international map was redrawn following the collapse of four empires and the creation of new states in their wake. With even the victors discontented with aspects of these outcomes, the peace that emerged was fragile and fractious. Britain's empire swelled in the war's aftermath, as it absorbed the administration of former German and Ottoman territories, but it was increasingly difficult to control parts of that empire – notably India – as they sought greater independence in return for their wartime efforts.

As ever, the arts of the avant-garde sensed and addressed the discord and instability, and 'dada' was European's art first recoil from the First World War, emerging as early as 1916 among a group of left-wing artists and writers in Zurich, in neutral Switzerland. Less a movement and more of a gut reaction to the folly and carnage of war, dada used nonsense and absurdity as an expression of its opposition to a society that rationalised and cheered on the war. Dada soon spread elsewhere, to Berlin, Paris and New York, where Marcel Duchamp first displayed his infamous 'readymade' *Fountain*, an upturned urinal, in 1917. While dada was short-lived, it did influence a new cultural movement, surrealism, which emerged in 1924, in Paris. Over the next few decades, surrealism would become a truly global phenomenon – a means for artists to subvert norms and express revolutionary ideas wherever it spread.

In the parallel world of politics, the 1920s saw the arrival of fascism with the founding of the Italian National Fascist Party in 1921, led by Benito Mussolini. The huge cost of Italy's war, compared to its gains, had caused widespread dissatisfaction and political instability, which the Fascists exploited to seize power in 1922. They believed in nationalism, militarism, authoritarianism, imperialism and racial superiority, providing inspiration to Adolf Hitler's rising National Socialist (Nazi) Party in Germany. Unlike their German counterparts, the Italian Fascists encouraged modern art – so long as the artists were sympathetic to the cause – and the founder of Futurism, Filippo Tommaso Marinetti, was an early Fascist supporter. Mussolini became a patron to many Futurist artists, including Renato Bertelli (1900–1974), who in 1933 sculpted him in *Profilo continuo (Testa di Mussolini)*, or *Continuous Profile (Head of Mussolini)*. Futurism, with its celebration of modernity, violence and speed, evolved in the 1930s to allow artists also to draw on the country's glorified

John Piper, *The Passage to the Control-room at South West Regional Headquarters*, Bristol (detail) (1940)
Oil on panel, 762 x 508 mm

During the Second World War, Britain's home front – under attack as never before – became a major subject for war artists. John Piper was commissioned to paint Air Raid Precautions control rooms, producing a series of striking, modern images. His experience as a stage designer and his interest in architecture are evident in the work he produced, as in this example. Following on, Piper painted his most celebrated images of the war: hauntingly beautiful silhouettes of the bomb-damaged ruins of British cities, including Coventry Cathedral and churches in the City of London.

George Grosz, *Fear* (1933)
Watercolour and ink on paper, 470 x 660 mm

In this image, Grosz articulates the frightening sense of chaos and persecution that led him to leave Germany; indeed, the drawing might refer to a dream that finally convinced him to flee with his family.[1]

Renato Bertelli, *Profilo continuo (Testa di Mussolini)*, or *Continuous Profile (Head of Mussolini)* (1933)
Terracotta, 340 x 280 mm (diameter)

The spinning profile evokes the Roman god Janus, whose two faces look towards both past and future. Here, it signifies the all-seeing power of the man Italians called *il Duce*. A smaller, paperweight-style version was mass-produced during the dictator's reign.

Roman past, in line with Fascism's nationalistic principles and Mussolini's ambitions to create a Second Roman Empire.

Germany, like Italy, was politically unstable. A weak constitutional republic, initially based in Weimar, had followed the abdication and exile of Kaiser Wilhelm II in 1918, but it was powerless to curb the rival paramilitaries bringing violence and intimidation to the streets. The country was struggling financially under 'reparations' following the war, before it was struck by the effects of the global economic slump in 1930: the Great Depression. During this time there were some important artistic developments, including the establishment in 1919 of the influential and pioneering Bauhaus art school in Weimar and the work of war veterans and dadaists Otto Dix and George Grosz, who satirised the era's decadence and corruption. Indeed, the power of Grosz's work was such that throughout the 1920s he was brought to trial by the German state on charges of insulting the army, defaming public morals and blasphemy.

But worse was to come. Desperation brought on by the impact of the Great Depression pushed millions of people towards the embrace of political extremes. By 30 January 1933, Mussolini's admirer Hitler was German chancellor and his Nazi Party the largest in Germany's parliament; and by March 1933, following the burning down of the parliament building (blamed on a communist plot) and another general election, an Enabling Act gave Hitler's government the power to make and enforce laws without parliamentary check. Following years of pressure on the Bauhaus, which was now located in Berlin, the party finally closed it in April 1933. Dix, who was among a number of artists labelled by the Nazis as 'degenerate', was sacked from his post as an art teacher at the Dresden Academy. Meanwhile, Grosz had escaped with his family to New York just weeks before Hitler became chancellor. Grosz had faced years of threats from Nazi paramilitary Brownshirts, and his studio and apartment were searched soon after his departure. He felt that he had narrowly escaped death and made a watercolour, *Fear* (1933), in response. Once he was resettled in the United States, Grosz abandoned caricature and deliberately softened the nature of his work.

In Britain during the 1920s, the Bloomsbury set remained influential, and artists generally pursued their own diverse and individual approaches to landscape, to still-life and to capturing the figure. For some artists, these years were especially difficult: C R W Nevinson rapidly lost the respect he had garnered following his success as a war artist. A compulsive self-promoter, he nursed a persecution complex, which only served to alienate him from the British art world. Instead, he took to a motor caravan with his wife, roaming and painting the English countryside. But by the 1930s, like many others, he was alert to the prospect of another war, writing:

> I was overwhelmed by the stupidity of Europe, which allows itself to be governed by braggarts and grabbers who are not merely preparing for another slaughter, but are using all the arts to distort truth, and all methods of reproduction to misinform. Liberty of thought has been killed and youth has been regimented.[2]

Nevinson expressed these feelings in his art through strange, nightmarish scenes such as *The Unending Cult of Human Sacrifice* (1934). Ever the contrarian, Nevinson flirted with fascism's aesthetics, with his taste for black silk shirts, and he was vocal in his approval of strong leaders. But he remained resolutely anti-war and anti-militarism following his First World War experiences.[3]

As the 1930s progressed, there was a shift in the British artistic landscape, with artists beginning to embrace international movements such as surrealism and abstraction. Both these movements, and an enthusiasm for all things modern, inspired Paul Nash in 1933 to found Unit 1, a group of artists and designers that included the rising sculptors Henry Moore and Barbara Hepworth, the painter Edward Burra, the former vorticist and dazzle painter Edward Wadsworth, and the abstract artist Ben Nicholson. That year also saw the formation of the politically engaged Artists' International Association (AIA). Primarily a response to the rise of European fascism, it brought artists of all stripes together in support of social causes. The AIA held a series of lectures, conferences and large group exhibitions such as *Artists Against Fascism and War* (1935), which included works by Moore and Paul Nash.

While the AIA was active for the next few decades, Unit 1 was short-lived, lasting less than a year. But the latter's legacy was enduring, and by 1936 many of its artists were included in the British section of the *International Surrealist Exhibition* in London. This event was the first time that the British public and press were exposed to surrealist imagery, with its deliberately illogical and disorientating qualities, evoking dreams and the subconscious. These were artworks that prized imagination, upended convention and aimed to disrupt the notion that human beings were guided by rational thoughts and behaviours. The exhibition caused a sensation. Many art critics still did not take the movement seriously, seeing it as nothing more than a gimmick; but surrealism was here to stay, and it continued to influence British artists in the late 1930s and beyond.

By 1936, the AIA's efforts were focused on supporting the left-wing Republican government in the Spanish Civil War (1936–1939), against the Nationalist rebellion, formed of fascists and other right-wing groups, led by General Francisco Franco. The Republican side drew support from the Soviet Union and international volunteers, while the Nationalists had the backing of Fascist Italy and Nazi Germany, whose aerial bombing of Republican-held cities provoked international outrage – but did not alter Britain and France's official policy of non-intervention. This foretaste of horrors to come provoked

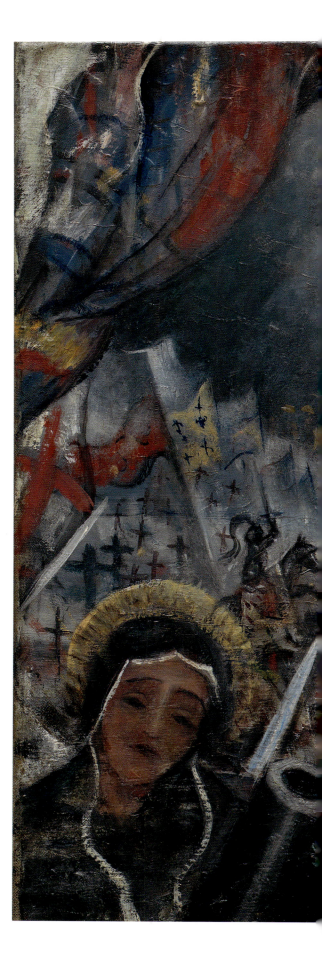

C R W Nevinson,
The Unending Cult of Human Sacrifice (1934)
Oil on canvas, 460 x 610 mm

Nevinson's painting combines modern and medieval battle imagery to evoke a vista of doom. Here, both Christian and nationalist ideology are condemned as fuelling a continuous cycle of violence over the centuries.

Pablo Picasso into creating his vast painting entitled *Guernica*, after one of the bombed towns. Commissioned by the Republican Spanish government to promote their plight at the 1937 *Paris International Exhibition*, *Guernica*'s original reception was mixed, but it went on to become one of his best-known works: a powerful – and universal – anti-war response, expressing the devastating human cost of war.

Many British artists who were concerned about the spread of fascism in Europe supported the Spanish Republicans, including John Armstrong (1893–1973), a member of Unit 1. He painted a series of responses to the conflict including *Pro Patria* (1938), its title, 'For the Fatherland', a slogan that Armstrong saw on posters all over Rome during his visit there in 1938.[4] The rise of fascism chilled Armstrong to the bone, and his painting shows the influence of surrealism in its nightmarish vision.

John Armstrong, *Pro Patria* (1938)
Tempera on plywood, 758 x 936 mm

Here, fascism's tyranny has brought about the collapse of European civilisation. Amid the desolate landscape, authoritarian speechmakers – or faces howling in anguish – stare out from the peeling posters.

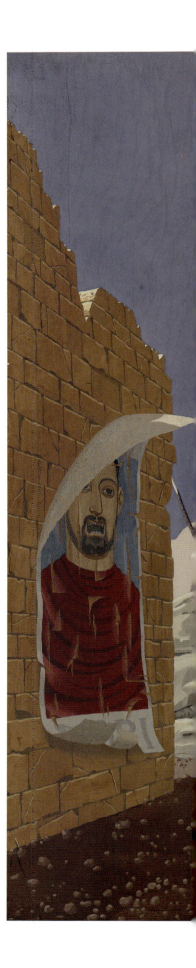

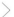

Beatrice Fergusson, *Liberty's Fool*, from the 'Snapshots' sketchbook (1938)
Ink and coloured pencil on paper, 130 x 195 mm

This page, from art student Beatrice Fergusson's sketchbook, shows the influence of the surrealist movement in 1930s' Britain. Such imagery was an effective way to convey fears about the rise of fascism and express the dark atmosphere of the period.

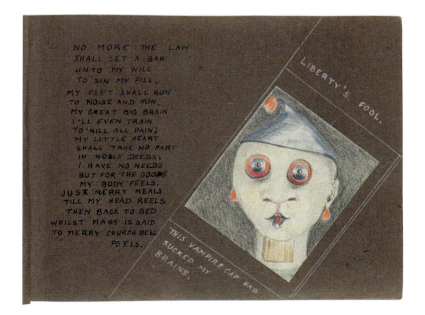

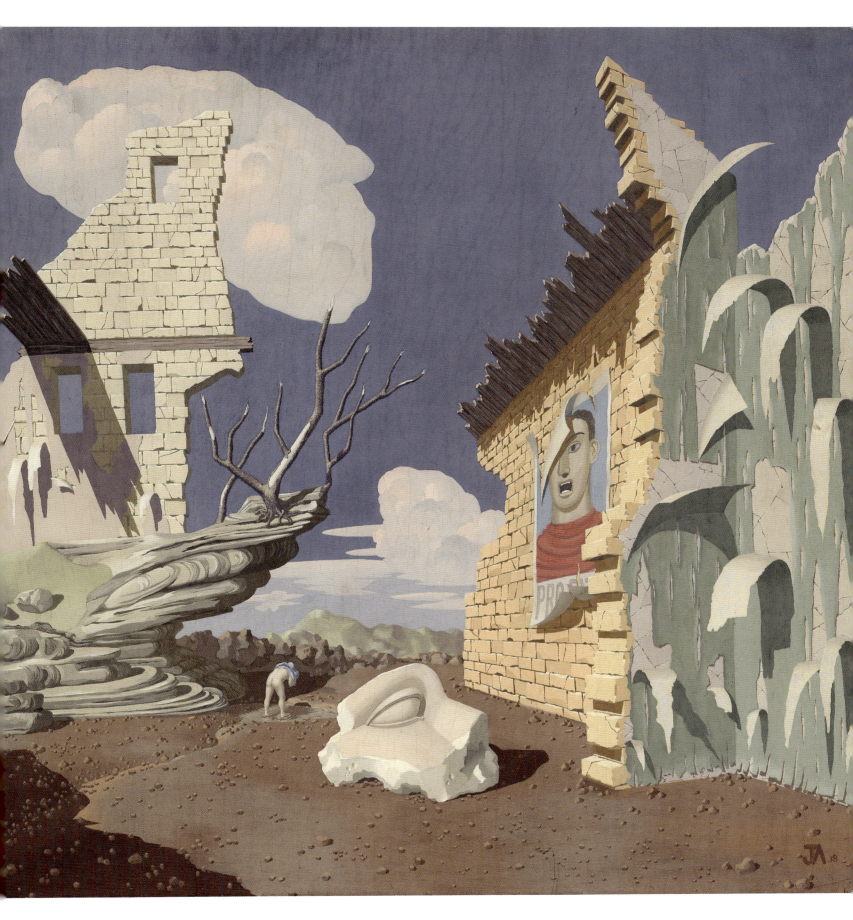

In Germany, the regime intensified its campaign against so-called *entartete Kunst* (degenerate art), which Nazi racial theories framed as 'un-German', 'primitive', communist and Jewish. The authorities confiscated 650 works to form the notorious *Entartete Kunst* exhibition of 1937, held in Munich. It inevitably included the work of Otto Dix and George Grosz – along with art by more than a hundred other German artists, representing whole schools of art, including expressionism, dada and surrealism. For now, modern art in Germany had no future, as artists fled, or stopped producing work, or went underground, and as museums and collections were systematically stripped of offending works. Germany's loss was Britain's gain; indeed, many progressive artists, designers and writers emigrated from all over central Europe, adding to a spirit of internationalism in British artistic circles in the 1930s.

By 1938, stability in Europe was fracturing as an increasingly threatening Germany absorbed Austria. Desperate to avert another total war, Britain and France then reluctantly accepted Hitler's annexation of the German-majority areas of Czechoslovakia later that year. Yet, while hoping Germany's ambitions were now satiated, Britain and France had also begun to prepare for the prospect of war. Sure enough, in March 1939, German forces seized most of the remaining parts of Czechoslovakia. Six months later, following the invasion of Poland on 1 September, Britain and France were once more at war with Germany.

One fairly rapid result was that around 70,000 Germans and Austrians living in Britain were classed as 'enemy aliens', including the thousands of Jewish people who had fled Nazi persecution. Initially, only a few hundred were interned, but this changed as fears of German invasion increased. By spring 1940, a further 8,000 Germans and Austrians living in the south of England were arrested and taken to internment camps. Among them was the artist Fred Uhlman, who had settled in Hampstead, North London, in 1936 with his English wife Diana Croft. There, he had founded the Free German League of Culture and opened his house to other exiled artists. Uhlman was taken to Hutchinson camp on the Isle of Man. He and the others had no idea of when they would be released, and it was a bitter blow to be facing state hostility once again. With so many freethinking artists-in-exile in one place on the island, however, the camp was a hive of creativity. Among others, Uhlman met the dadaist Kurt Schwitters, who created sculpture out of porridge and whose morning routine would involve barking like a dog; Schwitters also painted a conventional portrait of Uhlman. For his part, Uhlman made around 200 drawings during his six months of captivity, including *A Dream of Open Gates* (1940), which invoked the spirit of his daughter Caroline, born just a week after his internment began.

One small aspect of Britain's pre-war contingency planning had been the establishment of a 'shadow' Ministry of Information. First discussed in 1935, it operated briefly, for a week, following the 1938 Nazi annexations in Czechoslovakia. The ministry's existence had been an official secret known to only a small group of public servants, MPs, government advisors and BBC officials.[5] And one of this number was Kenneth Clark, Director of the National Gallery and an important private patron of the arts.

Fred Uhlman, *A Dream of Open Gates* (1940)
Ink, wash, pencil and conté crayon on paper,
171 x 209 mm

During his imprisonment, Uhlman cherished the figure of the child as a 'symbol of joy and liberty, marching with sure, unfaltering steps through the valley of death and terror – totally undisturbed, untouchable and triumphant'.[6]

Born into a wealthy family, Clark had attended public school and read history at Trinity College, Oxford; notably, his interest in art had been nurtured from a young age: he was sitting for artists including John Lavery by the age of 12. He grew into not only a collector but also a critical friend to artists, supporting many of them financially, and now his star was on the rise, for he was already a public figure who made regular appearances on BBC radio broadcasts.

On 4 September 1939, the day after Britain's declaration of war, the MOI emerged fully from the shadows, with Clark becoming Head of the Films Division and Controller of Home Publicity.[7] Clark had other concerns on his mind, too, for he knew how disastrous the onset of war was for artists, with opportunities for commissions and sales drying up overnight. This challenge was particularly acute for those artists at an early stage in their career, such as Evelyn Dunbar, a graduate of the Royal College of Art and a promising mural artist and illustrator. When war broke out, she went to work full-time at her sister's haberdashery shop on the High Street in Rochester, Kent.[8] Another artist, Leonard Rosoman, was teaching and starting to receive commissions before he decided to sign up with the Auxiliary Fire Service in London. Even established artists were affected: in France, Paule Vézelay (née Margery Watson-Williams) was at the peak of her career when she had to abandon the Paris art scene – where she had exhibited with Jean Arp and Wassily Kandinsky, among others – to live with her elderly parents in Bristol. All in all, within the first two months of the Second World War, as many as 9,000 artists in Britain were out of work.[9]

This time around, the British government introduced conscription for men from the start of the war – and Clark was determined to prevent artists he admired from being called up to fight. He made the case for a war artists commissioning body within the MOI, taking inspiration from the work of the British War Memorials Committee during the First World War, which he had admired in his youth. In its early days, the ministry was a rather chaotic, amateurish operation. Clark, with his self-confidence and drive, took advantage of this atmosphere of free-for-all to pursue his scheme for commissioning artists. Accordingly, in November 1939 the MOI established a War Artists Advisory Committee (WAAC).

The MOI had a large remit, well beyond art, being responsible for all government communications intended to permeate culture at home and abroad, and in all media: films, posters, radio, photojournalism, comics and advertising. These communications were aimed at winning the trust of the general public and uniting them behind the war effort. Out of its initial disorder, the MOI developed to be a much more sophisticated operation. This can be discerned in, for example, its poster campaigns, where it began to engage well-known

Fougasse, *'But for Heaven's sake, don't say I told you!'* – from the *Careless Talk Costs Lives* series (1942)
Photolithograph on paper, 318 x 203 mm

Fougasse felt that, rather than preach, effective propaganda should be humorous. His *Careless Talk Costs Lives* series was his most popular poster campaign.

cartoonists like 'Fougasse' (Cyril Kenneth Bird, 1887–1965), who offered his services for free.[10] Fougasse's memorable series *Careless Talk Costs Lives* (1942) used humour and sparseness of design to get the message across.

Throughout the Second World War, the WAAC would sit rather awkwardly within the MOI, where its position was not always secure. Although Brendan Bracken, who became Minister of Information in 1941, was an enthusiastic supporter of war art, many others at the ministry doubted whether art could be harnessed as an effective weapon in the communication war. Rather than being overtly propagandist, the WAAC's aim was to collect artworks that recorded all aspects of Britain's war. As in the First World War, the power attributed to war art was that it could be presented by its commissioners as an impartial medium for recording events, despite the subjective nature of art.

The official emphasis was on the artists' roles as eyewitnesses and their ability to interpret momentous events pictorially. Collecting and commissioning war art was a subtle way of boosting morale and promoting Britain's image. Unlike in the previous war, when official war art was targeted at an educated elite, WAAC art was selected to appeal to *all* levels of society, in line with Kenneth Clark's personal mission to increase appreciation for the arts among the wider British public. And so, as well as being displayed in wartime exhibitions at the National Gallery, WAAC artworks were to appear in many popular touring exhibitions around the country, were reproduced in booklets, newspapers and magazines, and were even sent on touring exhibitions around the world.

As for the artists chosen for the scheme, Clark's own taste played a large role. His favoured artists for tackling war subjects included Graham Sutherland, Henry Moore, John Piper and Paul Nash, whose work he saw as exemplifying spiritually 'English' qualities. Many of the First World War artists were reconsidered for commissions; in addition, many of the WAAC artists chosen had worked in design, publishing, advertising or book illustration. Their track-record of work was eye-catching, modern and proven to be accessible to a mass public. By contrast, the committee purposely sidelined abstract artists such as Ben Nicholson and Barbara Hepworth, regarding their approaches as unsuitable for war art.

Also somewhat sidelined was the Imperial War Museum itself. During the interwar years it had struggled to find a home: after vacating the Crystal Palace in 1924, it had made do with just two galleries at the Imperial Institute in South Kensington. The museum finally landed the site of the old Bethlem Royal Hospital, or 'Bedlam', in 1936, with Director-General Martin Conway telling Parliament: 'I do not think that a lunatic asylum is at all a bad place for a War Museum myself.'[11] With the advent of war, and with most of its younger staff called up to serve, it was clear that the IWM did not have the resources to begin an ambitious collecting project of its own. Instead, Muirhead Bone, who was still a museum trustee, was appointed by Clark as a WAAC member; by now, Bone was widely regarded as a specialist on the subject of war art. Between the two organisations, there was an informal understanding that the IWM would be the principal recipient of WAAC artworks at the end of the war.[12]

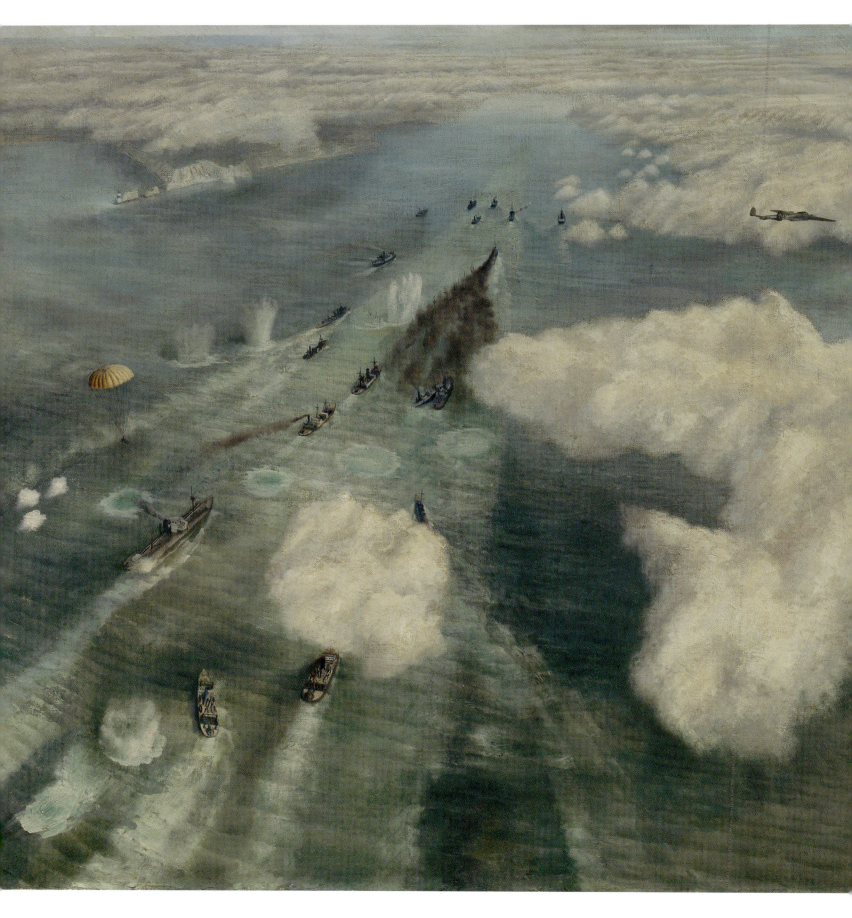

At the beginning of the war, and for all the aggression demonstrated in Germany's swift overrunning of western Poland, the first seven months following September 1939 became known in Britain as the 'Phoney War', marked by stalemate and inaction on land and in the air. During this time, the WAAC began engaging artists; as in the previous war, some were sent with the British Expeditionary Force (BEF) to France and Belgium, while others were appointed to cover aspects of the home front and the war effort around Britain.

Paul Nash was initially appointed in March 1940 as a war artist to the Air Ministry. Clark had admired Nash's *The Soul Visiting the Mansions of the Dead* (1932), displayed at the *International Surrealist Exhibition*, and felt that the famous war artist, known for his fascination with flight, could express something unique about the air war. But it did not take long for the Air Ministry to find fault with his approach: they were looking for a more literal interpretation of the subject and could not understand Nash's preoccupation with 'the personality of planes' – the title of a *Vogue* article he would publish in March 1942.

Just weeks after Nash's appointment, the war in Western Europe ignited, first with the successful German invasion of Norway, and then *Blitzkrieg* against the Low Countries, Denmark and France. The evacuation of hundreds of thousands of British, French and Belgian troops from Dunkirk, on the northern French coast, was swiftly followed by the shock defeat of France in June 1940. Next, Germany began its aerial assault on Britain, targeting firstly the RAF and its infrastructure – in the Battle of Britain – and then British towns and cities, in the sustained series of attacks known as the 'Blitz'.

With these alarming developments, WAAC artists who had been depicting the more workaday aspects of daily life – such as recruitment and training in Britain, and soldiers waiting around in France – were suddenly provided with far more dramatic subject opportunities. As the painter Richard Eurich, writing to the committee, put it:

> ... now the epic subject I have been waiting for has taken place. The Dunkirk episode. This surely should be painted and I am wondering if I would be considered for the job! It seems to me that the traditional sea painting of Van de Velde and Turner should be carried on to enrich and record our heritage.[13]

Richard Eurich,
Attack on a Convoy as Seen From the Air (1940)
Oil on canvas, 760 × 1,014 mm

Eurich's imagined perspective over the convoy, through gaps in the cloud, animates the scene, in which the splashes and rings in the water indicate where bombs have just fallen. A destroyer throws out a smoke screen, while the cloud affords valuable cover for the aircraft before they attack again.

THE UNREALITY OF IT ALL: ART OF THE SECOND WORLD WAR

Eurich (1903–1992), another protégé of Henry Tonks at the Slade School, was a figurative artist who was starting to establish himself as a marine painter before the war broke out. His works, which consciously evoked the great naval painters from the past, betrayed an eye for bold, epic scenarios. The committee felt that the major events of the British war experience – such as the evacuation from Dunkirk and the Battle of Britain – would also need to be painted in retrospect, in the manner of commemoration. For these subjects, the committee allowed artists to work in a way that was not strictly eyewitness, but more traditional, involving researching, interviewing survivors and using their imaginations to construct spectacular compositions.

Eurich's wish was granted, when he was commissioned to paint *Dunkirk Beaches, May 1940* (1941), a highly detailed and panoramic composition. He also painted other momentous events and spectacular aerial views for the committee, such as *Attack on a Convoy as Seen From the Air* (1940) – despite his never having flown in an aircraft. Instead, he used his extensive knowledge of the waters around the Isle of Wight – in this case the Needles – together with his command of aerial perspective and the effects of light, to create such paintings.

Following the termination of his contract with the Air Ministry in December 1940, Paul Nash agreed a flexible contract with the WAAC so that he could continue to make work on RAF subjects. In his short time at the ministry, Nash had been enthused by what he saw, working up his sketches made at an aircraft dump at Cowley in Oxfordshire to create his key work of the war, *Totes Meer (Dead Sea)* (1940–1941). He followed this with the commemorative *Battle of Britain* (1941), a celebrated and much reproduced image, which distances the action depicted and renders it as beautiful spectacle – like an air show – rather than a deadly battle. Nash worked from a combination of aerial photographs and his own observations of vapour trails and tiny formations of aircraft in the skies. Due to his asthma, he was never deemed fit enough to fly, and so his most vital ingredient was his imagination.

In 1942, Nash started working on a third painting to complete the suite that began with *Totes Meer* and *Battle of Britain*. Nash's Second World War paintings do not offer the same possibilities of pacifist interpretation as his First World War ones. The start of the British 'area' bombing campaign against German cities that year inspired *Battle of Germany* (1944), which imagines the bomber's approach to its target, its multiple viewpoints representing the changing landscape as seen from the aircraft. When it was completed, its near-abstract approach was a challenge to the WAAC, even confusing the usually supportive Clark.

Paul Nash, *Battle of Germany* (1944)
Oil on canvas, 1,219 x 1,828 mm

Nash's Second World War paintings reinvented battle painting for the modern era. Combining his favoured motifs of bomb-clouds and mushroom-shaped parachutes, this painting is an awe-inspiring and – more troublingly – visually pleasing vision of war.

While Nash interpreted the war in the air, on the home front WAAC artists were sent nationwide, on official visits to factories, mines, quarries and shipyards. They created dramatic industrial scenes, often with a deliberately spiritual atmosphere, in keeping with the neo-romantic style of the times. Mervyn Peake's (1911–1968) commission at the Chance Brothers' glass-blowing factory in Smethwick, near Birmingham, is an enchanting example. The assignment inspired many drawings and paintings, including *The Evolution of the Cathode Ray (Radiolocation) Tube*, as well as a collection of poems, *The Glass Blowers*, published in 1950.

>

Mervyn Peake, *The Evolution of the Cathode Ray (Radiolocation) Tube* (1943)
Oil on canvas, 850 x 1,104 mm

Peake was fascinated with the process of creating the glass tubes – important components in radar. Here, he presents the workers as performers, arranged in a kind of mystical dance, and illuminated by the glowing hot glass and blinding furnaces.

The prize for the most ambitious and epic WAAC project must surely go to Stanley Spencer, for his *Shipbuilding on the Clyde* series. In 1940, he was commissioned to make only one painting; but, following his first visit to Lithgows' shipyard at Port Glasgow, his ideas developed rapidly. He produced, instead, diagrams for an arrangement of 11 canvasses as a frieze measuring over 20 metres long.[14] The committee members, at pains to accommodate this respected artist, agreed to expand the commission. The first painting to be completed was *Burners*, in August 1940, delivered in three sections to the delighted committee. Spencer managed to produce seven further canvasses by 1946, when the project had to be brought to a halt. During those six years, Spencer took many trips to the shipyards, exhibiting a deep interest in the lives and work of the welders, plumbers, riveters, riggers and burners. In the paintings, he dressed them all in unifying Harris Tweed and banished most of the women, presenting a kind of spiritual masculine order and work ethic. Today, the paintings serve as a monument to a way of working-class life that has long since disappeared from the ports of Britain.

For those artists who were working independently, gaining access to such sites for the purposes of drawing could be very difficult indeed. Paule Vézelay (1892–1984) applied to the WAAC for 'special facilities' to draw the

Stanley Spencer, *Shipbuilding on the Clyde: Burners* (centre section) (1940)
Oil on canvas, 1,067 x 5,588 mm

Spencer was impressed with the shipbuilders' affinity with their workplace and sense of pride in their craft. He was fascinated with the burners' use of 'a flame' to cut steel plates to 'in some mysterious way leave a clean edge.'[15]

90 VISIONS OF WAR: ART OF THE IMPERIAL WAR MUSEUMS

Paule Vézelay, *Barrage Balloon* (1942)
Pastel and charcoal on paper, 817 x 990 mm

The barrage balloons, intended to deter or snare low-flying enemy aircraft, were a gift to artists like Vézelay who could see the visual absurdity in their billowing, monstrous proportions.

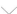

construction of barrage balloons but received a dismissive response – perhaps because of her avant-garde credentials. She eventually had success after appealing to the Director of Bristol Museum and Art Gallery for permission. Before the war, her work was completely abstract; but *Barrage Balloon* (1942), drawn from studies made at No. 11 Balloon Centre, Pucklechurch, shows Vézelay's eye for the surreal.

Other artists, like the young Margaret Abbess (1922–2008), did not even attempt to gain permission to draw. At the start of the war, Abbess was 16 and studying a foundation course in art in Walthamstow. The family was then evacuated to Devon, where she was able to finish her art studies before returning to London in 1942, after which she worked in a factory, making parts for aircraft. The high level of security involved meant that she had to make tiny quick sketches in secret; she also worked up her ideas from memory into drawings such as *Arriving at the Factory* (c.1943) once she had returned home.

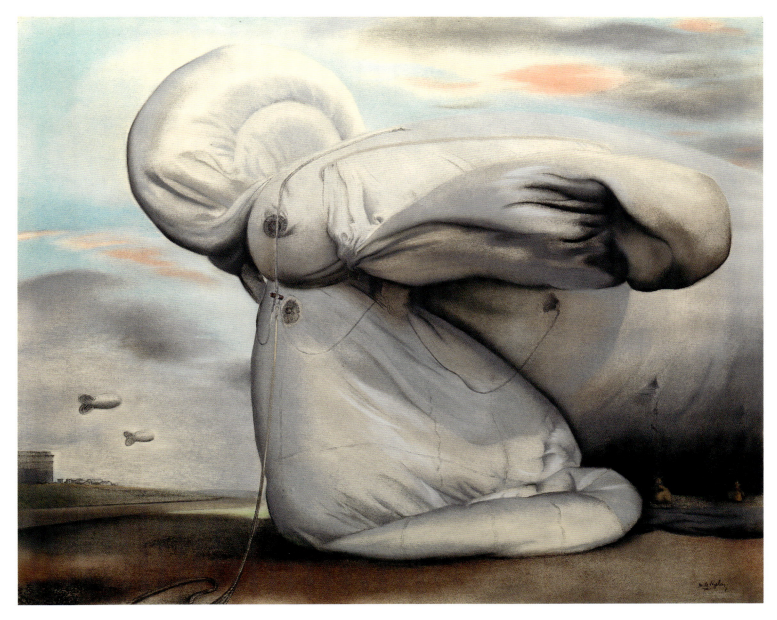

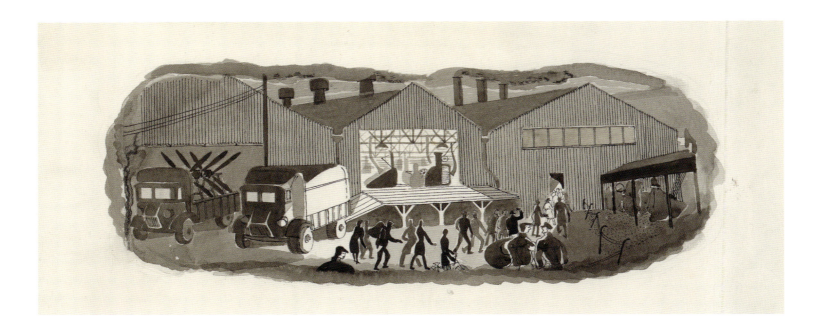

Out of the WAAC's 401 artists, just 52 were women, representing about 13 per cent. This was not simply a reflection of wider societal attitudes: throughout the first half of the century, women outnumbered men as students at the Slade School for example, while estimates of the number of artists working and exhibiting in Britain during this period put women at about a third of the total.[16] The committee's misgivings towards women making war art were apparent in the fact that women were given fewer and shorter commissions, as well as less financial reward. Women artists also received less publicity than their male counterparts, all of which contributed to their enjoying less prestige.[17] In addition, for most of the WAAC's lifespan, the view still held – inherited from the First World War – that women artists should only portray female subjects. Whatever the deficiencies of this situation, those artists who were engaged by the WAAC were, for the most part, grateful for the work.

Evelyn Dunbar (1906–1960) was the only woman among the 36 WAAC artists given salaried positions. She wrote to the committee in December 1939, politely asking to be considered for a commission and stating her interest in 'women's agricultural or horticultural work, or anything connected with land work; I feel I could do this with very keen understanding'.[18] She had begun to make a name for herself, painting an impressive set of murals at what was then Brockley School, Lewisham, South London, and had been championed by the Director of the Tate Gallery, John Rothenstein.[19] And so, she became one of the first women approached by the WAAC in 1940, following lobbying by IWM trustees Lady Norman and Muirhead Bone to cover the women's services, whose numbers increased after women's conscription was introduced in December 1941.[20]

In military support organisations such as the Auxiliary Territorial Service (ATS) or the Women's Auxiliary Air Force (WAAF), women were, as in the First World War, working in roles formerly the preserve of men, provoking societal discomfort and admiration in equal measure. Anthony Gross and

Margaret Abbess, *Arriving at the Factory* (c.1943)
Ink and wash on paper, 177 x 431 mm

Made from memory, this drawing shows night-shift workers walking up to the brightly lit factory in the dark – an ordinary scene, which Abbess manages to imbue with a dream-like quality.

Evelyn Dunbar, *A Knitting Party* (1940)
Oil on canvas, 457 x 508 mm

Dunbar was an astute observer of human behaviour, and this carefully constructed scene reveals an overlooked – and somewhat chilly – aspect of British wartime society.

Edward Ardizzone were the first WAAC artists to draw the ATS, but they brought their own (male) preconceptions to their subjects: Gross's ATS members are somewhat generic 'pretty' women, while Ardizzone poked fun by emphasising the masculine characteristics of the ATS officers.[21] Mercifully, the WAAC's women artists were able to provide a fuller and less objectifying record of women's war work – though this did not make them immune from the occasional idealisation of women.[22]

Dunbar's first assignment was to paint the activities of the Women's Land Army (WLA), who supported the nation's agricultural effort, and the resulting paintings, including *Land Girl with Bail Bull* (now at the Tate), proved that the artist and her commission were well matched. One Land girl remembered how 'Evelyn would get up early and trudge around the farm in all weathers, squat on windy hillsides or perch precariously in all positions to obtain her records.'[23] While Dunbar had a particular kinship with women working the land, her subjects ranged widely, encompassing nursing, camouflage, Air Raid Precautions, army clothing, and even people queueing for food. Many of her portrayals are characterised by a sense of industrious earnestness and sympathetic humour, exemplified in the austere atmosphere of *A Knitting Party* (1940).

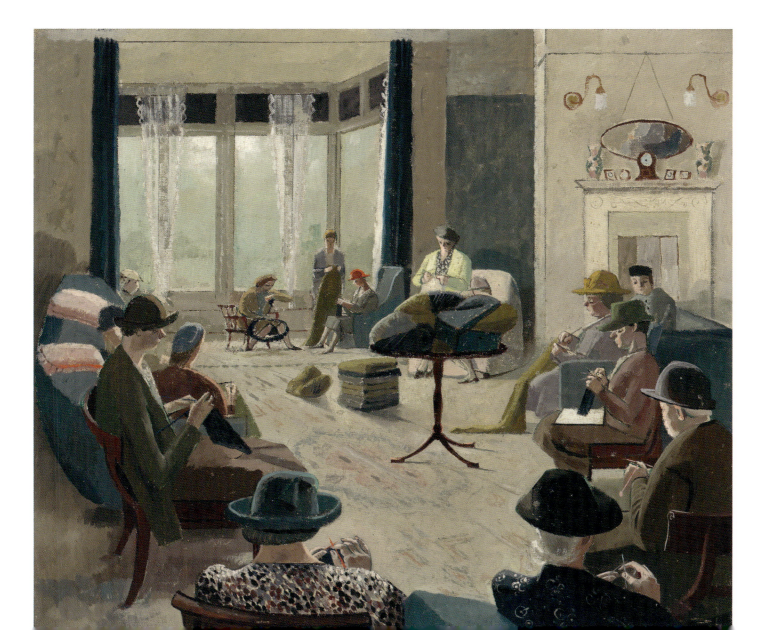

This quality of stark seriousness is found elsewhere in the WAAC's output – notably in the imagery of Air Raid Precautions (ARP) control rooms as produced by John Piper *(see p. 72)* and Eric Ravilious. Both artists were drafted in to draw ARP subjects early in 1940, but it took time for the Admiralty to release Ravilious from his work documenting coastal defences in Britain and, later, naval action in the waters off Norway (following the Allies' failed attempt to thwart the German invasion there). In the meantime, the long-feared bombardment of British cities had become a reality in September 1940, with the start of the Blitz. Ravilious was finally released from his navy assignment in May 1941, during the last month of the Blitz, so that he could work for the Ministry of Home Security. He was sent to its newly opened fire-control centre, situated underground at Whitehall.

The resulting series of drawings, such as *Wall Maps* (1941), are windows into a secretive world of teleprinter machines and quietly efficient control rooms. Ravilious was valued by the committee for his eye-catching textured watercolours, which employed elements of surrealism and exuded a kind of eerie modernism. He went on to work for the Air Ministry and was posted to Iceland in September 1942, after the island had been taken over by the Allies, but this would be his last assignment: within weeks he tragically disappeared, after failing to return from a reconnaissance flight.[24]

The Blitz was fertile territory for art. Outside Ravilious's world of underground control rooms, many artists and photographers were moved to depict the aftermath of the bombs' destruction, the emergency response and the people's efforts to take shelter. Such imagery would come to define the British home-front experience during the Second World War, for years to come. Henry Moore described the 'unreality of it all':

> In the daytime in London, I can't believe any bombs can fall, – the streets seem just as full as ever, with people on buses, & in the shops, going along just as usual, until you come across a slice of a house reduced to a mess of plaster, laths & broken glass, and on each side above it film sets of interiors with pictures in position on the walls & a bedroom door flapping on its hinges… its [sic] like being at the cinema… .

By contrast, Moore's night-time was 'another world – The noise is terrific & everything seems to be going on immediately over one's own little spot – & the unreality is that of exaggeration like in a nightmare'.[25]

›

Eric Ravilious, *Wall Maps* (1941)
Watercolour on paper, 397 x 522 mm

Ravilious's control rooms are reassuringly modern, brightly lit spaces. Possessing an air of quiet command, ethereal figures inhabit the interiors.

THE UNREALITY OF IT ALL: ART OF THE SECOND WORLD WAR

Drawings and paintings of the bomb damage flowed in to the WAAC, which favoured images of bomb-damaged public buildings and churches rather than people's homes. Expressing the theme of life carrying on amid the ruins was a way to address the circumstances of the Blitz optimistically; and the government was keen to promote an image of 'plucky' Britain both at home and to Allied and neutral countries. But there were exceptions. William Ware (1915–1997) sent *Fired City* (1942) to the WAAC for consideration, though he was surprised when the committee agreed to purchase it, remarking later that 'paintings of a wrecked city were less in favour than those of firemen, land army girls, and factory workers toiling cheerfully for victory'.[26] The artist, who was unfit for military service, would continue to spend his war years in London, painting scenes of the bomb-damaged city. Owing to the scarcity of paint, he had to grind his own pigments.

The Auxiliary Fire Service – which had been recruiting thousands of volunteers to assist the regular fire brigades since 1938 – contained a number of artists and designers who banded together as the 'Firemen Artists', exhibiting their work to raise money for the service. They included Leonard Rosoman (1913–2012), whose *A House Collapsing on Two Firemen* (1940), based on a scene witnessed during the course of his duty, appeared in the Royal Academy's *Fireman Artists* exhibition (1941). Although this forceful painting made Rosoman's name – and gained him the attention of the WAAC, which acquired it – he would later express some dissatisfaction with it as too literal an interpretation of his experience.

Leonard Rosoman, *A House Collapsing on Two Fireman, Shoe Lane, London, EC4* (1940)
Oil on canvas, 918 x 768 mm

In sealing this moment of flashback in paint, Rosoman creates a disturbing and powerful image of his experience during the Blitz.

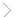

William Ware, *Fired City* (1942)
Oil on panel, 539 x 641 mm

Ware's painting is an unusually bleak yet striking example of the WAAC's collecting. Based on a sketch he made in East London, it shows the capital as unrecognisable amid the flames.

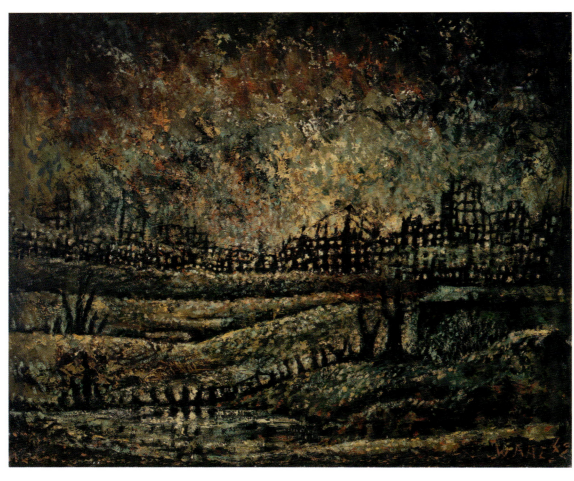

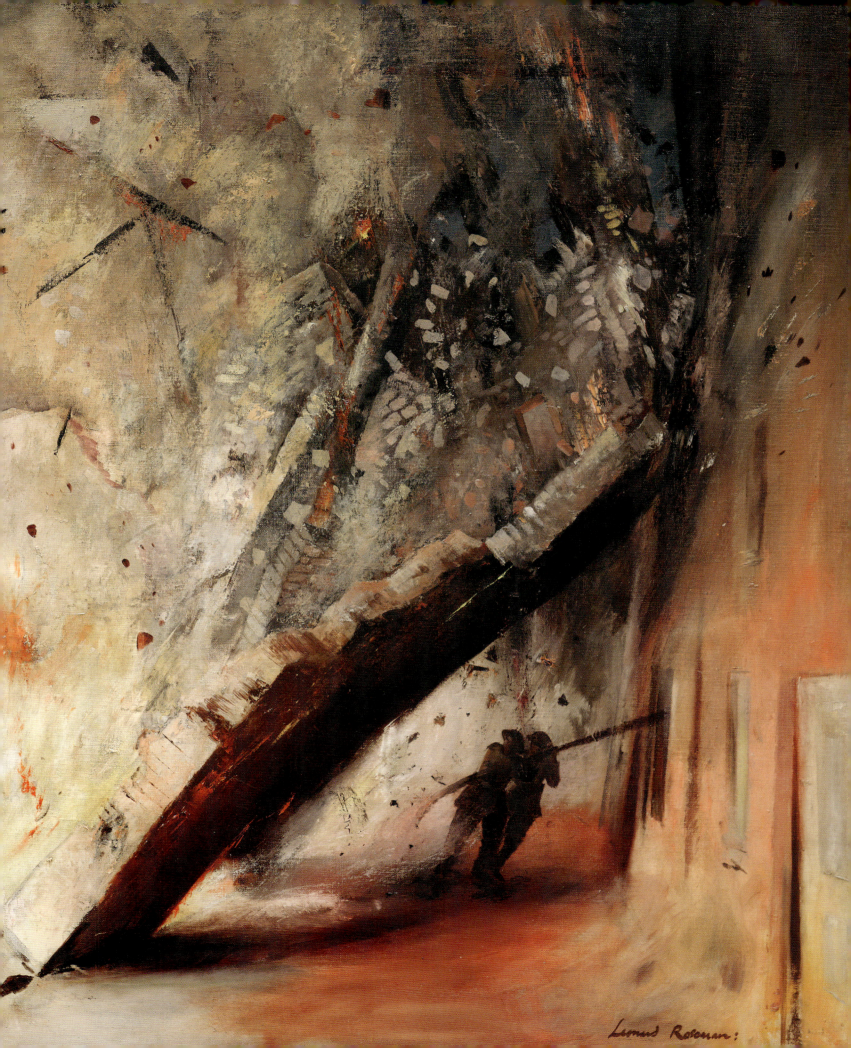

Graham Sutherland (1903–1980), another of Clark's favourite artists, was given a commission to depict the ruins of bomb-damaged London. Sutherland's work embodies trauma and emotion, symbolised in violence against buildings rather than against bodies. Hugely influential, he was at the forefront of a 1940s' resurgence of romanticism in art, inspired by the nineteenth-century painters William Blake and Samuel Palmer. Neo-romantic art connected to a tradition of English landscape art and was infused with a spiritual connection to living things. Its development and spread were directly related to the turmoil of the war – a time when the British art scene was cut off from European artistic developments. Sutherland and others gave English romantic art a twentieth-century twist, showing that it could be attuned to the built landscape under threat.

Away from the WAAC, many artists were finding innovative ways to depict their experience of the assault from the skies. Their works – distinctive and powerful – were personal, offering insight into how the threat from the air must have felt, and their art was produced away from the strictures of an official art scheme.

Graham Sutherland, *Devastation in the City: Twisted Girders Against a Background of Fire* (1941)
Gouache on paper, 368 x 457 mm

In this dark vision of strange, mangled forms, Sutherland presents man-made structural remnants as organic, like stems or leaves. His poetic interpretation of the subject influenced many British artists of the period.

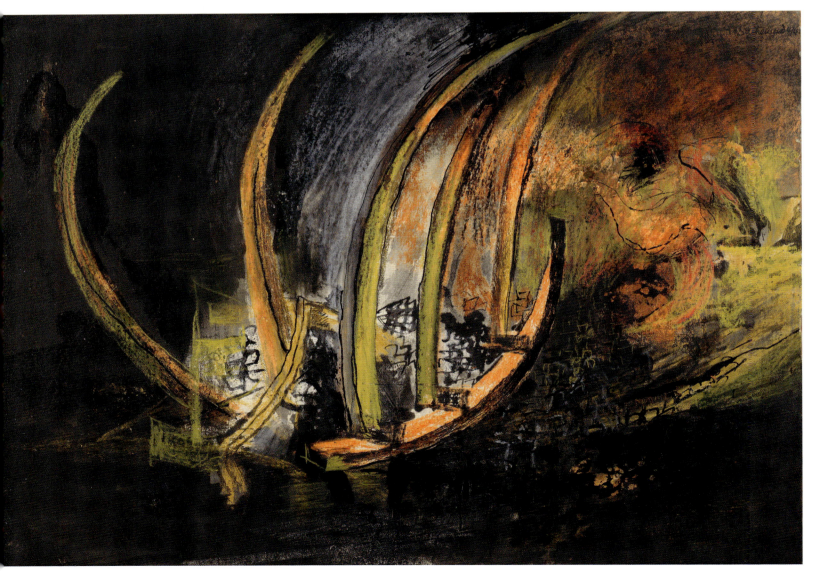

Keith Vaughan, *Echo of the Bombardment* (1942)
Watercolour, ink and crayon on paper, 318 x 464 mm

With its composition and tones reminiscent of Picasso's *Guernica*, this drawing presents an otherworldly street, devoid of any human presence. Instead, the creepy, coiled shapes seem to be the only life-form, adding to the drawing's latent sense of dread.

Examples of this kind of artwork were acquired by the IWM in later years as it sought to expand its collection: they include works by Keith Vaughan, John Minton, Edward Burra and others.

Keith Vaughan (1912–1977) served as a non-combatant attached to the British Army's Pioneer Corps after registering as a conscientious objector. He continued to draw, with some of his drawings of soldiers in barracks then purchased by the WAAC. Vaughan's *Echo of the Bombardment* (1942) is an emotional and arresting response to the experience of war, which demonstrates the influence of both neo-romanticism and surrealism on the artist's developing practice. The work formed part of a series entitled *Destruction of the Human City*, expressing the anxiety of living with the threat of air raids.

THE UNREALITY OF IT ALL: ART OF THE SECOND WORLD WAR

Following the war, Vaughan would share a studio with fellow artist John Minton (1917–1957). In 1941, Minton was awaiting the outcome of his own (ultimately unsuccessful) claim to register as a conscientious objector, while spending his nights roaming London's East End. One purpose in taking advantage of the blackout was to pursue discreet and – by the laws of the day – illegal sexual encounters with men, often walking downriver to Poplar, to meet 'sailors mostly' (in his own words); another was to find inspiration for his eerie drawings and paintings of the shattered landscape, such as *Blitzed City With Self-Portrait* (1941).[27]

Before the war, Edward Burra (1905–1976) had exhibited with the English surrealists and travelled widely, including to Spain in 1936, where he had witnessed the ruins and anarchy of the Spanish Civil War. His experiences had a profound effect on his art, but rather than take political sides he depicted the human impact of war and began to use bird-like forms to convey the macabre and the absurd. He had suffered from ill health since childhood and found that working in watercolour, seated at a table, suited him best. Unsurprisingly, during the Second World War Burra was not deemed fit for war service. Instead, he lived in his hometown of Rye, where he witnessed aerial attacks on the radar stations along the English south coast. In *Blue Baby, Blitz Over Britain* (1941), Burra created an embodiment of that aerial threat by way of a monstrous figure, – and it is perhaps revealing of 1940s' cultural attitudes that a large and wild female body becomes, here, a malevolent force. The artist's influences also harked further back in this version of the classical harpy, the creature from Greek mythology that is part-bird, part-woman.

John Minton, *Blitzed City With Self-Portrait* (1941)
Oil on board, 305 x 400 mm

A rare work in oil by this artist, this image remains typical of Minton's highly personal output during this period, reflecting his double life and expressive of his sense of alienation, shame and his melancholic state of mind.

Edward Burra, *Blue Baby, Blitz Over Britain* (1941)
Watercolour and gouache on paper, 688 x 1016 mm

Burra was influenced by earlier painters such as Hieronymus Bosch, whose depictions of the afterlife featured demonic human–animal hybrids. While *Blue Baby* borders on the ridiculous in both name and form, it remains a terrifying and powerful image.

Julian Trevelyan (1910–1988) had also exhibited at the *International Surrealist Exhibition*, and he was active in the Artists' International Association. While awaiting his call-up in London during the summer of 1940, Trevelyan produced an extraordinary series of paintings full of grotesque imagery, which expressed despair at the advance of fascism. *Premonitions of the Blitz* (1940) – an example from this series – is an emotional and instinctive painting, which speaks of the effect of living under the threat of annihilation. (Trevelyan would go on to serve as a camouflage officer and was sent to the Middle East via Nigeria, where he produced some drawings of West African life that were accepted by the WAAC.)

A different effect of war on the home front – the numbness and fatigue – was captured by William Scott in his painting *Soldier and Girl Sleeping* (1942). A graduate of the Royal Academy, Scott (1913–1989) was at an early stage in a promising painting career when the outbreak of war forced him and his wife to leave France. By 1942, Scott had decided to volunteer for the Royal

Julian Trevelyan, *Premonitions of the Blitz* (1940)
Oil on canvas, 385 x 510 mm

Trevelyan's intention was to express the anxiety of people living in the East End of London during the summer of 1940. He was influenced by Mass Observation, a social research project founded in 1937. Through volunteer diarists, the study recorded people's behaviour and conversations across Britain to create 'an anthropology of ourselves'.

William Scott, *Soldier and Girl Sleeping* (1942)
Oil on canvas, 409 x 508 mm

Scott's overriding impressions of the war – as a bleak and exhausting time, with long periods of crushing boredom – are distilled into this tender scene.

Army Ordnance Corps. Based in London, and away from the family home in Somerset, he was able to draw and paint in his spare time, producing works that reveal the pervasive influence of Graham Sutherland and the neo-romantic tendency. Around him, Scott saw 'people asleep everywhere. It was one of the things about the war. It was like a kind of neurosis. Young soldiers especially were constantly asleep.'[28]

Despite Scott's approach to the WAAC, the committee did not take an interest in his work, although it appears that Kenneth Clark intervened in 1944 to recommend the artist to the map-making section of the Royal Engineers in North Wales – where many other artists and designers were stationed. There, Scott produced several drawings and watercolours of his fellow servicemen, some later acquired by the IWM.

The sight of people taking shelter underground – both in the London Underground and in other locations – was an intriguing and moving subject for artists and photographers. Together with newsreels, such imagery did much to establish the 'myth of the Blitz', the idea that shared hardship brought out the best in people, creating new communities who helped each other out. This narrative was encouraged by a government anxious about the possibility of class conflict, for it was in working-class areas such as the docklands of East

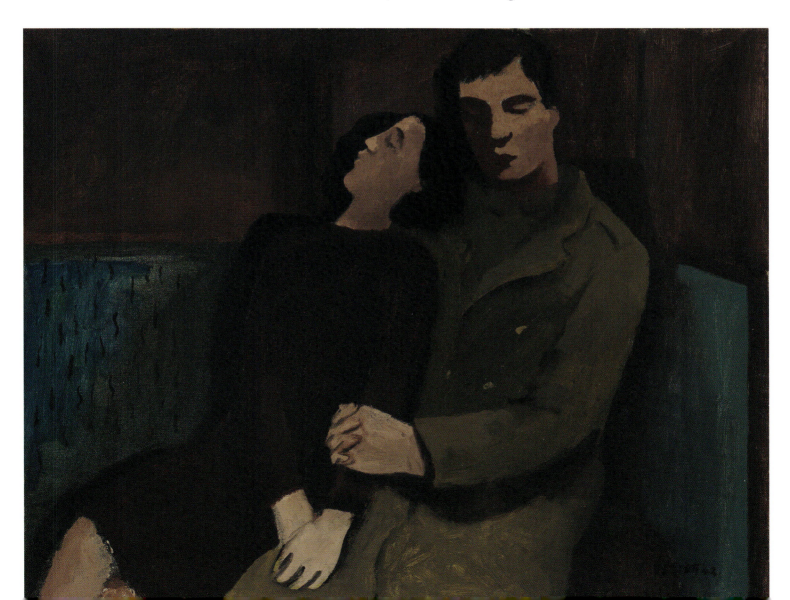

London where so many of the bombs fell, inflicting disproportionate damage and suffering on some of the nation's most deprived communities. Blitz imagery accordingly dwelled on Londoners' optimism and resilience in the face of hardship and danger, with newspapers running human-interest stories centring on East Enders' stoicism and 'Cockney' good humour.[29]

In reality, only a small proportion of city-dwellers took shelter underground, while others used their own private shelters (such as the corrugated 'Anderson' ones erected in gardens) or local communal ones above ground; some people even trekked out of the cities at night, while others took no special efforts to seek shelter or safety. None of these other responses to the bombing offered the same potent interpretative opportunities as the underground shelters did, so they were not covered by WAAC artists.[30]

Edward Ardizzone (1900–1979) was best known for writing and illustrating children's books such as *Little Tim and the Brave Sea Captain* (1936) when the WAAC chose him, in 1940, as a full-time war artist. On the face of it, it was an unlikely selection. But Ardizzone's images humanised aspects of the war, resonating with many people when they were shown. His light-hearted scenes, such as *In the Shelter* (1940), remained believable and recognisable, and they managed to diminish the more squalid and terrifying aspects of sheltering underground.

The series of *Shelter* drawings by Henry Moore, inspired by scenes in the London Underground, are probably the most well-known artworks of the whole of the WAAC's collection. Moore (1898–1986) was a British Army veteran of the First World War, who, post-war, decided to embark on a much more hopeful and creative path, using his ex-serviceman's grant to study art. By 1940, he was already gaining a reputation as one of Britain's leading avant-garde sculptors, when his studio in Hampstead, North London, was damaged during an air raid; he and his wife Irina moved out to Hertfordshire, and he switched his attention from sculpture to drawing. Moore made frequent visits back to the capital, where, while making his way home one evening, he was profoundly moved by the sight of people bedding down on a station platform. Finding this scene especially heart-breaking, he began to draw the shelterers discreetly in his sketchbook. A WAAC commission followed, with the result that the *Shelter* drawings quickly became a huge success, propelling Moore to a new level of fame nationally but also internationally. His drawings have both modern and timeless qualities, which meant that they went beyond the specifics of their wartime London context. Moore's imagery expresses something far more universal about humanity's dark struggles and the need to cope in adversity.

Edward Ardizzone, *In the Shelter* (1940)
Watercolour and ink on paper, 260 x 323 mm

Despite his fluency in drawing, Ardizzone rarely sketched at the scene, preferring to rely on notes and memory. His shelter drawings are an exception, as in this, a typical example of the artist's affectionate and gently humorous treatment of the subject.

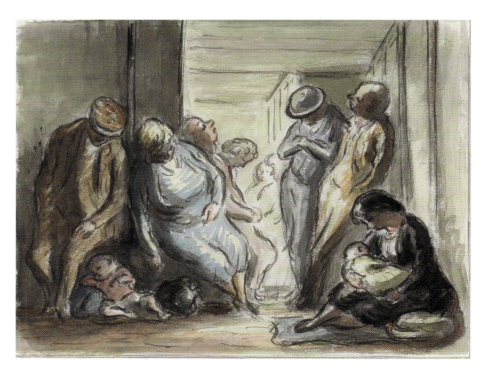

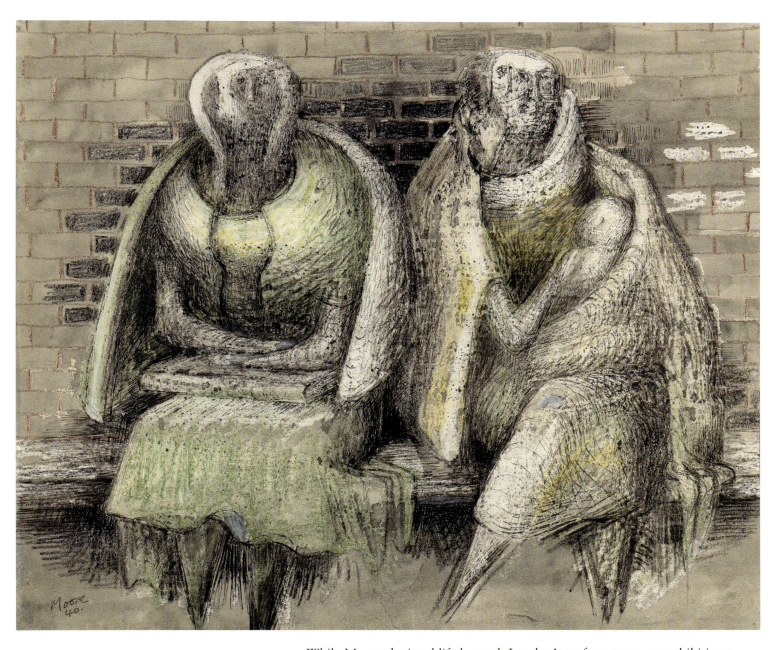

Henry Moore, *Two Women With a Child in a Shelter* (1940)
Pencil, conté crayon, wax crayon, ink and watercolour on paper, 350 x 400 mm

Loath to impinge on people living through such hardships, Moore made all his *Shelter* drawings later, from memory. He mostly drew women and children, figures who embody dignity and stoic endurance, forming a theme to which he would return in his sculpture of the 1950s.

While Moore depicted life beneath London's surface, some art exhibitions were even held underground – notably in the basement of the John Lewis department store on Oxford Street, which had been adapted to serve as a bomb shelter early in the war. By 1943, the store above was still partially ruined from bomb damage; but below, the Artists' International Association installed a group exhibition entitled *For Liberty*. More activist than the WAAC, the AIA continued to support artists and passionately oppose fascism in the belief that beyond merely recording the war effort, art could also vividly express the reasons for continuing to fight.

Among the assembled works, a remarkable painting entitled *Lama Sabachthani?* (1943), by Morris Kestelman, was given a prominent position. Kestelman (1905–1998) had studied at the Royal College of Art and designed theatrical costumes and stage sets before the war. The son of Jewish

immigrants from Russia, he had grown up in Whitechapel, in East London, and was part of a community who were far more alert to the reports of the violent persecution coming from Europe than were many others in British society at the time. His painting is a rare British response to news of Nazi atrocities against Jewish people. Although intelligence about mass killings had filtered through by 1942, and reports had begun to circulate in Britain, images of the extermination camps had yet to emerge. It is striking that Kestelman's interpretation anticipates such imagery. The artist also explicitly foregrounds the anguish and torment of the Jewish people, imagining them desperately appealing to God in utterly godless circumstances.

At the time of the *For Liberty* exhibition in 1943, the WAAC had already begun sending artists out of Britain to cover various fighting fronts – although it would be another two years before its artists would witness the grim reality of the Nazi concentration camp system at first hand. Many of the 36 full-time artists given long-term contracts were sent on various assignments, including overseas. The committee often favoured illustrators for its full-time positions, for practical reasons: drawings and watercolours could be made quickly and more or less *in situ* and were easily transportable. In the effort to cover some of the war's many and far-flung fronts, a handful of these artists travelled extensively. Their treks, hardships and encounters followed the well-worn paths of previous generations of Western explorers in foreign lands.

Only the WAAC's male artists were officially allowed to travel during the war's duration, and they welcomed their overseas commissions as the chance of a lifetime. 'I want to take this opportunity for thanking the committee for all their kindness and consideration towards me,' began Anthony Gross, reflecting in 1946 about his own 'terrific experience'. He continued: 'Seldom could an artist, tied down to his studio, to his habits, his regular haunts of landscape and holidays imagine himself transported by a governmental magic carpet all over the world!'[31]

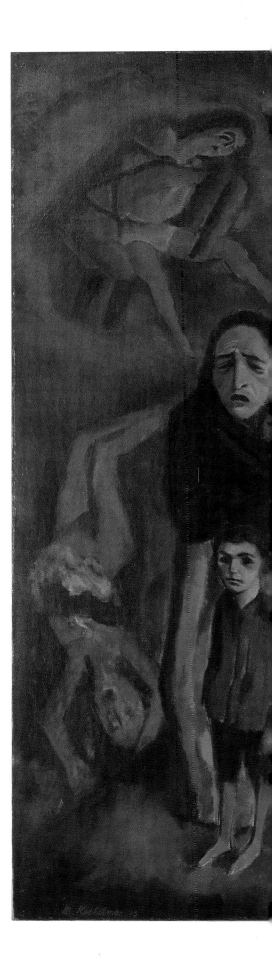

>

Morris Kestelman, *Lama Sabachthani?* (1943)
Oil on canvas, 1,170 x 1,530mm

The title is taken from Psalm 22 in the Old Testament, and it translates as 'Why have you forsaken me?'. Kestelman evidently saw profound resonances in the psalm; other lines read: 'a company of evildoers encircles me. My hands and feet have shrivelled; I can count all my bones.'

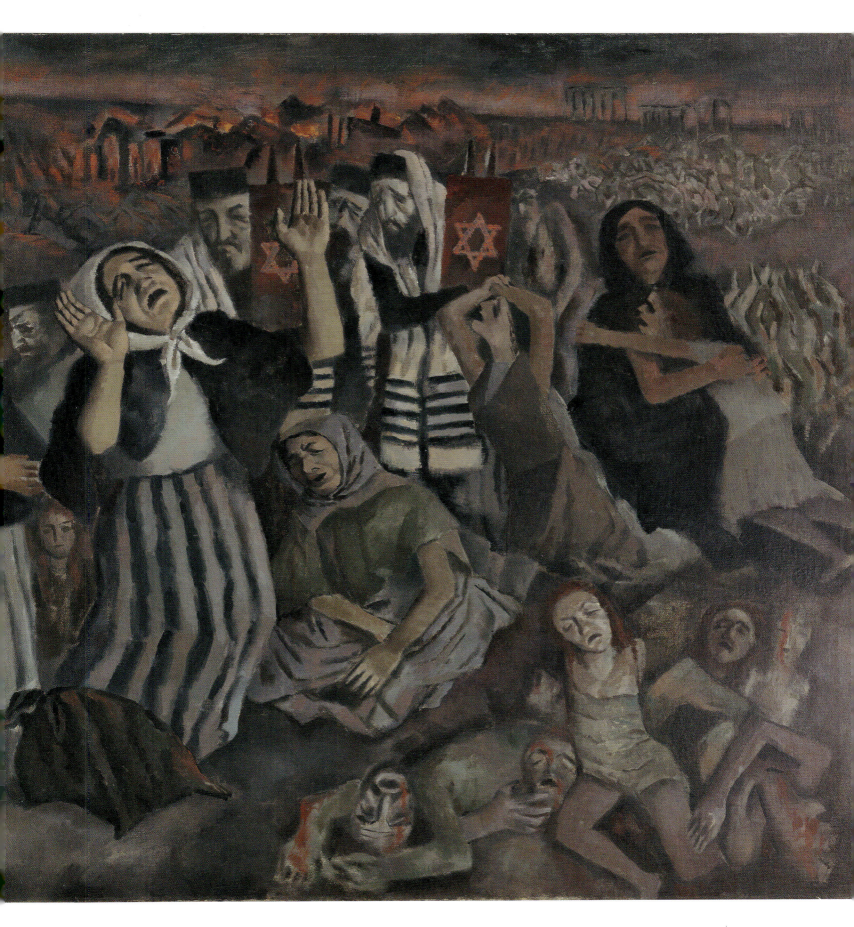

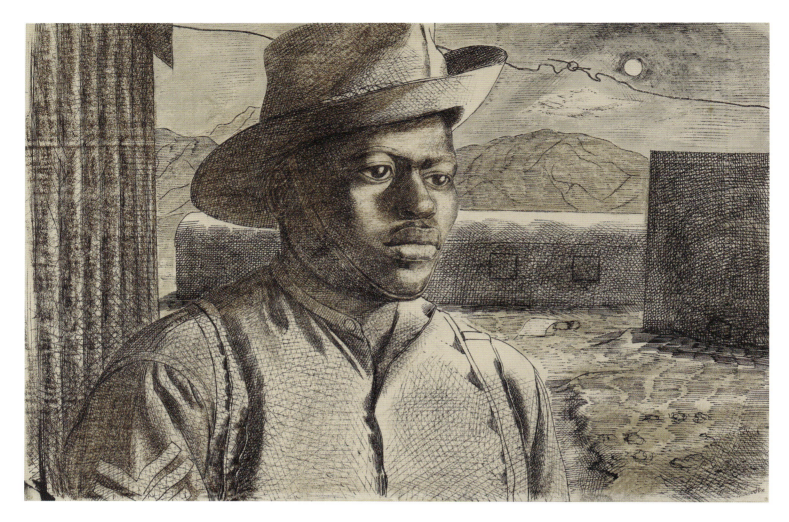

Among this group, three artists – Anthony Gross, Edward Ardizzone and Edward Bawden – had all started working for the WAAC in 1940, and they would become the committee's most prolific artists, producing more than 350 artworks each over the course of the war. Ardizzone and Bawden were both present at the evacuation of Dunkirk; following their return home they were redeployed. In August 1940, the WAAC sent Bawden to the Middle East Command, which was charged with responding to enemy attacks on British colonies and interests in North Africa and regions around the eastern Mediterranean. Uninterested in home-front subjects, Bawden was delighted; his first stop was Cairo, before travelling to Khartoum in Sudan at the end of the year. Meanwhile, Ardizzone stayed in Britain drawing bomb shelters and the activities of the Home Guard, until he was sent out to replace Bawden, joining Gross in Egypt in 1942.

Bawden (1903–1989) was a close friend of Eric Ravilious, whom he had met at the Royal College of Art, where they were taught by Paul Nash. Both artists had enjoyed some success before the war, often working together, in mural painting, watercolour painting, printmaking, design and book illustration. But they had very different experiences as war artists. Bawden spent almost the entire war overseas, travelling much more extensively than Ravilious was ever able to: to Egypt, Sudan, Ethiopia, Eritrea, Lebanon and Iraq, drawing

Edward Bawden, *Sergeant Samson: 1975th Bechuana Coy, 64 Group, Army Auxiliary Pioneers Corps, near Ideide, Lebanon* (1942)
Ink and wash on paper, 462 x 645 mm
Bawden's portrait of Sergeant Samson is haunting and meticulously observed, seemingly made at the end of a long day's physical labour.

landscape, architecture and group encounters. The people he met, of different ethnicities, proved irresistible subjects, and Bawden broke new ground artistically, turning for the first time to portraiture. He travelled to Lebanon in 1942, the year after it had been wrested from the Nazi collaborationist control of Vichy France. At this point, the British had organised the arrival of the Colonial Pioneer Corps, who built defences, roads, bridges and railways, and Bawden drew portraits of the soldiers from Bechuanaland (now Botswana), including *Sergeant Samson* (1942).

Influenced by a new generation of travel writers like Freya Stark and Robert Byron, Bawden reflected those writers' fascination and admiration for people living under colonial rule. Their work went some way to countering previous stereotypes of savagery and indolence.[32] As Bawden wrote to the WAAC:

> Native life does interest me a very great deal, & for choice I would rather be with Africans, Indians or living alone in a reed hut in the heavy, steamy malarial heat of Sheikhdom than in the improvised, unprofessional discomfort of an English troops camp, where our ridiculous sense of humour & too-frequent use of a common expletive are needed in order to put up with conditions which with a little care & thought could be easily improved. Natives without exception have better manners; the man from the Punjab or Bechuanaland is a gentleman.[33]

If Bawden's writing betrays a romantic, idealised – and colonial – attitude towards the people he encountered, his portrayals nevertheless emphasised their individual humanity.

Wherever he went, Ardizzone continued to draw on the lighter side of life during his travels in France, Belgium, North Africa, Italy and Germany. He often illustrated gently humorous social interactions to connect home audiences to his experiences. Confronting the worst of the war was not his natural inclination: 'must try and make some drawings of the horrors but don't want to,' he told himself, while travelling through Sicily in July 1943.[34] The sheer dynamic nature of events could be a problem, too: in another diary entry, he bemoaned the 'maddening war', where 'only the dead and dying stay still enough for you to draw'.[35] A gregarious and upbeat soul, albeit with a dark streak of humour, Ardizzone chose not to draw what he could not comprehend, and he instinctively turned to the theme of coping in adversity, time and again.

The wartime output of Anthony Gross (1905–1984) covers most of Britain's theatres of operations from the early home front to, in victory, the Allied occupation of Germany in 1945. He created visually harmonious compositions of crowd scenes and vistas, using colour to convey his locality: while Britain was brown, grey and navy blue, his convoy series, made at sea, was predominately grey and blue. His palette in North Africa and the Middle East comprised mainly ochres, and in Burma (modern Myanmar) he used luscious greens, yellows and browns.

The WAAC's coverage of the activities of Britain's armed services was not comprehensive. Instead, it prioritised subjects judged compelling or relatable for its potential audiences.[36] It took the committee time to respond to events in the Far East. Finally, the WAAC chose Gross, in 1943, as its first artist to travel to the region, following the devastating losses of the British colonies of Hong Kong and Singapore to Japanese forces the previous year. He arrived in colonial Burma when British and Indian forces were struggling to expel the invading Japanese Army. Part of Gross's brief was to present a picture of unity between British and Indian troops at a time in India of growing calls for independence and opposition to the war. While not many of the drawings show the two nationalities working side by side, Gross was adept at group portraiture, as in scenes of the *Battle of Arakan* (1943). His work noticeably developed from employing mainly blank masses of faces, at the start of his war artist journey, to a much more expressive and detailed rendering of faces that showed evident war fatigue, and which exhibited tense group dynamics,

Anthony Gross, *Battle of Arakan, 1943: Men of the 7th Rajput Regiment Resting on South Hill With a Parasol Captured Near the Mayu River on the Rathedaung Front* (1943)
Ink and wash on paper, 485 x 635 mm

The drawing suggests a calm aura of familiarity between the artist and his subjects. Gross wrote that, according to the officer, the parasols had belonged to the 'geisha girls' accompanying the Japanese troops.

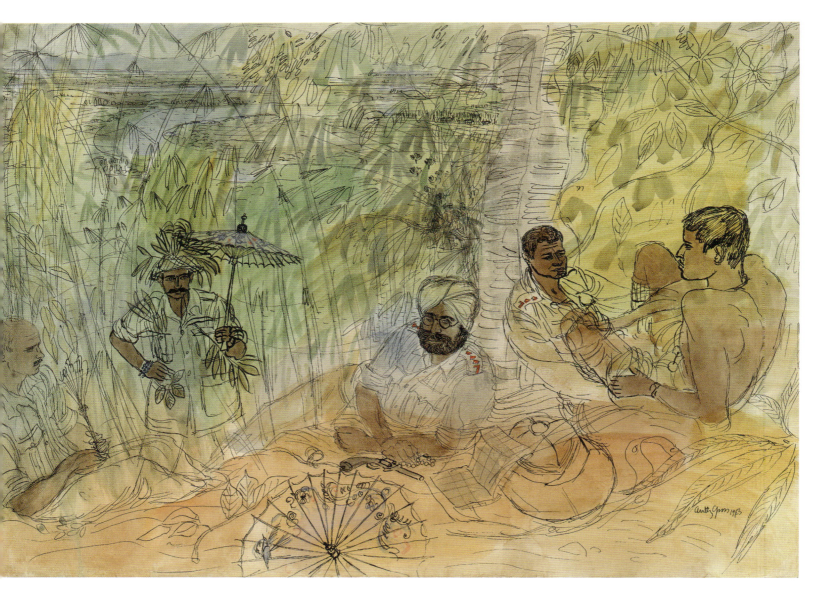

112 VISIONS OF WAR: ART OF THE IMPERIAL WAR MUSEUMS

towards the end of his WAAC assignment. On 18 November 1943, the WAAC opened an exhibition of Gross's works entitled *India in Action*, at the National Gallery. The only solo exhibition given over to one of their artists, it went on to tour Australia, New Zealand and the United States.[37]

As with many men of their generation and class, the WAAC artists on foreign wartime assignments approached their task with a good humour that either instinctively veered away from the horrors of the war (Ardizzone) or attempted to address the subject with a kind of professional detachment (Gross). They portrayed British relations with the peoples of the countries they visited as a series of friendly or pragmatic alliances. While their background and worldview, not to mention the nature of their work for the WAAC, would have made it difficult to make reference to the implications and power dynamics of empire and colonialism, Bawden's output does at least suggest a developing ambivalence among British artists and writers towards colonised people. And collectively, the work of the WAAC's travelling artists underlines just how vast and far-reaching both the war and the British Empire were.

Portraiture was a popular genre for the WAAC; it was a way to build a picture of the 'people's war' that focused on individual heroism or ingenuity.[38] The committee's approach to portraits differed from that taken in the First World War, in that now named individuals were portrayed rather than generalised 'types'.[39] This emphasis on individuals, as demonstrated in the works of Bawden and Gross, gave distant theatres of war a human face, making it easier for visitors to the WAAC's touring exhibitions, in Britain and Australia, to relate to these topics. Many portrait artists were commissioned, including William Coldstream (1908–1987), who travelled to Italy and Egypt, where, despite his slow and painstaking technique, he completed several portraits of Indian soldiers. At home, Eric Kennington produced portraiture for the Air Ministry in the form of an unabashed pantheon of heroes, at least until his resignation as a war artist in August 1942: he felt that the WAAC was not making full use of his works for propaganda.[40]

As well as sending its home-grown artists abroad, the WAAC was considering another way to represent the global nature of the war and the empire. In June 1941, the committee discussed a scheme for collecting war art by non-European artists living in Britain's colonies, feeling 'that the political significance of the scheme should be considerable'.[41] Accordingly, the WAAC approached the Colonial Office in London to spread the word, and an initial approach went out to the colonial governments in Jamaica, the Gold Coast (now Ghana), Uganda and Nigeria, 'to encourage the depicting of any activity in connection with the Colony's war effort'. Suggested subjects included 'the raising and training of troops, the manufacture of war materials or the production of supplies, including food supplies'. The project had its own name: the 'Scheme for the Preservation of Pictures Recording the War Effort of the Empire', or, more concisely, the 'Native-born Colonial Artists Scheme'.[42] Devised before the United States' entry into the war on the Allied side, the scheme was an acknowledgement of the important contribution of empire to the British war effort: these four countries alone provided hundreds

of thousands in terms of manpower, not to mention natural resources and financial support for the war.[43]

Although largely ignorant of the artistic practices in these places, the WAAC was nevertheless quite prescriptive. It was concerned lest 'some academically-minded local resident' might think that 'an imitation of a second-rate European art was better than a picture characteristic of the native-born artist'.[44] The WAAC suggested the subjects to be depicted, and it stipulated that artists should use techniques 'typical of the locality'; but, paradoxically it did not want three-dimensional art in regions where wood carving was the predominant traditional artistic practice. This was in line with its overall preferences, for although at home Jacob Epstein was successfully commissioned to sculpt politicians and military leaders, sculpture was otherwise only very rarely commissioned or collected by the WAAC.

For the Gold Coast, the WAAC thought that it had found a good local arbiter of the right type of art in Herbert Vladimir Meyerowitz, someone 'eminently suitable to conduct an undertaking of this kind'.[45] Meyerowitz was a German émigré artist whose enthusiasm for traditional West African wood carving had brought him to the Gold Coast, where he taught at an elite boarding school. European colonialism in Africa had led to a decline in traditional art. In Uganda for example – a British protectorate since 1894 – European missionaries had first arrived in the 1870s, whereafter they had excluded traditional arts from their schools and forced converts to destroy such artefacts before they were allowed into the Church. Meyerowitz initiated a renewal of training in traditional African arts and crafts, and clearly he had made a name for himself as far away as London.[46]

Unfortunately, the plans unravelled. The WAAC had not fully grasped Meyerowitz's findings, which he summarised in November 1943: 'no tradition of representational painting exists in the Gold Coast'.[47] He was willing to hold a competition, as the WAAC suggested, to find artists – but it is not clear whether this ever happened. Although the call-out was circulated to more colonies, the only other government to take an interest was in Ceylon (now Sri Lanka). Artworks were eventually submitted from Jamaica, Uganda, Nigeria and Ceylon, but the committee was generally unimpressed with them and selected very few. The project was beset with mishaps, indicative of its slow and complex administration, and of the practical difficulties of getting the art to London. Works by Nigerian artist Ben Enwonwu, who is now regarded as a pioneer of African modernism, went missing in transit to London; and the committee passed over works by Albert Huie, an artist known today as the 'father of Jamaican painting'.

The scant detail in the WAAC's surviving file about this scheme's artworks makes clear a lack of interest, as summed up by the committee's secretary, who described the Ugandan drawings as 'akin to contemporary children's'.[48] The project fizzled out, with the MOI advising the Colonial Office: 'the War Artist's Committee do not feel that the pictures are of sufficient interest to warrant holding a small exhibition nor are they of sufficient artistic merit'.[49] What the

Gregory Maloba, *The King's African Rifles in Camp* (1941)
Watercolour on paper, 457 x 581 mm

Maloba's drawings for the WAAC were made at an early stage of his artistic development. Influenced by Jacob Epstein, among others, he went on to become Uganda's first professional sculptor, creating Kampala's bold, modernist independence monument in 1962.

committee members could not grasp was that it would have been impossible for trained artists in colonial countries to set aside what they knew of Western art and the European tradition. There was no such thing as a 'pure' traditional African art, untainted by colonialism. Moreover, many of the artists were young, and some still at school where colonial art education did not progress beyond secondary level; and they were trying to satisfy the criteria of a far-away committee panel they did not know, through intermediaries.

In fact, the scheme's small collection of 16 paintings and drawings includes the early work of some of the most significant modern artists in their respective countries. Indeed, in Nigeria and Uganda, the post-war (and post-colonial) modernist movements would show how artists had absorbed all their cultural influences and fused them together to take their art forward.

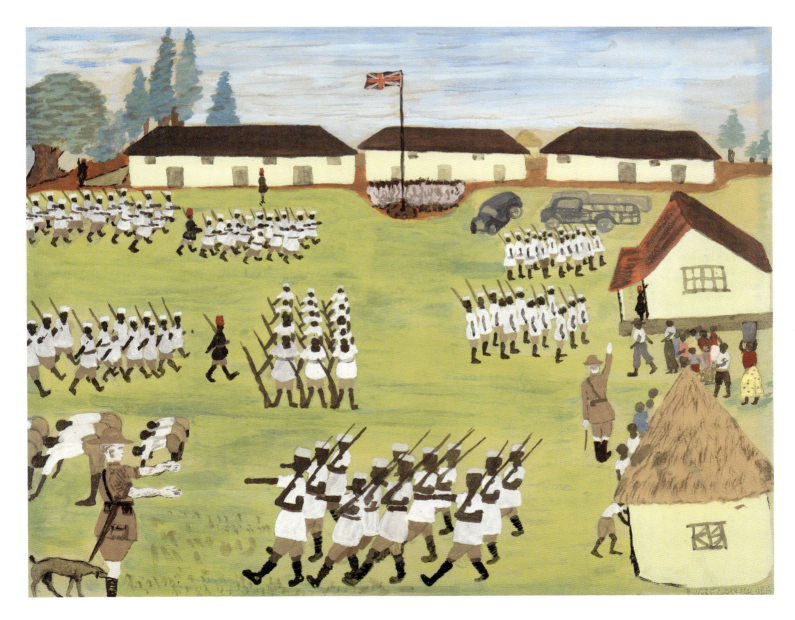

THE UNREALITY OF IT ALL: ART OF THE SECOND WORLD WAR

Kenyan-born Gregory Maloba (1922–2007) was just 19 years old and already showing great promise as a sculptor when he took part in the scheme. He and the other students at Kampala's Makerere College painted subjects chosen by Uganda's colonial governor, Charles Dundas – subjects of the type they would have seen in MOI propaganda films, as they had no direct experience of the war themselves.[50] The WAAC chose three of Maloba's watercolours for its collection, including *The King's African Rifles in Camp* (1941). In Nigeria, Akinola Lasekan (1916–1972) had been working as a textile designer and book illustrator, while taking courses in fine art. He established his own art school in 1940. In 1944 he became Nigeria's first political cartoonist under the pen-name 'Lash', in which capacity he ridiculed failings of the colonial system for the *West African Pilot* newspaper. His work *A Reflection on the Savings Week in Lagos* (1942) shows some of his humorous streak. Its thoughtful-sounding title sits in contrast with the rather festive image of Nigerians dancing in the street and holding a banner urging people to 'Kill Hitler with Nigerian Savings Certificates'.

The WAAC selection from Jamaica was another lost opportunity: only three works were chosen, one by an English artist (John Wood) who happened to be there at the time, and two relating to food production by T V Ferguson, a little-known painter. Jamaica's modern art movement was in its infancy too, but it would soon grow and flourish in the post-war years. The situation with Ceylon was very different. In the colony's capital, Colombo, there existed the '43 Group – a disparate cluster of artists committed to freedom of expression, who were pushing for their own form of modernism. The group was named after the year in which it was formed – the same year that the artists made their paintings for the WAAC – and its members were generally more established in their careers than were their African and Caribbean counterparts. Stylistically, they were attempting to break free from a rather stifling and derivative style of Victorian orientalist art that was widely practised in the colony.[51] The committee acquired works by George Claessen and Ivan Peries (1921–1988), a founding member of the group.

While the colonial artists scheme was quietly wrapping up, in 1943 the fortunes of war were changing. Following their victory in North Africa, the Allies invaded Italy, as Soviet forces were gaining ground in the East and US forces moved ever closer to Japan. Against the backdrop of its relentless

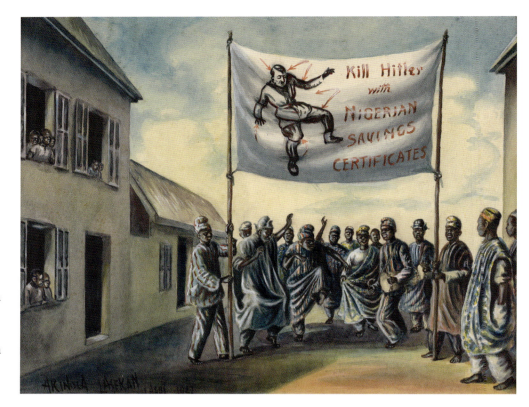

Akinola Lasekan, *A Reflection on the Savings Week in Lagos* (1942)
Watercolour on paper, 203 x 260 mm

Lasekan's satirical eye is evident in this work. He later became one of Nigeria's foremost modern artists, using European realist painting techniques to depict scenes of Yoruba legends.

Ivan Peries, *Combined Control and Report Centre* (1943)
Oil on canvas, 825 x 625 mm

Peries's painting is bold, modernist and faintly surreal. The subject, of women control-centre workers overseen by a man at a desk, projects a sense of cross-cultural cooperation that would have appealed to the WAAC.

116 VISIONS OF WAR: ART OF THE IMPERIAL WAR MUSEUMS

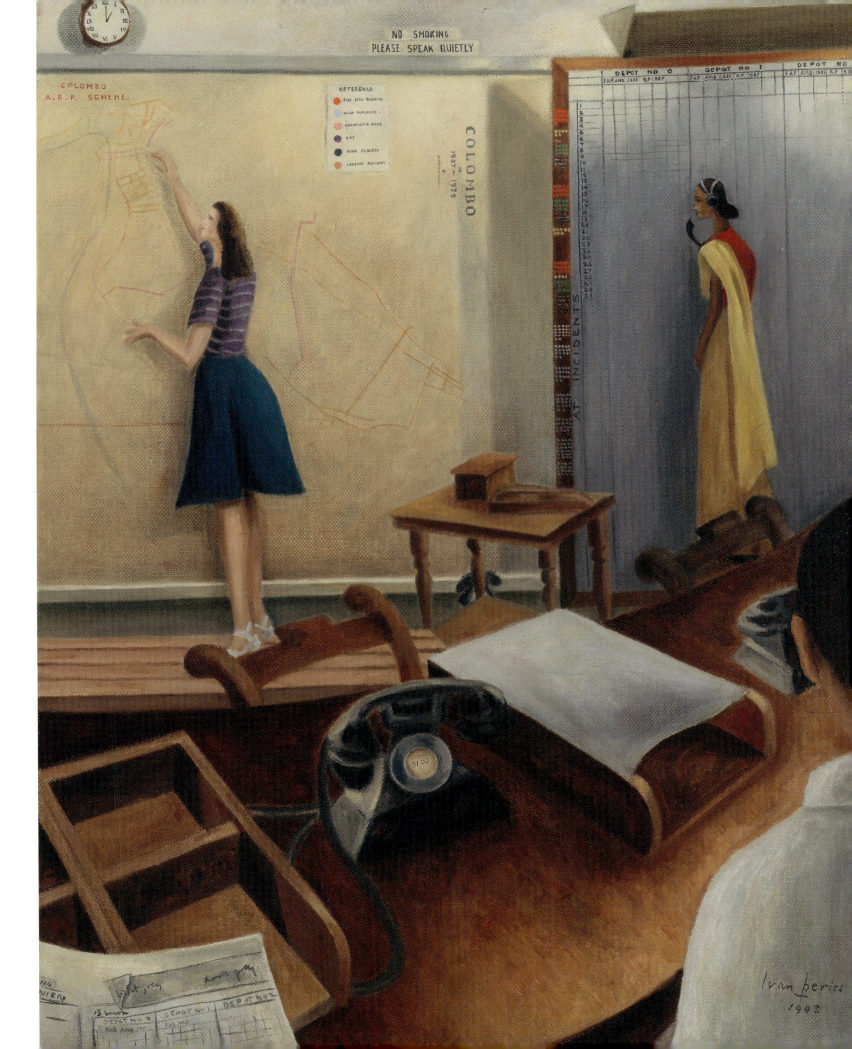

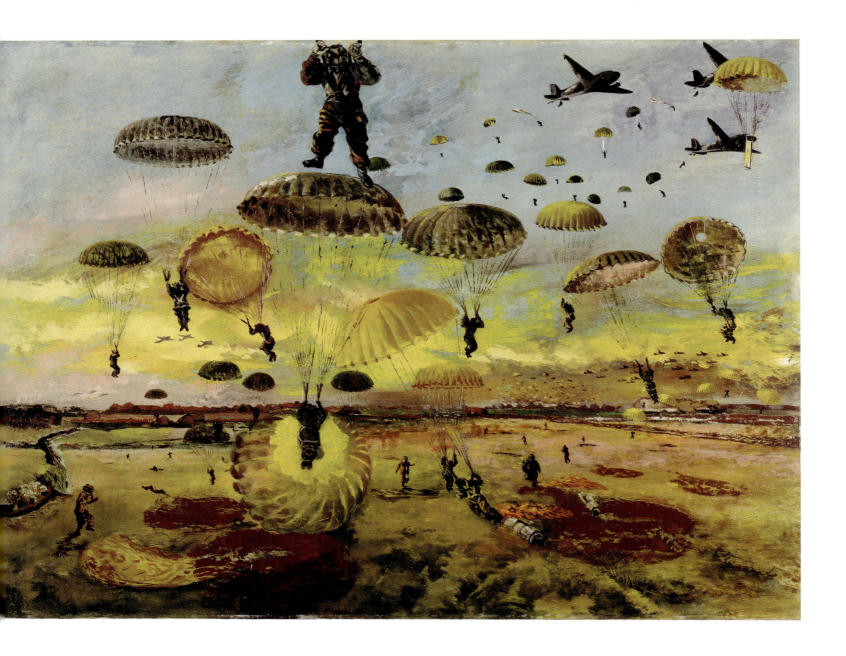

bombing campaign against Germany, the Allies started preparing for the liberation of France and a new front against Hitler, starting with 'D-Day' on 6 June 1944.

In May 1944, the WAAC selected Thomas Hennell, Edward Ardizzone and Barnett Freedman to paint 'coming events'.[52] All three made it to Normandy in June to draw aspects of the D-Day landings, while Richard Eurich arrived the following month to research his panoramic canvas *Preparations for D-Day* (1944). Albert Richards (1919–1945) was also working for the WAAC, on a special contract that allowed him to stay in the Parachute Regiment.

During his training in the lead-up to D-Day, Richards painted *The Drop* (1944). He was a promising young artist who had been called up only three months into his studies at the Royal College of Art. After being parachuted

Albert Richards, *The Drop* (1944)
Oil on panel, 549 x 752 mm

Richards was a promising but little-known artist who was given a platform by the WAAC to depict action as he experienced it on the frontline. Here, he produced a dramatic vista of the Parachute Regiment drifting down from the skies at sunset.

Thomas Hennell, *Pioneers on a Frozen Road at Kapelle near Goes, Zeeland* (1945)
Watercolour on paper, 314 x 478 mm

Hennell was admired by fellow artists Bawden and Ravilious for his distinctive and methodical approach to watercolour. Hennell's figures are often ghostly or transitory; for him, the landscape was always the main attraction.

into France on D-Day, he continued to draw and paint his experiences as he made his way through France and the Low Countries. Sadly, Richards did not manage to see the war out, for he was killed on 5 March 1945 near Gennep, in the Netherlands, after driving over a landmine.

Following his experiences in Normandy, Thomas Hennell (1903–1945) made his way north through Belgium to the Netherlands, where he painted *Pioneers on a Frozen Road at Kapelle near Goes, Zeeland* in January 1945, a work that demonstrates his easy ability to enliven a scene with light and texture. Hennell was known as a watercolour painter of English rural life. He successfully turned his technique to the new landscapes he encountered on his wartime travels, first in Iceland in 1943 (replacing his friend Eric Ravilious following his disappearance), then in Normandy and Belgium, and eventually much further afield. He took to his role as a war artist with enthusiasm and purpose, despite previously suffering from mental health issues involving some years in an asylum.

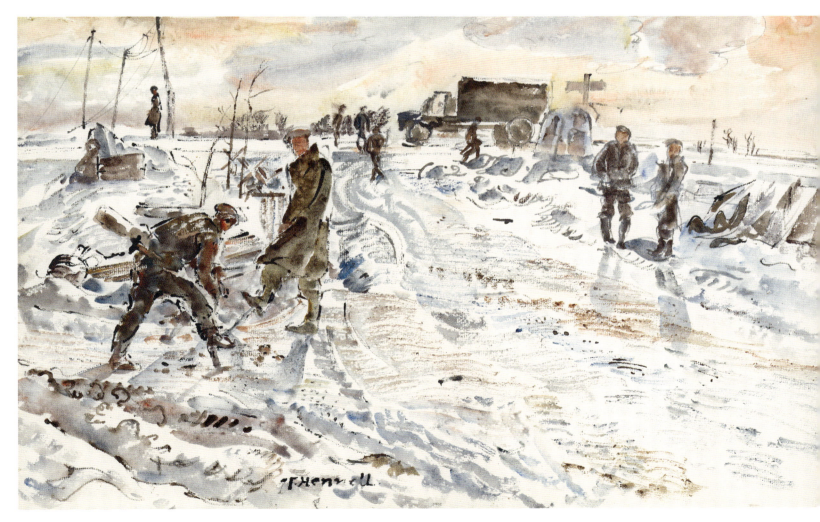

The last months of war in Europe brought liberating armies into direct contact with the physical remnants of the concentration-camp system. As their effort pressed forwards, Allied soldiers discovered places that were often desperately overcrowded with prisoners after their captors had forced them back deeper into the Reich from camps elsewhere. Many of these prisoners were the survivors of the Nazi campaign of persecution and annihilation – a campaign that amounted to attempted genocide (the Shoah, or Holocaust) in the case of Europe's Jewish people, as well as towards the Roma community. Now, artists – alongside war reporters, filmmakers and photojournalists – recorded indelible images of the horrors they found at places such as the Bergen-Belsen camp, liberated by the British Army on 15 April 1945.

This group of artists included the Scottish-born Doris Zinkeisen (1898–1991), who, with her sister Anna (1901–1976), was a successful portrait painter and commercial artist before the war. They had both trained at the Royal Academy before launching their careers together, often working on joint commissions, including murals. Doris worked in theatre design and costume, while Anna concentrated on advertising and illustration. Their experience as working artists informed their decision to turn down commissioned work for the WAAC, preferring instead to work on their own terms by submitting paintings for consideration.[53] During the war, both sisters worked as auxiliary nurses at St Mary's Hospital in Paddington, London, making and submitting paintings to the committee in their spare time.

In 1945, Doris began working for the Red Cross, on a commission to record the activities of doctors and nurses across north-western Europe. It was this role that brought her to Bergen-Belsen shortly after its liberation; indeed, she was the first artist to arrive there.[54]

At Bergen-Belsen there were more prisoners found than in any other of the liberated camps. For Doris Zinkeisen, 'The shock of Belsen was never to be forgotten... The stable was used to wash any living creatures down before sending them into hospital to be treated... The horror of the place had to be seen to be believed.'[55] Nevertheless, there is a sense of detachment and a quiet order in her *Human Laundry*, which depicts former prisoners being cleaned and treated for the typhus that was tearing through the camp. Zinkeisen's painting remains one of the most powerful artistic responses to the camps after liberation.

Doris Zinkeisen, *Human Laundry* (1945)
Oil on canvas, 804 x 1,000 mm

Doctors and nurses from a nearby German military hospital were pressed into service following the liberation of Bergen-Belsen. Zinkeisen contrasts their well-fed bodies with the emaciated forms of the surviving prisoners.

In May 1945, Mary Kessell (1914–1977) was commissioned by the WAAC 'to undertake drawings or paintings of refugees or similar subjects on the continent'. She was the first of only two women artists whom the committee would send on overseas commissions – both of them after the ending of hostilities in Europe. Having drawn French refugees in Britain, she wished to go to Germany to draw the effects of the war on the people and infrastructure there. She did not know that she would also witness the aftermath of the Holocaust when her travels also brought her to Belsen in August 1945, once it had become a displaced persons camp. Four months on from the camp's liberation, Kessell observed a sense of optimism, as the people there – many of whom had been rescued from the brink of death – were given the opportunity and assistance to start new lives. There was a school for the children and even a supply store nicknamed 'Harrods' where people could get donated clothing. But she also noted that:

> There are people in this camp who can never go home, because they have nowhere to go. Children who will never know what it's like to have a mother and a father, sisters and brothers, and who will never have an opportunity to do the work they love. There are babies here who should not have been born. Unwanted, born of lust and fear. Babies of five, six months old who look as if they should still be in the womb, they are so tiny and unformed... [56]

Her drawings entitled *Notes from Belsen Camp* (1945) are often tiny, charcoal and sanguine [blood-red chalk] studies, intense and anonymous, and arguably they are the most sensitive to be produced on the subject. As with her other drawings, including of refugees in Germany's railway stations, she removed the context, by using a solid black or red-brown background. This blurring of the distinction between her subjects allowed the images to speak to universal human suffering.

It would take decades for the world to start developing a fuller picture and a deeper understanding of the Holocaust. But the artists who bore witness at the time included some who had been victims themselves. Jan Hartman (1926–2009) had lived with his brother Jirí and their parents in Prague, before the German annexation. They were an affluent and secular Czech family, and Hartman did not even know that both his parents had Jewish ancestry. Following the invasion of Czechoslovakia, the family were subject to increasing restrictions on their lives, and from September 1941 they were forced to wear yellow Stars of David. Finally, Hartman and his brother were separated from their parents and transported to the Theresienstadt ghetto, about 40 miles north of Prague, in 1942. He was 16 years old. From there, they were moved through the camp system, including to Auschwitz-Birkenau – a place that Hartman would later allude to in his drawings. The brothers survived the experience and were finally liberated at Buchenwald concentration camp in April 1945, by the advancing US Army. Later, they learned that their parents had been killed at Auschwitz.[57]

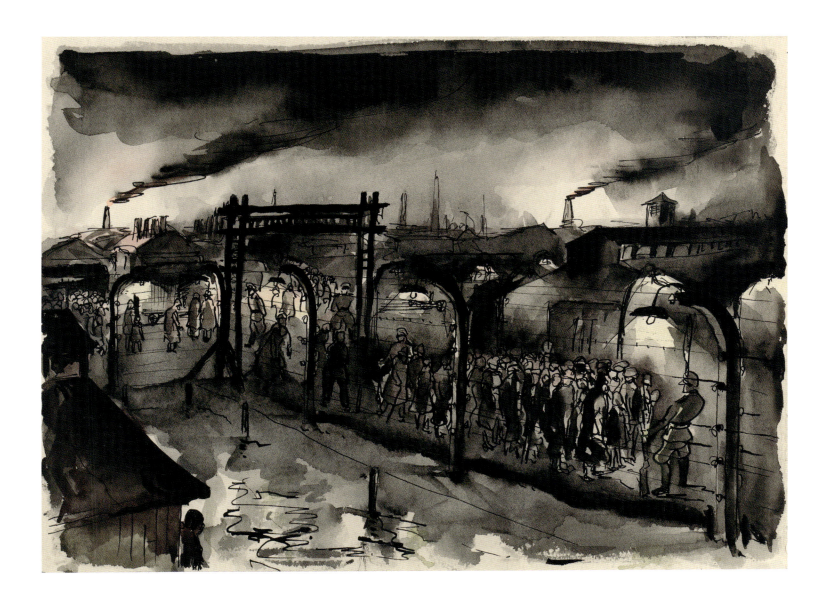

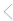

Mary Kessell, *Notes from Belsen Camp, 1945* (1945)
Sanguine on paper, 107 x 107 mm; 107 x 152 mm

Kessell's drawings are unusually abstract and ambiguous for WAAC imagery. In their simplicity, they embody humanity's potential for both hope and desolation.

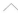

Jan Hartman, *Death March – View into the Camp* (1945)
Gouache and ink on paper, 222 x 300 mm

Drawn while the artist's memory was still fresh, this shows the chimneys that were visible from across the camp. The many large lamps also left an impression on the artist. Here, an officer would make life or death decisions, in Hartman's case opting to spare the teenager to work in slave labour.

Before the details of his experiences had receded from his memory, Jan Hartman made a series of drawings in the summer of 1945. They were collectively titled *Death March*, encompassing not only the deadly forced marches he survived, but many other aspects of his ordeal as an internee.

Richard Grune (1903–1983), from Kiel on Germany's Baltic coast, was a promising artist who had studied at the world-famous Bauhaus school in Weimar, in 1922, where the teachers included Wassily Kandinsky and Paul Klee. In 1933 he had moved to Berlin but was arrested the following year. Although Grune was a member of the Social Democratic Party and working on anti-Nazi newspapers, the justification for his arrest was his homosexuality. Despite its illegality, homosexuality had long been tolerated in the capital city; but in the fevered atmosphere of Nazi Germany, Grune was denounced by a private citizen.[58] He served a prison sentence of 15 months, before he was transferred to the Sachsenhausen concentration camp in October 1937, and then on to the Flossenbürg concentration camp in April 1940. He eventually escaped in April 1945, just before the Nazi regime evacuated the camp. Like Hartman, Grune decided to commit the horrors of his experiences to drawing, as a testament to the suffering of his fellow prisoners. He exhibited works including *Kostentzug*, meaning 'Deprivation of Food', in late 1945. Two years later, he included them in two portfolios of prints: *Die Ausgestossenen* [The Outcasts] and *Passion des XX. Jahrhunderts* [Passion of the 20th Century].

Grune and Hartman were relatively unusual in committing to paper so soon their experiences of the Holocaust. Other artist-survivors of the Holocaust would come to the subject decades later, when they found they could no longer suppress their memories, taking their time to find ways to articulate something of their experience through art (*see pp.218–21*).

The Hungarian artist George Mayer-Marton (1897–1960) was never, himself, a camp prisoner. He had been a successful artist in Vienna before fleeing to Britain in 1938, with his wife Grete, and bringing his most cherished work with him. Two years later, his London studio and home were destroyed – along with his life's work – by an incendiary bomb. Grete never recovered her mental equilibrium following this added trauma. In the summer of 1945, Mayer-Marton found out that his parents had been deported from the Jewish ghetto in his hometown, Győr, and subsequently killed at Auschwitz.[59] In response to his sense of grief, he painted *Women with Boulders* (1945), in which two women, one cradling a newborn, inhabit a desolate landscape of scattered boulders. Together, these elements evoke a sense of irredeemable loss.

The war in Europe came to its official end on 8 May 1945 with the unconditional surrender of Germany, signed in Berlin. While the WAAC now focused on the conflict's aftermath in Europe, it also turned its attention to the ongoing war against

Richard Grune, *Kostentzug* (1947)
Lithograph on paper, 270 x 200 mm

Grune was one of the first artists to depict the sadistic details of prisoner abuse and degradation. Here, weaker prisoners are targeted for not keeping up with their tasks. They were not permitted to eat and instead were made to hold out their meal with outstretched arms.

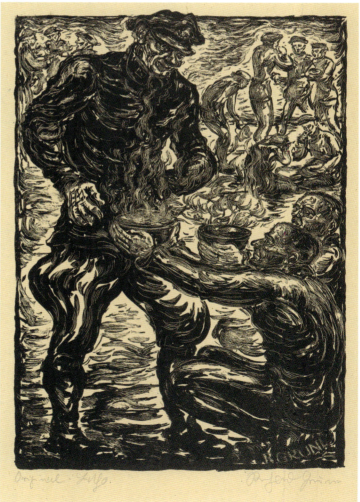

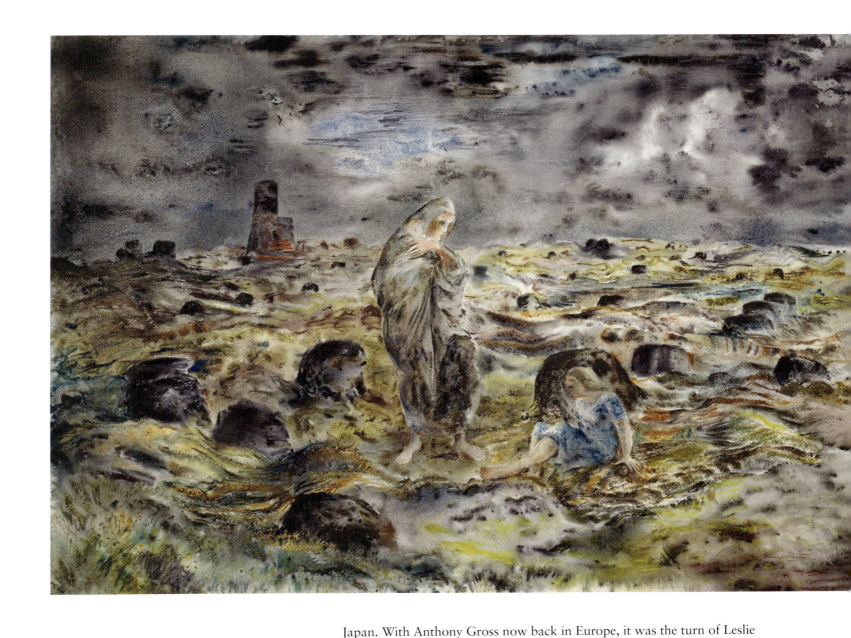

George Mayer-Marton, *Women with Boulders* (1945)
Watercolour and pen on paper, 573 x 792 mm

Here, Mayer-Marton expresses both his personal grief and the wider sense of loss experienced by so many in the Holocaust's immediate aftermath. The imagery invokes the Jewish tradition of placing stones on graves to protect the body waiting for resurrection.

Japan. With Anthony Gross now back in Europe, it was the turn of Leslie Cole (1910–1976) to follow this line of enquiry. Up until this point, Cole had witnessed his fair share of brutality and horror, painting Malta in the wake of the Axis bombing campaign, death and decay in 1945 during the prelude to the Greek Civil War, and Bergen-Belsen soon after its liberation. He did not flinch from composing and painting the most appalling scenes with an ostensible cool objectivity. Of his painting *Belsen Camp Compound for Women* (1945), he recounted that 'During my visit the victims were still dying in the open & the woman in the centre of the picture collapsed while I was drawing.'[60]

In June 1945, Cole departed for South East Asia Command (SEAC), joining fellow artist Thomas Hennell. In Burma, the two men had to adjust to hot, humid and unrelentingly damp conditions. From Rangoon, Cole accompanied the army into the interior, where small groups of Japanese soldiers were retreating over the Irrawaddy River. The British, working together with Burmese guerrillas, hunted them down – as Cole painted in *Burmese Guerrillas in Action* (1945).

THE UNREALITY OF IT ALL: ART OF THE SECOND WORLD WAR

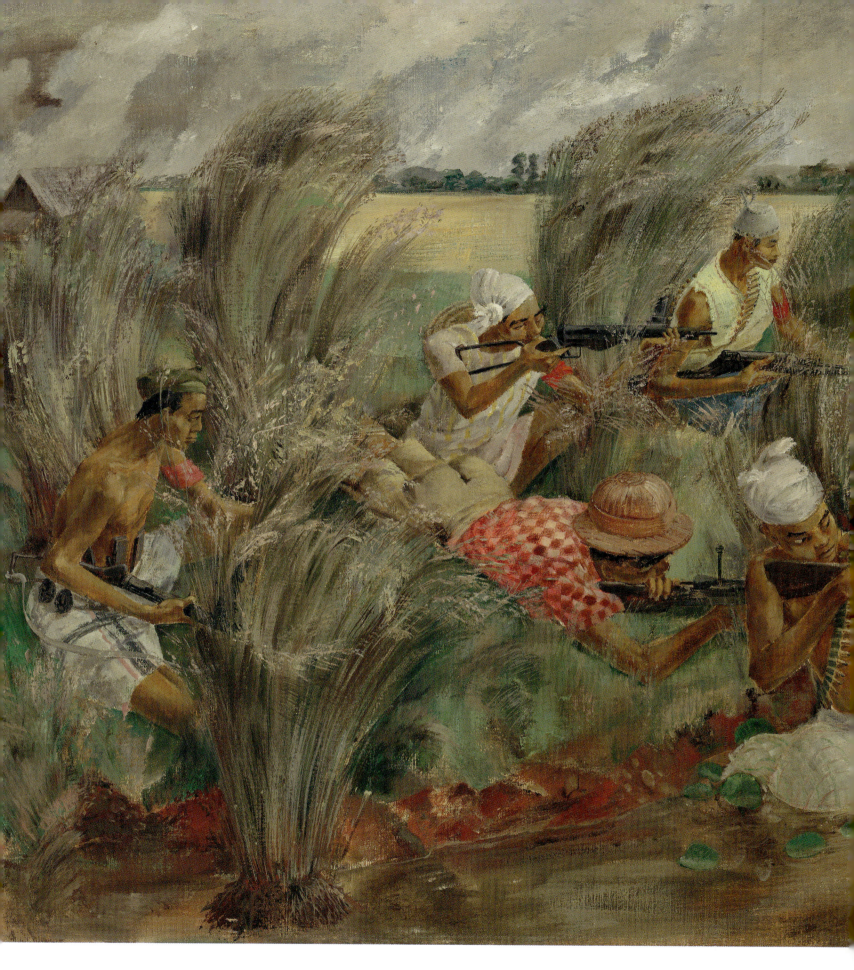

Leslie Cole, *Burmese Guerrillas in Action* (1945)
Oil on canvas, 655 x 918 mm

Cole shows the Burmese irregulars who assisted the British in expelling the remaining Japanese troops from Burma. Despite the ruggedness of this scene, Cole's colours and brushwork lend it a lively and engaging lyricism.

THE UNREALITY OF IT ALL: ART OF THE SECOND WORLD WAR

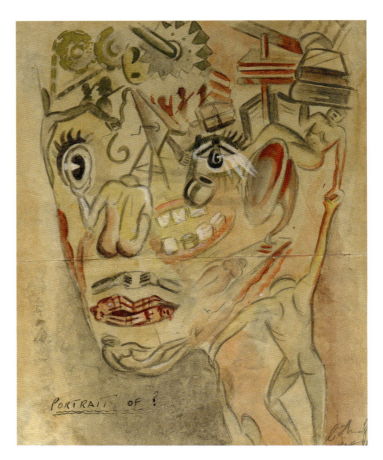

Not long after this episode, news reached Cole of the Allies' victory over Japan. He was horrified by the earth-shattering circumstances surrounding the Japanese surrender announcement on 15 August. 'I have been terribly depressed for the last two days after hearing about the Atom Bomb. God! What right has anyone to do that to a city and thousands of civilians. I'll end up a pacifist after all! The potentialities are beyond reckoning – I'm frankly scared stiff.' As for his art, 'I did no painting when I heard of it but am getting used to the idea.'[61] Japanese surrender brought freedom to surviving British and other Allied servicemen and civilians who had been interned for years; and Cole now visited camps, bearing witness in his art to both the suffering the prisoners had endured and the start of their long recovery. For two nights, Cole stayed at Changi Gaol in Singapore, where there were still thousands of freed men, slowly being nursed back to health.

Among these ex-prisoners was Ronald Searle (1920–2011), who had been captured in 1942 after the Japanese invasion of Singapore. During his imprisonment, Searle was part of the mass of Allied prisoners forced to work on constructing the notorious Thai–Burma railway, before he was transferred back to Changi in May 1944. Despite the conditions, he still drew as much as he could, with no subject off limits, making more than 400 drawings of the everyday life of prisoners suffering malnourishment, disease and cruelty. He never imagined that one day others would see his work, later describing it as 'the graffiti of a condemned man'.[62]

Ronald Searle, (left) *Inspecting Officer, Changi 1942* (1942)
Ink and pencil on paper, 211 x 124 mm

A captive of the Japanese since the year this drawing was made, Searle was an exceptional observer of people, even managing to draw the Japanese guards with a remarkable degree of humanity.

Charles Thrale, (right) *Executed For No Apparent Reason: A Study of the Mind or Something* (1942–1945)
Watercolour and pencil on paper, 231 x 184 mm

Few subjects were off-limits for Thrale, and this example is his most surreal. Creativity was a source of mental strength for the prisoners, and those who had an outlet – be it crawing, writing or even performing – were more likely to be able to endure their captivity.

Philip Meninsky, *Emergency Operation, c.1946* (1946)
Ink on paper, 190 x 209 mm

Many of Meninsky's drawings document the rudimentary medical procedures performed by medics on their fellow prisoners. Amputations were common, on account of the devastating effects of tropical ulcers.

Charles Thrale (1918–1981), too, was imprisoned at Changi and he also endured the ordeal of the Thai–Burma railway. Before the war, he had been a professional portrait painter and commercial artist. He enlisted with the British Army in 1940, travelling to Singapore via South Africa the following year. In Japanese captivity, he drew his experiences using any materials he could find: not only pencil and watercolour, but also brass polish, medicine sediment – and even his own blood. Thrale drew many types of subject: portraits, group scenes, depictions of prisoners' injuries and illnesses, scenes of forced labour and marches, and scenes revealing prisoners' living conditions. Another survivor of Changi and the Thai–Burma railway, Philip Meninsky (1919–2007) endured several illnesses and was sent from camp to camp. At Chungkai hospital camp, Thailand, he met the Australian surgeon Major Arthur Moon, who asked him to draw the details of the equipment and of the improvised medical operations in the sick huts and operating theatre. *Emergency Operation, c.1946* depicts one such procedure. Meninsky also recorded excruciating cases of tropical ulcers and treatment for beri-beri, the disease caused by a deficiency of thiamine (Vitamin B1).

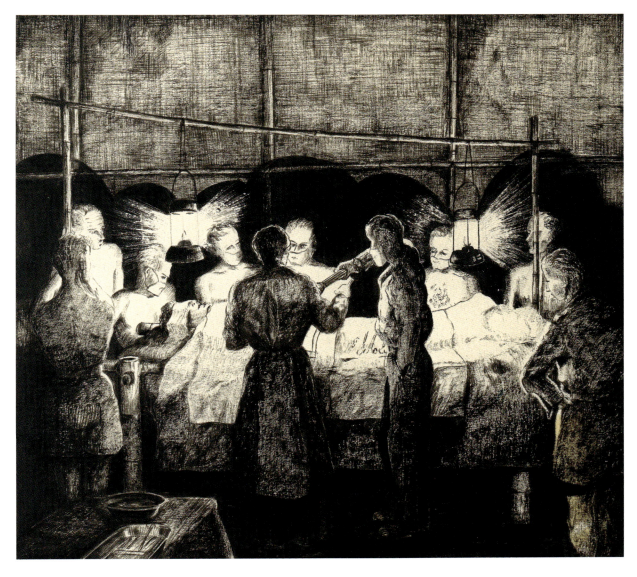

The artists working in captivity would have often risked severe punishment, even death, for making their drawings, and so they went to great lengths to keep their activity secret from the camp guards, burying their stashes of drawings in the ground, or even hiding them in the bedding of cholera sufferers.[63] Far removed from the dynamics of official commission or selection, their work is a reminder of how the drive for survival is interconnected with creativity, even though these artists could not know whether they would ever experience freedom, much less whether their art would see the light of day. For them, the act of making drawings was itself a means of motivation and survival.

Yet, in a trickle if not a flood, their art reached the public. From October 1945 onwards, ships sailed into Southampton and Liverpool bringing former Far East prisoners home. A picture was beginning to emerge of the enormous suffering they had endured, though it would take a long time for historians to gather the details; many returnees were understandably reluctant to speak of their experiences – and were not generally encouraged to do so. But some of the artist-survivors put their work on display, including Searle, whose drawings were exhibited in 1945, at the Cambridge School of Art.[64] After this, he continued to draw, turning to much lighter themes to become one of Britain's best-known cartoonists. Charles Thrale mounted a long-running touring exhibition (called *The Valleys of the Shadow of Death*), as did another prisoner-artist, Leo Rawlings.[65]

By contrast, Philip Meninsky stored his wartime drawings for 30 years before looking at them again.[66] The family then decided to sell a large part of this collection to the IWM in 1973; a decade later, after a long deliberation, Searle would also decide to present his war drawings to the museum as a gift, an act that brought him an unexpected sense of relief. By that time, the IWM was beginning to establish a reputation as a repository for Far East Prisoners of War (FEPOW) materials, including also diaries and journals. This collection would acquire enormous documentary importance, as very little photographic or film evidence existed of the events in the Far East camps.[67] As such, it would tie in neatly with one of the WAAC's original aims: to document the history of the British perspective of the Second World War.[68]

As for the WAAC's Leslie Cole, he continued travelling around the Bay of Bengal until April 1946. Several months earlier, he had broken the news to the WAAC that his friend Hennell had disappeared and was presumed dead, having been last seen in Surabaya, Java.[69] Following the Japanese surrender, nationalists in the Dutch East India Colonies (modern Indonesia) fought to prevent the Dutch re-exerting colonial control; in the chaos of the ensuing violence, Hennell was attacked by a mob and was never seen again.

Cole survived his Far Eastern experience, but the war took a toll on his life when he returned to Britain and began teaching at the Central School of Art in London and the Brighton College of Arts and Crafts. Although his work had been widely reproduced in magazines and booklets during wartime, that outlet dried up as soon as the war in Europe was over, so that far fewer people saw his Far East works. As he struggled to find a new subject for his art, his

memories of the war were disrupting his ability to sleep. He drank heavily and gave up painting in the hope that this would bring him some peace.[70] Thirty years after his Far East assignment ended, a final drinking session sent him into a coma, and he died two months later.[71]

On 13 October 1945, two months after Japan's initial surrender, the WAAC staged an *Exhibition of National War Pictures* at London's Royal Academy. The Director of the Tate Gallery, John Rothenstein, wrote solemnly:

> In Great Britain, between 1939 and 1945[,] the war directly engaged the energies of almost the whole people; and it has taken them into every corner of the earth. There is hardly an aspect of their infinitely various activities, hardly a variation of the ordeal which they have undergone[,] which the war artists have left unrecorded. Their work constitutes, therefore, a great chapter of history.[72]

In fact, the selection of art proved both less controversial and less well attended than the war art exhibition that had followed the First World War in 1919. One reason was that the pictures were already well known, because of the wartime displays at the National Gallery and on tour. Moreover, unlike the audiences of 1919, the public in 1945 had been thoroughly saturated with images of war in general and were ready to move on. Politically, they already had, sweeping away Churchill from power and voting in a Labour government in July 1945.

The young artist and critic Michael Ayrton was certainly unimpressed with the *National War Pictures*: 'If I may express an opinion of the whole vast display, I should say that it consists of ten per cent art, fifty per cent competent journalism, and forty per cent junk. The vast majority of the portraits are particularly deplorable.' However, he singled out some for praise: 'A final commendation would be for Captain Albert Richards, a young man who became one of the few real war artists and was killed in action. He is a very great loss to English painting.' He also highlighted those artists who, in his opinion, had been neglected: 'A final complaint would be that the committee never commissioned John Minton, who was in the Army, [n]or for the matter of that a number of other good artists such as William Scott (who is still in the Army).'[73]

By the time that the exhibition closed, on 25 November 1945, the world's media was gripped by an unprecedented event beginning in Germany, which attempted to bring a final reckoning for crimes perpetrated by leading Nazis now in captivity. The International Military Tribunal became much better known, colloquially, as the Nuremberg trials. The sessions took place in the same city that had provided the backdrop for the Nazi Party's annual rallies, lending them a potent symbolism. Laura Knight (1877–1970), who had completed many successful portrait commissions for the WAAC, sensed an opportunity for a final if challenging assignment: 'What about the trial at Nuremberg for a subject… ? It seems a pity for such an event to be unrecorded, and I feel that artistically, it should prove exciting.'[74]

The WAAC agreed with Knight, and, as a result, she became the second woman whom the committee commissioned to travel abroad, in this case designated as a 'war correspondent' at Nuremberg. The momentousness of the event made it one of the most important assignments of her career. (It was also the first time that the indomitable artist, aged 68, had travelled by air.) And the commission had a profound impact on Knight, whose painting *The Nuremberg Trial* (1946) departed from her usual strict realism, as she felt compelled to introduce the imagery of the burning cityscape overlaying the courtroom scene:

> In that ruined city death and destruction are ever present. They had come into the picture[;] without them it would not have been Nuremberg as it now is during The Trial, when the death of millions and utter devastation are the sole topic of conversation wherever one goes – whatever one is doing.[75]

The tribunal took place against the background of a defeated nation, a landscape ruined, and a people shattered by war. In 1947, the Scottish artist Robert Henderson Blyth (1919–1970) was among those who took on the vast subject of the war's aftermath and consequences. He had recently finished his service in the Royal Army Medical Corps, where his last posting had been in Hamburg – the city ravaged by the intensive British and US aerial bombing of Operation 'Gomorrah' in July 1943. The bombing campaign was on a scale of intensity unseen before – or after – in Europe, in which incendiary bombs caused a firestorm that killed around 40,000 people during a week of air raids. The wrecked setting in Blyth's painting *In the Image of Man* (1947) is most likely the streets of Hamburg, and its title a bitter parody of the Judeo-Christian concept of man created in the image of God. It was donated to the IWM by the artist's widow, several years after Blyth's death.

The War Artists Advisory Committee was wound up in December 1945. A total of three of its artists – Ravilious, Richards and Hennell – had been killed on active duty. While the WAAC's objective of keeping artists safe from the perils of the frontline had not been entirely successful, overall its work had done its duty. Its pictures did not preach, but instead gently articulated wartime's 'new normal': the everyday work of Air Raid Precautions personnel, factory workers, Land girls and many others. These portrayals of the home front dominated the WAAC's war art exhibitions around the country, offering recognisable imagery to visitors, which contributed to a strong sense of national unity.

Although the WAAC's scheme had excluded the radical avant-garde (and its tastes were certainly conservative in comparison with the BWMC's approach in the First World War), there had been enough variety in its range of artists – who were, on the face of it, given a free rein – to boast a distinction between Britain's treatment of artists and Nazi Germany's.

Laura Knight, *The Nuremberg Trial* (1946)
Oil on canvas, 1,828 x 1,524 mm

Here, Knight both records her perspective of the trial – from the broadcasting box above the prisoners – and reflects on the magnitude of the occasion and sense of history in the making.

The WAAC left a legacy, too. Its framing of Britain as a courageous island nation, an underdog, which quietly triumphed over the dark forces of extremism, proved enduring. Many of the artworks offered an understated impression of the British getting on with the task in hand; they demonstrated a quiet pride rather than triumphalism or bombast. And the WAAC's model of state sponsorship for the arts made it a forerunner of the modern Arts Council, which was established in 1946.

Nevertheless, it is also striking how many doom-laden images were collected by the scheme – for example, William Ware's *Fired City* and many of Leslie Cole's works; there is much that is bleak, too, in the work of Graham Sutherland and Henry Moore. The inclusion of these works among the WAAC commissions serves as a reminder that neither the scheme nor its artists were ever trying to sugar-coat the British experience of the Second World War.

In 1947, more than half of the WAAC's 6,000 artworks came to the IWM; and in the many decades since, the museum has continued to collect artworks that complement and bolster this official war art. These later acquisitions include, for example, John Armstrong's terrifying and prescient *Pro Patria*, the lively, surreptitious drawings of Margaret Abbess, the angst-ridden imagery of Keith Vaughan, and Ronald Searle's harrowing records of life as an inmate in the Far East. They are small aspects of a vast and deeply complex chapter in history; but, together, the official and unofficial art provide a multifaceted vista of Britain's Second World War, as seen by the artists living through it.

>

Robert Henderson Blyth, *In the Image of Man* (1947)
Oil on canvas, 1,270 x 1,016 mm

With its surreal imagery of a hollow crucified body and backdrop of ruins, denoting the wholesale destruction of Western civilisation, Blyth's painting echoes Armstrong's and Nevinson's earlier works that warned of war.

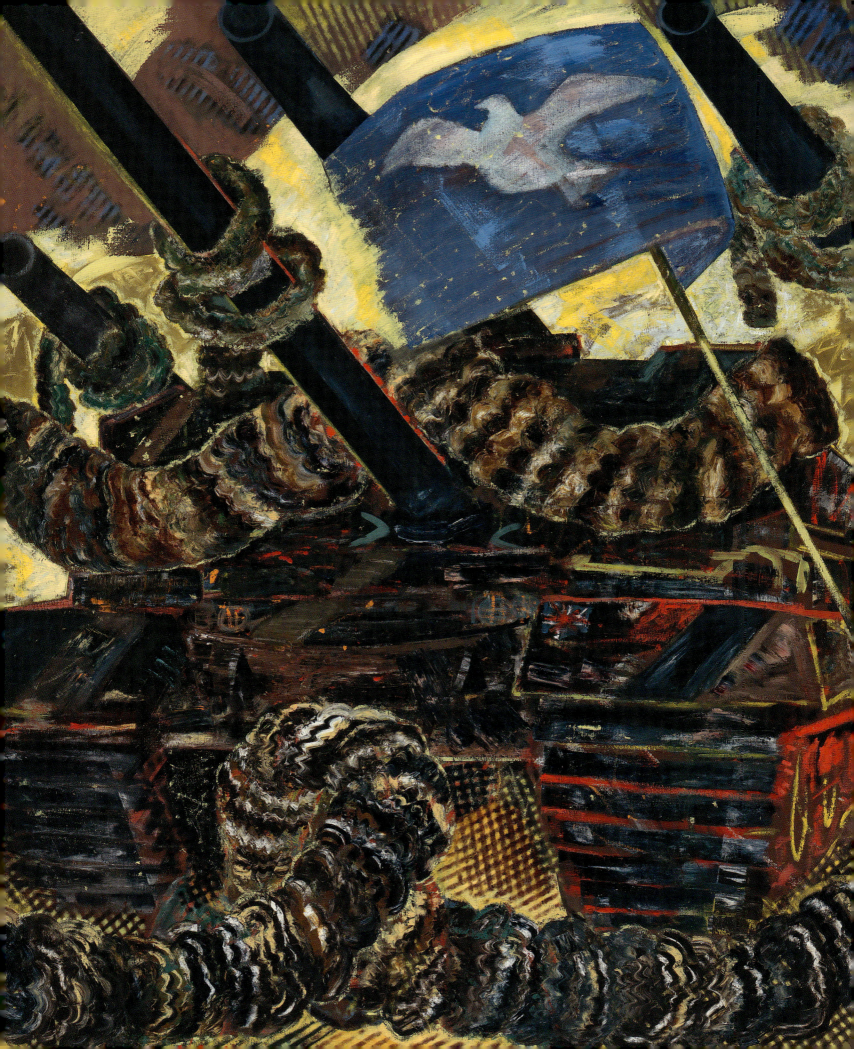

Pale Armistice
Art of the Cold War Era

The decades following the Second World War were marked by massive political, social and cultural upheavals across the world. In the wake of the 1945 victory celebrations, it did not take long for peacetime to merge into the 'Cold War', defined by the tensions between two opposing blocs dominated by the two new post-war superpowers: the United States and the Soviet Union. No longer united against a common enemy, these superpowers emerged from the Second World War with their opposing ideologies centre-stage, competing for supremacy.

The divide between US-style capitalism and Soviet communism had global implications, including new military alliances formed either side of the 'Iron Curtain', notably the US-dominated North Atlantic Treaty Organization (NATO) and the Soviet-dominated Warsaw Pact. And the development of a nuclear arms race between the two sides in the late 1940s brought a new, terrifying dimension to the standoff.

The shifting balance of power from Europe to the United States and the ideological split between East and West were reflected in the art world, too. New York became the new hub of Western art – in part thanks to the arrival of avant-garde European artists from the late 1930s onwards. By the 1950s, the city's art scene was thriving, dominated by the movement known as 'abstract expressionism' – and later, by pop art. Artists associated with abstract expressionism included the painters Jackson Pollock, Mark Rothko and Willem de Kooning, but there was considerable variety within the movement. Broadly speaking, the works of the abstract expressionists were emotional, expressive and not generally figurative, instead foregrounding the qualities and disposition of the paint itself. Art critics understood and promoted the movement as the next natural progression after surrealism, framing it as a pure art that came directly from the artist's subconscious, free from any social or political influence.

Paradoxically, the obvious contrast between abstract painting and the socialist realist art of the Soviet Union (as well as the art of the defeated Nazi regime) was not lost on an otherwise conservative American political establishment. The Central Intelligence Agency (CIA), founded in 1947, bought paintings and organised international exhibitions, promoting abstract expressionism as representing artistic freedom and embodying the democratic principles of the world's newest superpower.[1]

Sonia Lawson, *Two minds with but a single thought (Peace Demonstration and Tanks)* (1984)
Oil on canvas, 1,532 x 1,226 mm

In 1984, in the context of the Cold War divide and the potential threat from Warsaw Pact nations, Britain's armed forces undertook their biggest mobilisation since the Second World War. It was called 'Exercise Lionheart', and the IWM commissioned artist Sonia Lawson to tackle it. Observing a tank adored with camouflage, Lawson thought it appeared unintentionally festive, echoing the proudly raised flags of a peace demonstration that she had witnessed.

In Britain meanwhile, Henry Moore and Barbara Hepworth became the nation's foremost modern sculptors, their work coming to represent an optimistic modernism in contrast to the Nazi aesthetic, which staunchly favoured portrayals of 'realistic' figures set within scenes evocative of a mythical, idealised past. But in post-war Britain and Europe it was harder to separate art from its social context than it was in the United States. The fragile elongated figures of influential Swiss sculptor Alberto Giacometti explored the human condition in a world struggling to come to terms with the Holocaust. Sculpture by British artists including William Turnbull, Lynn Chadwick, Reg Butler and Kenneth Armitage was showcased at the Venice Biennale in 1952, prompting the critic Herbert Read to coin the term 'the geometry of fear' to describe their work: spikey, twisted, metal creatures that encapsulated a post-war angst. In painting, the work of Francis Bacon best expressed this atmosphere.

The IWM remained far removed from all these post-war developments. The late 1940s and 1950s were a difficult time for the museum: like Britain at large, it was worn down and depleted, suffering the same problems of austerity and shortage of labour. Having taken on more than half of the WAAC's collection, the IWM now had its hands full cataloguing the 3,268 artworks. There was also the question of finding room for them, since space was already a problem in the museum's Lambeth home.

In addition, the deep psychological rupture of the Second World War was crushing for the IWM's Director-General Leslie Bradley and his small team of staff, who were all veterans of the First World War. They had poured their energies, from their personal experiences, into building a comprehensive monument to a period so devastating that, they assumed, it could never be repeated. But 'never again' had come round all too soon, and the IWM was now suffering an existential crisis. Barely three decades on from the museum's foundation, its future was far from certain.

During this period, the IWM was not alone in experiencing drift and neglect. Many other national museums had become 'musty' and run down. But the IWM did at least turn an eye to the future, extending its remit in 1953 to cover all campaigns involving British and Commonwealth forces since 1914. In the austere climate, it would take a few decades before art collecting could begin in earnest, and so most of the artworks relevant to Britain's immediate post-war decades were acquired much later, after the fact.

In the early post-war years, Britain's blighted cities were memorably captured by street photographers such as Roger Mayne and Shirley Baker. A number of painters, such as Frederick Cook (1907–1982), also took on the subject. Cook had sold some of his paintings of London's ruined buildings to the WAAC in 1944. Following the war, he moved to Polperro in Cornwall. On a visit to Plymouth's city centre, which had been severely bombed due to the proximity of its large naval base, Cook was struck by the extent of the damage that was still being cleared in the 1950s. His painting *Aftermath: The Prudential Building, Plymouth 1951* transports the viewer back to the war years in its neo-romantic style, while evoking something disquieting about the dismal post-war era.

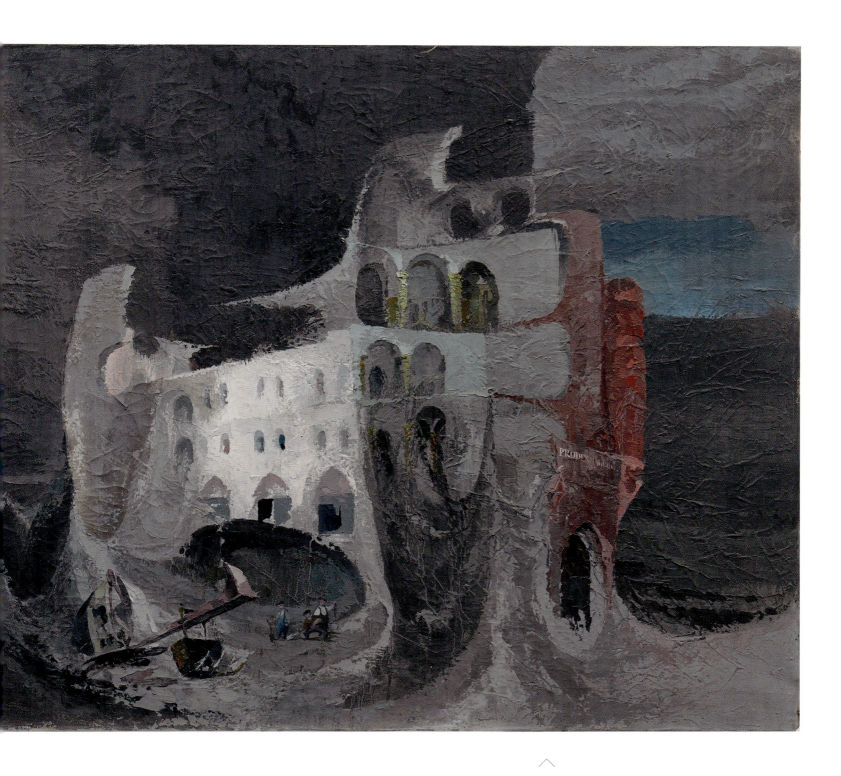

Frederick Cook, *Aftermath: The Prudential Building, Plymouth 1951* (1951)
Oil on canvas, 760 × 915 mm

Cook's treatment of Plymouth's Prudential Building – a local landmark and one of the last buildings demolished to make way for a new city centre – turns it into a dreamlike shipwreck. The painting reflects the proximity of the Second World War and its lingering legacy on both the mental and physical landscape of Britain.

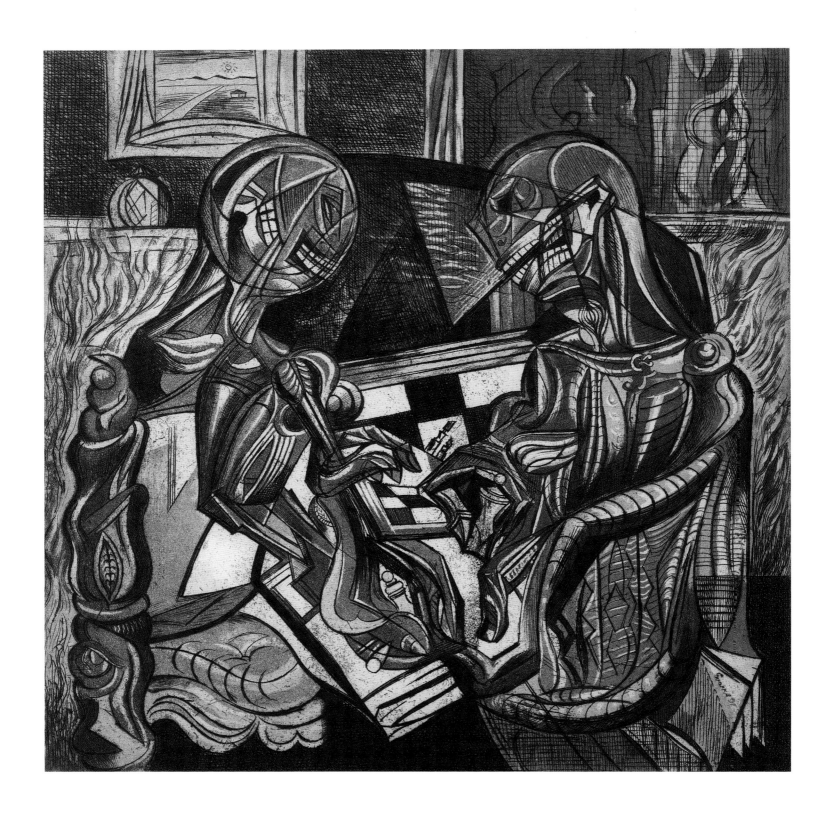

It would take time for artists to address the developing Cold War. Merlyn Evans (1910–1973) was one of the first to do so, in his etching *The Chess Players* (1951). During the Second World War, Evans had served as a sapper [military engineer] with the British Army in North Africa and in Italy, where he painted *The Execution* (1945), also in IWM's collection, in reaction to images of the corpse of Mussolini hanging upside down at the Piazzale Loreto in Milan. He had already made a first study for *The Chess Players* in 1940: a tense and claustrophobic painting that refers to the 1939 non-aggression pact between Germany and Russia, whose secret clauses had carved up Poland and so foreshadowed the war. That study was not exhibited until 1949, at which time Evans began to make versions as etchings. Rather than depict Hitler and Stalin, Evans rendered his chess players as two belligerent robotic figures with mechanised teeth, therefore leaving room for ambiguity. His implication – that two opposing powers were prepared to sacrifice smaller countries as pawns in the game – could be applied to the emerging power relationships in this new Cold War era.

In this new age, Britain's status on the world stage was swiftly declining, reflected, for example, in rapid decolonisation across South and Southeast Asia. More conflict was to follow: the so-called 'Malayan Emergency' began in 1948, with British and Commonwealth forces fighting a long and vicious counter-insurgency war against the communist-leaning Malayan National Liberation Army (MNLA), who were fighting for an independent Malaya (now Malaysia). In 1950, the first 'proxy war' of the Cold War erupted in Korea, which had been partitioned in 1945 into the Soviet-influenced North and the US-influenced South. When the North's Korean People's Army (KPA) advanced south, the United Nations authorised an international force, including from Britain but led by the United States, to fight alongside South Korea. By the time an uneasy armistice was agreed in 1953, the conflict had drawn in communist China, too, on the North Korean side.

Despite the serious military commitments involved, neither Malaya nor Korea fostered a return to an official British war art scheme akin to that of the WAAC. These conflicts were not 'total' wars in which the whole of Britain was put on a war footing; everyday life for people living in Britain remained peaceful, albeit lived in the omnipresent shadow of the nuclear age. Britain's military essentially resumed the habits of its imperial role, whether suppressing local uprisings or attempting to resist nationalist movements – especially if, in the Cold War climate, such threats were Soviet-backed or came from supporters of communism. In such an atmosphere, the need for art propaganda was limited – in fact, the less shown the better, although parts of the armed services had warmed to the idea of having a war artist portray their activities and continued to commission at their own discretion.

Pamela Drew (1910–1989), Lady Rathdonnell of Lisnavagh, was one artist who fulfilled that function – and the only one of the time to gain the approval of the RAF, who commissioned her to accompany the Force on a 1955 tour of Middle East Command. Over the next two years, she painted its activity in Aden (in modern-day Yemen), Cyprus, Jordan, Iraq and in Kenya during

Merlyn Evans, *The Chess Players* (1951)
Etching on paper, 575 x 512 mm

The rendering of the figures shows the influence of vorticism, although Evans had a unique voice as an artist – working somewhere between abstraction, cubism and surrealism. Rather than drawing on his subconscious, Evans always related his work to its social and political context: in this case the latent aggression between two matched opponents.

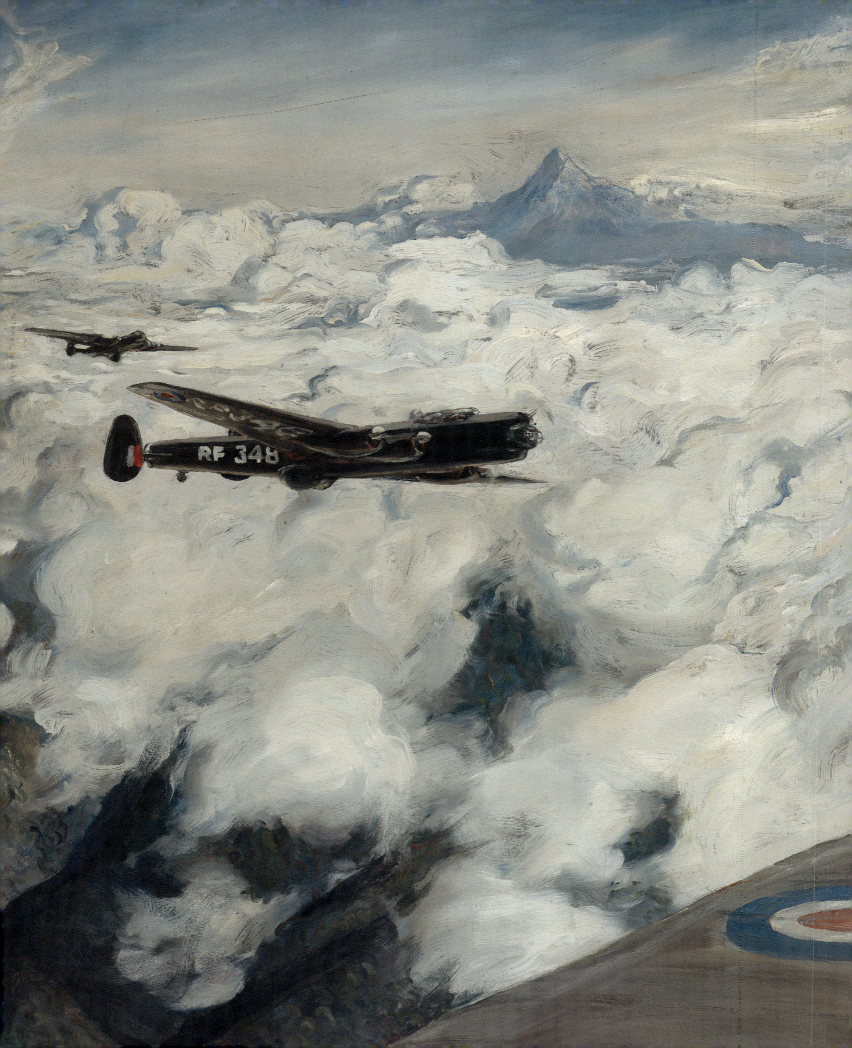

its own 'Emergency': the Mau Mau Uprising of 1952–1960. On her return to Britain in 1957, Drew sold three of these paintings to the IWM; they were the only contemporary artworks acquired by the museum that decade. Her spectacular air landscapes showcase RAF prowess and were far removed from the effects of RAF bombing campaigns against the poorly armed Mau Mau guerrillas, in a conflict that saw the British detain thousands of suspected insurgents in camps, often in brutal circumstances.

Meanwhile, various art movements thrived in Britain as major international exhibitions returned to the capital, and there was a general feeling of opening up again following the Second World War. In this progressive international atmosphere, the English neo-romantic style associated with the war was seen as inward-looking, and much of the art from the schemes of both the First and Second world wars quickly appeared outdated.

William Crozier (1930–2011) was one of a generation of young artists who were profoundly influenced by the colours and the energy in the works of Pablo Picasso and Henri Matisse, shown in London exhibitions during the late 1940s. These were the first overseas artists to be exhibited in Britain since before the Second World War. After he graduated from the Glasgow School of Art in the 1950s, Crozier travelled to Paris, drawn to its art and history, as well as by the philosophy of figures such as Jean-Paul Sartre. While hitchhiking along the main route between Calais and Paris, Crozier came across Bourlon Wood, the site of fierce fighting during the First World War. Contemplation of the scars of the world wars on both the geography and society of Europe led Crozier to create a series of paintings featuring skeletal figures in the landscape, which included *Bourlon Wood* (1962). It was painted in the same year as the Cuban Missile Crisis, when US–Soviet tensions over Soviet missiles secretly shipped to Cuba placed the world on the brink of nuclear catastrophe. The heightened atmosphere of the period, with its sense of existential threat, permeates Crozier's work.

Pamela Drew, *Kenya – Lincolns of No.49 Squadron Attacking Hideouts with Bombs, Mount Kenya Beyond* (detail) (1955)
Oil on aluminium, 914 x 609 mm

Drew's formative experiences of flight were with the RAF Coastal Command at Plymouth during the Second World War, when she was serving in the Women's Royal Naval Service. They inspired her to specialise in aerial painting, in the technical and romantic tradition of the earlier 'aero-artists'. Her work often conveys a reassuring sense of maintaining order in unpopulated landscapes.

Although surrounded by the legacy of the Second World War, Crozier's generation was nevertheless part of a rapidly changing society in a changing world. Britain's diminishing status was signalled most clearly following the Suez Crisis in 1956, in which Britain's military operation, with France and Israel, to seize control of the Suez Canal from Egypt prompted international outcry and brought humiliation. Britain's resulting loss of influence in the Middle East, combined with economic turmoil at home, caused the younger generation to question everything. This included the role of the military in the assertion of the nation's status and upholding of its power all over the world. At the same time as the 'Great War' was passing into the realm of legend in the nation's consciousness, its justification as a noble and worthwhile endeavour was also increasingly disputed. The phrase 'lions led by donkeys' was coming to characterise that war, referring to the idea that brave soldiers were led by incompetent and stubborn generals.[2] This sardonic view reflected the 1960s' spirit of anti-elitism, when deferential wartime attitudes were ridiculed by young people eager to reject society's conventions. It was a time when, following the ending of compulsory National Service in the early 1960s, old military uniforms were adopted instead as fashionwear – and when First World War attitudes were critiqued in popular culture, famously in the satirical stage musical (and later film) *Oh, What a Lovely War* (1963).

The seeds of the 1960s' rebellion against established social and cultural conventions lay in the alternative movements of the 1950s, such as the Beat Generation of writers in the United States, and a reinvigorated drive for peace, spearheaded from 1957 in Britain by the Campaign for Nuclear Disarmament (CND). Another expression of this burgeoning counter-culture was a new artistic movement: pop art. In Britain, it was forged by members of the Independent Group of artists, including Richard Hamilton and Eduardo Paolozzi. In the United States, towards the end of the decade, the work of Jasper Johns, Robert Rauschenberg and Andy Warhol all came to define the American approach to pop art. Many of these artists made collages from advertising, comics and other elements of American pop culture, collapsing the distinction between 'high' and 'low' culture. By the 1960s, pop art had entered the mainstream in Britain, with playful, ironic works by the young artists David Hockney and Peter Blake that expressed the exuberance of the Swinging Sixties.

William Crozier, *Bourlon Wood* (1962)
Oil on canvas, 1,540 x 1,230 mm

Crozier invoked symbols of the First World War – in the artwork's title, the style of tin helmet and the poppy-red field – to reflect on current anxieties, demonstrating the sway of the earlier war over subsequent generations. His paintings were also inspired by Spanish religious carnivals that celebrated death, such as 'Semana Santa' and 'Día de los Muertos', which he had encountered on further travels.

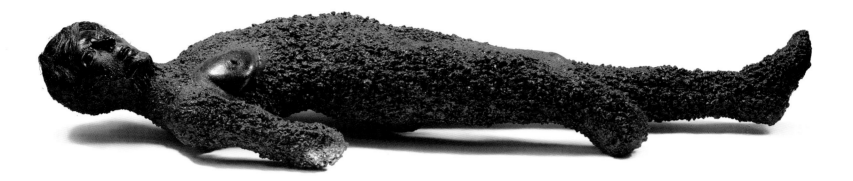

Some other artists though, like Colin Self (b.1941), used the language of pop art to make darker statements about contemporary culture. The Cuban Missile Crisis had a momentous effect on Self, who remembered growing up with paralysing anxieties about nuclear war. These feelings came flooding out when he was studying at the Slade School of Art in the early 1960s, in works such as *Humanity Hanging By a Thread* (1962), with its sinister, smiling, disembodied head suspended from a line reaching to the top of the canvas. Self, a leading figure in the British pop art movement, was one of the first artists to address, consciously, the anxieties of the nuclear age. The IWM began to acquire his work from the 1980s onwards, including his drawing *Guard Dog on a Missile Base, No. 4, 1966,* inspired by his memory of staying on a farm near a US air base in Norfolk:

> By day one could see a solitary, massive white nuclear missile poised vertically and still. By night the howling of guard dogs chilled the air and imagination. Animal and technological threat were united in one fearful ground.[3]

Self worked in sculpture, too, taking the subject of women as passive victims of war to a new horrifying extreme in *The Nuclear Victim (Beach Girl)* (1966). In the context of pop art, which often used glamorous imagery of fashionable women in subversive ways, *The Nuclear Victim* was a deliberately shocking image of the effects of nuclear devastation. The disfigured mannequin teeters on the edge of being a sick joke; but the artist was earnest in his fear, embodied in the sculpture.

Colin Self, *The Nuclear Victim (Beach Girl)* (1966)
Mixed media, 280 x 1,700 x 580 mm

Self made this sculpture from a shop mannequin, adding fibreglass, paint, cinders and hair. For him, it was imperative that art should reflect the major developments of the day, however disturbing they were. The work remains an outlandish and perverse totem of the nuclear age.

146 VISIONS OF WAR: ART OF THE IMPERIAL WAR MUSEUMS

Philip Hicks, *Posthumous 2*, from the series *War Requiem* (1968–1969)
Oil on metal and wood, 2,311 x 1,346 mm

Posthumous 2 articulates the artist's mixed feelings on soldiering. The *War Requiem* works divided opinion along generational lines when they were first displayed.[4] Hicks drew from a range of imagery, including American pop and anti-war art, as well as photographs of the Vietnam War reproduced in magazines.

Philip Hicks (1928–2021) left the army and retrained as an artist at the Royal Academy in the early 1950s. Later, he turned to the arresting visual language of pop art to address the subject of militarism and its effects both on society and the individual soldier. When the IWM acquired his *War Requiem* series (1968–1971) in 1974, it was the first time that the museum had collected post-war artworks that made any kind of anti-war statement. But, as Hicks explained, the work was also personal:

> [*War Requiem*] was done as a statement about war in humanist terms, drawn from my own experiences in the British Army 1946–49, and in the memory of my father who was a regular officer throughout the first and second world wars... He died in 1967. I chose the Vietnam War as a vehicle because it was going on at the time, and gave a focus for many of the things I wanted to say.[5]

As the 1960s went on, the Vietnam War (1955–1975) came to dominate the consciousness of politically engaged young people in the West, particularly in the United States, where young men were drafted into fighting on the side of South Vietnam against the communist North Vietnamese forces and 'Viet Cong' insurgents. While the British state did not send troops to Vietnam, the war still held huge cultural significance, as graphic photographs, film footage and reports of atrocities against Vietnamese civilians and of the deaths of US conscripts were splashed across the news. As a result, the young counter-cultural generation across the United States and Europe turned against the war *en masse*.

One painter who literally found the war's imagery encroaching into his work was Eric Auld (1931–2013). Based in Aberdeen, Auld specialised in painting the Scottish landscape, and although he was a member of CND, as many artists were, his politics did not usually enter into his art. In 1968, however, he painted *Intruding Image*, succinctly representing the effect of news about the Vietnam War on the psyche of concerned observers thousands of miles away.

Meanwhile, much closer to home, tensions were building in Northern Ireland, nearly 50 years on from its partition from the rest of Ireland. While the latter had followed a path to independence, first as the Irish Free State in 1922, and then as a republic from 1949, the six counties in the north had formed the self-governing province of Northern Ireland, remaining within the United Kingdom. In 1969, additional British Army units were deployed in the province, in the face of mounting violence between its Protestant and Catholic communities. The ensuing conflict, with its contending paramilitaries, came to be known as 'The Troubles' and would be a major focus of the IWM's more proactive approach to collecting post-1945 material in the early 1970s.

In order to tackle this theme, the museum sought the assistance of General Sir Harry Tuzo, who was the British Army's General Officer Commanding and Director of Operations in Northern Ireland, in a project to collect firearms (from an amnesty in 1971). Tuzo took the

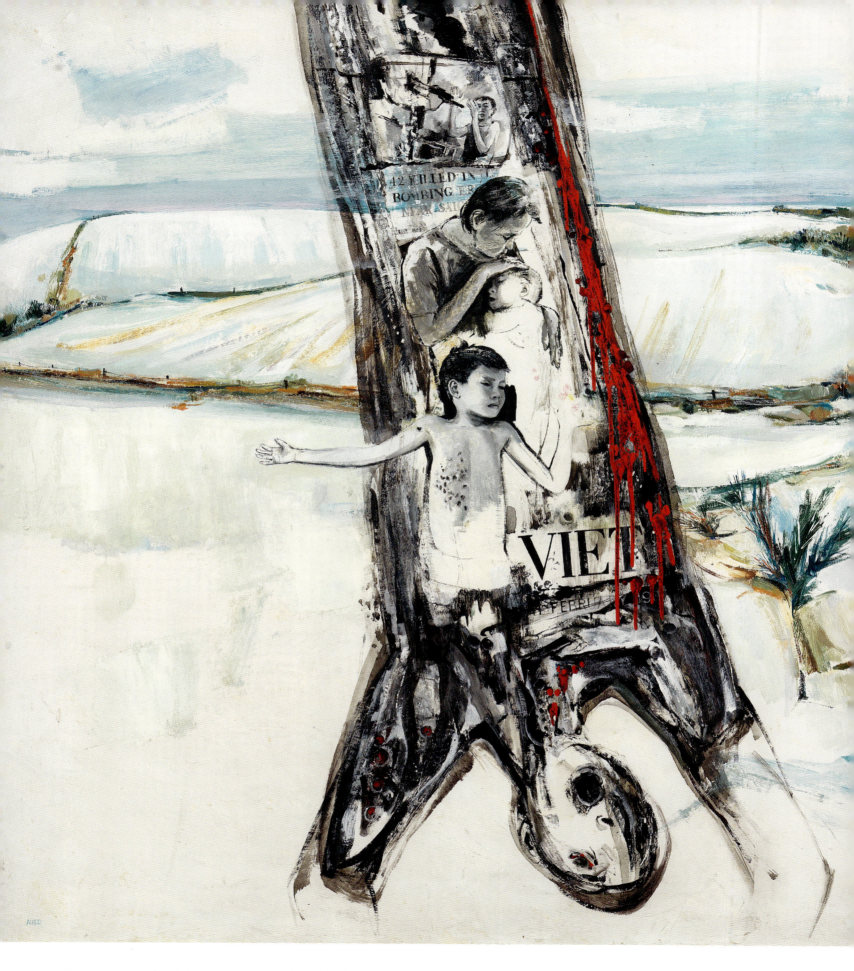

opportunity to mention to the IWM that he was 'agitating with the Ministry of Defence to get one or more official war artists accredited to the Security Forces out here in order that some of the atmosphere of this unusual campaign can be properly recorded'.[6] There was still no official war artists scheme in place, and the MOD was not particularly interested in one; but Tuzo hoped that the IWM might lend weight to the idea.

While the museum held no sway over the MOD, Tuzo's plan had planted a seed, prompting the IWM to look at creating an art commissioning committee of its own. Thus, the Artistic Records Committee (ARC) was created, just a few months after the notorious events of Bloody Sunday on 30 January 1972, when soldiers from the Parachute Regiment opened fire during a protest in Derry/Londonderry, killing 14 Catholic civilians. The circumstances could not have been more different from the Second World War, but nevertheless the museum modelled its newest committee on the WAAC – albeit in a very scaled-down way, since, at most, the ARC would only have the capacity to commission one or two artists a year.

The stated purpose of the committee was to 'commission or acquire for the Imperial War Museum works of art as historical records of conflicts'.[7] And the influence of the museum's art commissioning in the First World War was evident: subjects for commissions would be chosen and matched with artists, and, crucially, the idea that such art could form a documentary record of war prevailed. While the development of pop art in the 1960s had given artists new ways to confront the social and political complexities of the era, other artists were still using reportage – drawing on the spot – to respond to war and conflict. It was not particularly fashionable, but the legacy of the First World War had established reportage as the twentieth century's traditional form of war art, replacing the large commemorative battle scenes of the previous era.

Although now equipped with its new commissioning committee, the IWM found it difficult to find artists living in Northern Ireland who addressed the conflict there. Understandably, it would take some time for local artists to get to grips with the situation; and an institution with the word 'Imperial' in its title was always going to struggle to engage some communities. Instead, a London-born artist – Ken Howard (1932–2022) – was given a commission, following a recommendation from the Royal College of Art. Howard had built a solid career, culminating in a retrospective at Plymouth City Art Gallery in

Eric Auld, *Intruding Image* (1968)
Oil on hardboard, 1,100 × 1,250 mm

The anguished overturned body is a purposefully jarring device, obstructing the peaceful Highland landscape. The figure is adorned with disturbing images and newspaper headlines, which reference February 1968, a turning point in the war following the start of the Tet Offensive and a peak in the number of US military deaths.

PALE ARMISTICE: ART OF THE COLD WAR ERA 149

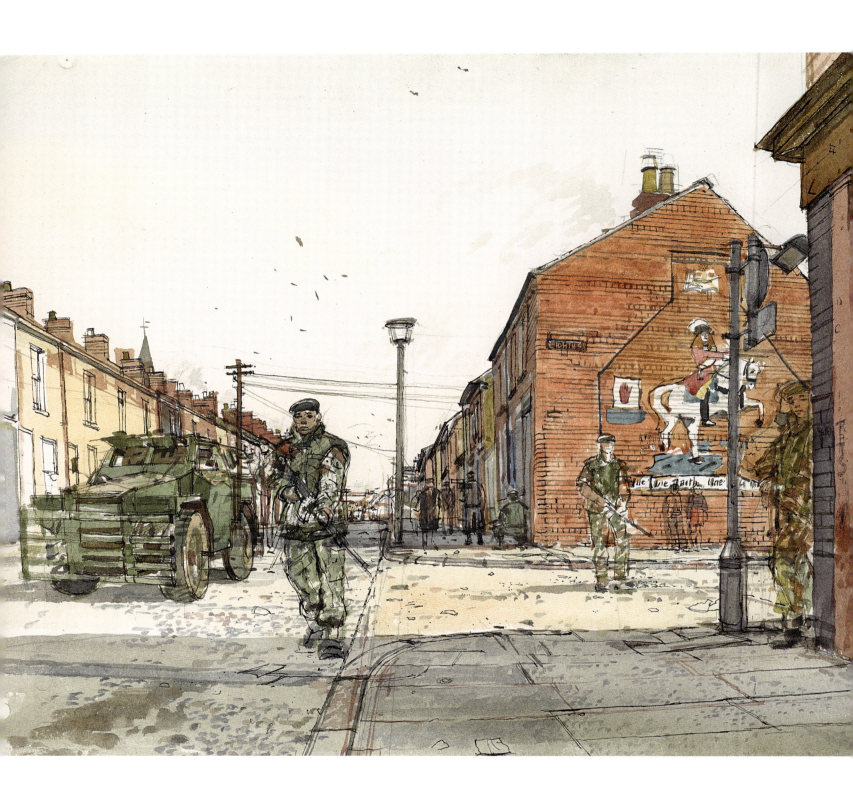

Ken Howard, *"King Billy and the Brits", Belfast* (1978)
Watercolour and ink on paper, 393 x 577 mm

Howard presents the British Army patrolling streets that — apart from the presence of the near invisible boy in the foreground — seem more like backdrops to army exercises rather than scenes from real life.

1972, despite his unfashionable figurative style of painting. In the mid-1950s, he had been an enthusiastic recruit during his National Service as a Royal Marine, before going on to study at the Royal College of Art under former WAAC artists Rodrigo Moynihan and Carel Weight. The ARC arranged for Howard to travel to Northern Ireland in 1973 and stay with units of the British Army; he made a second trip later in the decade. His approach was very much in the mould of the earlier war artists, and the rationale was the same: drawing allowed him the flexibility to sketch on the go, and Howard's work invites comparisons with that of Muirhead Bone or Adrian Hill.

Despite the conflict's controversies, as exemplified in events such as Bloody Sunday, the ARC members reflexively saw the role of their artist as being aloof from the suffering of local people, following the tradition of those earlier 'objective' artists. Howard's calm and orderly scenes run counter to the messy violence of the conflict, and the artist noted:

> I was very popular with the regiments because of the way I work, being very figurative, expressing the life of the regiment, rather than making any sort of comment on what they were doing. I was making fairly dispassionate and objective depictions of the life of this order in Northern Ireland.[8]

However, plans to display Howard's work at the IWM were shelved as the situation in Northern Ireland deteriorated in the 1970s. The IWM acknowledged that the museum's building was itself a potential target of attack by the Nationalist paramilitary fighters of the Provisional IRA (Irish Republican Army) and was understandably nervous of sending out any message that might be regarded as provocative. (The building at Lambeth Road would indeed suffer a fire-bomb attack in 1992 – one of three targeted at London tourist sites.[9]) As for Howard, a career as a military artist was opening up, as he continued to travel with the British Army – to outposts in Norway and Belize as well as in Northern Ireland – making drawings for reproduction in army publications. All the while, during the 1980s and beyond, the IWM would continue to quietly collect art on the Troubles (*see pp. 222–27*).

Following on from Ken Howard's commissions, the ARC continued to appoint artists to depict the work of Britain's armed forces at home and around the world, including in Cyprus, Belize and Hong Kong. Meanwhile, the museum's Department of Art began to collect the work of artists who were responding to the pervasive threat of living in the nuclear age, as well as to war's wider implications for society. Many of the artists were intrigued by the long shadow cast by past wars and the ways in which these conflicts were remembered and honoured by both individuals and society. This was a generation that had either lived through the Second World War as children or was born shortly afterwards. For some, the effect of their memories and the legacy of the war stirred a lifelong fascination with a conflict that had done so much to shape their families' lives and wider society in its aftermath. For others, the act of reflecting on both the world wars as well as current conflicts raised profound questions about the place of war in society; it was therefore part of a reckoning, in the wake of the 1960s' counter-cultural backlash.

Ian Hamilton Finlay (1925–2006) was a highly original artist and poet whose National Service had taken him to post-war West Germany. Much of his work combined a lifelong interest in the Second World War with more general themes of war and nature, and with the connections between opposing impulses such as creativity and destruction, order and disorder. Finlay's sculpture, poems and prints often reference Greek mythology and are complex in concept, many of them made with collaborators, from stone-carvers to poets.

New Zealand artist Alexis Hunter (1948–2014) was also interested in themes of war and nature, though from a feminist perspective. In works including *War and Nature* (1979), she used the device of a female hand interacting with stereotypical male imagery to produce art that was radical and which challenged patriarchal society. While *War and Nature* references contemporary news reports on apartheid South Africa's incursions into neighbouring countries, it is also a much broader statement on war itself.

Ian Hamilton Finlay and George Oliver, *Arcadia* (1973)
Lithograph on paper, 267 x 357 mm

This work is an example of Finlay's collaborative practice: a visual poem that references the classical utopian garden, a recurring theme in his work. The pattern on the tank is redolent of beautiful wallpaper rather than military camouflage, and the work is an ironic reflection of the ubiquity of the tank in popular culture.

Alexis Hunter, *War and Nature* (1979)
Colour photocopies on paper, 2 panels, each 1,230 x 400 mm

Hunter's work reads as a comic strip: Mother Nature – represented by the feminine hand – works in a powerful cycle over the land. But War – as waged by men – is represented by the toy soldiers and newspaper clippings, disrupting the natural recurrence of death and rebirth.

Gilbert & George, *Battle* (1980)
Mixed media, 660 x 1,270 mm

A cloud of nostalgia hangs over this work, with the black and white imagery of the men of the First World War – in training, in repose or amidst ruins – forming a protective boundary around the colourful chocolate-box landscapes of Britain. The technique echoes propaganda posters of the Second World War, which used images of British landmarks and landscape to symbolise a sense of patriotism.

PALE ARMISTICE: ART OF THE COLD WAR ERA

Deanna Petherbridge, *Debris of War* (1984)
Ink and wash on paper, 1,432 x 1,120 mm

This image is a fever-dream of fragments, suggesting columns, cannons, parts of tanks, all with a sense of overwhelming scale. Like much of Petherbridge's work, it embodies a sense of the sublime: something all-powerful, superhuman and terrifying.

In their postcard sculptures, such as *Battle* and *Victory March* (1980), the famed pop art duo Gilbert & George (Gilbert Prousch, b.1943, and George Passmore, b.1942) were articulating rather than challenging Britain's culture and society. The artists collected early twentieth-century postcards, curating and arranging them in a way that distilled all kinds of patriotic, nostalgic and imperialist notions into the work. These 'postcard sculptures', as the artists described them, also express something of the First World War's mythic status in British culture in a way that is haunting and reverent rather than parodic.

By contrast, the work of Deanna Petherbridge (b.1939) represents a much more critical, and frightening, visualisation of humanity's predicament. She began to gain recognition throughout the 1970s for her large pen and ink drawings of architectural and mechanistic vistas, full of tension between order and chaos. War, politics and current affairs have continued to be important themes in her art ever since.

During the 1970s and 1980s, fears about the existential threat from nuclear weapons continued to run deep. *Protect and Survive*, the British government's civil defence campaign of the 1970s, was roundly mocked for exacerbating fears rather than calming them. In popular culture, fantasies of nuclear apocalypse played out in Raymond Briggs's 1982 graphic novel *When the Wind Blows* and the terrifying television drama *Threads* (1984). And, by 1983, US President Ronald Reagan's denunciation of the Soviet Union as an 'evil empire' helped refuel tensions between the superpowers following the decade of improved relations known as *détente*.

Graham Ashton (b.1948) made a series of drawings to help him address a subject that was beyond comprehension, including *815681945 or the Hiroshima Cartoon* (1978). Ashton acknowledges that his interest in the subject of war was stimulated by his parents' service in the Second World War, as well as by witnessing his father's increasing bitterness at what he saw as the government's failure to provide for war veterans or to reintegrate them back into society. In addition, as he put it:

> My innocent belief in 'the war to end all wars' was shattered in 1956 when I saw the US footage of effects of the A bomb tests in Nevada and in the same period I discovered that we were at war over Suez.[10]

Those two events left an abiding interest in the nuclear issues. 'In 1978,' he noted:

> ... the fear of a holocaust was very real. No-one knew when they were going to press the button. Everyone was living under that kind of fear, since the limits of the nuclear issue hadn't been defined. But if you look at something closely enough you get to grips with it no matter how frightening it may be. You can fit it into the context of your own existence.[11]

158 VISIONS OF WAR: ART OF THE IMPERIAL WAR MUSEUMS

Graham Ashton, *815681945 or the Hiroshima Cartoon* (1978)
Ink, watercolour and wax crayon on paper, 760 x 1,311 mm

The drawing shows the first atomic bomb, dubbed 'Little Boy', in four stages, as in a comic strip. The title refers to the precise time and date of the bomb drop on Hiroshima — 8.15am, on 6 August 1945 — emphasising the bleak immensity of that moment in history.

⟨

Peter Kennard, *Never Again* (1983)
Lithograph on paper, 420 x 296 mm

Never Again demonstrates the simple power of Kennard's imagery, a deliberate strategy during a time when he felt protest images of nuclear war were in danger of becoming hackneyed. In its title, the artist deliberately invokes the sentiments of 1918 to bring his message home.

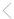

Clive Barker, *German Head 1942* (1974)
Brass, 400 x 210 x 370 mm

Integrating the then-familiar form of a 1940s gas mask into this gleaming, alien-like sculptural bust, Barker articulated a sense of horror – both old and new – about war and violence.

Peter Kennard (b.1949) was coming to prominence as a political artist in the early 1980s, designing posters for CND during a time of renewed support for the peace movement. Using photomontage – made by physically cutting out and gluing different prints – Kennard made eye-catching and jarring new compositions, employing the techniques of poster propaganda to deliver a subversive message of shock and protest. Kennard also satirised *Protect and Survive* in the series *Target London,* commissioned by the Greater London Council in 1985.

In this period, British artists working in sculpture were also addressing the shadow of past wars and present threat. They combined familiar imagery in absurd ways, using the language of surrealism and pop art. Many of these three-dimensional works embody an almost mystical power, exemplified in *German Head 1942* (1974), by Clive Barker (b. 1940). Like Colin Self, Barker made pop artworks that lent a distinctly sinister flavour to the post-war era. Rejecting the notion that sculpture had to be handmade by the artist, Barker used highly finished materials and methods of mass-production, which he had learned while working at the Vauxhall car factory in Luton, in the early 1960s. He began his artistic life by making classic pop art – metal Coca-Cola bottles and fondant fancies – but switched to a series of gas masks. The change in subject was precipitated by wartime memories of his father, who died in 1970. A surreal departure from the traditional military bust, *German Head 1942* highlights the strangeness of its principal subject, the gas mask, presenting it as a frightening fetish for the times. Despite the British government's provision of gas masks for all in 1938, when fear of possible chemical attack was at its height, they were never needed during the Second World War. But they remained creepily ubiquitous thereafter, in photographs, films and documentaries, not to mention museums.

Bill Woodrow (b.1948) also worked with found objects, although in a very different way to Barker. In the early 1980s, Woodrow was beginning to gain attention with his 'cut-outs': sculpture made by cutting out metal from discarded objects, such as washing machines. The sculptor's unique method showed his working out: in *Two Blue Car Doors* (1981), the metal from the car doors is cleverly ribboned to conjure an AK47 (Kalashnikov) assault rifle floating in between them. It was part of a series of sculptures concerned with urban violence and guerrilla warfare. The presence of the Soviet-designed weapon here instantly recalls its iconic status as a weapon of choice for paramilitaries the world over. But the car doors also evoke insurgent violence, in the context of drive-by shootings and car bombs, from the Troubles in Northern Ireland to the civil war in Lebanon.

There is something very powerful about creating a sculptural object that can hold and represent one's fear. So it was in the case of Hugo Powell (1919–2014). A lifelong pacifist, Powell had registered as a conscientious objector during the Second World War, going on to serve in the (Quaker) Friends' Ambulance Unit in Britain and, from 1941, the Hadfield-Spears Hospital Unit in North Africa and Europe, where he witnessed and attended to gruesome battle injuries. Following the war, he worked as an artist-craftsman and

Bill Woodrow, *Two Blue Car Doors* (1981)
Car doors, enamel paint, 1,030 x 930 x 120 mm (each door)

Woodrow's 'cut-outs' are distinctive because they combine a 'host' object (in this case, the car doors) with a made object (the Kalashnikov). It is the relationship between these elements that imbues the sculpture with meaning, which here seems to emphasise an unsettling, yet familiar, connection between cars and guns in armed struggle.

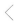

Hugo Powell, *Salome* (1981)
Fibreglass and wood, 820 x 230 x 250 mm

Powell described this sculpture as 'deliberately irrational, a sort of dream of a thing... it suggests fear. Life is full of strange horrors as well as sublime beauty.' Its forms were inspired by wartime memories of the creatures he encountered in Egypt's Western Desert.

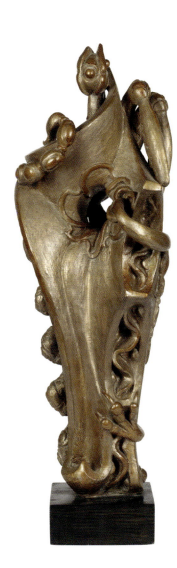

monumental mason, and in his spare time he began developing his own artistic language, influenced by Paul Klee and Henri Gaudier-Brzeska. His work was mostly, in his words, 'cheerful' but haunted by his war experience, which occasionally came to the fore. Of his *Salome* (1981), Powell said: 'It's one of my most horrific sculptures. Sometimes I simply can't look at it. It was very much triggered by the unearthly beauty of some form of insect life... .'[12]

Taking inspiration from the desert scorpions, locusts and praying mantises that Powell encountered, *Salome* symbolises the horrors of war through the extremes of the natural world. Characterising the mantis as a kind of *femme fatale*, he made the link in his mind to Salome, the biblical character whose dance for King Herod is so seductive that he grants her whatever she wishes – which turns out to be the head of John the Baptist. For the artist, *Salome* represented all that was cold, emotionless, violent and powerful. The layers of memory and dreams contained in the sculpture make it an intensely personal response to the war experience. The work also demonstrates the profoundly traumatic effect of war even on those who choose not to fight.

Salome was completed at the beginning of a decade in which the IWM's own commissioning really took off. By the end of the 1980s, the ARC had acquired for the collection around 230 works by 35 artists. Overseas commissions continued, with the committee explicitly addressing the Cold War for the first time in 1981, through its commission on Berlin.

For more than 30 years, Berlin had uniquely encapsulated the political fracture between East and West, ever since Germany, as well as Berlin itself, was divided into areas of Allied occupation in the aftermath of the Second World War. Decisions over the future of Germany had soon become a source of Cold War tension themselves: in 1949, the British, US and French occupation zones merged to form the democratic Federal Republic of Germany (colloquially, West Germany), swiftly followed by the creation of the Communist Party-controlled German Democratic Republic (colloquially, East Germany), formed from the Soviet occupation zone. The Soviet sector of Berlin was recast as East Germany's capital, while the sectors of West Berlin, still controlled by the British, US and French occupiers, were now marooned within East Germany. With hostility ratcheting up, and refugees fleeing East Germany, in 1961 the East German authorities hastily erected the Wall dividing East and West Berlin – and which would become synonymous with the city and the Cold War divide.

The IWM chose Paul Hogarth (1917–2001) to travel to Berlin to record the city, marking 20 years since the Wall's construction. Hogarth, an English artist and illustrator best known for his cover designs for Graham Greene's books, was the committee's second choice, after Ronald Searle had turned down the commission: Searle had drawn the Wall going up in 1961 and was not interested in returning.

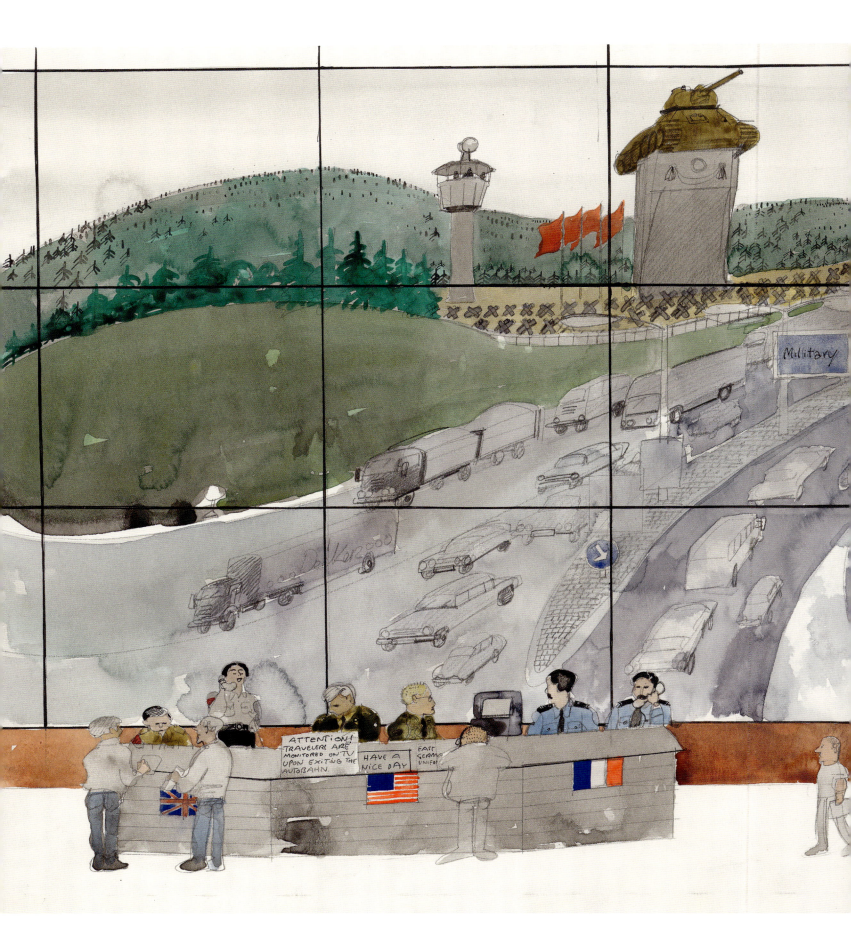

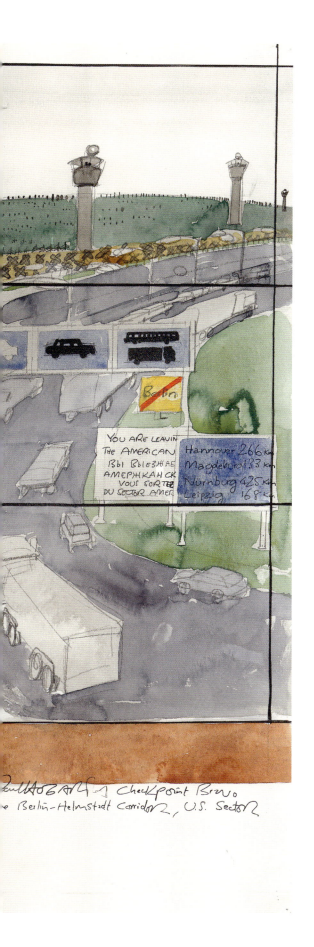

The Berlin Wall commission stands out because it was the first time that the subject of a commission was not purely military; in drawings such as *Checkpoint Bravo, US Sector, Berlin 1981*, Hogarth shows the life of a modern city carrying on despite the omnipresent military interventions. He drew all aspects of Berlin – including fortifications, no-go areas and even the bloodthirsty 'war dogs' used by the East German authorities to guard the Wall – with an illustrator's eye that could sometimes stray into the jaunty and humorous, rather than remaining cool and detached as in the work of other commissioned artists.

Of his work in general, Hogarth said: 'The problem is how to make an image compelling, even in an aesthetic way – not just to sit down and make a record.'[13] This could have been said by Gross, Bawden or Ardizzone, and he was in fact closer in age to that generation. In the 1930s, Hogarth had joined the British Communist Party, lying about his age so that he could fight in the Spanish Civil War. His party membership debarred him from fighting for Britain in the Second World War, although he did work as an illustrator for the Ministry of Information. Following the war, he had built a successful career and was well respected as an artist-illustrator; in this regard, he was a war artist in the WAAC tradition.

Following the Berlin commission, the ARC chose the painter Ray Walker (1945–1984) for the subject of army recruitment. This was an interesting choice for a committee that had so far seemed rather removed from the political upheavals of the day. Walker was an active socialist and member of London's thriving community-mural movement, which had taken off in the 1970s. He was passionate and ambitious about including layers of meaning in his ambitious *Army Recruitment* (1981–1982), a large triptych:

> ... my first consideration was to be as objective as possible regarding the current crisis in unemployment and youth unemployment particularly, the current levels of recruitment saturation, military psychology, the toughness of recruit training, the war in Northern Ireland, and the role of the army in an age of possible thermo-nuclear destruction.[14]

'It is,' he concluded, 'a vast and serious and harrowing subject.' Walker's verdict on his work was that he had been 'as realistic and inventive as possible'.

Paul Hogarth, *Checkpoint Bravo, US Sector, Berlin 1981* (1981)
Watercolour, ink and pencil on paper, 470 x 633 mm
The drawing shows the view at Checkpoint Bravo, which spanned the motorway in the south-west of the city, giving a sense of the pervasive military infrastructure there. Details such as the tank stranded atop a tower highlight the menacing yet absurd atmosphere.

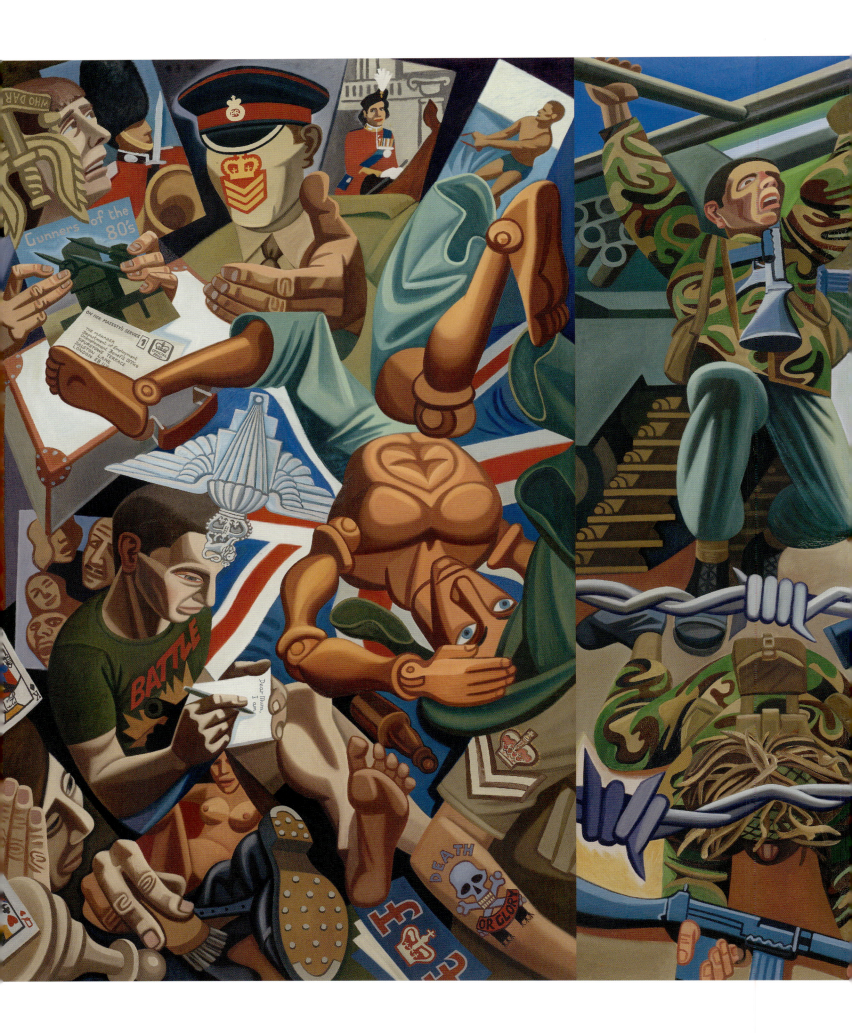

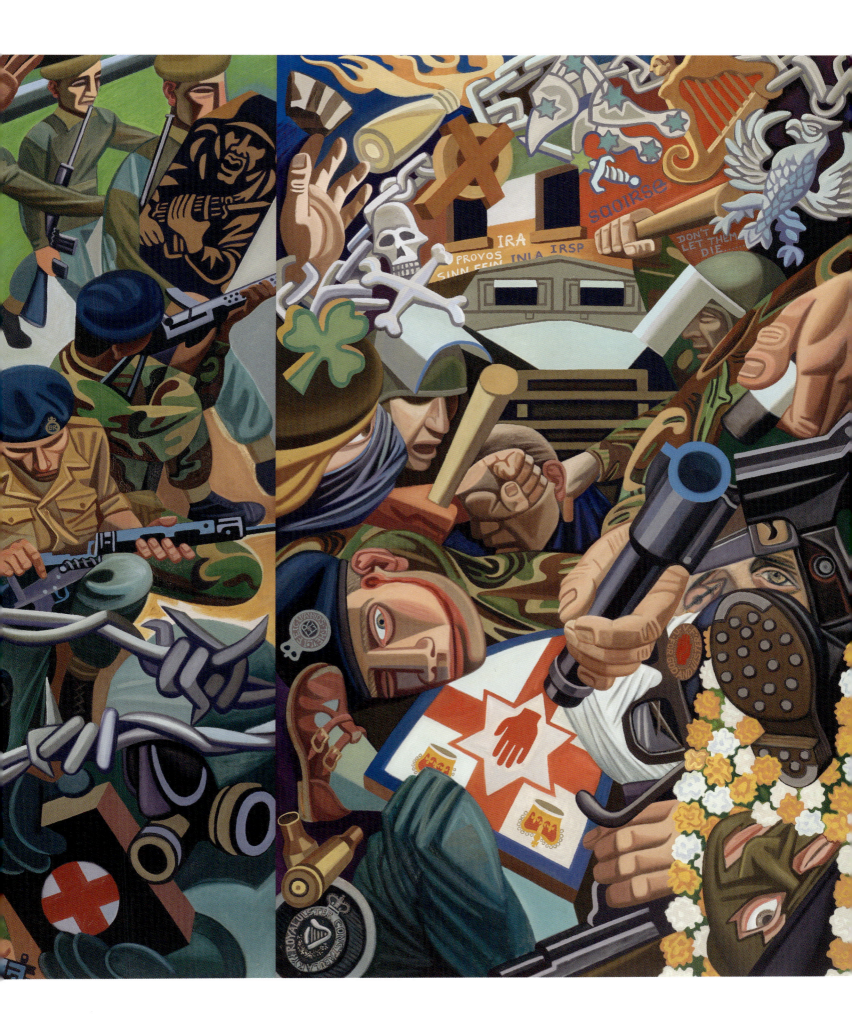

As a mural painter, Walker did have something in common with many from the previous generations of war artists: Edward Bawden, Eric Ravilious, Evelyn Dunbar and George Clausen had all painted indoor murals for public buildings. But the new mural scene was distinctly political, commemorating important chapters in class struggle or making anti-war statements, and it owed more to the work of Mexican painter Diego Rivera and street art – particularly the sectarian murals in Northern Ireland – than to those forerunners. Despite Walker's left-wing allegiances, the ARC was happy with the results, its minutes noting that Walker's triptych was 'forceful and immediate in its impact, was very personal in its quality and had developed well in concept and strength from the initial drawings'.[15] It gained success, too, beyond the IWM when it was accepted for the then annual Whitechapel Open exhibition at the Whitechapel Gallery, East London, in 1982.

The ARC continued to collaborate with the Ministry of Defence's Public Relations Department to decide on subjects for commissions, recording aspects of the work of the British armed forces away from actual war: exercises, training, equipment and uniform-making. This included the women's services, which were still separate from the men's at the time. Eileen Hogan (b.1946) was chosen to depict women in the Royal Navy and she spent almost a year travelling to various naval air stations and hospitals. Hogan, a senior lecturer at Camberwell School of Art, admitted that she had no knowledge of the Royal Navy beforehand; but she took to her subject, believing that it helped her become a better artist. She drew women working as air mechanics at Portland, in Dorset, and the work of Queen Alexandra's Royal Naval Nursing Service at Haslar, near Portsmouth, intrigued by the technical side of their work and moved by the supportive communal atmosphere she discovered among them.

Sonia Lawson (b.1934), known for her willingness to tackle dark subjects in her political art of the 1960s and 1970s, was chosen for a commission to West Germany to depict Operation Lionheart in 1984, the British Army's largest exercises since the Second World War. Following four years of preparation, 130,000 troops were mobilised in a rehearsal of their plans to counter any attack from the Warsaw Pact. Lawson returned with many drawings and went to work in the studio. Her paintings came out of her observations, but they also relate to her long interest in human history and progress. In *Two minds with but a single thought (Peace Demonstration and Tanks)* (1984; *see p. 136*), Lawson takes the approach of an anthropologist: without choosing sides, she instead manages to find commonalities between the military and the pacifist movement.

For many reasons, however, one commission of the 1980s stands out: the assignment awarded to artist Linda Kitson. In April 1982, Britain sent a naval taskforce carrying troops to the Falkland Islands to retake this UK Overseas Territory, known as 'Islas Malvinas' to the invading Argentinian forces. The sovereignty of the Islands had been contested between Britain and Argentina since the early nineteenth century (and it remains so), but this was the first time in the modern era that military conflict had erupted. That same month, the IWM reacted swiftly, by commissioning an artist who would accompany British forces on their deployment some 8,000 miles away in the South Atlantic Ocean.

(Previous page)
Ray Walker, *Army Recruitment* (1981–1982)
Oil on canvas, 2,440 x 4,575 mm

Walker researched the various stages of the recruitment process to make this painting. The left section represents the young people who are drawn to the hierarchical life of the army; the centre section shows their training process, and the right section relates to the recruits' possible deployment – in this case, in Northern Ireland.

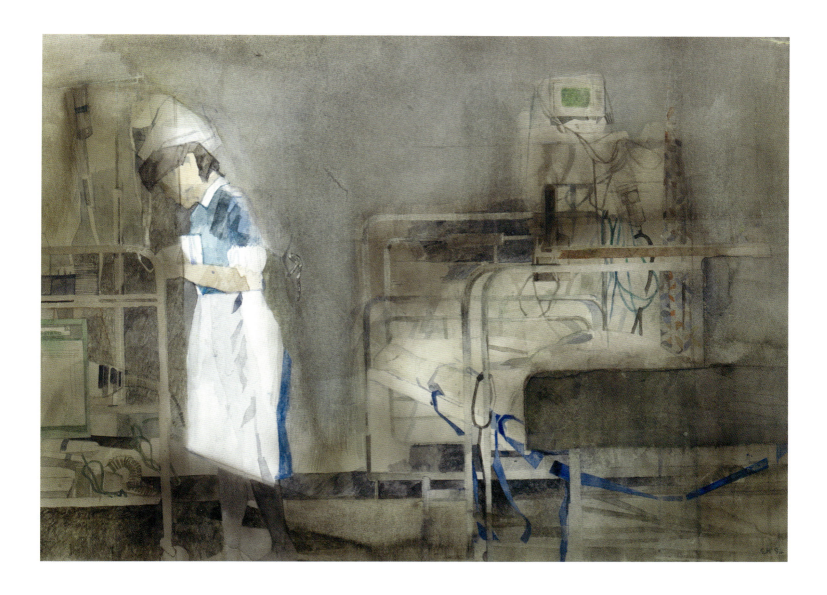

Eileen Hogan, *Coronary Care Ward, Royal Naval Hospital, Haslar 1983* (1984)
Watercolour on paper, 358 × 498 mm

Hogan's observations of the naval nurses' sense of professionalism and attention to detail are apparent in this drawing. Her emphasis on the role, rather than on the individual, gives the work an almost eerie atmosphere, recalling Eric Ravilious's drawings of control centres in the Second World War.

The IWM's decision provoked a flurry of media interest, perhaps because the institution was still widely regarded as old-fashioned and expected to be slow to react to current affairs. But it was the IWM's choice of a 'punkish' young woman for the job of 'war artist' that especially galvanised the press.

Linda Kitson (b.1945), an illustrator by training, was chosen because she was adept at making observational drawings on the spot, with a quick and cool objectivity – in line with the war artist tradition. Her most recent commission at the time – undertaking behind-the-scenes drawings in the offices of *The Times* – had demonstrated the strength of her work in this regard.[16] But commissioning Kitson for the Falklands Conflict would prove a far from straightforward endeavour, for in the 1980s women were still barred from Royal Navy vessels. The ARC seriously considered putting a male artist on stand-by until a solution presented itself.[17] Ultimately, Kitson was permitted to sail on the RMS *Queen Elizabeth II* (better known as the *QE2*), the civilian ocean liner adapted to transport troops on their long journey to the South Atlantic. She was one of the very few women on board.

Between the commission's announcement and the artist's departure, in May 1982, there was a press storm, with reporters camped outside Kitson's home.[18] Articles made much of her appearance, focusing especially on what the *Daily Express* called 'a razored punk style haircut'.[19] The *Sunday Telegraph* spoke of her 'bounding down the gangway looking slightly daunting in black jeans, black gymshoes, black sleeveless anorak, red shirt and a kind of pirate's scarf – plus of course, the punkish haircut'.[20] While Kitson's image was at odds with that of the IWM, it helped build a sense that her commission was reflecting the changing times – at a moment when it was Britain's first woman prime minister, Margaret Thatcher, who was leading the country to war.

Perhaps it was Kitson's background that helped her gain acceptance among the soldiers whose lives she would witness. The Kitsons were an elite military family, for at the time her cousin, General Sir Frank Kitson, was a senior officer in the British Army. Linda Kitson also felt that the troops understood and respected the role of a war artist and were happy to act as models; she commented later that 'they were either past caring, or else thrilled to see someone taking any sort of interest in them'.[21]

By mid-June 1982, the Argentinian forces had surrendered. The reaction to Kitson's subsequent return from the Falkland Islands, on 29 July, was, if anything, more frenzied than her departure, and a few days later the IWM hosted a busy press conference in which a few of her 350 drawings were shown.[22] Many of them were made in extreme and freezing conditions, but the journalists' reactions ranged from indifferent to disparaging. For the *Daily Express*, Celia Brayfield wrote: 'War artist Linda Kitson calls her drawings of the Falklands campaign "squiggles" which seems a fair description'; they were, in her view, 'remarkably uninformative'. Brayfield concluded:

> Perhaps Ms Kitson's appointment was part of the Ministry of Defence's plan to obscure the facts of the fighting as much as possible. It seems odd to brief an artist to draw the events at all, when film, video and photography are better suited to the task.[23]

As with the approach taken by Edward Ardizzone in the Second World War, Kitson did not see it as her place to show violence and brutality, which she thought was better dealt with by photographers. Her drawings, such as *Red Alert from Argentinian Look-Out at Goose Green, 8 June 1982*, formed a behind-the-scenes view of the daily lives of the soldiers as she followed them – from San Carlos to Darwin and Goose Green, to Fitzroy and Bluff Cove, and to Stanley itself.[24] The work of Ardizzone and the other WAAC artists was not widely known in 1982, and Kitson's drawings now prompted a debate about what war art should look like, and whether it could still be relevant. Despite the press criticisms, Kitson's work proved popular, with the exhibition of her Falklands drawings touring the UK following its opening at the IWM in November 1982.[25]

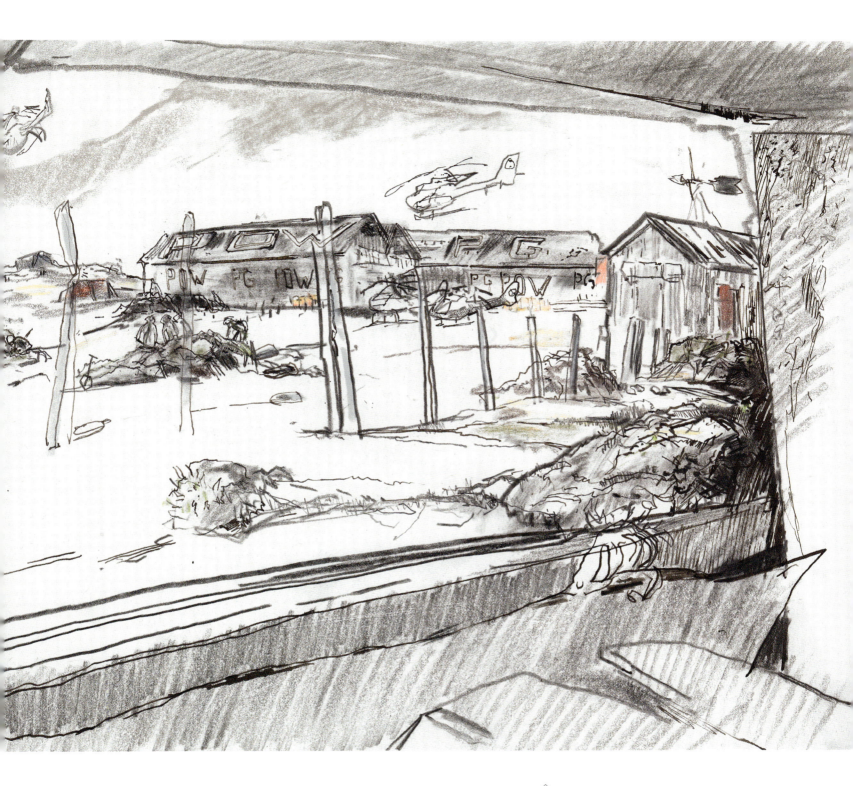

Linda Kitson, *Red Alert from Argentinian Look-Out at Goose Green, 8 June 1982* (1982)
Conté crayon, ink and oil pastel on paper, 295 x 420 mm

Kitson made this drawing while taking shelter in an abandoned Argentinian look-out post. The view shows the prisoner-of-war camp at Goose Green, on East Falkland, when the area was occupied by 1/7th Gurkha Rifles.

PALE ARMISTICE: ART OF THE COLD WAR ERA

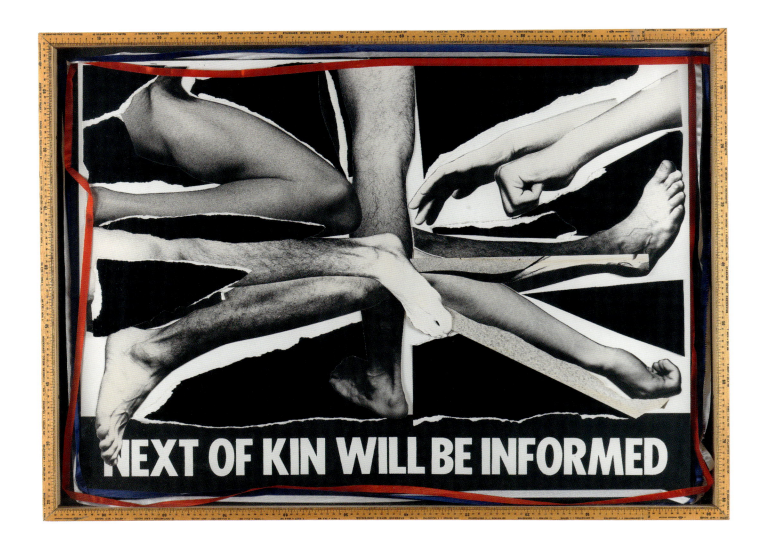

For Kitson, her experiences of the Falklands Conflict profoundly affected the course of her life. With her new-found understanding of, and sympathy towards, British servicemen, she felt isolated from her more pacifist peers in the art world and found it hard to return to her previous subjects. She had witnessed trauma that she was unprepared for; moreover, she did not have the kind of debriefing or support that the returning soldiers were able to access.[26] Kitson's experience is indicative of the differences between earlier wars and Britain's military campaigns after 1945: without the equivalent of a home front, and with conflict being fought at a distance, most people in Britain were not personally invested in the military's activities in the South Atlantic – however much they were following events unfold.

The Falklands Conflict certainly attracted considerable media and political opinion, and in this respect many artists in Britain were profoundly affected by its events. Apart from Kitson, no artists were allowed anywhere near the actual fighting, so they made work based on news reports, revealing the tenor of the political atmosphere in Britain. Michael Peel (1940–2017), an artist who taught the print-making course at Central St Martin's School

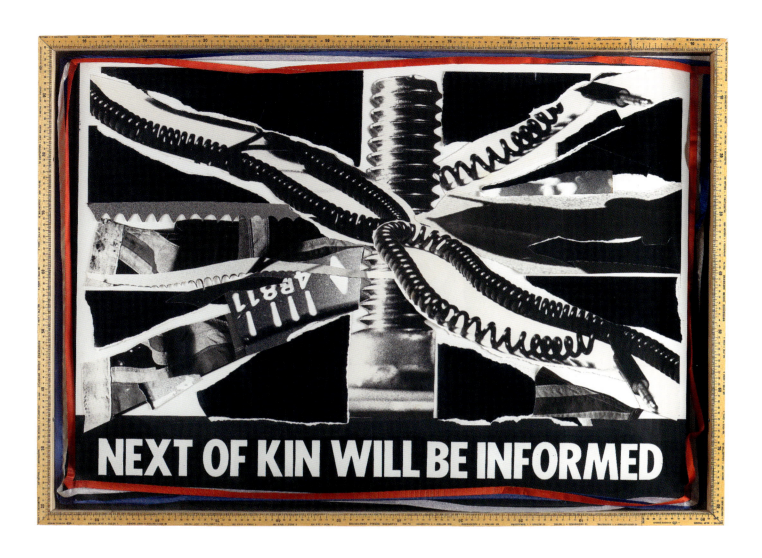

Michael Peel, *Rejoice, Rejoice* (1983)
Photomontage and ribbon on board, 835 x 2,270 mm

The title is taken from Prime Minister Margaret Thatcher's jubilant comments to the media in April 1982, following British forces' successful recapture of South Georgia, an inhospitable island to the east of the Falklands. Peel's work is an incisive and ironic rebuke to the flag-waving jingoism of the era.

of Art and Design, was moved to create *Rejoice, Rejoice* (1983), a pair of photocollages. Lifting images from the press, as well as collaging anatomical and technological imagery, his work uses the simple and direct devices of visual propaganda for maximum impact. Following this, he created a long-running series of posters entitled *MODERN WORLD*, many of which are in the IWM's collection too. The series continued to explore themes relating to current affairs, power, politics, war and the media, as raised in *Rejoice, Rejoice*, and were designed to be viewed outside of the usual setting of an art gallery. Indeed, Peel fly-posted them around London and sent them to educational institutions, as well as exhibiting them in galleries and museums. Commenting on his preoccupations, Peel has said:

> During the recent years the rise of nationalism at all levels of our society and the resulting divisions in attitudes have produced tensions which provoke anxiety for future individual freedom. My work reflects and amplifies my personal attitudes and sensations towards 'limbless ex-service men', the technology of war, eyes in the sky and *1984*.[27]

Debates on the 'death of painting' have periodically surfaced over the years – in the nineteenth century, following the invention of photography, and in the twentieth century, following the birth of conceptual art. But in the early 1980s, there was much hype and discussion in the Western art world around the so-called 'return of painting', as critics observed a broad postmodern movement of painters working in expressive, symbolic, figurative and often monumental styles. This development was widely understood as a riposte to the apparent limitations of the minimalist and conceptual art dominant during the 1970s. The sculptor and conceptual artist Bruce McLean (b.1944) was one artist who turned to painting amidst this mood. He rarely addressed the subject of war in his work but was moved by the political atmosphere and legacy of the Falklands Conflict to create a large diptych, *Broadside* (1985), a fiercely expressive and gestural work. This was followed by a related work in collaboration with David Ward, *Song for the North* (1986), an epic art piece performed at Tate Liverpool and involving water cannons, light projections and a choir.

The Falklands Conflict provided an obvious rationale for war art. Yet, throughout the 1980s, the prescriptive nature of the ARC commissions and the narrow focus on the military – as opposed to the broader effect of war on people's lives and wider society – was a concern for some members of the committee. One way to address the issue was to consider proposals from artists themselves, many of whom had become aware of the ARC following the publicity from Kitson's commission. Tom Phillips (1937–2022) approached the committee in October 1984 with an idea for a research visit to Crete to inform a new sculpture – in the form of a memorial – about the island's history of occupation, with particular reference to the activity there during the Second World War. It was a departure from the IWM's usual approach, but the committee was interested.[28] Following a period of research, Phillips returned to propose a sculpture in the form of a double-sided headstone. While visiting historic sites in Crete, he had been struck by the sight of a headstone in a German cemetery bearing the name 'Adolf Wagner'. A few days later, in a British cemetery, he had come across the headstone of a Jewish soldier called Richard Wagner, who had been killed within days of Adolf Wagner. Phillips recreated the two headstones he had seen, combining them as the two faces of one sculpture, *Einer an Jeder Seite / One on Either Side* (1985–1988) and thereby poetically connecting two lives lost in the war.

⟨

Bruce McLean, *Broadside* (1985)
Acrylic on canvas, 2,130 x 3,340 mm

The illuminated warship was inspired by a well-known news photograph of HMS *Antelope* exploding after a failed attempt to defuse Argentinian bombs onboard. McLean combines the tumult of the Falklands Conflict with an implied attack (or 'broadside') on the contemporary art world, mocking its bombast and hype around the 'revival' of painting.

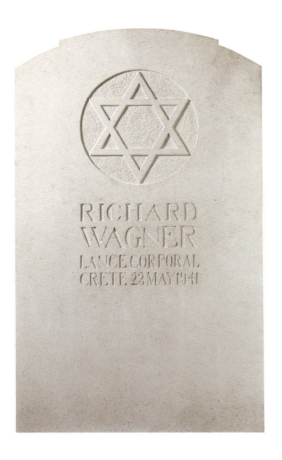

Phillips's piece joined a growing collection of works that reflected on earlier conflicts, and on the role of memorial in forming public memory and understanding of those conflicts. Earlier, during the 1970s, the sculptor Keith Milow (b.1945) made a series of formal, pared-down sculptures, mostly based on the form of the crucifix, but some inspired by the Cenotaph, Edwin Lutyens's 1920 modernist monument to the dead of the Great War. Milow's reworking of these potent symbols, simplifying them to their abstract elements, was an experiment in making them appear anew. The most radical element of *Iron Cenotaph* (1979) is the sculpture's sideways, horizontal positioning: it was designed to be displayed with its base attached to the wall, creating a jarring, weightless impression of the heavy earthbound original. Sixty years on from the Cenotaph's creation, Milow's work appeared during a period when artists were questioning the role and function of such seemingly immutable national symbols.

Exploring and critiquing the form and function of war memorials has become something of a fixation for the artist Michael Sandle (b.1936), too. His bronze *A Twentieth Century Memorial* (1971–1978), in Tate's collection, marked a turning point in his work. With a clear lineage from pop art, it features a skeletal Mickey Mouse figure in charge of a machine gun, referencing the Vietnam War and subverting the genre of sculptural memorials and

Tom Phillips, *Einer an Jeder Seite / One on Either Side* (1985–1988)
Portland stone, 1,120 x 572 x 100 mm

Phillips's concept was an understated attempt to reconcile wartime divisions and prejudices, made in the same Portland stone used by the Imperial (later Commonwealth) War Graves Commission. His work emphasises the concept of death as equaliser and connects across the divisions of faith and nationality.

Michael Sandle, *Untitled 1985 (Death and the Bulldozer with Three Drummers)* (1985)
Etching on paper, 421 x 379 mm

Armoured bulldozers were first used by the British in the Second World War and continue to be used today by the US and Israeli militaries. Here, the artist combines this crude machinery with a medieval figure of Death and pagan drummers, thereby critiquing notions of Western progress and superiority.

monuments.[29] But Sandle's work in general is an extravagant contrast to Milow's: in puncturing the pomposity of Western civilisation by likening its war machine to a kind of death cult, it is foremost about the tragedy of the human condition. These ideas are also explored in his series of prints *Death and the Bulldozer* (1985). While taking on the big themes, Sandle's work is also extremely personal, informed by his memory of taking cover from Luftwaffe bombing raids on Plymouth when he was a boy.[30] And he was part of the last post-war generation to do National Service, in his case in the Royal Artillery. Although he is highly critical of society's capacity for war and destruction, his study of, and fascination with, the role of memorial has led to some notable commissions, including the International Memorial to Seafarers on Albert Embankment, London, and the island of Malta's Siege Bell Memorial.

PALE ARMISTICE: ART OF THE COLD WAR ERA

In *Pale Armistice* (1991), the artist Rozanne Hawksley (1931–2021) created a wreath made from a variety of pale-coloured gloves – previously worn by men, women and children – as well as plastic flowers and bone, forming a memorial piece that was both personal and public. It is laden with symbolism: the gloves represent the men and women, young and old, long since departed; three lilies suggest death and the Holy Trinity; and the whole wreath itself instantly evokes the wreaths of poppies regularly made for Remembrance Sunday. The artwork was also inspired by Hawksley's memories of her grandmother, a widow who stitched collars for sailors at Portsmouth's dockyard until the end of the Second World War. *Pale Armistice* quietly, powerfully and unnervingly embodies the mourning and suffering – not exclusively, but markedly – of a particular generation of women.

As Hawksley made *Pale Armistice*, a new and uncertain era in the world's geopolitics had already begun to take shape. Momentous changes behind the Iron Curtain ushered in a thawing of the Cold War and the prospect of an end to the impasse between East and West. Few could predict what lay ahead for the world, or indeed how the next generation of artists would choose to respond.

Rozanne Hawksley, *Pale Armistice* (1991)
Plastic, textile, silk, bone and metal, 510 mm diameter

The title seems an appropriate summation of the post-1945 years, when, instead of an era of peace, the nature of warfare and diversity of conflicts simply evolved. In its form, the work suggests the cyclical nature and permanence of war – a source of bitter realisation among the post-war generation.

Theatre of Fantasy
Art from the Cold War to the Digital Age

In 1989, the IWM was rebranding as the 'New Imperial War Museum', complete with a refurbished London site containing a new atrium and galleries. As it entered a new decade, the museum was eager to position itself as an organisation in step with an ever-changing world.

For 40 years, the Cold War had conditioned the global balance of power. All that was now changing with the dismantling of the Berlin Wall, following popular protests in East Germany and liberalisation in neighbouring countries such as Hungary. The fall of the Wall held enormous symbolism in heralding the demise of the Eastern Bloc's communist regimes, the end of the Cold War and the collapse of the Soviet Union, which, by 1991, was dissolving into the Russian Federation and an array of independent republics. That same year saw the start of the Gulf War, in which the United States led a formidable military coalition against Iraq, signalling its supremacy in what now appeared to be a 'unipolar' world.

Britain maintained a 'special relationship' with its powerful transatlantic ally; by now, it had largely seen out the often painful, complex and violent processes involved in its post-1945 retreat from empire, too. At home, despite the economic setback of Black Wednesday in 1992, the country revived, enjoying a sustained period of economic growth throughout the rest of the decade, and an accompanying spirit of confidence. Encapsulated in Prime Minister Tony Blair's New Labour slogan and theme song, 'Things Can Only Get Better', this confident atmosphere was prominently on display in British art. As the 1990s progressed, London's thriving art scene became increasingly commercial, with the price of contemporary art soaring. A group of artists known as the YBAs ('young British artists') – including Damien Hirst, Sarah Lucas and Tracey Emin, and promoted by collector Charles Saatchi – achieved huge success and attention. The YBAs, whose label became a kind of brand for the sense of assuredness summed up in the phrase 'cool Britannia', were difficult to categorise. But while art about war remained largely outside of this mainstream, the YBAs' prominence would precipitate an increasing openness towards all kinds of conceptual art, using different approaches and materials; and this trend, by the end of the 1990s, would be reflected in the IWM's art commissions too.

As the decade opened, the IWM's Artistic Records Committee (ARC) sent Paisley artist Jock McFadyen (b.1950) to Berlin to record the city in the

Tony Carter, *American Dream/Arabian Night* (1991)
Acrylic and emulsion on canvas, MDF, full and empty wine bottles, bronze casts, water canteens, 3,450 x 4,270 x 610 mm

The end of the Cold War standoff was swiftly followed by a new war in the Middle East. In Carter's artwork, the line-up of bottles – full or empty of the wine of life – suggests opposing armies or assembled dignitaries. The stars of the US flag have been released from their familiar rigid arrangement to form a cosmic backdrop. The implied sense of eternity leaves room for hope and therefore the possibility of peace and reconciliation – an overarching theme of the artist's work.

aftermath of the Wall's dismantling. McFadyen was acquainted with the former West Berlin from previous trips in the 1980s, so now he took the opportunity to explore the newly opened-up East side of the city. By the time he arrived, most of the Wall had already disappeared, leaving a large open area of wilderness in the middle of Berlin. McFadyen painted disabled buskers and people working on reconstruction; he also collected found material to make sculptures of figures on the move, symbolic of Berlin's state of flux. On the surface of the Wall, too, he found inspiration, including for his painting *Die Mauer* (1991), 'The Wall'.

This sense of turning a new chapter infused the work of the ARC, whose members decided to focus their new commissions on momentous events of relevance to the IWM rather than on workaday aspects of the British military.[1] The prospect of an international military intervention in the Persian Gulf had been brewing since Iraq's invasion of Kuwait on 2 August 1990. As the British military readied itself for war, the ARC prepared for a likely commission to the region. The committee chose the painter John Keane (b.1954), whose work explored themes of war and the human condition – a direction he had discovered during the Falklands Conflict, when he had been shocked at the jingoism engendered among part of the British public. Keane's travels had taken him to Nicaragua and Northern Ireland to learn about the reality of the conflicts there. At a time when so-called 'political art' was viewed as peripheral to mainstream art, Keane was building a reputation and niche for himself as an artist who responded to the events of contemporary history. He was honoured to be approached for the IWM's commission but understandably apprehensive too; at the time, many feared that Iraq's leader, Saddam Hussein, would deploy chemical or even biological weapons in the region.[2]

The British press was intrigued that the IWM – still largely characterised as conservative and old-fashioned – was sending a young (maybe even pacifist) artist to cover the crisis. Also, now that the buzz of the Kitson Falklands commission had long faded, the press remained largely unfamiliar with the IWM in the role of art commissioner; and to many art critics, the idea of sending a war artist at all, alongside the television crews and photojournalists, seemed rather 'quaint'.[3] As for the Ministry of Defence, it was in no hurry to assist Keane in his passage to Saudi Arabia, where the US-led Coalition forces – including British troops – were training and making preparations. The IWM's art commission was understandably low down the ministry's list of concerns; moreover, Britain was not (yet) at war, so MOD officials would not countenance the use of the term 'war artist'. The museum agreed instead that Keane would be the IWM's 'official recorder' in the Gulf.[4]

The Coalition's Operation Desert Storm, to repel Iraqi forces from Kuwait, began on 17 January 1991 with a series of US-led air and missile attacks. The campaign that followed was broadcast as it unfolded, on television, to millions of viewers around the world, through the military's own footage released to rolling news channels like CNN, and through the reports of embedded news teams. Keane finally had the green light from the MOD to travel to Riyadh in early February 1991; he spent a month with British troops in the desert

Jock McFadyen, *Die Mauer* (1991)
Oil, spray paint and markers on canvas, 2,636 x 2,640 mm

McFadyen's painting replicates the Wall's famous graffiti and its state of disintegration hastened by 'wall-peckers' – the people who chipped away fragments as souvenirs. Beyond the Wall, just green and sky await, giving us a glimpse of an open future beneath the stark glare of the rising sun.

before the start of the Coalition's ground assault, followed by a brief stopover on a Royal Navy vessel patrolling the Persian Gulf, and finally five days in Kuwait City after its liberation. He had little time to observe the burning oil wells ignited by fleeing Iraqi troops or the desolation of the Basra Road, dubbed the 'Highway of Death' from its pounding by Coalition airstrikes. Using a camera and video recorder to document his impressions was vitally important for Keane: with this kit in place of a sketchbook, he was treated like another member of the press pool.[5] A few commentators took exception to such methods, but these concerns were mild compared with what was to come.[6] Keane remembered this time as 'a bit of a tourist experience really', expressing his unease as an outsider. Yet he found the whole experience in the Gulf disturbing, too.[7]

Returning to his studio in London, Keane started work on his paintings, which were finally shown to an impressed ARC in December 1991. They decided on *Mickey Mouse at the Front* (1991) and three other works for the collection, agreeing that the artist's works were 'powerful and emotional paintings'.[8]

However, when news of the museum's decision to acquire the work broke, in January 1992, it caused a furore. The painting was decried as 'depraved'; it was misunderstood as an image of Mickey Mouse crouched on the toilet, mocking the situation in the Gulf.[9] Keane had, in fact, witnessed the abandoned children's rocker, surrounded by excrement, inside a room that Iraqi soldiers had used as a latrine, and he had been immediately struck by the loaded symbolism. Here, without any artistic interference, was the smiling face so redolent of US global culture, ultimately degraded.[10]

But that controversy was not all, for the IWM's director-general, Alan Borg, took the decision to withdraw another of Keane's paintings, *Alien Landscape*, from the exhibition *John Keane: Gulf* (1992), following consultation with Dr Zaki Badawi, Principal of the Muslim College in London. Keane had pasted pages of the Koran – from a copy found discarded in the desert – around the edge of the painting. It was never his intention to shock, for he often stuck found material onto his work. Here, it serves as a memento of his experience as a bewildered and detached outsider, wandering around the surreal landscape of the warzone.[11] Nevertheless, Borg's decision provoked more headlines, and the IWM's official recorder now found himself referred to as 'controversial artist John Keane'.[12]

>

John Keane, *Mickey Mouse at the Front* (1991)
Oil on canvas, 1,730 x 1,985 mm

Keane's observations in the Gulf underscore the themes of his work as a whole: here, the shopping trolley and Mickey Mouse rocker represent the detritus of consumer culture. Amid the destruction, they encapsulate something of the absurdity inherent in humanity's darkest excesses.

The Gulf War changed the public conception of modern war and its technology, as millions of viewers around the world watched events play out via the media. Excerpts from the footage of the bombing campaign, captured by cameras on board Coalition aircraft, brought the war into people's living rooms, showcasing military precision and deadly efficiency. These military camera systems both inspired video games and were game-like in their appearance, keeping the human impact and carnage on the ground at an unseen distance. While the Vietnam War had come to be known as the first 'television war', the Gulf War would come to be referred to as the first 'video game war'; it anticipated future technical advances, such as the use of unmanned combat aerial vehicles (UCAVs, better known as 'combat drones') against targets in the twenty-first century.

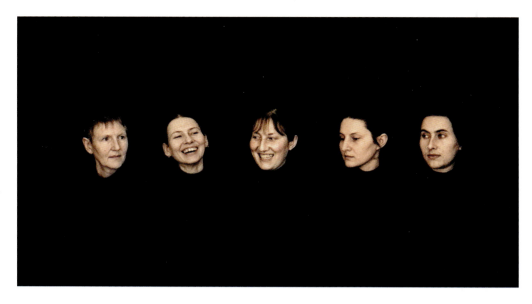

These developments prompted artists into thinking about this question of war fought at a distance, both physical and emotional, and the IWM began to collect a variety of their responses. The work of Jananne Al-Ani, Rasheed Araeen and Nicola Lane highlights national and cultural influences, and the role of the news media in formulating public understanding of a far-flung war; while sculptor Tony Carter attempted something more philosophical and eternal in his response.

Jananne Al-Ani, born in Iraq in 1966 to an Iraqi father and an Irish mother, had long been living in Britain when she made a series of personal works about the Gulf War. An early work of hers collected by the IWM, *Untitled May 1991 [Gulf War Work]* (1991), was an initial response to watching war unfold far away in her home country. The arrangement of 20 small, framed photographs juxtaposes family snaps and portraits with ancient cultural artefacts and media images of the conflict, referencing the cultural and personal costs of the war.

The IWM followed that acquisition with a commission from Al-Ani, resulting in a video installation entitled *A Loving Man* (1996–1999). This intensely personal work was intended as a foil to the abundance of IWM photographs depicting the war from a military perspective – images of Iraqi tanks, guns and helmets. It addresses her family's experience of loss and family breakdown: while they had left Iraq long before, her father had stayed behind, and war had brought the pain of separation to the fore.

Jananne Al-Ani, *A Loving Man* (still) (1996–1999)
5-screen video installation, 15 minutes

The work is arranged so that the viewer is encircled by five screens, each one devoted to one of the four sisters and their mother. Taking turns, they recite their memories of their absent father/husband in the form of a repetitive memory game.

In 1997, the IWM purchased *White Stallion* (1991) by the British-Pakistani artist Rasheed Araeen (b.1935). The work is a thoughtful and multi-layered response to the different cultural perceptions of the Gulf War, prompted by the

Rasheed Araeen, *White Stallion* (1991)
Mixed media, 1,625 x 1,990 mm

Central to the work is the defiant yet hapless figure of Saddam, enclosed by four US military aircraft in the form of a cross. Araeen's use of green in the work has many different associations: the flag of Pakistan; in Islam, the Prophet Muhammad and moderation; nature in general; and, in Western culture, youth, hope – and naivety.

artist's visit to Pakistan at the start of the conflict. There, he had been struck by the many positive images he saw of Saddam Hussein, who enjoyed popular support in the country. Indeed, one poster of the Iraqi leader astride a white horse sold 2 million copies in Pakistan: this was imagery that held profound resonances for Muslims, as it evoked Saddam's namesake Husayn Ibn Ali, a grandson of the Prophet Muhammad, who fought the tyrant Yazid I in the seventh century. Deliberately echoing Jacques-Louis David's painting *Napoleon Crossing the Alps* (1801–1805), Araeen places a horse-riding Saddam in the centre of *White Stallion*. Saddam is superimposed on an image of General Schwarzkopf, the US commander-in-chief of Operation Desert Storm, giving a press conference, as seen by the artist on CNN coverage.

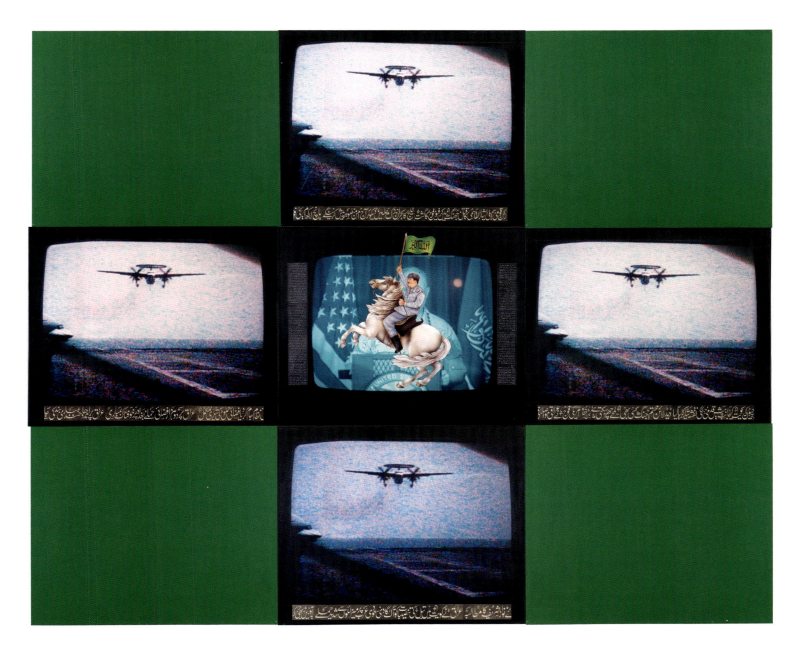

THEATRE OF FANTASY: ART FROM THE COLD WAR TO THE DIGITAL AGE

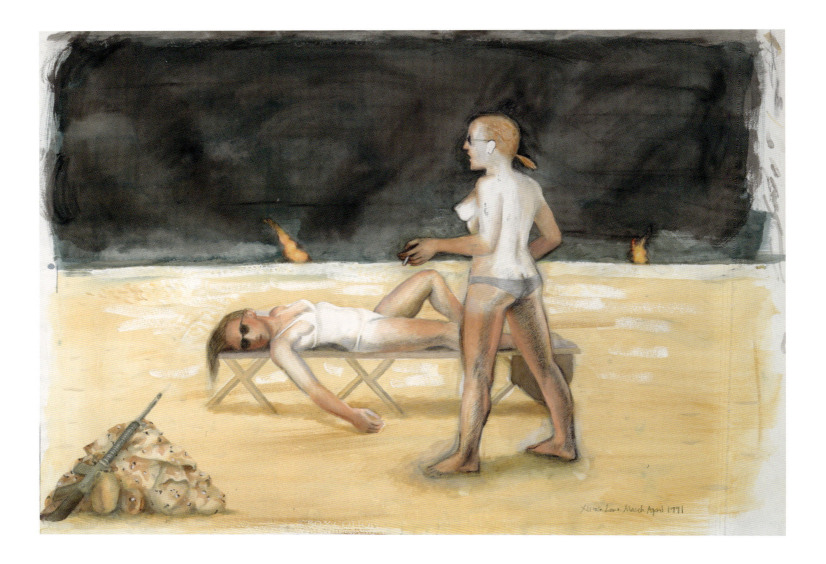

Nicola Lane (b.1949), an American-born British artist, also drew on news images to highlight the conflict's absurd and jarring elements. Her *Sunbathing Sergeants* (1991) was donated to the IWM shortly after the war. The Gulf War saw the largest single deployment of women to a combat zone in US military history, a phenomenon that drew in curious media onlookers.[13] Lane based her drawing on a photograph of two US Army sergeants – one cleaning her rifle and one sunbathing – as published in the *Independent* newspaper. She was struck by the nonchalance of the women, who treated their job as being like any other, spending their free time sunbathing against the background of a sky darkened by burning oil wells.

The presence of Western armies gathering in the Arabian desert moved Tony Carter (1943–2016) to create *American Dream/Arabian Night* (1991; *see p. 180*), an installation ripe with meaning and associations. It was first shown at the IWM in 1991, as part of a touring exhibition of Carter's work, and it was later donated to the museum by his widow, the artist Wendy Smith. Carter worked with everyday objects, arranging and transforming them into artworks full of presence and symbolism. In this case, the colours on the water canteen –

Nicola Lane, *Sunbathing Sergeants* (1991)
Watercolour on paper, 695 x 996 mm

Lane's work is an arresting image of war in a new era: a time, in the West, of supposed liberation, when women were increasingly offered space within the world of men, yet still bound within stereotypical, sexist roles.

reminiscent of the US flag – were his starting point, although the artwork was not a specific critique of the United States but rather a more timeless reflection on the variations of political precondition necessary for war. On the situation in the Gulf at the time, Carter commented that 'once again, and as so many times before, a pretext was found and a place determined for an engagement in killing'. Acknowledging that 'it's a theatre of fantasy this "theatre of war"', he created a deliberate, staged feel to the work, whose arrangement and imagery linked the celestial and the earthbound. This sense of duality also relates to a wider theme of Carter's work: the endless choices and split allegiances that people face, torn as they are 'between options at every level from the heroic to the base'.[14]

If the demonstration of Western military might in and over Iraq was one manifestation of the post-Cold War 'new world order', another was violent fragmentation in the Balkans, in what had been the Socialist Federal Republic of Yugoslavia (SFRY). In 1991, two of its constituent republics broke away, ushering in two wars, one brief (bringing Slovenia's independence) and one, between the Serb-dominated Yugoslav state and Croatia, lasting until 1995.

However, much of the worst violence resulted from the complex struggle over the fate of a third former Yugoslav republic, Muslim-majority Bosnia. In 1992, British troops arrived in the region as part of a United Nations (UN) 'protection force', in response to the vicious fighting in Bosnia's war, waged between Serbs, Croats and Bosnian Muslims. The conflict and its campaigns of 'ethnic cleansing' were reported widely in the international media.

In 1993, *The Times* approached the IWM with a proposal to collaborate in sending an artist to Bosnia. The museum agreed to the commission, and, from a shortlist of nine artists, representatives from *The Times* and the ARC chose Peter Howson (b.1958), a painter known for his preoccupation with the darker aspects of human nature. Although his work, inspired by trauma, depicted violence and confrontation, Howson – unlike Keane – did not have experience of previous warzones. In fact, he later admitted that he was not at all mentally prepared. The reality of the situation in Bosnia hit him hard the moment he stepped off the aeroplane.[15]

In the end, Howson made two trips to Bosnia, in June and December 1993. He described the experience as like arriving in the middle of a battle-zone in an alien spaceship.[16] During the ill-fated first trip, Howson fell ill and narrowly avoided sniper fire; and false rumours were printed that he had 'sensationally quit' after only four days.[17] Howson returned from Bosnia so depressed that he could not paint for six months. However, following his second trip, the artist managed to start rationalising his experiences. When he finally began to work, painting the horrors proved therapeutic. The Bosnia commission marked a turning point in Howson's work and profoundly changed him as an artist, though at a huge cost to his personal life.[18]

On 8 August 1994, ARC members viewed Howson's paintings for the first time. Their minutes recorded that they:

> ... agreed that the images were very powerful; some were most upsetting, and all portrayed the horrific nature of the conflict in Bosnia. It was established that some images depicted events which the artist had himself witnessed; others were compositions based upon a combination of experiences and reports from army contacts.[19]

The committee chose *Cleansed* (1994) for the museum's collection. It portrayed a desperate family of Bosnian Muslims, who had been driven from their homes at gunpoint by Croatians, and whom Howson had witnessed outside the UN camp where he was staying. He was unable to bring himself to draw them *in situ* (as the British soldiers had urged him to do), but their situation had nevertheless left a major impression on him, and he was able to work on *Cleansed* from memory and with the aid of video footage.[20] Two of Howson's smaller paintings, *Entering Gornji Vakuf 1993–1994* and *Three Miles from Home 1993–1994*, and three drawings were also selected for the IWM's collection. But again, controversy ensued, this time over an artwork that was *not* chosen: *Croatian and Muslim,* a painting of a violent rape scene. The committee's vote had been close – with the two women members in favour of its acquisition; but Borg's view that the artist had not personally witnessed the scene, and that therefore the work could not be included in an Artistic *Records* Committee acquisition, ultimately carried the day.[21]

Croatian and Muslim was included in the *Peter Howson: Bosnia* exhibition of 35 paintings, which was mounted concurrently at IWM London and Flowers East Gallery in September 1994. However, the ARC's decision not to acquire it for the IWM's collection provoked debate in the press about the merits of imaginative painting – albeit based on numerous witness accounts – as opposed to painting based strictly on the artist's own observations. The painting's subject matter – rape – had long been a weapon of war but one that was still largely a taboo subject, or at least only associated with brutal conflicts of the past, not modern Europe. However, reports of the Bosnian conflict brought the scale of its sexual violence to the attention of a shocked public. In the view of *The Times* leader article, *Croatian and Muslim* was 'terrifying in its art and in its impact: and according to many, the most specific symbol of a savage racial war in which rape and rumours of rape have played so dominant a part'.[22] But the newspaper had some sympathy with IWM's decision, having decided not to publish an image of the painting itself.

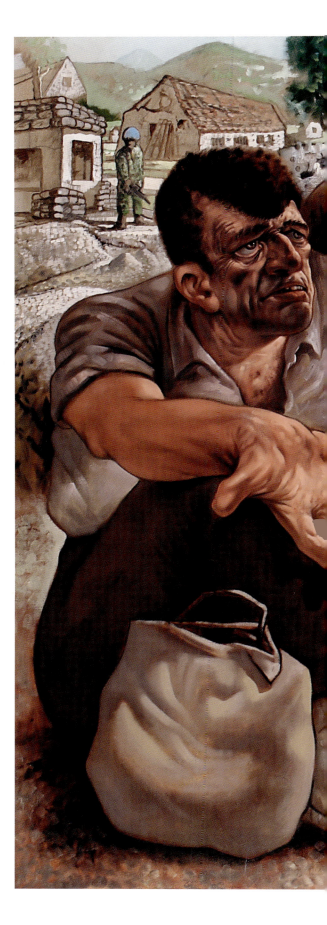

›

Peter Howson, *Cleansed* (1994)
Oil on canvas, 1,828 x 2,463 mm

Here, a vulnerable family group are left exposed to gunfire, having been denied entry to a UN camp, despite their appeals to the soldiers there. Howson evokes a sense of the group's desperation, while portraying them as monumental, almost grotesque, encapsulating his feelings on the ugly cruelty of war.

THEATRE OF FANTASY: ART FROM THE COLD WAR TO THE DIGITAL AGE

Beyond Howson's commission, the IWM went on to collect works by independent artists relating to Bosnia and the Yugoslav Wars – works that demonstrate the depth, thought, and originality of artists' personal responses to war, without the dynamic of a commission. Trio Sarajevo was a design collective based in Sarajevo, the Bosnian capital, during the city's four-year siege (1992–1996) by Bosnian Serb forces. Consisting of husband and wife Bojan and Dalida Hadžihaliliović, and their collaborator Lejla Hatt-Mulabegović, the Trio was strongly influenced by both pop art and punk, making their images on postcards at first, an affordable medium for satirising the situation they faced. They subverted recognisable commercial and artistic imagery such as the Coca-Cola logo or Edvard Munch's *The Scream*; later, many of the designs were remade as posters and reproduced by the international media.

In December 1995, the warring parties signed the Dayton Accords in Paris, producing a framework for ending the Bosnian War. Three years later, Israeli artist Ori Gersht (b.1967) went to Sarajevo to create his *AfterWar* series, now that media interest in the conflict had fallen away. He took a series of photographs, including *Vital Signs* (1999 *see pp.194–5*), indicating the renewal of life in and around the city; typically, they depicted modernist buildings that, on closer inspection, revealed the scars of the recent conflict, but also signs of recovery. Gersht's work represents a growing interest during this time in artworks that moved away from graphic depictions of violence in favour of a 'forensic' aesthetic, focused on the aftermath of war.[23] In Gersht's case, his interest in the relationships between history, memory and landscape created a thread running through his body of work.

The year in which Gersht visited post-war Sarajevo marked the outbreak of more conflict in Former Yugoslavia, this time in the Serbian province of Kosovo, whose autonomy had been stripped by the Serbian government in 1989. From 1997, tensions between Serb nationalists and the ethnic Albanian (and Muslim) majority of the province erupted into an armed uprising by the Kosovo Liberation Army (KLA), who met with Serbian state violence; and the region witnessed another campaign involving ethnic cleansing: the Kosovo War (1998–1999).

Frauke Eigen (b.1969) had first travelled to Bosnia as a young photographer in 1996, with Technisches Hilfswerk (THW), a German government disaster-relief agency specialising in infrastructure repair. She continued to work with THW, documenting their work in Serbia, Macedonia and Afghanistan, but also in Kosovo.[24] In the province, she witnessed the exhumation of a mass grave filled with victims of the ethnic cleansing, close to where she was working. Instead of photographing the bodies, she chose to document the discarded possessions in a series of black and white photographs called *Fundstücke Kosovo (Lost and Found From Kosovo)* (2000).

Trio Sarajevo, *Sarajevo Park* (1994)
Lithograph on paper, 479 x 700 mm

Repurposing the famous logo of the blockbuster film *Jurassic Park*, released in the same year, the Trio highlight besieged Sarajevo's plight with their typically dark humour.

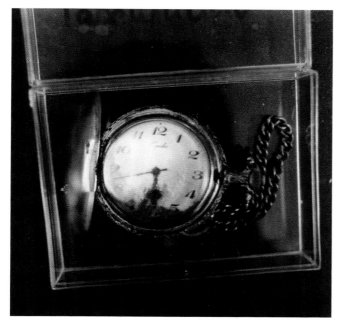

Frauke Eigen, from *Fundstücke Kosovo (Lost and Found From Kosovo)* (2000)
Silver gelatin prints, 499 x 500 mm (each)

This selection from Eigen's portfolio of 14 photographs demonstrates the stark and unnerving quality of the *Fundstücke Kosovo* series. To the artist, shirts, trousers and watches felt far more personal than dead bodies: these garments and other artefacts representing a sense of the humanity that had been extinguished.

Back at the ARC, the members were considering their own commission to Kosovo. By now, in 1999, NATO's member states had decided to intervene, conducting a bombing campaign against Serbian military targets and infrastructure, including in the Serbian capital, Belgrade. The military action was justified on humanitarian grounds, though it also attracted controversy. The strikes went ahead without UN Security Council approval, and many civilians were killed; furthermore, Serbia's initial response was to step up its campaign against the province's ethnic Albanians, forcing hundreds of thousands of people into neighbouring countries. This time, no newspaper was interested in sponsoring the IWM's commission; moreover, fewer artists responded to the call than for previous commissions.[25]

Ori Gersht, *Vital Signs* (1999)
C-type print, 1,223 x 1,533 mm

In this strikingly flat yet monumental photograph, Gersht shows people relaxing and enjoying an outdoor swimming pool in Sarajevo. Despite the mortar damage visible on the concrete wall beyond them, it is an optimistic scene, showing signs of normal life returning to the city.

The IWM was also hoping not to have to rely on the Ministry of Defence to assist the artist, so it explored working with other organisations, such as the UN, aid agencies and media agencies. When the shortlist of artists was revealed, it marked a first in the IWM's history of commissioning: there were no painters at all. This was a reflection of the nature of most contemporary art of the time – to the dismay of some committee members but to the approval of others.[26]

The commission was ultimately awarded, in September 1999, to Graham Fagen (b.1966), an artist once associated with the YBAs. His working methods involved extensive research: for the Kosovo commission, he wanted to develop his understanding of the conflict's influence on outside organisations such as the various armed forces involved, aid workers and the media, as well as their relationships with the Kosovan people.[27]

When he set off for Kosovo, Fagen knew what he wanted to do: to create a play about breakdown.[28] This idea drove his research. He learned as much as he could about the situation in the region, all the while reading classic plays and texts on themes of war, power, governance and the nature of justice, including Shakespeare's *Henry V* and *Macbeth*, Plato's *Republic* and Homer's *Iliad*.[29] On a practical level, he received some coaching from the BBC's Chief News Correspondent (and veteran of the region's conflict-reporting) Kate Adie about the kind of kit he would need and how to get around. The trip had been arranged after major hostilities were over, in December 1999. This timing certainly helped things go more smoothly with the MOD, whose Army Media Operations Unit was very helpful in getting the artist to where he wanted to be. Fagen later admitted: 'As an ex-punk and member of CND, I went out there with great respect for the media and deep suspicion of the military, but I came back with my views reversed.'[30]

The months of research paid off, because in the end Fagen had little time to pull together his proposal, which went before the ARC in January 2000. The resulting work, simply called *Theatre*, combined recorded performance with an installation of stuffed rooks and plants native to Kosovo, as well as photographs taken by the artist during his trip. It went on display in May 2000 as an immersive experience: visitors entered a theatre foyer before walking into a small auditorium, where a recording of the play was screened on a continuous loop. In it, the actors are divided into two groups, distinguished by their shirts; they begin to argue violently in languages neither side understands. The rooks are a reference to the 1389 Battle of Kosovo Polje – Serbo-Croatian for 'Field of Blackbirds' – a battle freighted with huge national sentiment for Serbs. On

Graham Fagen, *Theatre* (2000)
Mixed media installation, dimensions variable

Fagen used his time in Kosovo to gather ideas and visual material for his work, which aimed to address the power of national symbols in the collective imagination. *Theatre* is also about the breakdown in communication between communities and the way in which such intransigence can lead to violence.

that occasion, the army of Serbian Prince Lazar was defeated by the invading Ottoman forces led by Sultan Murad, heralding several centuries of Ottoman dominance. Since 1953, the site has been marked by a patriotic monument, situated outside Kosovo's capital, Pristina. It was here in 1989 that Serbian leader Slobodan Milošević delivered a speech to a huge crowd, inflaming the growing divide between Kosovan Serbs and Albanian Kosovars. Today, the monument remains a focus of national pride to the former but a bitterly resented symbol of oppression to the latter.

Fagen's work showed how people's stories of conflict from the distant past continued to bear on current tensions and underlined the importance of historical sites in the collective imagination. Around this time, as a new century approached, a new generation of young artists was tackling the subject of Europe's twentieth-century past. This generation was one stage removed from any experience of the Second World War, even as children. Nevertheless, for different motives and at different times, some of these artists decided to travel to the sites of the Auschwitz concentration-camp network, in and around the Polish town of Oświęcim. The IWM collected examples of the resulting works by Darren Almond, Paul Ryan and Mirosław Bałka, demonstrating the thoughtful and intellectual approaches of artists who chose to confront this most challenging of subjects.

Darren Almond (b.1971) was, like Fagen, associated with the YBAs and pursued an investigative type of artistic practice concerned with themes of travel and the passage of time. He felt the events of the Second World War to be completely abstract to him – a feeling of disconnection to history that he likened to being on a bus, deciding whether to get off at a stop to explore or just carry on without looking.[31] Indeed, following his arrival at Oświęcim, he chose to film two bus stops there: one busy with visitors for the museum opened at the former concentration camp, in 1947; the other, where fewer people waited, for buses heading further into Poland. This footage became his installation *Oświęcim, March 1997*, which was shown on two screens and slowed down to create a sense of an agonising wait. Replicas of bus shelters also featured in his other installations about Auschwitz, as did the town's entry and exit signs, which formed the work entitled *Border* (1999).

Darren Almond, *Border* (1999)
Cast aluminium and paint, 2,060 x 1,320 x 610 mm (each)

Like all of Almond's work about Auschwitz, *Border* is concerned with themes of arrival and departure. His methods aim to convey something of the atmosphere and emotional weight of the place via minimal and unsentimental means.

A more conventional practice – at least on the face of it – was followed by Paul Ryan (b.1968), an artist for whom drawing is central. His work aims to retain some of the spontaneity and vitality of his original sketchbook drawings, by faithfully recreating them as much larger replicas. This technique forces the artist to significantly slow down the drawing process, turning his practice into a much more contemplative endeavour.

Ryan visited Auschwitz-Birkenau around the same time as Almond, making many quick drawings in small A6-sized sketchbooks. When he returned home, he began working on *Concentrate* (2001), a reconstruction of one of his sketches. The drawing won a Jerwood Prize for its intellectual depth, derived from the meditative nature of its execution.

Paul Ryan, *Concentrate* (2001)
Ink on paper, 830 x 1,090 mm

In this work, Ryan used patterns of dots and dashes in black ink to painstakingly imitate the effect of quick pencil marks. The title can be taken as instruction to both viewer and artist – it is also a sobering reminder of the historic function of the buildings and watchtowers depicted.

Ten years older than Ryan, the Polish artist Mirosław Bałka (b.1958) is known for his works referencing the horrors of recent Polish history, such as the extraordinary installation *How It Is* (2009) for Tate Modern's Turbine Hall. Supplementing his installations and sculpture are his print works, including *A Crossroads in A. (North, West, South, East)* (2006), four images of a crossroads within the Auschwitz complex.

By the time that Bałka completed *A Crossroads in A.*, geopolitical events had propelled the world's pressing security concerns in a sudden new direction, sparked by the shock of '9/11': the deadly terrorist attacks that struck New York's World Trade Center and the Pentagon on 11 September 2001. In response to this – the most devastating attack against US territory since the Japanese assault on Pearl Harbor in 1941 – President George W Bush announced a global 'War on Terror' just days later. By 7 October, the United States, with an international coalition (including the UK), had invaded Afghanistan with the aim of toppling its fundamentalist Islamic Taliban regime

Mirosław Bałka, *A Crossroads in A. (North, West, South, East)* (2006)
Lithograph on paper, 563 x 766 mm (each)

By blanking out all identifying features, including any human presence, Bałka's images simultaneously allude to unspecified traumatic events while questioning whether it is even possible to try to articulate them fully.

and destroying Osama bin Laden's al-Qaeda terrorist network there, whose operatives were responsible for 9/11.

Three days into what became the War in Afghanistan, the IWM's ARC met, with much to discuss. The committee felt that 'the museum had established its role in creating an artistic legacy of serious events and should, therefore, do something', noting that, in the febrile atmosphere post-9/11, anything they commissioned would attract publicity. Initial ideas for themes included media responses to the war, the effect on Muslim communities in the UK, and the 'fall-out' in countries bordering Afghanistan such as Pakistan and Uzbekistan.[32]

During this time, the committee decided to change its name to the Art Commissions Committee (ACC), in recognition of its evolution. Rather than aiming for a reportage-style image, or 'artistic record', of events, the emphasis was now on individual artists' responses to conflicts in which Britain was involved.[33]

Over the course of 2002, the idea of war's aftermath became important too, as the committee admitted that the strength of its commissioning practice lay in generating more considered, reflective responses. After all, it was not always clear whether an international crisis would turn into a war situation, and it was not the IWM's job to act like a news channel, nor the job of the artist to be a journalist. The experience of Kosovo had shown that – aside from all the practical limitations, including access to the warzone, safety, insurance – it was often more productive for artists to visit sites of conflict later, employing a more reflective practice without the hubbub of the accompanying press pack.[34]

In February 2002, then, for a commission on 'The Aftermath of 11 September and the War in Afghanistan', the ACC selected Paul Seawright, as well as the artist-duo Langlands & Bell. This was the first time that the committee had sent more than one artist to cover the same conflict, although it had long been an ambition to do so; the impetus came following Graham Fagen's feedback on his commission to Kosovo. Fagen's experiences had confirmed the solitary nature of the war artist's role, as compared to, for example, journalists and aid workers in conflict zones, who had clear roles and support groups. His homecoming, rather than relieving this sense of isolation, had intensified it; he even felt distant from former war artists, for they had not attended the same conflict zone, with all its unique complexities.[35]

When the artists reached Afghanistan in 2002, Western forces and politicians regarded the war as being over. British media referred to the 'liberation of Afghanistan [being] memorialised in some excellent photographs by Paul Seawright and video installations by Langlands & Bell'.[36] The language seems bitterly ironic in the light of the long years of instability and insurgency that followed, and the eventual reconquest of Afghanistan by the Taliban in 2021 following the withdrawal of Western forces. But at that time, it was understood that the artists were surveying a country in the aftermath of war, responding to a landscape that bore the recent scars of conflict and to a society that was beginning to piece itself together again.

Seawright (b.1965), then Director of the Centre for Photographic Research in Newport, Wales, was an artist-photographer whose star was on the rise. The Afghanistan assignment was an important commission for him, bringing together ideas developed since the beginning of his career, and which he described as the opportunity of a lifetime.[37] Beginning in June 2002, his visit was organised with the help of Landmine Action, and hosted by the landmine-clearance NGO HALO Trust and the United Nations.[38] He was interested in accompanying these organisations as they mapped contaminated areas of land, so that he could photograph the barren landscapes of minefields.

Seawright was influenced by the pioneering photography of Roger Fenton, who had documented the Crimean War in 1855. Because of the limitations of his equipment – primarily, the long exposure times – Fenton did not take images of action, but of aftermath. One of Seawright's photographs from his resulting series, *Hidden* (2002), references Fenton's most well-known photograph, *Valley of the Shadow of Death,* which shows a dirt road littered with cannonballs. Seawright's photography of Afghanistan's landscapes leaves much unsaid and unseen, showing a silent but lethal world, and forming a counterpoint to mainstream photojournalism.

Hidden was a critical success, joining the IWM's growing collection of art photography on the subject of war, landscape and aftermath – a group including works like Ori Gersht's *Vital Signs* (1999; *see pp. 194–5*), Willie Doherty's *Unapproved Road 2* (1995; *see p. 227*) and Angus Boulton's *Cinema mural, Krampnitz. 16.3.99* (1999; *see pp. 222–3*). In using photography to document sites charged with past meaning, all these artists brought an archaeological quality to their work.

Paul Seawright, *Mounds,* from the series *Hidden* (2002)
Cibachrome print, 1,010 x 1,265 mm

Like much of Seawright's photography, *Mounds* gives a sense of a place filled with hidden significance and foreboding. Afghanistan's minefields were vast expanses of sand with no discernible features; here instead, the mounds represent pits of missiles and rockets, carefully collected by the mine-clearers and ready to be blown up safely.

The artist-duo Ben Langlands (b.1955) and Nikki Bell (b.1959) were chosen for Afghanistan because of their interest in conveying humanity's complex, artificial relationships – such as communication systems and networks – constructed to negotiate the world. Like Seawright, they were trying to expose that which is normally intangible, hidden from view. Their work is cerebral and often clinical in its presentation; it seemed unlikely at the outset that this commission would court controversy.

Langlands & Bell spent two weeks in Afghanistan, in October 2002. Like Seawright, they did not work with the MOD, because the British Army was not present in, nor involved in, the areas where their interest lay. Instead, they were given a contact at UNESCO, and once they arrived they were largely free to make their own contacts with local people, journalists and NGOs.[39] It was through their own initiative that they were able to visit a remote abandoned house near the village of Daruntah, in eastern Afghanistan, where Osama bin Laden had once lived; and their arrival at Kabul's Supreme Court coincided with the trial of an alleged murderer, Abdullah Shah, which the artists were even able to film. The free rein they had in Afghanistan was remarkable, though the circumstances reflected where power now lay in a country where numerous Western NGOs and aid agencies were operating, funded by the same countries that had financed the war.

Langlands & Bell's commission resulted in a trilogy of works: *The House of Osama bin Laden*, which worked like an interactive game, enabling viewers to explore a virtual reconstruction of the house and surroundings with the aid of a joystick; *NGO*, a dual channel photo animation about the proliferation of NGOs in Afghanistan; and *Zardad's Dog* (2003), a short film made from footage taken at the Shah trial. The latter film was named after Shah's nickname: while in the service of warlord Faryadi Sarwar Zardad, he had supposedly attacked his victims with his teeth before killing them.

The exhibition of these works at IWM London in April 2003 gained the artists a nomination for the Turner Prize in 2004 – a first for an IWM-commissioned artist. However, the Tate's Turner Prize show fatefully coincided with the landmark UK trial of Zardad himself, in October 2004. On the advice of the Tate's lawyers, the film was pulled from the show for fear of prejudicing the trial. The work's withdrawal inevitably attracted press coverage containing lurid details of Shah's crimes – and IWM art was again the subject of controversy.

Beyond this episode, Langlands & Bell acknowledged their experiences in Afghanistan as being intense and traumatic – experiences that continued to exert a powerful effect on their work for years afterwards.[40] Meanwhile, over the next two decades other artists addressed Afghanistan's long-running conflict.

Langlands & Bell, *Zardad's Dog* (stills) (2003)
Video, 12 minutes

The first still shows one of the witnesses testifying at the trial of Abdullah Shah, who is shown in the second still. The artists filmed the proceedings, later describing the experience as seeming 'to symbolise the struggle of the Afghan people to come to terms with the devastation of the last 23 years, as they rebuild their lives'.[41]

David Cotterrell (b.1974) was commissioned by the Wellcome Trust in 2007 to travel to Helmand province, with the support of the MOD, to record the work of the medical staff at Camp Bastion, the British Army's main base in Afghanistan. The previous year had witnessed a resurgence of the Taliban insurgency, fought against the Afghan regime and the multinational forces, with Helmand experiencing some of the worst fighting and generating mounting British casualties. While he was there, Cotterrell took the chance to photograph the work of the medical team, as they worked on the airstrip at Kandahar, transferring their patients from one aircraft to another, bound for Selly Oak Hospital in Birmingham. As the only bystander observing this activity, he was struck by the airstrip's function as a portal between the warzone and the soldiers' home country. Cotterrell traced all the soldiers he had photographed, after their recovery, to confirm their agreement to being shown in such vulnerable states. All of them wanted the images to be seen by others.[42]

David Cotterrell, *Gateway II* (centre section) (2009)
C-type print, 990 x 1,470 mm

Cotterrell's *Gateway* series is a window on the complex procedures of the army medical team; here, they are preparing to transfer their sedated patient between aircraft, as he is sent back to the UK.

The Indian-born British artist artist Shanti Panchal (b. 1951) turned to the subject of the War in Afghanistan in his work *Boys Return From Helmand* (2010). All Panchal's work has an element of autobiography, and this double portrait is above all an intensely personal tribute to his sons, who served with the Royal Marines in Afghanistan. But it is also revealing of the artist's conflicting emotions as an immigrant settled in Britain, for his distinctive contemplative style brings a degree of ambivalence to the occasion of his sons' return. Differing emotions on the part of the artist can be read into their impassive stance: pride, concern, unease over generational differences, and love. All of these relate to a central theme of Panchal's work: the idea of the spiritual journey, informed by his own passage from the tiny village of Mesar in Gujarat to London, in 1978, on a British Council scholarship to study at the Byam Shaw School of Art. Panchal's own convictions about the spirituality of all human beings and the importance of our connection to nature and the earth may well sit at odds with his sons' decision to serve in the armed forces – but that is just one facet of this deceptively simple work.[43]

There were plenty of questions over British involvement in Iraq after Britain joined another US-led coalition, in March 2003, to topple Saddam Hussein's regime. The dictator had been identified as a part of a so-called 'Axis of Evil' by President Bush and for years had been viewed as a thorn in the side of the Western powers. Early success in Afghanistan persuaded the United States that the same could be done in Iraq. The immediate pretext was the danger inherent in Saddam's presumed possession of weapons of mass destruction (WMD): chemical weapons he had used before, against Iraqi Kurds in 1988, and which, it was alleged, posed a danger to other countries. However, controversy surrounded the veracity of intelligence reports about the WMD, and some Western allies, such as France, refused to back the invasion. There were also mass protests against the prospect of war, including in London in February 2003, where an estimated 1 million people took to the streets.

A new war meant a new IWM commission, and in May 2003 the ACC chose the Turner Prize-winning artist Steve McQueen (b.1969) from a shortlist of many high-profile artists who pitched for it.[44] McQueen's task was beset with difficulties. President Bush had trumpeted 'Mission Accomplished' on 1 May, after the rapid collapse of Saddam's regime and his military; but that made way for a complex and combustible situation in the country. When, in December 2003, McQueen made a brief visit to the southern city of Basra, with the assistance of the MOD, it could not have been more different to Langlands & Bell's experience in Afghanistan. The MOD was so concerned about safety that McQueen was more or less confined within the camp boundary. He hoped to make a second trip to Baghdad, but over the course of 2004 the situation did not improve, and the MOD felt that it was too dangerous to host the artist, much to McQueen's frustration.

A different approach was needed. McQueen came up with the idea of a set of commemorative postage stamps, featuring British service personnel who had died in Iraq. During his short time with the army, McQueen had been moved by the commitment of the young soldiers. At the ACC meeting in February 2005,

Shanti Panchal, *Boys Return From Helmand* (2010)
Watercolour on paper, 776 x 592 mm

This portrait of Panchal's sons, standing dutifully for their father after their military service in Afghanistan, is rendered in the artist's characteristic style, blending Indian and European influences. Their distinctive brows reference a 'third eye', often seen in traditional Hindu art.

members approved the idea of honouring the soldiers, feeling that it 'linked well with the Museum's role as a memorial to effort and sacrifice', although they anticipated that it would be 'complex and difficult to organise and administer'.[45] Indeed, there followed a prolonged period of negotiation with the Royal Mail, but by early 2006 it was clear that the postal organisation would not agree to turn McQueen's idea into an official set of postage stamps. The MOD had decided it could not grant the museum access to the soldiers' families, because of sensitivities surrounding their loved ones' deaths – and the Royal Mail did not want to be involved without MOD approval.

With such complications, McQueen's Iraq commission stalled until 2007, when the Manchester International Festival stepped in to co-commission the work. Now entitled *Queen and Country*, it comprised a custom-made cabinet with pull-out racks to view the stamps, which were now unofficial facsimiles. The festival would fund its production, as well as providing the artwork's first venue: Manchester's Central Library.[46] While the MOD remained lukewarm towards the idea, McQueen and his team did their own research to find and contact the families of the deceased soldiers, discovering that the vast majority of families wanted to be involved.

Neither explicitly pro- nor anti-war, McQueen's work tapped into a general feeling of sympathy and support for those serving in both Iraq and Afghanistan – this despite the public's growing disenchantment with Britain's military commitments there.[47] After Manchester, *Queen and Country* went on display at the IWM, striking such a chord with the public and the art world that the fundraising charity Art Fund agreed to gift the work to the museum in November 2007. Art Fund even launched a campaign for the Royal Mail to issue McQueen's work as postage stamps, a cause taken up by a significant section of the press in March 2008, during the build-up to a UK tour of the work – but ultimately without success.[48]

Both conflicts, in Afghanistan and more controversially in Iraq, were framed as aspects of the ongoing 'War on Terror'. While it was a contentious phrase, and even a nebulous concept, the ramifications of the policy were nevertheless profound. For a start, military actions were no longer defined by a conventional state of war between states. There was a rise in the use of combat drones to attack targets thousands of miles away. The CIA began a programme of 'extraordinary rendition', abducting terrorist suspects and transporting them to secret locations and third-party countries around the world, and subjecting them to 'enhanced interrogation techniques'. In the UK, the potential threat from terrorists prompted draconian new anti-terrorism legislation, such as the power to detain suspects indefinitely without charge. This heightened climate, with its sense of continuous conflict and tension, provoked a range of artistic responses, at the same time as the old distinctions between 'political' art, or activist art, and the mainstream art world were beginning to break down.

Steve McQueen, *Queen and Country* (2006–2010)
Mixed media installation, 1,900 x 2,600 x 1,400 mm

McQueen's installation is an oak archival cabinet containing pull-out drawers of sheets of stamps, each bearing portraits of a British serviceman or woman who died in Iraq. Reminiscent of a catafalque and casket, the piece is both a formal and intimate memorial to the dead.

The IWM began to collect a range of works responding to this theme. These included one of the most memorable images to come out of the Iraq War, *Photo Op* (2007) by kennardphillipps – a collaboration between Peter Kennard (b.1949) and Cat Phillipps (b.1972). They began making work in response to their anger at the British government's decision to support the invasion. kennardphillipps use digital collage to create arresting juxtapositions, of which *Photo Op* is a prominent example and has been widely shared online.

kennardphillipps produced this, and other images, for the Stop the War Coalition, which had organised the mass protest in February 2003. *Photo Op* also prefigures the shadow that Iraq has cast over Blair's legacy ever since.

kennardphillipps, *Photo Op* (2007)
Pigment print on paper, 560 x 547 mm

The image is a punchy critique of British Prime Minister Tony Blair, who took the UK into the Iraq War. By implicating him as an enthusiastic warmonger, *Photo Op* exemplifies the imagery of the anti-war movement of the time.

> 2001 Black smoke from a tall tower seen across roofs and skyscrapers its twin to the left intact and a plane slightly tilted black silhouetted against the blue sky

Edmund Clark and Max Houghton, *Orange Screen: War of Images* (still) (2016)
Looped film, 5 minutes

This still from the film describes one of the infamous images of the 9/11 attacks on the World Trade Center. By replacing the actual images with descriptive text, Clark both reminds us of the photographs' ubiquity and makes them appear anew, distancing them from their context.

Edmund Clark (b.1963) confronts many different disturbing aspects of the War on Terror in his work, from photographs of the US military detention facility for terror suspects at Guantanamo Bay, Cuba, to works that document the reality of life for those under 'control orders' in the UK. Introduced in 2005, control orders could render individuals subject to various constraints, such as forced relocation, tagging and curfews – conditions akin to house arrest.[49]

After exhibiting Clark's work in the show *War of Terror*, IWM purchased his film *Orange Screen: War of Images* (2016). Made in collaboration with the writer and curator Max Houghton, it focuses on the visual language of the War on Terror by referencing the most well-known images of the period. The film scrolls through a timeline of events in the years 2001–2016, using text to describe familiar and widely published media photographs. Clark's use of orange relates to the notorious uniform of the inmates at Guantánamo Bay. The colour orange went on to be exploited for propaganda purposes from 2014 by the Islamist insurgents of ISIS (Islamic State of Iraq and al-Sham), during their campaigns in Iraq and Syria, when they dressed their Western captives in the same type of orange jumpsuits as used at Guantánamo Bay.

In 2004, reports and photographs began to emerge of the abuse, torture and sexual humiliation of prisoners by US military personnel at Abu Ghraib prison in Iraq. The images shocked the world, and many artists responded in their work. Albert Adams (1929–2006) made a series of drawings on Abu Ghraib, part of wider body of work confronting humanity's atrocities. His background as a young man of African and Indian heritage growing up in apartheid South Africa fuelled his commitment to the themes of political injustice and conflict. Adams was barred from art education in South Africa but gained a scholarship to study at London's Slade School of Art in the 1950s, and he remained in the city for the rest of his life. A prolific artist, Adams made paintings, drawings and prints that channelled the pain and alienation of his life to create expressive and compelling works, which often address humanity's base, brutal instincts.

British artist Rachel Howard (b.1969) was also moved to respond to the events at Abu Ghraib. Although she works mostly as an abstract painter, she was struck by the image of Ali Shallal al-Qaisi, an Iraqi detained at the prison, who was forced to stand hooded on a plinth-like box. The photograph was reproduced on the cover of the *Economist* in May 2004 with the headline 'Resign, Rumsfeld' – in reference to the US Secretary of Defense (2001–2006) whose policies and attitudes were blamed for enabling the prisoners' mistreatment. The image reminded Howard of the Crucifixion. Like Adams, she approached the notorious news imagery with sensitivity, making a small painting in response and later creating a print, *Ali Shallal al-Qaisi* (2016).

For Cuban-American artist Coco Fusco (b.1960), 'What surprised me most about the pictures of prisoner abuse at Abu Ghraib was the presence of women in them.'[50] She researched this topic further in her video work *Operation Atropos* (2006), for which she booked a training course with Team Delta – a group of ex-US military interrogators who offered 'authentic military experiences' to civilians, for a fee. Fusco filmed herself and six other women volunteers undergoing the immersive training, which required them to be subjected to the interrogators' methods. The work explores the shifting role of women in global warfare, as well as the blurred line between interrogation techniques and torture.

To supplement *Operation Atropos*, IWM acquired Fusco's *A Field Guide For Female Interrogators* (2008), a parody of a CIA manual, which explores women's new roles in the US military, and which details – with diagrams – ways in which female interrogators can use sexual assertiveness to induce breakdown, and thus compliance.

Rachel Howard, *Ali Shallal al-Qaisi* (2016)
Archival pigment print in colours, 584 x 432 mm

Writing the victim's name in reverse is a tactic designed to encourage slower reading and thus time to absorb his name, which, Howard felt, had been forgotten. The work is a humane and understated tribute to a man who suffered at Abu Ghraib as well as a symbol of the wider injustices that took place after the Iraq War.

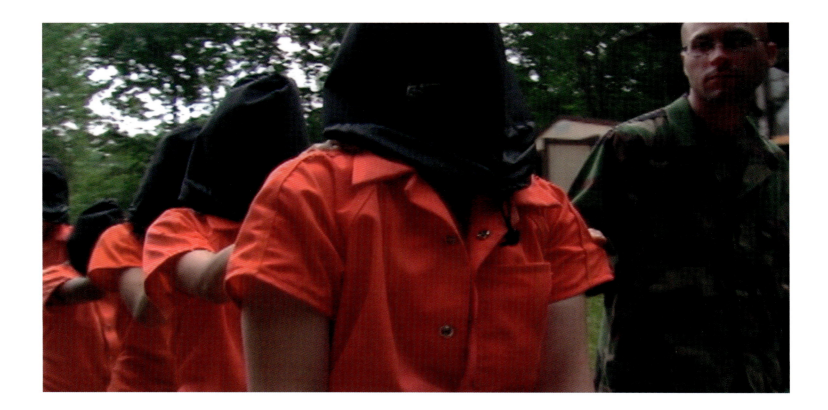

The notoriety of Abu Ghraib continues to have resonance, especially for Iraqi artists who remember how the prison had also been a site of fear and torture under Saddam's regime. Mohammed Sami (b.1984) was born in Baghdad, living through Iraq's subsequent wars before eventually leaving the country as a refugee in 2007, to settle initially in Sweden. He went on to study fine art at the University of Ulster and at Goldsmiths College (University of London), making paintings that express a kind of muted horror. Finding that 'belated memories' of war were triggered by common everyday objects, Sami made the objects themselves the subject of his paintings. In 2023, IWM acquired his *Abu Ghraib* (2022), a typically jarring painting, showing the shadows cast by a pair of trousers, hung from a wall.

For artists who have survived the worst excesses of war, such as campaigns of attempted genocide, it is not straightforward to address their experiences in their work. The process can often take decades, as artists find themselves confronted by the subject again many years later, when painful memories resurface. It is not – as the cliché goes – that art is a way to release, or work through, past trauma, for there is nothing that neat about making work of this kind; rather, it is that, as artists, they are using the tools that come naturally to them, and with which they are well practised: communication, visual fluency and imagination. Work in this vein shows the endless creativity of artists in expressing their worlds, and the capacity for art to communicate human loss and pain. Although such artists are not always professionals, it is often those who have honed their craft who are able to devise the most original and interesting responses. Even so, taking on their traumatic past is often a lengthy process, beset with difficulties.

Coco Fusco, *Operation Atropos* (still) (2006)
Single channel video, 55 minutes

Fusco's film reveals the techniques used by military interrogators, including the so-called 'love of comrade' tactic: that is, compelling a captive to confess in order to prevent a fellow detainee from being hurt. In the film, the instructors conclude that this method is particularly effective on women prisoners.

Mohammed Sami, *Abu Ghraib* (2022)
Mixed media on linen, 2,150 x 1,400 mm

The form and starkness of this painting evoke the infamous images of the prison's abused prisoners, while the artist's decision to focus on a banal, everyday item conveys something of the disturbing and ongoing repercussions faced by survivors of conflict.

Osman Ahmed (b.1962) had direct experience of the brutality of Saddam Hussein during his regime's Anfal campaign, in 1988. Notoriously, government forces used chemical weapons (mustard gas and sarin) as part of a genocidal attack against the Kurdish people of northern Iraq, who – partly through the efforts of Kurdish *peshmerga* fighters – had achieved *de facto* autonomy in the 1980s. The Anfal campaign is estimated to have left almost 182,000 dead. Ahmed, who was born in Sulaimani (in northern Iraq), in the south of what he and many Kurdish people define as 'Kurdistan', witnessed these atrocities before he fled over the border to the Kurdish region of Iran, where he taught art to child refugees from the gas attacks at Halabja. He was later taken prisoner in Tehran, before travelling as a refugee to Syria, Russia and eventually to Britain. It was in the UK that he started to put pen to paper, studying for an MA in drawing at Camberwell College of Arts before gaining a PhD at Chelsea College of Art. Ahmed's flashbacks and dreams of the Anfal campaign found their way into drawings such as *Migration* (2007) – drawings that blur figuration and abstraction, with the implication that some memories are too traumatic to reveal fully. The drawings were displayed in his solo exhibition *Displaced* at IWM London, in 2008. They later formed the basis for vast iron friezes installed at three former sites of the Anfal campaign in Iraqi Kurdistan, where the artist now resides.

Roman Halter (1927–2012) suffered powerful flashbacks, too, and chose to recreate them in his work. Originally from Poland, Halter was a Holocaust survivor – the only survivor from among his family. Following the Second World War, he came to Britain with more than 700 child survivors, subsequently nicknamed 'The Boys', and was sent to Windermere in the Lake District, to receive physical and social care. Halter went on to study architecture, after which he established a successful practice. He took up art in the 1970s, working in painting, drawing and stained-glass. Most of his work celebrated the beauty of life; but he also made a series of paintings reflecting the brutality of his wartime experiences. In the last decade of his life, Halter started making tiny watercolours of the beautiful Dorset countryside near his daughter's home. Around this time, his sleeping patterns changed; now he could remember vivid dreams and painful nightmares relating to his childhood experiences in Poland. He documented these too, incorporating them into the otherwise peaceful landscapes and creating the series *Dreams of the Holocaust*.

Osman Ahmed, *Migration* (2007)
Ink on paper, 80 x 232 mm

Ahmed's deceptively simple line drawing technique conveys how a mass of people becomes a distinct entity in itself. It also shows how the forced displacement of people serves to dehumanise them.

Roman Halter, *Dreams of the Holocaust: Gathering Jewish People From Village in Dorset Landscape* (2005)
Watercolour on paper, 203 x 291 mm

Here, Halter describes an idyllic landscape, with 'turquoise-light blue' sky and 'green, late spring fields', but within it is a wire enclosure containing tightly packed Jewish women and children, guarded by members of the Nazi SS. Of this, and his flashbacks in general, he writes: 'why always just mothers and their children? Is [it] because my mother & my half sister with her two small children were taken to the extermination camp of Chelmno-on-Ner?'

In my dream on Sund. 27. Nov. 2005 @ 1:28 am. The sky was turquoise-light blue, mist grey, white snow in parts of the Alps, the way we saw the mountains when we travelled from Geneva by bus to Meribel. But the fields were not winter fields. They were green, late spring fields. In the middle behind a wire-fence enclosure, tightly packed & all standing, were Jewish mothers with their children (Why always just mothers and their children? Is because my mother & my half sister with her two small children were taken to Chelmno-on-Ner?) The S.S. guards were evenly positioned on the outside, all around the wire compound/wire pen.

Shmuel Dresner (1928–1920) created *Benjamin* (1982), a remarkable personal tribute to a friend he met at Buchenwald concentration camp in 1942, when they were both teenagers. The artist remembered Benjamin, a year older than him, as a young man of style: despite being forced to wear the same clothes for two years, Benjamin had found ingenious methods to repair them. His Polish navy-blue four-cornered hat completed the look. Benjamin was always optimistic – and too trusting. When their names were called before the next deportation, Dresner remembered that his friend was convinced that this meant they were to go by train, while the others would walk. For some reason, Dresner decided to hide when the time came; and that night he found out that Benjamin and the others answering the call had been shot. Like Roman Halter, Dresner came to England as one of 'The Boys'. Suffering from tuberculosis and malnutrition, he spent years in recovery at Windermere, where he started painting as a form of therapy.

Shmuel Dresner, *Benjamin* (1982)
Burnt newspapers and acrylic paint on paper, 445 x 375 mm

Forty years on from his wartime experiences, Dresner developed a technique of using burnt paper to make works that invoke the violence and destruction brought about by Nazi Germany. This portrait of his friend Benjamin is a haunting example.

The legacy of the Holocaust was one theme within a wider, more reflective approach to war art, which the IWM had been developing in the first decade of the twenty-first century. Another aspect of this collecting was the contested legacy of the Soviet era, addressed in works by Angus Boulton (b.1964) and Kerry Tribe (b.1973). Boulton visited abandoned Soviet military bases in and around Berlin between 1998 and 2006, using photography to document their interiors and exteriors before they were pulled down. *Cinema mural, Krampnitz. 16.3.99* (1999) is one example. Tribe's documentary-style film, *The Last Soviet* (2010), tells the story of Sergei Krikalev, the cosmonaut who lived onboard the Mir space station for months during the collapse of the Soviet Union in 1991. Known as 'the last Soviet', Krikalev found his mission extended when the Union's dissolution meant that he was unable to return home at the planned time.[51] Blending archival footage with scenes shot inside a model of the space station, the film's accompanying, but mismatched, narration brings an unsettling dimension to the work. In this way, Tribe draws our attention to the construction of such historical narratives, calling into question the reliability of both memory and history.

This reflective approach also came to inform the commissioning programme of the ACC following the commissions in Afghanistan and Iraq. For the first commission to fulfil this perspective, the committee decided to return to its long-running founding subject: Northern Ireland's Troubles.

Over the 1980s, and beyond, the IWM had continued quietly collecting a rich and diverse selection of art on the Troubles, as more artists responded to this prolonged period of violence and political deadlock. Most of these artists lived in the province and turned to the subject as a way to express their experience and examine its complexities beyond the limitations of news reporting. Among others, this collection features works by artists Rita Donagh, John Kindness, Seán Hillen and Willie Doherty.

Angus Boulton, *Cinema mural, Krampnitz. 16.3.99* (1999)
C-type print, 405 x 508 mm

Boulton's photographs capture a sense of absence in the peeling walls and dilapidation of the spaces, long since abandoned following the end of the Cold War. The images also represent a record of a defeated ideology, its physical manifestation soon to be consigned to oblivion.

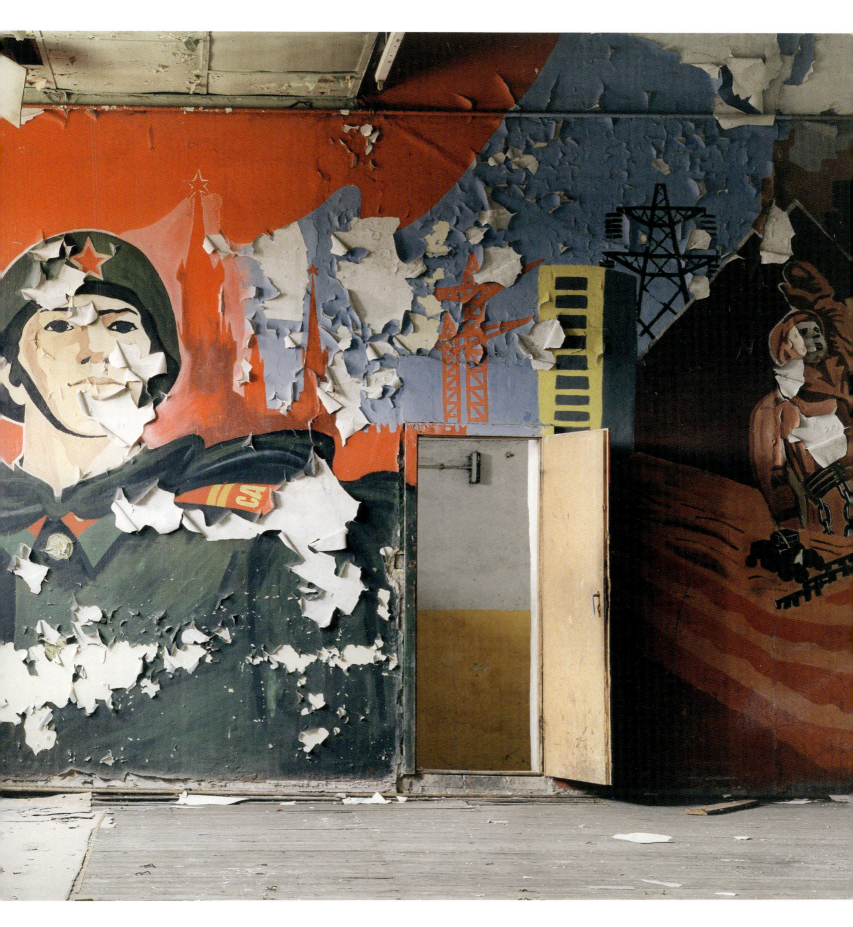

THEATRE OF FANTASY: ART FROM THE COLD WAR TO THE DIGITAL AGE

Rita Donagh (b.1939), a British-based artist of Irish descent, made many works that explicitly addressed current affairs, notably including the Troubles. She began with a series of contemplative and layered works that explored the province's cartography. In them, she repeatedly returned to certain themes: the subjective nature of map-making, and the plans of the Maze prison. Nevertheless, her works do not take sides and avoid simplistic interpretation.

A decade later, the Belfast-born artist John Kindness (b.1951) addressed the role of gender and identity in relation to sectarian violence in the sculpture *Sectarian Armour* (1994). Kindness transforms the 'uniform' of the denim jacket, worn by Belfast 'hard men', into a kind of medieval armour. Its formal symmetry shows the power of emblems in the construction of a fierce identity on both sides, with British Loyalist iconography of Queen Elizabeth II and the bulldog on one side, and Irish Republican iconography of the Ulster hog, the harp and the Virgin Mary on the other.

Seán Hillen (b.1961) uses photo-collage to satirise the strain and absurdities of living in Northern Ireland. Born in Newry, near the border with the Republic of Ireland, he came to study at the London College of Printing and the Slade School before returning to his hometown in 1993. The works do not shy away from presenting the tension of living with the threat of everyday violence, while often employing a dark and surreal humour.

Willie Doherty (b.1959), from Derry/Londonderry, is a pioneering artist working in film and photography, whose work explores the legacy of the Troubles as well as other sites of contested memory, such as Granada (Spain) and the US/Mexican border. His imagery centres on the troubled relationship between landscape and memory, inviting comparisons with that of his fellow countryman, Paul Seawright. Doherty's work documents the landscape, showing it as charged with meaning; it also demonstrates film and photography's capacity for ambiguity, acting as a foil to the news imagery of the province.

The ACC's return to the subject of Northern Ireland in 2008 was prompted by that year's milestone: ten years had passed since the signing of the Good Friday Agreement. Also called the Belfast Agreement, the historic settlement of 1998 – negotiated by the British and Irish governments, and the province's political parties – had brought a formal end to the Troubles. It ushered in a new power-sharing Northern Ireland Assembly to administer devolved power, while other reforms included a new police service, prisoner releases and agreements by the paramilitaries to get rid of their weapons.

John Kindness, *Sectarian Armour* (1994)
Etched steel and brass, 600 x 500 x 260 mm
Among the many details on this work is a parody of the Levi Jeans logo on the back, with politicians Gerry Adams (of the Republican Sinn Fein) and Ian Paisley (of the Democratic Unionist Party) pulling horses in opposite directions. Below them, mourners carrying a coffin are united in grief, the skeletons beneath their feet still clutching their handguns.

Rita Donagh, *Shadow of the Six Counties* (1981)
Pencil, ink, crayon, watercolour and gouache on card, 553 x 553 mm

The drawing shows the plan of the notorious Maze prison, where political and paramilitary prisoners were held. Its H-block layout looms large over layers of maps of Northern Ireland, merging abstract and representational forms. In contrast to the state of tumult and violence on the ground, the work is delicate and ambiguous, yet ominous.

THEATRE OF FANTASY: ART FROM THE COLD WAR TO THE DIGITAL AGE

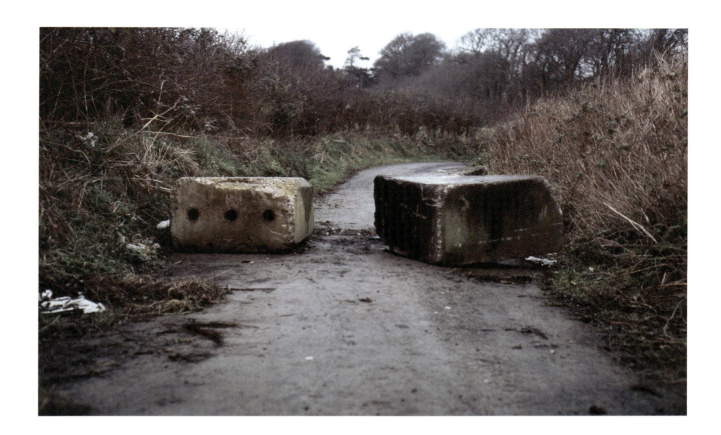

Seán Hillen, *Newry Gagarin Crosses the Border* (1993)
Collage on paper, 498 x 400 mm

This collage is typical of Hillen's wistful humour. With a distinctly Cold War flavour, he parodies life in the mainly Catholic border town of Newry – where the world beyond the frontier feels as remote and as difficult to navigate as outer space.

Willie Doherty, *Unapproved Road 2* (1995)
Cibachrome print, 1,255 x 1,830 mm

This photograph of concrete roadblocks, taken at a border road in Donegal, north-west Ireland, is characteristic of the artist's seemingly simple, yet tense imagery. Despite its forensic quality, revealing previous damage from an impact to one of the blocks, much is left unanswered, and the image hovers between the sinister and the mundane.

Glasgow-based artist Roderick Buchanan (b.1965) was one of small number of artists who were interested in taking on the subject: for him, it was personal, for he has both Catholic and Protestant roots. In fulfilment of his brief to create a new artwork 'on the legacy of the Troubles in Northern Ireland', Buchanan chose to collaborate with Glasgow flute bands, whom he had worked with before.[52] Buchanan's approach revealed the close link between Scottish and Northern Irish sectarianism. He worked with the Protestant Black Skull Corps of Fife and Drum and the Parkhead Republican Flute Band during rehearsals in Glasgow, before following them to Derry/Londonderry to film them during the marching seasons in 2009 and 2010.

There were still some sensitivities at play during this time: Unionists were not happy with Buchanan being referred to as a 'war artist'; and there was also concern at the commission's timing, given that in 2009 two soldiers and a policeman had been killed in the province, murdered by Republican splinter groups that rejected the Good Friday Agreement.[53] The resulting exhibition, *Legacy*, which opened at IWM London in May 2011, was the first IWM art exhibition to address explicitly the conflict in Northern Ireland. As well as Buchanan's film *Scots-Irish / Irish-Scots* (2011), it included portrait photographs of members of the bands.

 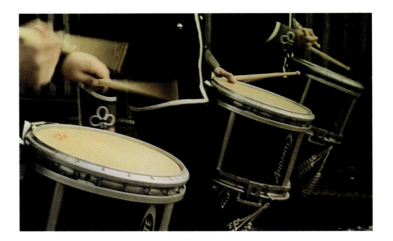

In 2011, Colchester gallery Firstsite decided to revisit the situation in Afghanistan, in association with IWM. They chose Mark Neville (b.1966) to accompany the British Army's 16 Air Assault Brigade on their deployment to Helmand, during a time when they were working alongside Afghan forces to repel the Taliban and help provide security for the rebuilding of civil society. With the insurgency grinding on, the mood was very different to the optimism of 2002 when Seawright and Langlands & Bell were commissioned. Neville's films and photographs show an arrestingly direct and poignant view of British troops and the Afghan civilians they encountered.

Looking at Neville's work can be an uncomfortable experience for the viewer, for the perspective involved evokes the old power dynamics of the colonial gaze: here, the artist's large camera mounted on the vehicle is met with the stares and scrutiny from the people in the market. This perspective, and the evident mix of expressions shown, suggest a complex relationship between the British Army and the people of Afghanistan.

For the ACC's next commission in this more reflective direction, it decided to tackle the legacy of British imperial involvement in Israel/Palestine and its relevance to the current situation in the Middle East.[54] This would build on the rich and varied existing collection relating to the region, including works by James McBey, Edward Bawden and John Keane. In June 2010, the committee selected Rosalind Nashashibi (b.1973) from a shortlist of five artists, for its commission to Gaza.

Nashashibi was born and brought up in Britain, but she remembered visiting the Gaza seaside as a child, with her Palestinian father. The smaller of the two Palestinian territories, the Gaza strip had been occupied by Israel during the 1967 Six Day War. By 2005, Israeli forces and settlers had begun a process of withdrawing from Gaza, with Israel retaining control over its airspace, waters and most of its borders. In 2007, the militant nationalist organisation Hamas took control of Gaza, and the ensuing tension between Israel and the Hamas authorities has resulted in open conflict several times since.

Roderick Buchanan, *Scots-Irish / Irish-Scots* (still) (2011)
Dual-screen projection, 70 minutes

Two films display simultaneously, on a loop, their screens separated by a partition, requiring viewers to face one side or the other. One film follows Parkhead Republican Flute Band during the annual Easter Rising Parade in Derry/Londonderry, 2010; the other follows Black Skull Corps of Fife and Drum around the walls of the city, on the 320th anniversary of the lifting of the city's siege imposed by pro-Catholic Jacobite forces. While one film is playing sound, the other, alternately, is silent.

Mark Neville, *Bolan Market* (still) (2011)
Single-channel projection, 6 minutes

Neville filmed this from a British armoured Husky vehicle during a single drive through the market at Lashkar Gah, soon after it was liberated from Taliban control. Its silent, slow-motion technique allows the viewer to see every nuance in the expressions of the people returning the gaze of the camera.

Anticipating the complexity of the commission, IWM decided not to announce the project until it had been completed. It was not plain sailing, with delays from the start and difficulties in finding a suitable NGO to host the artist. Serious concerns remained, regarding safety and access to Gaza; and the Egyptian military coup in the summer of 2013 had effectively sealed off access to the territory via Egypt.[55] Finally, in June 2014, Nashashibi spent about a week in Gaza, entering via Israel, but had to cut her visit short because of 'escalating trouble and a period of significant bombardment from Israel'.[56] Nevertheless, with the help of her extensive film footage from the trip, she began to develop ideas. She had Gaza's inaccessibility at the forefront of her mind; she was struck, too, by the scenes of everyday life carrying on regardless of the conflict. Nashashibi had hoped to make another visit, but this time the practicalities proved too difficult to overcome.

The film that Nashashibi created, *ELECTRICAL GAZA* (2015), premiered in October 2015 at IWM London. It was well received, earning the artist a Turner Prize nomination in 2017. Named after Gaza's charged atmosphere, the work aimed to portray the reality of life there, while also showing something of its nature as an alternative universe – a place under a spell.

Rosalind Nashashibi, *ELECTRICAL GAZA* (still) (2015)
HD transfer from 16mm film, with animation, 18 minutes

In this film, Nashashibi combines her footage of the cities, beaches and refugee camps of the Gaza strip with animated scenes. The still shows the Rafah Border Crossing between Egypt and Gaza rendered in computer animation.

As well as Nashashibi's film, IWM began a project to build a new collection, shared with Wolverhampton Art Gallery, about 'conflict in Israel/Palestine and its implications in the wider Middle East'. Works acquired included the series *GH0809* (2010) by Taysir Batniji (b.1966), a Palestinian artist based in Paris, who came to prominence following his receipt of the prestigious Abraaj Group Art Prize in 2012.[57] Batniji's approach to making art about the situation in his homeland employs grim humour and surrealism: *GH0809* parodies estate agents' boards to present houses in Gaza scarred by strikes during the five-week Israeli offensive known as 'Operation Cast Lead' (2008–2009), also called the 'Gaza War'. He was not permitted to travel to Gaza himself, so he asked a journalist friend to photograph the houses on his behalf. The wit of Batniji's approach is an unsettling device that serves to drive home the pervasive devastation and sense of loss all too familiar to the residents of Gaza.

Wolverhampton Art Gallery and IWM also acquired together *The Nation Estate* (2012), a film by Larissa Sansour (b.1973), which presents a dystopian sci-fi fantasy. The work was made during Palestinian representatives' bid for UN membership in 2011, with Sansour's ideas revolving around the problem of the ever-diminishing plot of land left for any Palestinian state. On the one hand, Sansour felt there was something absurd about translating the gravity of Middle Eastern politics into high production-value science fiction. However, she also believed that science fiction could encapsulate the Palestinian predicament effectively, because of the way that hopeful ideals can co-exist with a sense of fear and bleakness within the genre: 'sci-fi seems to lend itself well to capturing the decades of Palestinian yearning for a utopia that almost seems dated by now.'[58]

Larissa Sansour, *The Nation Estate* (still) (2012)
Single-channel projection, 9 minutes
In Sansour's futuristic fantasy, Palestinians finally have their state, but it is in the form of a vertical skyscraper housing the entire population. Each city – Jerusalem, Ramallah, Bethlehem, etc. – is on a separate floor, so that inter-city trips can now be made by elevator rather than be hampered by checkpoints.

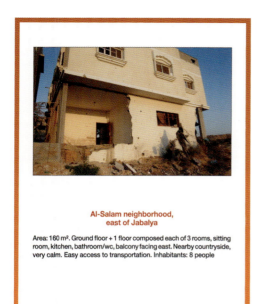

Also acquired was the series *Landscape of Darkness* (2010) by Yazan Khalili (b.1981), a Palestinian artist based in Amsterdam. Khalili frequently returns to his homeland to make artworks, including this series, which was taken at night in the area of the Occupied West Bank designated 'C'. Covering around 60 per cent of the West Bank, Area C has a paradoxical status, being recognised as Palestinian but administered by Israel.

Using the cover of darkness afforded by the roads out of Ramallah, the artist directed his camera at the well-lit Israeli settlements in the distance. The work was not only technically challenging, but fraught, considering the restrictions faced by Palestinians on these 'bypass' roads, designed to connect Israeli settlements.[59] The resulting works are subtle and thoughtful, if sinister – as the encompassing darkness symbolises many troubling aspects of life there. But Khalili also shows how, for Palestinians, the traditional meaning of light and dark becomes inverted, with the enveloping darkness offering cover and protection from the threat represented by the brightly lit towns in the distance.

Taysir Batniji, *GH0809 Maison # 20* (2010)
Digital print on paper, Perspex and metal,
357 x 271 mm (each)

In these works, Batniji seeks to convey a sense of the reality of living in Gaza when any attempt to live a normal life seems increasingly absurd. As well as the banal details that estate agents typically advertise, such as number of square metres and number of rooms, the accompanying text grimly includes the number of former inhabitants.

(Next Page) Yazan Khalili,
Landscape of Darkness – 30/f5 (2010)
C-type print, 660 x 1,000 mm

Here, the blanket of darkness can be read as symbolic of many things, including the inequality between those living in darkness compared with those possessing power and resources, as well as the wilful amnesia of one part of the population about the restrictions endured by another, as night-time hides the landscape's divisive infrastructure from view.

Acquiring the work of these artists represented a new strand in IWM's collecting, but it is a direction that – for many different reasons, including practical ones – has since been limited. One result is that the aspirations to include work by Israeli and British Jewish artists on the subject were not realised. Later, the museum's wider collecting policies would evolve again, refocussing contemporary collecting on conflicts in other parts of the region, such as Libya and Yemen, as well as tackling counter-ISIS operations, while continuing to collect on Iraq and Afghanistan – areas where Britain had interests and/or an active involvement.

As well as collecting artistic responses to such long-running conflicts as the Troubles and the Israeli–Palestinian conflict, with their deep roots and uncertain futures, IWM also embraced artists' engagement with war's ever-changing technology in the twenty-first century. This was the continuation of a persistent theme within the art collection as whole, connecting with works such as Edward Wadsworth's and J D Fergusson's striking images of First World War dazzle ships or the Carline brothers' dizzying depictions of early flight.

In 1978, the former Royal Navy light cruiser HMS *Belfast*, already moored on the Thames as a museum ship, transferred to the ownership of the IWM. More than 30 years later, Hew Locke (b.1959) took the ship as a subject for exploring collective memory and the changing perceptions of history. The ship saw active service during both the Second World War and Korean War, and Locke presents it as having rusted since its retirement in his painting *HMS Belfast* (2012). But he also invokes its glory days by surrounding it with symbols of power: thrusting fighter aircraft and aquatic versions of the lion and the unicorn. The painting was acquired and exhibited at IWM London in 2015; at the same time, Locke transformed the actual HMS *Belfast* into an installation, called *The Tourists*, which imagined the ship's crew – complete with masks and tattoos – preparing to take part in Trinidad's Carnival, in 1962. The idea was inspired by HMS *Belfast*'s last international voyage, when the ship did indeed call in on Trinidad that year – though three months after Carnival.

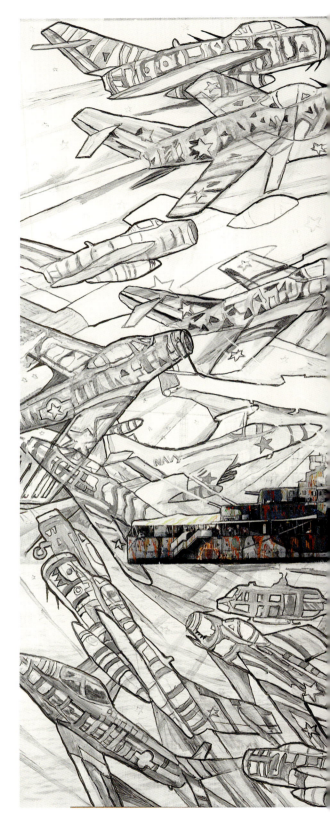

>

Hew Locke, *HMS Belfast* (2012)
Acrylic paint on photographic paper, 1,265 x 1,875 mm

The aircraft, used during the Korean War, highlight the ship's role there; stylistically they are inspired by American Cold War-era comics from Locke's childhood in Guyana, South America. The exploration of power is a central theme of the artist's work, and he is especially interested in the symbolism of ships as instruments of control in warfare, trade and culture around the world.

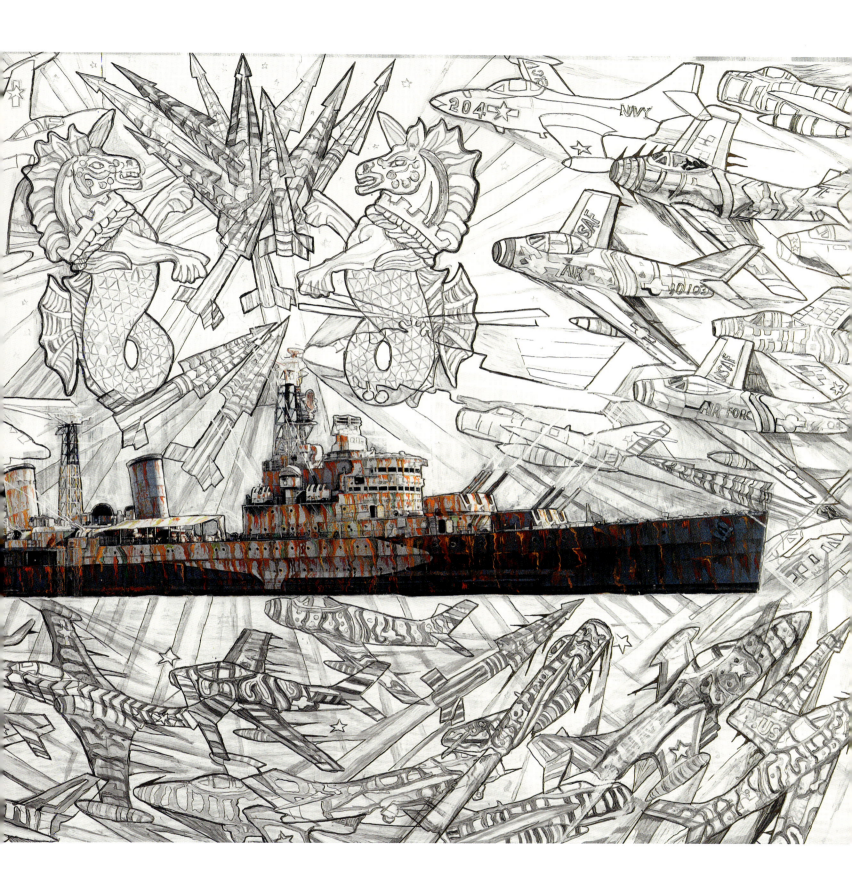

The imagery and potent symbolism of high-tech weaponry during the later twentieth and early twenty-first centuries has provided a source of grim fascination for many artists. For some, the idea of human creativity put in the service of producing something so destructive is an intriguing one. Although her visual language is mostly abstract, Alison Wilding (b.1948) created a series of *Drone* drawings, taking inspiration from recent developments in unmanned aerial technology. Her drawings emphasise the aircrafts' zoomorphic qualities, depicting them as bird-like silhouettes. The artist's approach to the subject is ambiguous, and not overtly political, but her imagery is no less sinister for it.

Mahwish Chishty (b.1980) also tackled the subject in her *Drone Art* series (2011–2017), depicting Reaper drones, stealth bombers and other aircraft. On a visit to her home country of Pakistan in 2011, Chishty was struck by the wealth of news coverage there about the attacks by US combat drones along the Pakistan–Afghanistan border – in contrast to the marked absence of information on the subject in her adopted country of the United States. Chishty discussed with her family the effect of the drones' presence – a presence that induced a constant state of psychological suspense and sense of threat among the people living there.

Alison Wilding, *Drone 1* (2012)
Acrylic inks on paper, 200 x 262 mm

Wilding's drones are bird-like creatures, menacing but also disarming: weaponry presented as beautiful objects to fetishise. Here, the aircraft's deadly arsenal appears almost heart-like, as it drops from the undercarriage.

As the twentieth century's machine age merged into the twenty-first century's digital age, with all the implications for the changing nature of warfare, artists have been finding ways to represent and interrogate such developments. *Five Thousand Feet is the Best* (2011), a film by the artist Omer Fast (b.1972), is based on a series of interviews with a former combat-drone operator, which took place in a Las Vegas hotel room. The title is a quotation from the interviewee, referring to the optimum altitude at which an armed drone can identify targets on the ground. Fast's use of high production values and striking aerial tracking shots leave a lasting impression on the viewer – intriguing and disturbing in equal measure.

Mahwish Chishty, *By the Moonlight*, from the *Drone Art* series (2013)
Gouache, tea stain and photo-transfers on birch plywood, 200 x 640 x 315 mm

Chishty's work references Pakistan's rich aesthetic traditions, combining traditional miniature painting and folk art patterns painted on lorries. These elements pick out the incongruous shape of the drone, hanging ominously over the streets of Lahore.

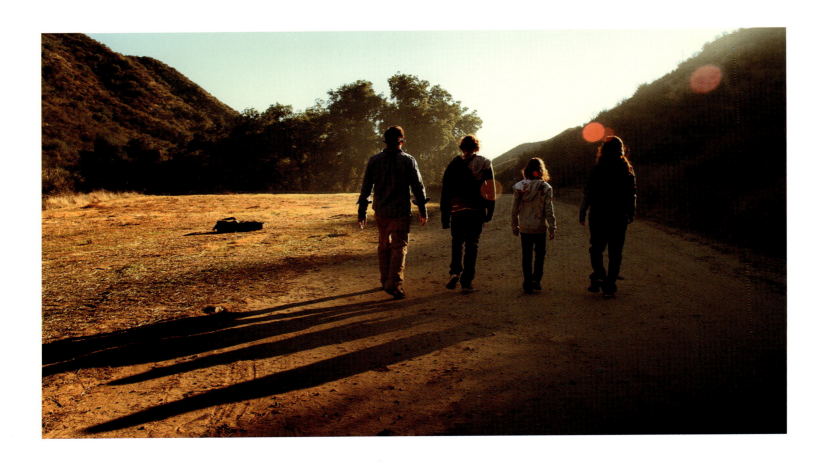

The US artist Joseph DeLappe (b.1963) used the medium of the computer game genre literally to create the work *dead-in-iraq* (2006–2011), which he has described as a 'game based performative intervention'.[60] In 2006, the official US Army computer game *America's Army* had 6 million registered users: it was an effective recruitment tool.[61] IWM acquired a film recording of part of the intervention. It shows DeLappe logging on to the online multiplayer *America's Army* as 'dead-in-iraq' and typing the names of Americans killed on duty in the Iraq War – often to the annoyance and confusion of the other players – until his avatar is killed. He continues to type while hovering over the dead body until the screen fades and he is 'reincarnated', allowing him to play again. DeLappe started the project in March 2006 and finished on 18 December 2011, the date when the United States officially withdrew its last troops from the country; by this point he had completed the list, inputting a total of 4,484 names to both memorialise the US war dead and protest against the cost of the Iraq War.

Three years after DeLappe finished his artwork, the Islamist fighters of ISIS launched the dramatic insurgency that would, for a time, create its self-proclaimed Caliphate across large swathes of Iraq and Syria, including the major Iraqi cities of Mosul and Tikrit. The advance of ISIS prompted a renewed US-led coalition effort known as the 'Combined Joint Taskforce – Operation Inherent Resolve', whose military actions were largely in the form of airstrikes. *The Messenger and the Message* (2015; *see p. 242*), by Navine G Dossos (b.1982), dates from this time. Dossos uses a traditional medium – gouache on

Omer Fast, *Five Thousand Feet is the Best* (still) (2011)
Single channel projection, 30 minutes

Fast's film combines an interview with a former attack-drone operator with cyclical, fictionalised scenes, creating a deliberately confusing narrative. The work explores the psychological and violent consequences of drone warfare.

Thomson & Craighead in collaboration with Steve Rushton,
A Short Film About War (still) (2009–2010)
Two-screen gallery installation, 10 minutes

Using only online sources, the artists take us on a disorientating journey around the world. The work highlights the internet's limitless circulation and manipulation of information, while also evoking its military origins.

panel – to address contemporary digital phenomena related to contemporary warfare. She has developed a system of patterns inspired by logos and emojis as a new visual language, to articulate concepts that are difficult to represent. *The Messenger and the Message* is from a series, *The Black Standard*, in which she uses elements of the black ISIS flag as a basis for each painting. It comprises two sides of the same painting and includes the logos for Twitter and KIK Messenger (social media channels used by ISIS), as well as the crossed-swords insignia of Inherent Resolve. There are also patterns based on Islamic architectural forms, to represent the much-commented-on social media phenomenon of the echo chamber, and satellite imagery, representing the geolocation of the site in Syria where US journalist James Foley was murdered by ISIS (as researched by the online investigative collective Bellingcat).

The fabric of the internet provides the raw material for the work of artist-duo Jon Thomson (b.1969) and Alison Craighead (b.1971). Their work, *A Short Film About War* (2009–2010), references various warzones by sourcing images from blogs and the photo-sharing site Flickr, in effect amplifying the concerns and preoccupations of these online communities. It is a two-screen gallery installation, with images taken around the world on one side and a text log on the other, showing the images' provenance, fragments from blogs and the GPS location of each element in the work.

By demonstrating a way of making documentary without needing to leave one's desk, *A Short Film About War* has remained increasingly relevant in the years since it was made. It questions the systems through which material is circulated – such as the panoptic Google Earth – and reveals how information is distorted as it is shared, gathered and mediated around the world. Just as war publicity and propaganda were harnessed during the world wars of the twentieth century, during the digital age it is the vast and endless streams of information that can be weaponised.

Afterword

Although it is difficult to predict what the rest of the twenty-first century might bring, many have warned that with climate change comes the threat of increased conflict in the world. It is a disheartening prediction. But, as we move through ever new and uncertain times, those artists whose themes include current affairs and the human condition will be among the first to make observations, warn, bear witness and try to form new languages to address difficult things. As ever, they will ask myriad questions about war's evolving technologies and humanity's (not so evolved) dark instincts and excesses. The subject of war and conflict is a study of humanity at its most extreme, providing fertile ground for such creative minds.

In looking back over more than a century of IWM art collecting, a picture emerges of different generations of artists grappling with the major issues of their times, often tackling the most difficult, harrowing subjects. The collection reflects, inevitably, a predominantly British perspective of this century of conflict, encapsulating aspects of the country's culture and shadowing its shifting position in the world. In the tumult of the First World War, modern artists brought their uncompromising new approaches to war in the machine age. The Second World War saw British artists embrace a kind of national soul-searching, before the Cold War era brought changing artistic perspectives and invention in art, laying the way for the cerebral and nuanced approaches of contemporary artists in the digital age.

Discernible throughout is the reality that art relating to war is a fascinating aspect of war history and culture. While IWM's collection is nothing near comprehensive, it does reveal something of British national identity – in so far as it reflects the changing concerns of a leading cultural institution. These works are about our collective fears, traumas, grief; but they also articulate a sense of fascination, sometimes even exhilaration, as well as feelings of worth and meaning. As such, the collection serves its own unique purpose – sometimes complementing established historical narratives, but sometimes complicating them, and above all confronting us with memorable, compelling and moving visions of war.

Navine G Dossos, *The Messenger and the Message* (2015)
Gouache on panel, 950 x 1,520 x 50 mm (each)

The paintings' combination of abstract symbols and patterns, with all their attendant connotations, create a sinister effect. This hypnotic imagery suggests the process by which extremist groups like ISIS exploit the power and echo chamber of social media to propagate their values and radicalise individuals.

Notes

Chapter 1

1. Umbro Apollonio (ed.), *Documents of 20th-Century Art: Futurist Manifestos*, translated by Robert Brain, R W Flint, J C Higgitt and Caroline Tisdall (1973), pp. 19–24.
2. Richard Ingleby et al., *C.R.W. Nevinson: The Twentieth Century* (1999), p. 15. (Collection of essays accompanying IWM exhibition.)
3. C R W Nevinson, *Paint and Prejudice* (1938), p. 95. © Harcourt, Brace And Company. The phrase about 'virile' art was quoted in the *Observer* in June 1914. © Observer.
4. Henri Gaudier-Brzeska, letter to Miss Kitty Smith (2 February 1915).
5. Paul Cornish, *The First World War Galleries* (2014), p. 127.
6. Both quotations from Nevinson, *Paint and Prejudice*, op. cit., pp. 99–104.
7. David Welch, *Propaganda: Power and Persuasion* (2013), p. 15.
8. Written 15 June 1917, Sassoon's statement was read out in the House of Commons on 30 July before appearing in print in *The Times* and elsewhere.
9. Nash, letter to Margaret Nash, written from France while on commission to make drawings at the Front as a war artist (13 November 1917), from collection of letters and papers of Paul Nash, Tate Archive: TGA 8313/1/1/162. © Tate.
10. Copy of McBey's contract (April 1917), IWM War Artists Archive, ART/WA1/103: James McBey 1917–1928.
11. Copy of letter from McBey to G S Intelligence Section, EEF (26 September 1917), ibid.
12. Robert Upstone, Roy Foster and David Fraser Jenkins, *William Orpen: Politics, Sex & Death* (2005), p. 37. (Collection of essays accompanying IWM exhibition.)
13. Minutes, War Cabinet meeting at 10 Downing Street (5 March 1917, 11.30 am), IWM Archive EN1/1/MUS/025/001/001.
14. Ibid. For budget details, *see* report entitled 'NATIONAL WAR MUSEUM' (1 November 1917), in the same file.
15. Report of the Imperial War Museum 1917–1918 presented to Parliament by Command of His Majesty, IWM Museum Archive EN1/1/MUS/025/001/001.
16. Letter from ffoulkes to the Inspector of War Trophies (15 February 1918), IWM War Artists archive, ART/WA1/084: Adrian Hill
17. Letter from Martin Conway to Sir William Robertson, War Office (13 December 1917) IWM War Artists Archive, ART/WA1/235: Jacob Epstein 1917–1952
18. Letter from Martin Conway to General Donald, France (3 January 1918), ibid.
19. 'Letter no. 4014 dated 18th Jan: 1918 from Gen Donald objecting to employment of Epstein in Gen Donald file. 3937 from Sir G Frampton. Both taken out as confidential. In Secs. Keeping C.ff. 17.4.19', ibid.
20. Letter from Martin Conway to Sir Hamo Thornycroft RA, London (24 January 1918), IWM War Artists Archive, ART/WA1/343: F Derwent Wood.
21. Anne Chisholm and Michael Davie, *Beaverbrook: A Life* (1993), pp. 154–7.
22. Sue Malvern, *Modern Art, Britain and the Great War: Witnessing, Testimony and Remembrance* (2004), p. 75.
23. Meirion Harries and Susie Harries, *The War Artists* (1983), p. 87.
24. Ibid., p. 39.
25. Malvern, op. cit., p. 81.
26. Meirion and Susie Harries, op. cit., p. 104.
27. Ibid., p. 110.
28. Ingleby et al., op. cit., p. 13.
29. Richard Cork: 'Crisis in the Trenches: David Bomberg and the Sappers at Work', in *Vorticism*, ICSAC Cahier 8/9 (1988), pp. 179–97.
30. Richard Cork, *A Bitter Truth: Avant-garde Art and the Great War* (1994), p. 229.
31. Ann M Compton (ed.), *Charles Sargeant Jagger: War and Peace Sculpture* (1985), p. 15.
32. Stacey Clapperton, 'Percy Delf Smith: Making Art as a Soldier on the Western Front', online: https://www.iwm.org.uk/history/percy-delf-smith-making-art-as-a-soldier-on-the-western-front.
33. These estimates were proposed by the Cabinet Committee (4 December 1917), at a time when the IWM was hoping for a purpose-built museum. The areas proposed were: for the War Office, 63,800 sq. ft; for Munitions, 34,000 sq. ft; for Library and records, 28,000 sq. ft. IWM Museum Archive: EN1/1/ACC/32.
34. Described by the writers Louis F Fergusson (letter dated 13 June 1918 to Beaverbrook) and John Middleton Murry (letter dated 9 June 1918 to Masterman) respectively, in their recommendations to the BWMC. IWM War Artists Archive, ART/WA1/238: J D Ferguson.
35. According to the artist's granddaughter and dazzle scholar, Camilla Wilkinson.
36. John Lavery, *Life of a Painter* (1940), pp. 151–2.
37. Angela Weight, 'John Lavery: An Intrepid War Artist', *Burlington Magazine* (September 2014), pp. 573–9. © the rights Holder.
38. Letter from Lieutenant A J Insall, observer officer, RAF, to Brigadier General A C H MacLean, president of IWM's Air Force Section (22 April 1919). IWM Museum Archive, Reports, Departmental: 1918–1919 EN1/1/REPD/001.
39. Both quotations in this paragraph taken from Victoria Monkhouse file in WM War Artists Archive, ART/WA1/037/6: Meeson–Morgan correspondence
40. *See* contract dated 4 March 1919, IWM War Artists Archive, ART/WA1/031: Miss Anna Airy.
41. Andrew Casey, *Anna Airy: The Story of Her Life and Work* (2014).
42. Letter from Anna Airy to Yockney (25 May 1919), IWM War Artists Archive, ART/WA1/031: Miss Anna Airy.
43. Kathleen Palmer, *Women War Artists* (2011), p. 41.
44. Pamela Gerrish Nunn, 'Flora Lion: Rediscovering a Talented Portraitist', online: artuk.org/discover/stories/flora-lion-rediscovering-a-talented-portraitist.
45. Sally Enzer, 'Gilbert Rogers: A Life' (unpublished research, 2019), pp. 13–14
46. Report of the Imperial War Museum 1918–1919 presented to Parliament by Command of His Majesty, IWM Museum Archive, EN1/1/REPD/001.
47. Letter from Nash to Yockney with suggested inscription for *The Menin Road* (29 October 1919), IWM War Artists Archive, ART/WA1/294/2: Paul Nash 1919–1949.
48. 'War Memories at the Crystal Palace with the RAMC', *The Times* (19 August 1920). © The Times.
49. Meirion and Susie Harries, op. cit., p. 149.
50. William Orpen, *An Onlooker in France* (1921), pp. 119–20. © the right holder.
51. Meirion and Susie Harries, op. cit., p. 152.
52. House of Commons *Hansard* (24 February 1920), oral answers to questions. Open Parliament Licence v3.0.
53. Wyndham Lewis, 'The Men Who Paint Hell: Modern War as a Theme for the Artist' (1919), newspaper clipping in IWM War Artists Archive, ART/WA1/273: Wyndham Lewis. © the right holder.
54. IWM War Artists Archive, ART/WA1/329: Henry Tonks.
55. Upstone et al., op. cit., p. 46.
56. IWM War Artists Archive, ART/WA1/093: William Orpen to Martin Conway, 20.2.28.

Chapter 2

1. Beth Irwin Lewis, *George Grosz: Art and Politics in the Weimar Republic* (1971), p. 229.
2. Nevinson, *Paint and Prejudice*, op. cit., p. 266. Although Nevinson does not give a specific date for this quotation, it occurs near the end of his book, which proceeds chronologically, so the 1930s can be assumed. © Harcourt, Brace And Company.

3. Ingleby et al., op. cit., p. 51. (Collection of essays accompanying IWM exhibition.)
4. *The Spanish Civil War: Dreams + Nightmares*, 2001 (book accompanying IWM exhibition).
5. *MOI Digital: A History of the Ministry of Information, 1939–46*, online: https://moidigital.ac.uk/.
6. Fred Uhlman, *Private Papers of Dr F Uhlman* (IWM Documents 6781). © Estate of Fred Uhlman.
7. Brian Foss, *War Paint: Art, War, State and Identity in Britain, 1939–1945* (2007), p. 1.
8. Christopher Campbell-Howes, *Evelyn Dunbar: A Life in Painting* (2016).
9. Foss, op. cit., p. 9.
10. James Aulich, *War Posters: Weapons of Mass Communication* (2007), p. 174.
11. Martin Conway, in House of Lords *Hansard* (30 November 1932). Open Parliament Licence v3.0.
12. Foss, op. cit., p. 22.
13. Letter, Eurich to WAAC, 10 June 1940, IWM War Artists Archive, ART/WA2/03/069: Richard Eurich.
14. IWM War Artists Archive, ART/WA2/03/061: Stanley Spencer.
15. Ibid.
16. *See* Foss, op. cit., p. 30.
17. Kathleen Palmer, *Women War Artists* (2011), p. 2.
18. IWM War Artists Archive, ART/WA2/03/074: Evelyn Dunbar.
19. Palmer, op. cit., p. 35.
20. Lady Norman to E M O'Rourke Dickey, in 'Women Activities' 7–11 May 1940, IWM War Artists Archive, ART/WA2/01/027.
21. In an IWM Sound Archive interview, Gross quipped about liking pretty girls. For Ardizzone, see *The Captain of the ATS*, 1940 (Art.IWM ART LD 342).
22. For example, see Laura Knight's *Ruby Loftus Screwing a Breech-ring, 1943* (Art.IWM ART LD 2850).
23. Letter (1971) from Josephine Davis, in ACQ1/ART/D/075/001 (IWM Evelyn Dunbar acquisitions file).
24. IWM War Artists Archive, ART/WA2/03/037: Eric Ravilious.
25. Henry Moore, writing to his friend Arthur Sale (10 October 1940). © Reproduced by permission of The Henry Moore Foundation.
26. William Ware to Angela Weight, 29 June 1983 – ACQ1/ART/W/020 (IWM William Ware acquisitions file).
27. Minton hid his homosexual encounters from his friends; but he did tell Michael Middleton in 1943 that he went 'to pick up anyone who would have me, sailors mostly, because I developed all sorts of obsessions about them (have you read your Cocteau?)'. Quoted in Angela Weight's case for acquisition of *Blitzed City with Self Portrait*, 12 March 2001, ACQ1/ART/M/109 (IWM John Minton acquisitions file).
28. Quoted in Angela Weight, 'William Scott: An Unlikely Romantic', *London Magazine* (July 1981). © Estate of William Scott.
29. Foss, op. cit., p. 72.
30. Ibid., p. 71.
31. Letter from Gross to the WAAC (26 January 1946). IWM War Artists Archive, ART/WA2/03/064: Anthony Gross.
32. *War Artists in the Middle East* exhibition.
33. Letter from Bawden to E M O'R Dickey, secretary to the WAAC (27 July 1942), IWM War Artists Archive, ART/WA2/044/1: Edward Bawden 1939–1944.
34. Edward Ardizzone, *Diary of a War Artist* (1974), p. 15. © The Ardizzone Trust, reproduced by permission of David Higham Associates.
35. Ibid., p. 28.
36. Foss, op. cit., p. 117.
37. Julian Francis, *My Brush is My Sword: Anthony Gross, War Artist* (2022), p. 109.
38. *See People's War* exhibition (2012), ART/AD08/SMA/148 (IWM exhibition file).
39. There was an exception: Henry Carr's *A Cockney Soldier* (1944), painted in Italy (Art.IWM ART LD 3902).
40. Kennington's resignation was discussed at the 96th meeting of the WAAC on 30 September 1942. *See* IWM War Artists Archive, ART/WA2/04/002.
41. IWM War Artists Archive, ART/WA2/04/002/12: Minutes of the 51st meeting of the WAAC (16 June 1941).
42. IWM War Artists Archive, ART/WA2/01/100: Scheme for War Pictures by Native-born Colonial Artists.
43. Kate Clements, Paul Cornish and Vikki Hawkins, *Total War: A People's History of the Second World War* (2021), pp. 69–71.
44. IWM War Artists Archive, ART/WA2/04/002/12, op. cit.
45. Ibid.
46. Angelo Kakande, 'Contemporary Art in Uganda: A Nexus Between Art and Politics', PhD thesis, University of the Witwatersrand, Johannesburg (2008), pp. 38–42.
47. Letter from Government House, Accra, to Oliver Stanley MP, Secretary of State for the Colonies (10 November 1943), IWM War Artists Archive, ART/WA2/01/100.
48. File note written by Elmslie Owen (secretary to the WAAC), IWM War Artists Archive, ART/WA2/01/100.
49. Letter from Barbara Shegog, Colonial Section, MOI to G A Girkins, Public Relations Dept, Colonial Office, Downing Street (21 March 1944), IWM War Artists Archive, ART/WA2/01/100.
50. *See* Kakande, op. cit.; *see also* IWM War Artists Archive, ART/WA2/01/100.
51. Neville Weereratne, *43 Group: A Chronicle of Fifty Years in the Art of Sri Lanka* (1993); online (2019): https://www.43group.org/.
52. IWM War Artists Archive, ART/WA2/04/003: WAAC minutes 101–160 (24 May 1944).
53. IWM War Artists Archive, ART/WA2/03/149: Doris Zinkeisen.
54. Palmer, op. cit., p. 13; *see also* Red Cross website: https://www.redcross.org.uk/stories/our-movement/our-history/doris-zinkeisen-second-world-war-artist.
55. IWM War Artists Archive, Doris Zinkeisen papers (Art.IWM ARCH 29). © the rights holder.
56. IWM Documents.18803: Private Papers of Miss M Kessell (includes war diary).
57. IWM sound archive, Jan Hartman 18557.
58. United States Holocaust Memorial Museum (USHMM) website: https:/perspectives.ushmm.org/item/lithograph-by-richard-grune
59. *See* mayer-marton.com.
60. 'Belsen Camp. Comp. for women', note in file written by Leslie Cole, describing his work in Belsen (undated), IWM War Artists Archive, ART/WA2/03/183: Leslie Cole
61. Cole, letter home (10 August), in Malcolm Yorke, *Today I Worked Well – The Picture Fell Off the Brush: The Artistry of Leslie Cole* (2010), p. 108. © Russell Falkingham.
62. See IWM exhibition leaflet, *Ronald Searle: To the Kwai and Back – War Drawings 1939–1945* (6 March to 6 July 1986), in Searle exhibition file (ART/AD08/SMA/053).
63. Meg Parkes, Geoff Gill and Jenny Wood, *Captive Artists: The Unseen Art of British Far East Prisoners of War* (2019), p. 286.
64. Ibid., p. 284.
65. *See* Parkes, op. cit., pp. 276–77. For Rawlings, *see* Parkes, p. 51.
66. Parkes, op. cit., p. 272.
67. Jenny Wood, Collections Review Report on IWM's FEPOW collection (2012) (Internal IWM document).
68. Foss, op. cit., p. 1.
69. IWM War Artists Archive, ART/WA2/03/183: Leslie Cole.
70. According to Cole's former student Patricia Buckley; see note (23 January

71. Yorke, op. cit., p. 135.
72. John Rothenstein, 'Reflection on the *National War Pictures Exhibition*', *Country Life* (2 November 1945). © the rights holder.
73. Michael Ayrton, in his 'ART' column for the *Spectator* (November 1945). © The Spectator.
74. Laura Knight, letter to Eric Craven Gregory, secretary to the WAAC (5 December 1945), IWM War Artists Archive, ART/WA2/03/487: Laura Knight.
75. Laura Knight, letter to Mrs Oxford-Coxall (11 May 1946), ibid.

(Note 70 cont.) 2009) in IWM collection file: Cole, Leslie ACQ1/ART/C/069.

Chapter 3

1. Lucie Levine, 'Was Modern Art Really a CIA Psy-Op?', *JSTOR Daily Newsletter* (1 April 2020), online: daily.jstor.org/was-modern-art-really-a-cia-psy-op/ (1 April 2020).
2. From military historian Alan Clark's *The Donkeys* (1961).
3. See catalogue entry, *Guard Dog on a Missile Base, No. 1* (1965), online: https://www.tate.org.uk/art/artworks/self-guard-dog-on-a-missile-base-no-1-t01850. © Tate.
4. Oral history interview with Philip Hicks in IWM sound archive, 610 (1975).
5. See IWM Philip Hicks acquisitions file, ACQ1/ART/H/070.
6. Letter from Tuzo to Dr C H Roads, Deputy Director, IWM (27 April 1971), IWM Museum Archive, ENG/2/ACC/05/001
7. 'Proposal to form an Artistic Records Committee' Board Paper (1972), IWM Museum Archive, ENG/2/BT/02/Vol/1.
8. See 'Ken Howard: Thoughts About Art', online (archived): http://www.arctotis.net/kenhoward.co.uk/Ken%20Howard%20RA%20Thoughts%20About%20Art.html. © Estate of Ken Howard.
9. See Minutes of the IWM trustees (23 September 1992) IWM Museum Archive, ENG/2/BT/01/009.
10. Email from Graham Ashton to the author (15 March 2015). © Graham Ashton.
11. Artist's comment, quoted in Art.IWM ART 17666 *(SLCM) Cruise Missile Drawing* (1977). © Graham Ashton.
12. From 'Conversations with Hugo' (1996), transcript of David Clark's interviews with the artist in his studio. © The Walton family.
13. Quoted in Paul Hogarth's obituary, *Independent* (7 January 2002) online: https://www.independent.co.uk/news/obituaries/paul-hogarth-9209470.html. © Artist's Estate.
14. Ray Walker case file, IWM Museum Archive, ENG/2/ACC/6/003.
15. Art Commissions Committee minutes (20 January 1982), IWM Museum Archive, ENG/2/ACC/02/1982.
16. Ibid., (27 April 1982).
17. Ibid.
18. Oral history interview with Linda Kitson, in IWM sound archive, 13727 (19 January 1994).
19. Adella Lithman, 'Ladies of War', *Daily Express* (12 May 1982). © Daily Express.
20. Anthea Hall, 'Flying the Flag of Art', *Sunday Telegraph* (16 May 1982). © Sunday Telegraph.
21. 'Artist tells of "misery and hell"', *South Wales Echo* (31 July 1982). © South Wales Echo.
22. Linda Kitson case file, IWM Museum Archive, ENG/2/ACC/6/004.
23. Celia Brayfield, *Daily Express* (5 August 1982). © Daily Express.
24. See exhibition booklet in the Linda Kitson artist file, IWM Museum Archive, ACQ1/ART/K/055.
25. ARC information leaflet (undated, likely c.1995–1998).
26. Steve Boggan, 'Scarred by the Art of War', *Independent* (9 Oct 1991).
27. Michael Peel, quoted in text accompanying *Declarations of War* exhibition of contemporary art from IWM's collection at Kettle's Yard, Cambridge (1993). By permission of the Peel family.
28. Art Commissions Committee minutes (31 October 1984), IWM Museum Archive, ENG/2/ACC/02/1984.
29. *A Twentieth Century Memorial* was purchased for the Tate collection in 1994.
30. See text accompanying *Declarations of War* exhibition (1993), op. cit

Chapter 4

1. See discussion under 'Any Other Business, Minutes of the Artistic Records Committee' (20 August 1990), IWM Museum Archive, ENG/2/ACC/02/1990.
2. IWM sound archive, John Keane 12744.
3. Sarah Kent, 'A Brush With War', *Time Out* (8 April 1992). © Time Out.
4. ARC information leaflet (undated, likely c. 1995–1998).
5. Ibid.
6. John Keane case file, IWM Museum Archive, ENG/2/ACC/06/011.
7. Oral history interview with John Keane, IWM sound archive, 12744 (1992). © John Keane.
8. Foreword, in *John Keane: Gulf* (1992), catalogue to exhibition held 26 March to 31 May 1992.
9. See Chris Brooke and Richard Kay, 'Outrage at War Artist's View of Tragedy in the Gulf', *Daily Mail* (14 January 1992), © Daily Mail; John Ingham and Alan Qualtrough, 'Gulf Artist Accused of Insult to Troops', *Daily Express* (14 January 1992).
10. Sara Bevan, *Art From Contemporary Conflict* (2015); see also Karen Attwood, 'War is Inside All of Us', *Independent* (24 April 2015).
11. Lisa Whittle, 'Alien Landscapes', *New Statesman* (20 May 1992).
12. See 'Show in Trouble...', *Richmond Herald* (2 April 1992), © Richmond Herald; 'Shock as Gulf Art is Ditched', *East London Advertiser* (10 April 1992), © East London Advertiser; 'Painting Withdrawn', *South London Press* (3 April 1992), © South London Press.
13. John McCain and Mark Salter, 'Sen. John McCain Remembers the Female Vets of the Gulf War', *Time* (11 November 2014), online: time.com/3576811/john-mccain-women-in-gulf-war/.
14. Tony Carter, interview with Charles Esche, quoted in *Tony Carter* (1990–1991), book accompanying Carter's exhibition at Kettle's Yard, Cambridge (1991).
15. Interview with Peter Howson in 'Face in the Crowd', BBC (1994).
16. Ibid.
17. Gordon Airs, 'War Artist Flees War!', *Daily Record* (7 June 1993). © Daily Record.
18. See interview with Peter Howson, op. cit.
19. Art Commissions Committee minutes (8 August 1994), IWM Museum Archive, ENG/2/ACC/02/1994.
20. Interview with Peter Howson, op. cit.
21. The two women members were Angela Weight (Keeper of Art) and the art critic Marina Vaizey, and their voting preference was recollected by Weight, in conversation with author (2022). Borg's view appeared in his letter to the Editor of BBC Radio 4 *Today* (19 September 1994); see Peter Howson case file, IWM archive, ENG/2/ACC/06/12.
22. '*Croatian and Muslim*: Rape, Realism and the War Artist', *The Times* leader article (20 Sept 1994). © The Times.
23. See Ralph Rugoff, *The Scene of the Crime* (1997), published to coincide with exhibition of the same name at the Hammer Museum, Los Angeles. © The MIT Press.
24. Paul Glinkowski, 'The Art of Conflict (Part 2)', *a-n Magazine* (October 2004). © a-n Magazine.
25. Paul Clinkowski, 'The Art of Conflict (Part 1)', *a-n Magazine* (September 2004). © a-n Magazine.
26. see Art Commissions Committee minutes (24 June 1999), IWM Museum Archive, ENG/2/ACC/02/1999.

27. Art Commissions Committee minutes (23 September 1999), IWM Museum Archive, ENG/2/ACC/02/1999.
28. John Calcutt, 'Conflicting Images', *Scotland on Sunday* (30 April 2000) (in the *seven* magazine supplement).
29. Ibid.
30. Paul Glinkowski, 'The Art of Conflict (Part 1)', op. cit.
31. Louisa Buck, 'UK Artist Q & A: Darren Almond', *Art Newspaper*, no. 101 (March 2000).
32. Art Commissions Committee minutes (10 Oct 2001), IWM Museum Archive, ENG/2/ACC/02/2001.
33. Ibid.
34. *See* comments by Angela Weight in Paul Glinkowski, 'The Art of Conflict (part 1)', op. cit.
35. Recording of lecture given to the Art Commissions Committee by Graham Fagen, IWM sound archive, 30341 (11 January 2002).
36. Mark Lawson, 'War Games and Gaffes', *Guardian* (19 April 2003). © Guardian.
37. *See* Art Commissions Committee minutes (22 November 2002), IWM Museum Archive, ENG/2/ACC/02/2002.
38. Art Commissions Committee minutes (22 November 2002), IWM Museum Archive, ENG/2/ACC/02/2002.
39. Glinkowski, 'The Art of Conflict (Part 1)', op. cit.
40. Ibid.
41. Artists' comment, quoted in IWM record for Art.IWM ART 17460 *Zardad's Dog* (2003). © Langlands & Bell.
42. 'David Cotterrell on Making Art in Afghanistan' (2017), online: https://www.iwm.org.uk/history/david-cotterrell-on-making-art-in-afghanistan.
43. Information on Panchal's background and convictions noted from online talk by the artist, organised by Ben Uri Gallery and Museum (22 November 2022).
44. *See* James Morrison, '"Tasteless" Stars of Britart Vetoed by War Museum', *Independent on Sunday* (6 July 2003).
45. Art Commissions Committee minutes (14 February 2005), IWM Museum Archive, ENG/2/ACC/02/2005.
46. Steve McQueen artist file, IWM Museum Archive, ACQ1/ART/M/136.
47. A Park *et al.* (eds), *British Social Attitudes: The 29th Report* (2012), online: www.bsa-29.natcen.ac.uk.
48. '"Public support" Iraq War Tribute', BBC News (7 March 2008), online: http://news.bbc.co.uk/1/hi/uk/7282606.stm
49. IWM exhibition text, 'War of Terror' (2016). Control Orders were repealed and replaced with other measures in the Terrorism Prevention and Investigation Measures Act 2011.
50. Coco Fusco, *Operation Atropos* (2006). © Coco Fusco.
51. Yekaterina Sinelschikova, 'The Last Soviet Citizen: The Cosmonaut Who Was Left Behind in Space', *Russia Beyond* (28 May 2019), online: https://www.rbth.com/history/330415-last-soviet-citizen-cosmonaut.
52. *Legacy* exhibition leaflet, Roderick Buchanan artist file, IWM Museum Archive, ACQ1/ART/B/119.
53. Stuart MacDonald, 'Fury Over New Scots War Artist', *Sunday Times Scotland* (29 March 2009). The murders of the two soldiers were claimed by the so-called Real IRA, while the murder of the policemen was claimed by the Continuity IRA.
54. Art Commissions Committee minutes (9 February 2009), IWM Museum Archive, ENG/2/ACC/02/2009.
55. Art Commissions Committee minutes (11 December 2013), IWM Museum Archive, ENG/2/ACC/02/2013.
56. Art Commissions Committee minutes (8 July 2014), IWM Museum Archive, ENG/2/ACC/02/2014.
57. 'Abraaj Group Art Prize Collection Acquired By Art Jameel', *Art Dubai* (17 February 2020), online: https://www.artdubai.ae/blog/abraaj-prize-collection-acquired-by-art-jameel/.
58. Interview with Larissa Sansour by curator Omar Kholeif, in leaflet to accompany *Subversion*, a group exhibition held at Cornerhouse, Manchester (2012). © Larissa Sansour.
59. *See* Massimiliano Cali *et al.*, *Area C and the Future of the Palestinian Economy* (2014), p. 13, online: documents.worldbank.org/curated/en/257131468140639464/Area-C-and-the-future-of-the-Palestinian-economy.
60. *See* Joseph DeLappe website: http://www.delappe.net/project/dead-in-iraq/.
61. Kathleen Craig, 'Dead in Iraq: It's No Game', *Wired* (6 June 2006).

Image List

Images © IWM unless otherwise indicated.
IWM has made every attempt to contact copyright holders and would be pleased to rectify any omissions in future editions.

Chapter 1
12 (Art.IWM ART 5728 © Perth & Kinross Council / Courtesy of The Fergusson Gallery, Perth & Kinross Council / Bridgeman Images); 15 (LBY E.87 / 381, © the rights holder); 17 (Art.IWM ART 17980); 18 (Art.IWM PST 5179 © 2022 the Estate of Barbara Bruce Littlejohn); 19 (Art.IWM ART 15600); 20 (Art.IWM ART 15357); 21 (Art.IWM ART 4655. Gift of C N Luxmoore, 1929); 22 (Art.IWM ART 15661); 24 (Art.IWM ART 5219. Gift of Fulham Borough Council, 1961); 26 (Art.IWM ART 2121 © Estate of Sir Muirhead Bone. All rights reserved, DACS 2022. Gift of the artist, 1919); 28 (ART/WA1/487/04, © the rights holder); 29 (Art.IWM ART 1146); 30 (Art.IWM ART 2932. Gift of the artist, 1920); 31 (Art.IWM ART 2376. Gift of the artist, 1918); 33 (Art.IWM ART 528); 34–5 (Art.IWM ART 935); 36 (Art.IWM ART 113, Gift of Sir Alfred Mond, 1917); 37 (Art.IWM ART 116, © artist's estate. Gift of John Lane, 1917); 38 (Art.IWM ART 577 © Estate of Adrian Hill. All rights reserved, DACS 2022); 39 (Art.IWM ART 2756 © The Estate of Sir Jacob Epstein/Tate. Gift of Sir Muirhead Bone, 1919); 41 (Art.IWM ART 1656); 42 (Art.IWM ART 2268); 43 (Art.IWM ART 1922); 44 (Art.IWM ART 2708. Gift of Sir Muirhead Bone, 1919); 45 (Art.IWM ART 6484); 47 (Art.IWM ART 16707 A. Gift of the artist, 1998); 48 (Art.IWM DAZ 0052 1 and 2); 49 (Art.IWM ART 16380); 50 (Art.IWM ART 1266); 52 (Art.IWM ART 2679); 53 (Art.IWM ART 3083); 54 (Art.IWM ART 2316; Art.IWM ART 2315 both © artist's estate); 55 (Art.IWM ART 4032); 56 (Art.IWM ART 3090); 57 (Art.IWM ART 4434 © artist's estate. Gift of the artist, 1927); 58–9 (Art.IWM ART 2242); 60 (Art.IWM ART 3835 © Helen Power, daughter of Mackey); 61 (Art.IWM ART 3635 © artist's estate; Art.IWM ART 16640 (1)); 62 (Art.IWM ART 2365 © artist's estate. Gift of Sir Muirhead Bone, 1919); 63 (Art.IWM ART 2003 © artist's estate. Gift of Sir Muirhead Bone, 1919); 64 (Art.IWM ART 1886); 65 (Art.IWM ART 2747); 66–7, 68 (Art.IWM ART 1460); 71 (Art.IWM ART 4438, Presented by the artist in memory of Earl Haig, 1928).

Chapter 2
72 (Art.IWM ART LD 170); 74 (Art.IWM ART 16661 © Estate of George Grosz, Princeton, N J / DACS 2022); 75 (Art.IWM ART LD 5975 © artist's estate. Gift of Miss S Reid, 1945); 77 (Art.IWM ART 16717); 78 (Art.IWM ART 17868. By kind permission of Sheelah Sloane. Gift of the family of Beatrice Fergusson, 2017.); 79 (Art.IWM ART 16547 © Estate of John Armstrong. All rights reserved 2023 / Bridgeman Images); 81 (Art.IWM ART LD 7526 © The Estate of Fred Uhlman. Gift of the artist, 1979); 82 (Art.IWM PST 3750); 84 (Art.IWM ART LD 1326); 87 (Art.IWM ART LD 4526); 89 (Art.IWM ART LD 3685); 90 (Art.IWM ART LD 432 – 4); 91 (Art.IWM ART 16534 © artist's estate); 92 (Art.IWM ART 17038 © artist's estate. Gift of the artist, 2005); 93 (Art.IWM ART 768); 95 (Art.IWM ART LD 1194); 96 (Art.IWM ART LD 2635); 97 (Art.IWM ART LD 1353); 98 (Art.IWM ART LD 1379); 99 (Art.IWM ART 17439 © The Estate of Keith Vaughan. All rights reserved, DACS 2023. Acquired with Art Fund support, 2008); 100 (Art.IWM ART 16739 © Estate of John Minton. All rights reserved 2023 / Bridgeman Images. Acquired with Art Fund support, 2001); 102 (Art.IWM ART 16500 © Estate of the Artist, c/o Lefevre Fine Art Ltd, London. Acquired with the support of Art Fund and the National Heritage Memorial Fund, 1993); 104 (Art.IWM ART 15756 © Estate of Julian Trevelyan. All rights reserved 2023 / Bridgeman Images); 105 (Art.IWM ART 16843 © the Estate of William Scott. Supported by The Heritage Lottery Fund and Art Fund, 2004); 106 (Art.IWM ART LD 472); 107 (Art.IWM ART 17976 © Reproduced by permission of the Henry Moore Foundation. Accepted in lieu of inheritance tax by HM Government from the Estate of Tan Jiew Cheng and allocated to the Imperial War Museums, 2020); 109 (Art.IWM ART 16786 Morris Kestelman RA Estate © Sara Kestelman. Gift of Sara Kestelman, 1999); 110 (Art.IWM ART LD 2184); 112 (Art.IWM ART LD 3334); 115 (Art.IWM ART LD 2749 © artist's estate); 116 (Art.IWM ART LD 3079 © artist's estate); 117 (Art.IWM ART LD 4201); 118 (Art.IWM ART LD 3924); 119 (Art.IWM ART LD 4919); 121 (Art.IWM ART LD 5468); 122 (Art.IWM ART LD 5747 e and 5747 f); 123 (Art.IWM ART 17446); 124 (Art.IWM ART 17884 © artist's estate. Presented by the Albert Adams Estate with Art Fund support, 2018); 125 (Art.IWM ART 16785. Gift of Johanna Braithwaite, 2000); 126–7 (Art.IWM ART 5687); 128 *Inspecting Officer, Changi* (Art.IWM ART 15747 49 © 1942 Reproduced by the kind permission of the Ronald Searle Cultural Trust and the Sayle Literary Agency. Gift of the artist, 1984); 128, *Executed for No Apparent Reason* (Art.IWM ART 15417 101© copyright holder / granddaughter of the artist. Gift of Mrs Bloch, 1981); 129 (Art.IWM ART LD 6526); 132 (Art.IWM ART LD 5798); 134 (Art.IWM ART 16010 © artist's estate. Gift of Mrs Isabel Henderson, 1985).

Chapter 3
136 (Art.IWM ART 16012); 139 (Art.IWM ART 16213 © The Family Estate. Gift of Mrs M Anyon Cook, 1986); 140 (Art.IWM ART 16441 © The Estate of Merlyn Evans www.merlynevans.co.uk); 142 (Art.IWM ART MW(A) 3); 144 (Art.IWM ART 17743 © The Estate of William Crozier. Acquired from Piano Nobile, London with Art Fund support, 2015); 146 (Art.IWM ART 15091 © Colin Self. All rights reserved, DACS 2022); 147 (Art.IWM ART MW(A) 32 © The Hicks family collection. Gift of the artist, 1974); 148 (Art.IWM ART 17873 © Estate of Eric Auld. Gift of the Auld family, 2018); 150 (Art.IWM ART MW(A) 49); 152 (Art.IWM ART 15809. By courtesy of the Estate of Ian Hamilton Finlay); 153 (Art.IWM ART 15570 © The Estate of Alexis Hunter. All rights reserved, DACS 2022.); 154–5 (Art.IWM ART 15376 © Gilbert & George); 156 (Art.IWM ART 15902); 158–9 (Art.IWM ART 15153); 160 (Art.IWM PST 9152 © 'Never Again' Peter Kennard 1983); 161 (Art.IWM ART LD 7548 © Whitford Fine Art, London); 162 (Art.IWM ART 15493 © Bill Woodrow); 163 (Art.IWM ART 17894 (c) artist's estate. Gift of the Walton family, 2017) 164–5 (Art.IWM ART 15294); 166–7 (Art.IWM ART 15423); 169 (Art.IWM ART 15753); 171 (Art.IWM ART 15530 39); 172–3 (Art.IWM ART 15654 © Family Peel); 174 (Art.IWM ART 16395 © Bruce McLean. All rights reserved, DACS 2022. Gift of the artist and the Anthony d'Offay Gallery, 1990); 176 (Art.IWM ART 16337); 177 (Art.IWM ART 16023 © Michael Sandle. Gift of the artist, 1985); 179 (Art.IWM ART 16410 © The Estate of Rozanne Hawksley).

Chapter 4
180 (Art.IWM ART 17896 © The artist's estate. Gift of Wendy Smith, 2017); 183 (Art.IWM ART 17456 © Jock McFadyen RA. Gift of the artist.); 185 (Art.IWM ART 16414); 186 (Art.IWM ART 16737 © Jananne Al-Ani); 187 (Art.IWM ART 16634 © Rasheed Araeen. All rights reserved, DACS); 188 (Art.IWM ART 16455 © Nicola Lane. Gift of Mrs A Willett, 1992); 191 (Art.IWM ART 16521); 192 (Art.IWM PST 8602 © the rights holder. Gift of Stephen Crump, 2001); 193 (Art.IWM ART 16804 © Frauke Eigen); 194–5 (Art.IWM ART 16818 3 © Ori Gersht); 196–7 (Art.IWM ART 16746 © Graham Fagen. All rights reserved, DACS 2023.); 198 (Art.IWM ART 16762 © Darren Almond); 199 (Art.IWM ART 16767 © Paul Ryan); 200 (Art.IWM ART 17594 © the rights holder); 203 (Art.IWM ART 16793 © Paul Seawright); 205 (Art.IWM ART 17460 © Langlands & Bell); 206 (Art.IWM ART 17871 Courtesy Danielle Arnaud Gallery and the artist. Presented by the Contemporary Art Society, 2017–2018); 208 (Art.IWM ART 17596 © Shanti Panchal); 211 (Art.IWM ART 17290 © Steve McQueen); 212 (Art.IWM ART 17541 © kennardphillipps); 213 (Art.IWM ART 17898 © Edmund Clark 2016); 215 (Art.IWM ART 17869 © Rachel Howard. All rights reserved, DACS 2023. Gift of the artist, 2017); 216 (Art.IWM ART 17867 © Coco Fusco); 217 (Art.IWM ART 18045 Courtesy of The Artist, and Modern Art London); 218 (Art.IWM ART 17651 © the rights holder); 219 (Art.IWM ART 17543 © artist's estate); 221 (Art.IWM ART 17632 © The Estate of Shmuel Dresner. Gift of Shmuel Dresner); 223 (Art.

IWM ART 16803 2 © Angus Boulton); 224 (Art.IWM ART 16636 © John Kindness); 225 (Art.IWM ART 15526 © Rita Donagh. All Rights Reserved, DACS 2023); 226 (Art.IWM ART 17277 © Seán Hillen); 227 (Art.IWM ART 16591 © Willie Doherty); 228 (Art.IWM ART 17576 © Roderick Buchanan); 229 (Art.IWM ART 17631 © Mark Neville); 231 (Art.IWM ART 17750 © the artist); 232 (Art.IWM ART 17633 © Larissa Sansour. Presented by the Contemporary Art Society with additional funding from Wolverhampton Art Gallery and IWM, 2014); 233 (Art.IWM ART 17585 © ADAGP, Paris and DACS, London 2023. Presented by Art Fund and the Esmée Fairbairn Foundation to IWM and Wolverhampton Art Gallery); 234–5 (Art.IWM ART 17636 © Yazan Khalili. Presented by Art Fund and the Esmée Fairbairn Foundation to IWM and Wolverhampton Art Gallery); 237 (Art.IWM ART 17670 © Hew Locke. All rights reserved, DACS 2022.); 238 (Art.IWM ART 17619 © Alison Wilding. Gift of Karsten Schubert); 239 (Art.IWM ART 17865 © Mahwish Chishty); 240 (Art.IWM ART 17856 © the rights holder. Presented by Art Fund to IWM and Towner Art Gallery); 241 (Art.IWM ART 17900 © Thomson & Craighead. Presented by Art Fund); 243 (Art.IWM ART 17901 © the artist. Presented by Art Fund.).

Author's Acknowledgements

A book like this gathers and builds on the work of many others, and I am indebted to IWM art curators past and present, as well as to other specialists, for giving me their time and sharing their knowledge, thoughts and expertise. They include Angela Weight, Kathleen Palmer, Richard Slocombe, Alexandra Walton, Sara Bevan, Jenny Wood, Belinda Loftus, Clare Carolin, Brian Foss, and my current colleagues Iris Veysey, Paris Agar and Rebecca Newell.

Setting the broad historical context for each part of the art collection is a challenge, and I am extremely grateful for the advice, attention to detail and support of my curatorial and other specialist colleagues: Alan Wakefield, Sarah Paterson, Tony Richards, James Bulgin, Craig Murray, Amanda Mason and Gill Smith.

IWM's publishing team have provided enthusiasm and encouragement right from the start; my heartfelt thanks go to Lara Bateman, Madeleine James, David Fenton, to Georgia Davies for her beautiful design, and to Mark Hawkins-Dady for his tenacious approach to the editing process.

Many thanks, also, to numerous other colleagues at IWM who have kindly lent their support in different ways, including Richard Ash, Sarah Henning, Jane Rosen, Suzanne Bardgett, Ian Kikuchi, Leila Harris, Tara Farrell, Stephanie Balk, Lyn Morgan, Afshan Hassan and Julie Robertshaw.

My thanks also go to Sean, Rory, Martha, Moira and Adrian for their loving support.

About the Author

Claire Brenard has been an Art Curator at IWM since 2012. She has contributed to numerous IWM exhibitions, including *Architecture of War* (2013), *Visions of War Above and Below* (2015), *Age of Terror: Art Since 9/11* (2017), *Wartime London: Art of the Blitz at the Churchill War Rooms* (2020) and the Blavatnik Art, Film and Photography Galleries (2023) at IWM London.

Index

A

Abbess, Margaret, *Arriving at the Factory* 91, *92*
abstract art 76
abstract expressionism 137
Abu Ghraib prison 214, *215–17*, 216
Adams, Albert 214
aerial warfare 52–3, 141, *142*, 143
Afghanistan *see* War in Afghanistan
Ahmed, Osman, *Migration* 218, *218*
Air Raid Precautions (ARP) 32, *34–5*, 72, 73, 93–4, *95*, 99, *99*, 105–7, *106–7*, 133
Airy, Anna 54–6
 Munitions Girls Leaving Work 55, *56*
 A Shell Forge at a National Projectile Factory, Hackney Marshes, London 55, *55*
Almond, Darren
 Border 198, *198*
 Oświęcim, March 1997 198
Anfal campaign 218, *218*
Angels of Mons 18, *19*
Al-Ani, Jananne
 A Loving Man 186, *186*
 Untitled May 1991 [Gulf War Work] 186
Araeen, Rasheed, *White Stallion* 186–7, *187*
Ardizzone, Edward 92–3, 106, 110, 111, 118
 In the Shelter 106, *106*
Armstrong, John, *Pro Patria* 78, *78*
Artists' International Association (AIA) 76, 104, 107
Artists' Rifles 16, 40
Ashton, Graham, *815681945 or the Hiroshima Cartoon* 157, *158–9*
Auld, Eric, *Intruding Image* 147, *148–9*
Auschwitz concentration-camp network 197–200, *198–200*
Auxiliary Fire Service 96
Auxiliary Territorial Service (ATS) 92–3
Ayrton, Michael 131

B

Badawi, Zaki 184
Bairnsfather, Bruce, *'Where did that one go?'* 18, *18*
Bałka, Mirosław, *A Crossroads in A. (North, West, South, East)* 200, *200*
Balkans *see* Bosnian War; Kosovo War
Barker, Clive, *German Head 1942* 161, *161*
barrage balloons 91, *91*
Batniji, Taysir, *GH0809* 232, *233*
Battle of Britain 85, 86
 see also Blitz
Battle of Mons 18, *19*
Battle of the Somme 20
Bauhaus art school 75, 124
Bawden, Edward 110–11, 113
 Sergeant Samson: 1975th Bechuana Coy, 64 Group ... near Jdeide, Lebanon 110, 111
Bayes, Walter, *The Underworld: Taking Cover in a Tube Station During a London Air Raid* 32, *34–5*
Beaverbrook, Max Aitken, 1st Baron 39

Bechuanaland (Botswana) 111
Belfast, HMS 236, *236–7*
Belgium 36, *36*; *see also* Battle of Mons
Berlin 163, *164–5*, 165, 181–2, *183*
Bertelli, Renato, *Profilo continuo (Testa di Mussolini)*, or *Continuous Profile (Head of Mussolini)* 73, *75*
Blair, Tony 212, *212*
BLAST magazine 15, *15*
Blitz 85, 94, 96, 98, 101, *102–3*, 105–7, *106–7*
Bloomsbury Group 14–15, 75
Blyth, Robert Henderson, *In the Image of Man* 133, *135*
bomb damage 96, *96–8*, 138, *139*
Bomberg, David, *Sappers at Work: Canadian Tunnelling Company, R14, St Eloi* 43, *44*, 45
Bone, Muirhead 25–6, 40, 45, 61–2, 83
 Tanks 26
Borg, Alan 184
Bosnian War 189–90, *190–2*, 192
Boulton, Angus, *Cinema mural, Krampnitz. 16.3.99* 222, *222–3*
Bracken, Brendan 83
Bradley, Leslie 138
Brayfield, Celia 170
British War Memorials Committee (BWMC) 39–40, 42, 45, 48, 54, 56, 57, 59, 64, 65, 69
Buchan, John 26
Buchanan, Roderick, *Scots-Irish / Irish-Scots* 227, *228*
Burleigh, Charles, *Interior of the Pavilion, Brighton: Indian Army Wounded* 36, *37*
Burma (Myanmar) 126, *126–7*
Burra, Edward, *Blue Baby, Blitz Over Britain* 101, *102–3*

C

camouflage 46, 48, *48–9*
Campaign for Nuclear Disarmament (CND) 145, 147, 161
camps *see* concentration camps; internment camps; prison camps
Canadian War Memorials Fund (CWMF) 39, 43, 48
Careless Talk Costs Lives 82, 83
Carline, Richard, *Jerusalem and the Dead Sea From an Aeroplane* 53, *53*
Carline, Sydney, *British Scouts Leaving Their Aerodrome on Patrol, over the Asiago Plateau, Italy 1918* 52, *53*
Carter, Tony, *American Dream/Arabian Night 180*, 188–9
cartoons 18, *18*, 82–3, *82*
censorship 25, 60
Central Intelligence Agency (CIA) 137
Ceylon (Sri Lanka) 116, *117*
Chishty, Mahwish, *Drone Art* 238, *239*
Clark, Edmund and Max Houghton, *Orange Screen: War of Images* 213, *213*
Clark, Kenneth 80, 82, 83, 105
Clausen, George 13
 Youth Mourning 20, *21*
Coke, Dorothy
 War Allotments in a London Suburb 62
 Wounded Men on Duppas Hill, Croydon 62, *62*
Cold War, 137, 141
Coldstream, William 113
Cole, Leslie 125, 128, 130–1
 Belsen Camp Compound for Women 125
 Burmese Guerrillas in Action 126–7

colonial artists 113–16, *115–17*
computer games 240
concentration camps 108, 120, *120–5*, 122, 124–5
 see also Auschwitz concentration-camp network; internment camps; prison camps
control rooms 94, *94–5*
Conway, Agnes 54
Conway, Martin 38, 39, 70, 83
Cook, Frederick, *Aftermath: The Prudential Building, Plymouth 1951* 138, *138–9*
Cotterrell, David, *Gateway II* 206–7, *207*
Crete 175
Crozier, William, *Bourlon Wood* 143, *144*
Cuban Missile Crisis 143, 146

D

D-Day landings 118
dada 73, 80
'dazzle' camouflage 46, 48, *48–9*
De Bruycker, Jules, *La Mort Sonnant le Glas au dessus des Flandres (Sounding the Death Knell Above Flanders)* 36, *36*
Death, theme of 36, *36*, 61, *61*, 177, *177*
'degenerate' art 80
DeLappe, Joseph, *dead-in-iraq* 240
Department of Information (DOI) 26, 27, 28, 31
 see also Ministry of Information (MOI)
Dix, Otto 75, 80
Doherty, Willie, *Unapproved Road 2* 224, *226*
Donagh, Rita, *Shadow of the Six Counties* 224, *225*
Dossos, Navine G, *The Messenger and the Message* 240–1, *242*
Dresner, Shmuel, *Benjamin* 220, *221*
dressing stations 40, 42, *42–3*, 60, *60*, *66–8*, 69
Drew, Pamela 141, 143
 Lincolns of No.49 Squadron Attacking Hideouts with Bombs, Mount Kenya Beyond 142
drones 238–9, *238–40*
Dublin, HMS 46, *48*
Dunbar, Evelyn 82, 92, 93
 A Knitting Party 93, *93*
 Land Girl with Bail Bull 93
Dunkirk evacuation 86, 110

E

Eigen, Frauke, *Fundstücke Kosovo (Lost and Found From Kosovo)* 192, *193*
Empire
 British 13, 36, *37*, 39, 73, 110–16, *110*, *112*, *115–17*, 125, *126–7*, 141–3, *142*, 145, 181, 236–7, *236–7*
 Ottoman 30, *30*, 197
Epstein, Jacob 14, 38–9
 The Tin Hat 38, *39*
Eurich, Richard 85–6, 118
 Attack on a Convoy as Seen From the Air 84–5, 86
 Dunkirk Beaches, May 1940 86
Evans, Merlyn
 The Chess Players 140, 141
 The Execution 141
exhibitions
 Displaced (Osman Ahmed, 2008) 218
 Exhibition of National War Pictures (1945) 131
 For Liberty (1943) 107–8
 India in Action (Anthony Gross, 1943) 113
 John Keane: Gulf (1992) 184
 Legacy (Roderick Buchanan, 2011) 227
 The Nation's War Paintings (1919) 63–4
 Peter Howson: Bosnia (1994) 190

F

factories 54, *54*, 57, *57*, 88, *88–9*, 91, *92*
Fagen, Graham 196–7, 201
 Theatre 196–7, *196–7*
Falklands Conflict 168–70, *170–4*, *172–3*, 175
Far East 112, *112*, 125, *126–9*, *128–31*
fascism 73, 75, 78
Fast, Omer, *Five Thousand Feet is the Best* 239, *240*
Fergusson, Beatrice, *Liberty's Fool* 78–9
Fergusson, John Duncan, *Dockyard, Portsmouth, 1918* 12, 48
ffoulkes, Charles 36, 38
film 204, *205*, 213–4, *213*, 216, 222, 227–9, *228–9*, 230, 232, 231–32, 239–41, *240–41*
Finlay, Ian Hamilton and George Oliver, *Arcadia* 152
Firemen Artists 96
First World War, start of 15–16
Fougasse (Cyril Kenneth Bird), *'But for Heaven's sake, don't say I told you!'* 82–3, *82*
found objects 161, *161–2*, 184
Frampton, George 39
France 70, *71*, see also Western Front; Battle of the Somme
Freedman, Barnett 118
Fry, Roger 14, 15
Fusco, Coco
 A Field Guide For Female Interrogators 214
 Operation Atropos 214, *216*
Futurism *14–15*, 15, 25, 73, 75

G

gas masks 161, *161*
gas, victims of *66–8*, 69
Gaudier-Brzeska, Henri 16, 20
 Le Martyr de St Sébastien 20, *20*
Gaza see Israel/Palestine
Germany 86, *86–7*
 see also Berlin; Hamburg
Gersht, Ori, *Vital Signs* 192, *194–5*
Gilbert & George, *Battle* 154–5, 157
glass blowers 88, *88–9*
Gold Coast (Ghana) 114
Gross, Anthony 92–3, 108, 110, 111–12
 Battle of Arakan, 1943: Men of the 7th Rajput Regiment Resting on South Hill... 112, *112*
Grosz, George 75, 80
 Fear 74, 75
Grune, Richard, *Kostentzug* 124, *124*
Gulf War 182, 184, *184–8*, 186–9

H

Halter, Roman, *Dreams of the Holocaust: Gathering Jewish People From Village in*

Dorset Landscape 218, *219*
Hamburg 133, *135*
Hartman, Jan, *Death March – View into the Camp* 122, *123*, 124
Hassall, John, *St George Over the Battlefield* 18, *19*
Hawksley, Rozanne, *Pale Armistice* 178, *178–9*
Hennell, Thomas 118, 119, 126, 130
 Pioneers on a Frozen Road at Kapelle near Goes, Zeeland 119, *119*
Hicks, Philip, *War Requiem* series 147, *147*
Hill, Adrian, *The Railway Bridge, Hamel* 36, 38, *38*
Hillen, Seán, *Newry Gagarin Crosses the Border* 224, *226*
history painting 13–14, 23, 59
Hitler, Adolf 75
Hoffman, George Spencer, *First World War Sketchbook, Volume 1* 46, *47*
Hogan, Eileen, *Coronary Care Ward, Royal Naval Hospital, Haslar* 168, *169*
Hogarth, Paul, *Checkpoint Bravo, US Sector, Berlin 1981* 163, *164–5*, 165
Holocaust 108, *108–9*, 120, *120–5*, 122, 124
Holocaust survivors 218, *219*, 220, *221*
hospitals 36, *37*, 56, *56*, 129, *129*, 168, *169*
Houghton, Max 213, *213*
Howard, Ken, *"King Billy and the Brits", Belfast* 149, *150–1*, 151
Howard, Rachel, *Ali Shallal al-Qaisi* 214, *215*
Howson, Peter 189–90
 Cleansed 190, *190–1*
 Croatian and Muslim 190
 Entering Gornji Vakuf 1993–1994 190
 Three Miles from Home 1993–1994 190
humour 18, *18*, 82–3, *82*, 93, *93*, 106, *106*, 111, 113, 192, *192*, 224, *226*, 232, *233*
Hunter, Alexis, *War and Nature* 152, *153*

I
Imperial War Museums
 Admiralty committee 46, 48, 51
 Air Force committee 51, 52–3
 Art Commissions Committee (ACC) 201, 209–10
 Artistic Records Committee (ARC) 149, 151, 163, 165, 168–70, 175, 181–2, 189, 190, 193, 196
 Cold War period 138, 143, 146, 147
 collaborations 168, 189, 210, 232
 collecting policies 32, 36, 57, 61–2, 186, 192, 197, 212, 222, 236
 Far East Prisoners of War collection 130
 founding of 31–2
 medical artists 59–60, 61
 The Nation's War Paintings exhibition (1919) 63–4
 Second World War, at the start of 83
 as target for Provisional IRA 151
 War Artists Advisory Committee collection 134, 138
 War Trophies committee 36, 38
 Women's Work committee 51, 54–6, *54–6*
India 113–14
Indian Army 36, *37*
installations 180, *180*, 196, *197*, 210, *211*, 241, *241*
 see also video installations and projections
internment camps 32, *33*, 80
 see also concentration camps; prison camps
Iraq *see* Gulf War
Iraq War 209–10, *211–13*, 212–14, *215–17*, 216
ISIS 240

Italy *52*, 63, *63*
Isle of Man 80
Israel/Palestine 228, 230, *230–4*, 232–3
Ivens, Dr Frances 56, *56*

J
Jagger, Charles Sargeant 45, 69
 'Wipers' – Maquette for the Hoylake War Memorial, West Kirby 45, *45*
Jamaica 113–14, 116
Japan 128
Jewish people 80, 107–8, *108–9*, 120, *120–5*, 122, 124
Jungman, Nico, *Ruhleben Prison Camp: Christmas Dinner* 32, *33*

K
Keane, John 182, 184
 Alien Landscape 184
 Mickey Mouse at the Front 184, *184–5*
Kennard, Peter 161, 212
 Never Again 160
kennardphillipps, *Photo Op* 212, *212*
Kennington, Eric 23, 27, 113
 The Kensingtons at Laventie 22–3, 23
Kenya 141, *142*, 143
Kessell, Mary, *Notes from Belsen Camp* 122, *122*
Kestelman, Morris, *Lama Sabachthani?* 107–8, *108–9*
Khalili, Yazan, *Landscape of Darkness* 233, *233–4*
Kindness, John, *Sectarian Armour* 224, *224*
Kitchener, Herbert, 1st Earl 16
Kitson, Linda 168–70, 172
 Red Alert from Argentinian Look-Out at Goose Green, 8 June 1982 170, *170–1*
Knight, Laura 131, 133
 The Nuremberg Trial 132, 133
Korean War 141
Kosovo War 192–3, *193*, 196
Krikalev, Sergei 222
Kurdistan 218

L
landmines 202
Lane, Nicola, *Sunbathing Sergeants* 188, *188*
Langlands & Bell 201, 204
 The House of Osama bin Laden 204
 NGO 204
 Zardad's Dog 204, *205*
Lasekan, Akinola, *A Reflection on the Savings Week in Lagos* 116, *116*
Lavery, John 13, 27, 48, 51, 61
 Scapa Flow, 1917 50–1, 51
Lawson, Sonia, *Two minds with but a single thought (Peace Demonstration and Tanks)* 136, 168
Leete, Alfred, *Britons. Join Your Country's Army!* 16
Lewis, Alfred Neville, *Artillery Drivers in the Snow, Italian Front* 63, *63*
Lewis, Wyndham 8, 15, 48, 62–63, 65
 A Battery Shelled 65, *65*
Lion, Flora
 Building Flying Boats 57
 Women's Canteen at Phoenix Works, Bradford 57, *57*
Lloyd George, David 26, 39

Locke, Hew
 HMS Belfast 236, *236–7*
 The Tourists 236

M

Mackey, Haydn Reynolds 60, *61*
Maclise, Daniel 14
Malaya (Malaysia) 141
Maloba, Gregory, *The King's African Rifles in Camp* 115, 116
Marinetti, Filippo Tommaso 15, 73
Masterman, Charles 25
Mau Mau Uprising 141, *142*, 143
Mayer-Marton, George, *Women with Boulders* 124, *125*
McBey, James 27, 30
 Cacolets 30
McFadyen, Jock 181–2
 Die Mauer 182, *183*
McLean, Bruce, *Broadside* 174–5, *175*
McLean, Bruce and David Ward, *Song for the North* 175
McQueen, Steve 209–10
 Queen and Country 210, *211*
medical subjects 56, *56*, 59–61, *60*, *61*, 66–8, 69, 129, *129*, 168, *169*, 206–7, *207*
Meninsky, Philip 129, 130
 Emergency Operation, c.1946 129, *129*
Meyerowitz, Herbert Vladimir 114
Middle East 30, *30*, 53, *53*, 110, *110*, 111
 see also Israel/Palestine
Milow, Keith, *Iron Cenotaph* 176
Ministry of Information (MOI) 39, 80, 82
Minton, John 101, 131
 Blitzed City With Self-Portrait 100–1, 101
modern art 14–15, 65, 73, 80
Mond, Sir Alfred 31, 63–4
Monkhouse, Victoria
 A Bus Conductress 54, *54*
 A Woman Ticket-collector 54, *54*
Moore, Henry 94, 106
 Shelter drawings 106
 Two Women With a Child in a Shelter 107
murals 168, 222, *222–3*
Mussolini, Benito 73, *75*

N

Napoleonic Wars 14
Nash, John, *'Over the Top'. 1st Artists' Rifles at Marcoing* 40, *40–1*
Nash, Paul 16, 27, 76, 85, 86
 Battle of Britain 86
 Battle of Germany 86, *86–7*
 The Menin Road 58–9, 59
 Totes Meer (Dead Sea) 86
 We Are Making a New World 28, *28–9*
Nashashibi, Rosalind 228, 230
 ELECTRICAL GAZA 230, *230–1*
naval warfare 46, 48, 51, 236–7
 see also HMS *Belfast*
Nazism 75, 80
Neilson-Gray, Norah, *The Scottish Women's Hospital:... Dr. Frances Ivens Inspecting a French Patient* 56, *56*
neo-romanticism 88, *88–9*, 98, 99, 105, 143
Netherlands 119, *119*
Neville, Mark, *Bolan Market* 228, *229*
Nevinson, C R W 15, 16, 23, 25, 27, 60, 75–6
 French Troops Resting 24–5, 25
 Paths of Glory 60
 The Unending Cult of Human Sacrifice 76, *76–7*
Nigeria 116, *116*
Norman, Priscilla, Lady 54, 56
Northern Ireland 147, 149, 222, 224, *224–8*, 227
nuclear weapons, threat of 157, 161
Nuremberg trials 131, *132*, 133

O

official war artists 25, *26*, 27–8, *28–31*, 30–1, 40
 see also British War Memorials Committee (BWMC); DOI; Imperial War Museum; MOI
Oliver, George 152
Operation Desert Storm *see* Gulf War
Operation Inherent Resolve 240
Operation Lionheart 168
Orpen, William 13, 27, 31, 61, 63, 70
 Blown Up 31
 The Signing of Peace in the Hall of Mirrors, Versailles, 28th June 1919 63
 To the Unknown British Soldier in France 70, *71*

P

Pakistan 187, 201, 238–9
Panchal, Shanti, *Boys Return From Helmand* 208, *209*
Paris Peace Conference (1919) 63, 70
Peake, Mervyn, *The Evolution of the Cathode Ray (Radiolocation) Tube* 88, *88–9*
Peel, Michael 172–3
 MODERN WORLD 173
 Rejoice, Rejoice 172–3, *173*
Peries, Ivan, *Combined Control and Report Centre* 116, *117*
Petherbridge, Deanna, *Debris of War* 156, 157
Phillipps, Cat 212
Phillips, Tom, *Einer an Jeder Seite / One on Either Side* 175, *176*
photography 25, 192, *193–5*, 202, *202–3*, 206, *206–7*, 224, 227, 232, *232–4*, 233
 see also video installations and projections
photomontage 161, *172–3*, 173
Picasso, Pablo, *Guernica* 78
Piper, John, *The Passage to the Control-room at South West Regional Headquarters* 72, 94
plays 18, *18*
pop art 145–7, 161
portraits *110*, 113
post-impressionism 14
posters 16, 82–3, *82*, 173
Powell, Hugo 161, 163
 Salome 163, *163*
prison camps 128–30, *128–9*
 see also concentration camps; internment camps
prisoners 214, *215–17*, 216
projections *see* video installations and projections
propaganda 16, 25, 26, 39

Protect and Survive 157, 161
Provisional IRA (Irish Republican Army) 151

R
Ravilious, Eric 94, 110
 Wall Maps 94, *94–5*
reportage 149
Richards, Albert 118–19, 131
 The Drop 118, *118*
Roberts, William, *Rosières Valley – Signallers Looping a Wire* 64, *64*
Rogers, Gilbert 59, 60
Rogers, Gilbert and Haydn Reynolds Mackey, *An Advanced Dressing Station, France* 60, *60*
romanticism 98
Rosoman, Leonard 82, 96
 A House Collapsing on Two Fireman, Shoe Lane, London, EC4 96, *97*
Rothenstein, John 131
Royal Air Force (RAF) 51–3, 141, *142*, 143
Royal Navy 46, 48, 51
Royal Pavilion, Brighton 36, *37*
Ryan, Paul, *Concentrate* 199, *199*

S
Sami, Mohammed, *Abu Ghraib* 216, *217*
Sandle, Michael
 Twentieth Century Memorial 176–7
 Untitled 1985 (Death and the Bulldozer with Three Drummers) 177, *177*
Sansour, Larissa, *The Nation Estate* 232, *232*
sappers 43, *44*, 45
Sargent, John Singer 13
 Gassed 66–8, 69
Saudi Arabia *see* Gulf War
Scapa Flow, Orkney *50–1*, 51
Schwitters, Kurt 80
Scott, William 104–5, 131
 Soldier and Girl Sleeping 104, *105*
sculpture
 Cold War period 138, 146, *146*, 161, *161–3*, 175–6, *176*
 First World War 14, 38–9, *39*, 45, *45*
 Second World War 73, *75*
Searle, Ronald 128, 130, 163
 Inspecting Officer, Changi 1942 128, *128*
Seawright, Paul 201, 202
 Hidden 202
 Mounds 202, *202–3*
Second World War, start of 80
Self, Colin
 Guard Dog on a Missile Base, No. 4, 1966 146
 Humanity Hanging By a Thread 146
 The Nuclear Victim (Beach Girl) 146, *146*
Shah, Abdullah 204, *205*
ships *see* Belfast, HMS; 'dazzle' camouflage
shipyards 90, *90*
Sickert, Walter 14, 18
 Tipperary 17, 18
sketchbooks 45–6, 78, 106, 184
sleepers 105, *105*

Smith, Percy Delf 46, 61
 The Dance of Death series 61, *61*
soldier-artists 20, *20–5*, 23, 25
South East Asia 112, *112*, 125, *126–9*, 128–9
Soviet Union 137, 181, 222
Spanish Civil War 76, 78
Spare, Austin, *Dressing the Wounded During a Gas Attack* 61, *61*
Spencer, Stanley 40, 90
 Shipbuilding on the Clyde 90, *90*
 Travoys Arriving with Wounded at a Dressing-Station at Smol, Macedonia, September 1916 40, *42*
sublime, concept of 59, 157, 163
Suez Crisis 145
surrealism 73, 76, 78, 99, 101, 104, 161
Sutherland, Graham, *Devastation in the City: Twisted Girders Against a Background of Fire* 98, *98*

T
tanks 26, 47
technology 236, 238–41, *238–42*
terrorism *see* War on Terror
 9/11 terrorist attacks 200
theatre 18, *18*
Thomson & Craighead, *A Short Film About War* 241, *241*
Thrale, Charles 129, 130
 Executed For No Apparent Reason: A Study of the Mind or Something 128, 129
Tonks, Henry, *An Advanced Dressing Station in France, 1918* 42, *43*
trauma, responses to 216, 218, *218–19*, 220, *221*
travelling artists 110–13
Trevelyan, Julian, *Premonitions of the Blitz* 104, *104*
Tribe, Kerry, *The Last Soviet* 222
Trio Sarajevo, *Sarajevo Park* 192, *192*
Troubles *see* Northern Ireland
tunnelling *see* sappers
Turner Prize 204, 209, 230
Tuzo, Sir Harry 147, 149

U
Uccello, Paolo 8, 40
Uganda, 113–16, *115*
Uhlman, Fred, *A Dream of Open Gates* 80, *81*
Unit 1 76, 78
United States of America 137, 181
US Army 116, 122, 146–7, 182, 187–8, 209, 213–4, 240
Unknown Warrior 69–70, *71*

V
Vaughan, Keith 99, 101
 Echo of the Bombardment 99, *99*
veterans of war 62, *62*
Vézelay, Paule (née Margery Watson-Williams) 82, 90–1
 Barrage Balloon 91, *91*
video installations and projections 186, *186*, 198, 204, *205*, 216, *216*, 228–9, *228–9*, 232, *232*, 239, *240*
Vietnam War 147
vorticism 15, *15*, 48, *49*, 64, *64–5*

W

Wadsworth, Edward, *Drydocked for Scaling and Painting* 48, *49*
Walker, Ray 165, 168
 Army Recruitment 165, *166–7*
War Artists Advisory Committee (WAAC) 82–3, 85, 88, 90–1, 92–4, 96, 98, 106, 108, 110, 112–16, 122, 124–5, 131, 133–4
War in Afghanistan 200–2, *202–3*, 204, *205–8*, 209, 228, *229*
war memorials 45, *45*, 69, 176, 177
 see also British War Memorials Committee (BWMC); Canadian War Memorials Fund (CWMF); Unknown Warrior
War on Terror 200, 210, 212–13
Ware, William, *Fired City* 96, *96*
Western Front 20, *22–5*, 23, *25–7*, *28–9*, 31, *31*, 36, *38*, 39, 40, *40–1*, *58–9*, 59, 64–5, *64–5*
 see also dressing stations; sappers
Wilding, Alison, *Drone* 238, *238*
Wilkinson, Norman 46
Wolverhampton Art Gallery 232
women artists
 after First World War *78*
 Cold War period 152, *153*, *156*, 157, 168
 Falklands Conflict 168–70, *170–1*, 172
 First World War 54–6, *54–7*, 57, 62, *62*
 Gulf War 186, *186*, 188, *188*
 Iraq War (2003–2011) 212, *212*, 214, *215*
 Israel/Palestine 228, 230, *230–2*, 232
 Kosovo War 192, *193*
 Northern Ireland 224, *225*
 Second World War 92–3, *93*, 120, *120–2*, 122, 131, *132*, 133
 and technology 238, *238–9*, 240–1, *242*
women, as victims of war 146, *146*
Women's Land Army (WLA) 93
women's work
 First World War 46, 51, 54–7, *54–7*
 Gulf War 188, *188*
 Iraq War (2003–2011) 214, *216*
 post-Second World War 168
 Second World War 92–3, *93*
Woodrow, Bill, *Two Blue Car Doors* 161, *162*
World Trade Center attacks 200

Y

Yockney, Alfred 26, 57, 63
young British artists (YBAs) 181, 196, 198

Z

Zinkeisen, Anna 120
Zinkeisen, Doris, *Human Laundry* 120, *120–1*